NEWTO

Also by Raymond Tallis

NOT SAUSSURE: A Critique of Post-Saussurean
Literary Theory

IN DEFENCE OF REALISM

THE EXPLICIT ANIMAL

THE PURSUIT OF MIND (*co-edited with Howard Robinson*)

Newton's Sleep

The Two Cultures and the Two Kingdoms

Raymond Tallis
*Professor of Geriatric Medicine
University of Manchester*

M
St. Martin's Press

© Raymond Tallis 1995

All rights reserved. No reproduction, copy or transmission of this publication may be made without written permission.

No paragraph of this publication may be reproduced, copied or transmitted save with written permission or in accordance with the provisions of the Copyright, Designs and Patents Act 1988, or under the terms of any licence permitting limited copying issued by the Copyright Licensing Agency, 90 Tottenham Court Road, London W1P 9HE.

Any person who does any unauthorised act in relation to this publication may be liable to criminal prosecution and civil claims for damages.

First published in Great Britain 1995 by
MACMILLAN PRESS LTD
Houndmills, Basingstoke, Hampshire RG21 6XS
and London
Companies and representatives
throughout the world

A catalogue record for this book is available
from the British Library.

ISBN 0–333–60643–4 hardcover
ISBN 0–333–63300–8 paperback

10	9	8	7	6	5	4	3	2	1
04	03	02	01	00	99	98	97	96	95

Printed and bound in Great Britain by
Ipswich Book Co Ltd
Ipswich, Suffolk

First published in the United States of America 1995 by
Scholarly and Reference Division,
ST. MARTIN'S PRESS, INC.,
175 Fifth Avenue,
New York, N.Y. 10010

ISBN 0–312–12865–7

Library of Congress Cataloging-in-Publication Data
Tallis, Raymond.
Newton's sleep : the two cultures and the two kingdoms / Raymond Tallis.
p. cm.
Includes bibliographical references and index.
ISBN 0–312–12865–7 (cloth)
1. Science—Philosophy. 2. Art—Philosophy. I. Title.
Q175.T215 1995
001—dc20 95–18080
 CIP

Dedicated to **Michael Schmidt**, poet, novelist, critic, essayist, teacher, editor and 'onlie begetter', without whose encouragement, backed up by the hospitality of his *PN Review, Newton's Sleep* would not have come into being. Even more than this crucial stimulus, I am grateful for his detailed and penetrating criticism of much of the text – in particular 'The Difficulty of Arrival'. Many single-author books give the impression of being a long monologue. In the case of *Newton's Sleep*, this appearance is deceptive: much of it is in dialogue with a silent interlocuter. For this dialogue, Michael, many thanks.

Contents

Acknowledgements	ix
Preface: The Two Cultures and the Two Kingdoms	x

PART I THE USEFULNESS OF SCIENCE

1	Omnescience	3
2	Poets, Scientists and Rainbows	11
3	The Eunuch at the Orgy: Reflections on the Significance of F. R. Leavis	29
4	'The Murderousness and Gadgetry of this Age'	42
5	Anti-Science and Organic Daydreams	55
6	Epilogue: The Consequences of Omnescience	68

PART II THE USELESSNESS OF ART

	Introduction	77
7	Misunderstanding Art: The Freezing Coachman Reflections on Art and Morality	79
8	Misunderstanding Art: The Myth of Enrichment	94
9	Metaphysical Interlude: The Uselessness of Consciousness	111
10	The Difficulty of Arrival	126
	Life as a Problem	126
	Art as a Solution	150
	Objections	162
	Conclusion	204

Postscript: Art, Science and the Future of Human Consciousness 209

Notes and References 214

Index 255

Acknowledgements

The six essays comprising Part I, 'The Usefulness of Science' first appeared in a slightly different form in *PN Review*. They have been modified in the light of the responses they provoked among the readership of that journal and I am grateful, in particular, to Grevel Lindop for his article 'Newton, Raymond Tallis and the Three Cultures', which not only corrected some of the crasser errors in my original text but demonstrated that 'opposition is true friendship'. An inspiring weekend at a conference on *The Two Cultures* organised by Interalia with Lewis Wolpert, and much time spent with his brilliant *The Unnatural Nature of Science*, have further improved these essays.

'The Freezing Coachman' and 'The Difficulty of Arrival' have been broadcast as talks on Radio Three and I am deeply grateful to David Perry for commissioning them and continuing many years of encouragement.

Finally, this is an opportunity to make public acknowledgement of the wonderful support of Tim Farmiloe, Belinda Holdsworth and, latterly, of Charmian Hearne of Macmillan. Their faith and kindness have ensured the publication not only of *Newton's Sleep* but also its two predecessors, *Not Saussure* and *The Explicit Animal*. It is difficult to imagine how I could have been better treated. Many, many thanks.

<div align="right">RAYMOND TALLIS</div>

Preface: The Two Cultures and the Two Kingdoms

In her Translator's Preface to Derrida's *Of Grammatology*, Gayatri Chakravorty Spivak makes much of the fact that, although prefaces are located before texts, are a 'prae-fatio', a 'saying beforehand', they are usually written after them: in a real sense, they succeed the texts they precede.[1] This whiff of 'paradox' occasions a good deal of post-Saussurean excitement, although it is obvious that it would be more paradoxical if the author wrote the Preface before writing the book. But it does draw attention to the fact that what is true for readers is true also for writers: only after we have completed a book do we know what it has been about. If the Owl of Minerva takes wing at sunset one cannot blame her. The best time to bet on the outcome of a race is after it has been run. Therein lies the secret of her wisdom: it dawns at dusk.

The Preface, a forward look for the reader, is inevitably a hindsight-lit backward glance for the author, who is consequently exposed to a great temptation: that of rational reconstruction, of suggesting that the book he has ended up producing was one he had in mind all along. The truth is that the completed book is never the same as the book we felt coming on when we started writing. We may write because we have had a thought, perhaps even two, but the act of writing our thoughts down causes us to re-think: if not to retract our thoughts, at least to modify them, in the light of our other thoughts, especially if they, too, are written down. Moreover, a written thought becomes a site of interaction with others' thoughts: objections, connections, counter-objections suggest themselves. Furthermore, the requirements of clarity, of form, of genre, of the need to tell a story with a certain familiar shape and a certain acceptable length, etc. – as potent considerations in non-fiction as in fiction – also change the inchoate, bubbling swirl of our interior monologue or silent dialogue with others into something quite different. Often disappointingly so: our books are inescapably less radical than the shafts of inlight, the glimpses over the edge, that drive us to write them. So much so, that Paul Valéry – in one or other of his **personae**[2] – suggested that completed works are a kind of

Preface

waste product, an excrement of the thinking mind. He believed in a deep antipathy between the process of thought and its characteristic literary productions, even arguing that the true thinker would sacrifice **construire** (the building of books or systems) for **connaitre** (knowledge of the self, and heightened self-presence). Few thinkers (and certainly not P.V. himself) are undividedly committed to living out the consequences of this thought.

Though we cannot even aspire to such intellectual purity, we should try to resist the temptation to exploit the advantage of hindsight and preface a book with a statement as to what (single thing) it is about and what (single) motive or occasion it had, as if the text were a realised **entelechy**. This temptation is powerful: we like to think of ourselves, or to exhibit ourselves, as more inwardly transparent, more coherent, more continuous, than we in fact are. 'I wrote this book because' suppresses accident, fudge, opportunism, compromise and all those other things that are necessary if the choppy sea of the thinking mind is going to serve itself up in neatly cut blocks of text.

A study could be made of the way titles are used to confer retrospective unity on books, beginning with the kind of ploy book reviewers use, when they collect their judgements in book form, to unify a higgle of pieces that have in common only the fact that they were commissioned from the same pen and serviced the same mortgage. There are some books that may have genuine, intrinsic rather than merely ascribed, unity: philosophical treatises approximate most closely to this condition. Schopenhauer's *The World as Will and Idea* is a case in point where many hundreds of pages of text are the unfolding of the single idea expressed in the title. This is the exception; more commonly, the title is a device to persuade the reader that he or she is getting something that is bigger than the sum of its parts, rather than a mere miscellany.

There are larger issues here, going deeper than the relationship between the thinking mind and its public output, touching on the hunger for a unified vision of the world to which there corresponds a unitary self. Isaiah Berlin addresses this in his wonderful *The Hedgehog and the Fox*. His title derives from a fragment of the Greek poet Archilochus: 'The fox knows many things, but the hedgehog knows one big thing'. Taken figuratively, he says,

> the words can be made to yield a sense in which they mark one of the deepest differences which divide thinkers and writers, and, it

may be, human beings in general. For there exists a great chasm between those, on the one side, who relate everything to a single central vision, one system, less or more coherent or articulate, in terms of which they understand, think and feel – a single, universal organising principle – and, on the other side, those who pursue many ends, often unrelated and even contradictory, connected, if at all, only in some **de facto** way, for some psychological or physiological cause, related by no moral or aesthetic principle. These last lead lives, perform acts and entertain ideas that are centrifugal rather than centripetal; their thought is scattered or diffused, moving on many levels, seizing upon the essence of a vast variety of experiences and objects for what they are in themselves, without, consciously or unconsciously, seeking to fit them into, or exclude them from, any one unchanging, all-embracing, sometimes self-contradictory and incomplete, at times fanatical, unitary inner vision.[3]

The first kind of personality belongs to the hedgehogs, the second to foxes. Berlin argues that Tolstoy's tragedy was that he was a fox (how could he be otherwise when he took such detailed notice of the real world?) who wanted to be a hedgehog. He was a man incapable of overlooking the variousness and multiplicity of the world but who nevertheless longed to be possessed by – or to possess the world through – One Big Idea.

The characters of the 'Hedgehog' and of the 'Fox' are perhaps less permanent characteristics of some writers than poles of the writing impulse: on the one hand to preserve the irreducible many-ness of things and on the other to gather it them all into one; the urge to find the Other and the equally strong urge to find that it is Same. In some cases, 'Hedgehog' and 'Fox' label impulses that may alternate with one another in a single writer who may sometimes feel foxy, at others hedgehoggy. I would count myself as such a case, being content at some times to find (in Lichtenberg's phrase) 'a Doctrine of Scattered Occasions' and at others seeking to uncover a single large idea, which can be unpacked into the world and into which the world can be packed.

This is a fox's rather than a hedgehog's book and I shall almost resist the temptation to pretend that it was conceived as a whole and to impose upon it unities of thought, vision and intention that no book has or could have. The lack of complete unity will be frankly avowed – if only because I am aware that it is betrayed in the

disparity not only of content but of style. The angry polemics of the pieces on the 'omnescience' of humanist intellectuals are remote from the more personal and reflective note of 'The Difficulty of Arrival'. In the long footnotes to that chapter, in particular, there is a more exploratory and 'essayistic' tone pointing to a different kind of book and to deeper uncertainties. The thread of the text is fluffy with unresolved and unexplored ideas and issues.

In spite of the claims this Preface will shortly make, multiplicity is built into *Newton's Sleep* from the beginning, since it has at least three different sorts of triggers. Two come from my experience in medicine and the third derives from my desire to revisit the philosophical intuitions that I have expressed elsewhere – but most explicitly in my one-thought, hedgehog book, *The Explicit Animal*.

First, medicine. As a pre-clinical student, I considered myself rather bright: I was fairly good at remembering things and was able to follow complex arguments and to grasp abstract concepts with comparative ease. Transition to clinical medicine came as a shock, partly because it meant facing the reality of responsibility and dealing with uncertainty: I had to learn how to cope with making absolute and irreversible decisions in the context of partial knowledge. But more than this, it was a discovery that I was stupid and that my stupidity was intimately bound up with the thing that had hitherto been the main prop of my self-esteem, my supposed intelligence. This was brought home to me as soon as I attempted that act central to medicine: making a diagnosis. In my first few weeks on the wards, I made a series of brilliant diagnoses in which I put together the patient's symptoms with a mastery that would have made Sherlock Holmes eat his heart out, recognising rare conditions from the slightest hints. Every single one of these diagnoses was wrong – and ludicrously so. And they were wrong precisely because they were brilliant. I learnt several things from this: that 'common things occur commonly', so that a sense of probability is more important than an ability to summon recherché information from the recesses of one's mind; and that the place of brilliance in the things that matter in practical life is somewhat limited. Painstaking observation and common sense may be more useful than rarefied and abstract thought. Most important of all, I learnt that interpretations that fit together brilliantly – and so reflect the brilliance of one's own mind – are almost certainly going to be wrong.

I was angry at this humiliating experience and my anger eventually spread out to much of the intellectual world with

which I had hitherto aligned myself against my seemingly narrow fellow students. I had a particular animus against those who, without fear of contradiction by ascertainable fact, were able to pronounce upon large stretches of the world. My most enduring contempt was for those humanist intellectuals whose professional life was devoted to making and printing and teaching assertions – about society or works of literature or about science – that could not be checked. Everything fitted in with **their** diagnoses – just as it did with my first year medical student diagnoses – but theirs, being uncheckable, retained their brilliance – until fashions changed and they were outshone by another diagnosis yet more brilliant. I regained my respect for science; and for those who worked in the realm of the testable, and addressed the opacity of matter in full recognition that the world was deeper than and different from the things we could think up in our clever little heads. When, as happened in the 1970s and 1980s, humanist intellectuals turned an increasingly hostile gaze upon science, my anger intensified. It seemed to me that the discourse about the future of the world, the battle over the world's soul, was dominated by sophomores, by individuals who would remain forever the equivalent of clever, first-year medical students. That anger pervades 'The Usefulness of Science'.

Second, medicine. For six months I was a junior doctor in obstetrics in a working class town in the West Midlands. My duties included care for women admitted to an ante-natal ward because they had the signs of pre-eclampsia. The treatment of this painless condition was rest and relaxation. For some patients, this meant that, for the first time in their lives, they had real leisure: no husbands, children, parents, siblings, bosses etc. expected anything of them. They were free to think, to reflect – and to read. Sadly, during my six months as Senior House Officer, I do not recall one of my patients reading anything other than tabloid newspapers or weekly magazines. The *'Magic Mountain* Effect' was not observed and no Hanna Castorps were born as a result of the weeks in the sanitorium. Perhaps it was silly to expect this: those who already had children were missing and worrying about them; and life as a hospital patient is a series of interruptions.

Even so, the experience made explicit what I had often thought implicitly: how small a place high culture – in particular, literature and philosophy – has in the world of ordinary people (and most human beings are ordinary). Medicine had already brought home to

me the totally consuming nature of illness and this had put literature and art in its place: even the dying were more concerned about having their pain controlled and getting to the toilet before they vomited than reflecting on the transience of life and the metaphysics of being and/or having a body. My months on the ante-natal words simply finalised my views: the Examined Life – and all its paraphernalia of reading and writing and preoccupation with art and philosophy and 'cultural issues' and one's soul – was the pursuit of a tiny minority.

Thirdly, philosophy. The drive behind almost everything I write is an astonishment, initially spontaneous, now increasingly cultivated, at Man, the Explicit Animal, the creature who tries actively to make sense of things, and who in some instances tries to round off that sense. This intuition was explored at length in my last book – unsurprisingly titled *The Explicit Animal*. With the exception of the piece on 'The Uselessness of Human Consciousness', there is little direct overlap between *Newton's Sleep* and that book. Nevertheless, the intuitions are active, both in my defence of science and admiration for those who try to extend our understanding of things, and in my theory of why we (or some of us) require art. The critique of science advanced by some humanist intellectuals is simply inadequate to its object: it is informed by an insufficient appreciation of the difficulty of making scientific discoveries; and by a shallow lack of wonder – at the achievement of sciences and at the mysterious fact that a handful of human beings have so enormously extended our understanding of things and utterly transformed human life, and so the possibilities of life (indeed matter) itself. This feeds back into my anger at the knowingness of those who are *au courant* with everything and feel able to pronounce on society, science and the universe, without fear of empirical test. If there is such a thing as a purely intellectual ethic, in my case it takes the form of a disgust at 'knowingness' – the fabric out of which much cultural criticism, particularly of the postmodern variety, is made. But that is the theme of another book:[4] my work has already been cut out making the pages that follow seem to tell one story.

This truly cunning preface therefore acknowledges the irreducible multiplicity of *Newton's Sleep* while at the same time asserting its essential unity by claiming that it is informed by a *Weltanschauung* perhaps distantly related to the implicit vision of *The Explicit Animal*. A yet more cunning preface would confer retrospective unity on the

book as follows. I am sure this is not honest and I am not sure that it is even desirable, but here goes.

We may legitimately demarcate two realms or Kingdoms: the Kingdom of (intermediate) Means and the Kingdom of (final) Ends. In the Kingdom of Means, we are concerned with those actions that will sustain life and comfort (or freely chosen discomfort). In the Kingdom of Ends, we are concerned with the ultimate purposes of life, with what we should do with the consciousness that is given to us, when the agenda of that consciousness is freely chosen rather than dictated by suffering and need. Medicine, for example, belongs to the Kingdom of Means: its best achievement is to restore someone to full health, to normal Tuesdays, Wednesdays etc. It does not answer the questions 'what should one do with a normal Tuesday?', or 'why live out a normal Wednesday?' For some, the answers to the questions are self-evident: the ultimate purpose of life (and comfort) is to be found in helping others to life (and comfort): the point of normal Tuesdays is to be found in the labour of returning others to normal Tuesdays. The Kingdom of Means becomes an end in itself. This is particularly attractive for those whose religious beliefs countenance the assumption that the good they do on earth will translate into treasure in Heaven. Serving the Kingdom of Means will be identical with serving the Kingdom of Ends. For others, this will not be a satisfactory answer: it will seem as if everyone lives by taking in everyone else's axiological washing. We need more than this. This 'more' has hitherto been provided by religious belief or, in the case of a small minority, the consolations – or at least the explorations and contemplations – of philosophy.

More in tune with contemporary thought, Matthew Arnold famously assigned this role to poetry:

> The future of poetry is immense, because in poetry, where it is worthy of its high destinies, our race, as time goes on, will find an ever surer and surer stay. There is not a creed which is not shaken, not an accredited dogma which is not shown to be questionable, not a received tradition which does not threaten to dissolve. Our religion has materialised itself in the fact, in the supposed fact; it has attached its emotion to the fact, and now the fact is failing it. But for poetry the idea is everything; the rest is a world of illusion, of divine illusion. Poetry attaches its emotion to the idea; the idea **is** the fact. The strongest part of our religion today is its unconscious poetry.[5]

Poetry, for Arnold, stands metonymically for all art. And more than metonymically: poetry is the paradigm art because it 'is thought and art in one'.

In 'The Uselessness of Art', I, too, assume that religion has lost its central place in the Kingdom of Ends and that this has been appropriated by art. In 'Misunderstanding Art', I endeavour to rescue literature and the other arts from the Kingdom of Means where moralists and ideologues and educationalists would hold them prisoner. In 'The Difficulty of Arrival' I propose that art enables us to dwell, if only temporarily, in the Kingdom of Ends. It completes, perfects, enlarges, rounds off experience sought for its own sake, so that it can be truly experienced. Unlike Matthew Arnold, I do not grant a pre-eminent place to poetry or to any single one of the arts. The perfected consciousness, in which ideas are realised in experience and experience is transilluminated by the idea of itself, may be made available through music, through poetry, through painting – through any medium in which 'the moving unmoved' of Form is realised.

Arnold's essay (indeed Arnold's entire ethos) is relevant to the concerns of *Newton's Sleep* – as are his views on the relationship between science and art:

> More and more mankind will discover that we have to turn to poetry to intepret life for us, to console us, to sustain us. Without poetry, our science will appear incomplete; and most of what now passes with us for religion and philosophy will be replaced by poetry. Science, I say, will appear incomplete without it. For finely and truly does Wordsworth call poetry 'the impassioned expression which is in the countenance of all science'.[6]

The implied opponents here are those, such as Spencer, for whom science had taken over the mantle of religion, expropriating both the value of its facts and the magnificence of its vision.

In his criticism of an earlier version of the essays in 'The Usefulness of Science'[7], Grevel Lindop quotes Herbert Spencer's answer to the question 'What Knowledge is of Most Worth?':

> Such facts as that the sensation of numbness and tingling commonly precede paralysis, that the resistance of water to a body moving through it varies as the square of the velocity, that chlorine is a disinfectant – these, and the truths of science in

general, are of intrinsic value; they will bear on human conduct ten thousand years hence as they do now. While that kind of information which, in our schools, usurps the name History – the mere tissue of names and dates and dead unmeaning events – has a conventional value only: it has not the remotest bearing on any of our actions.

This passage – from Spencer's essays on *Education: Intellectual, Moral and Physical* (London: Williams & Norgate, 1902) – has the voice and outlook of Mr. Gradgrind. But there are larger claims to come:

true science is essentially religious . . . inasmuch as it generates a profound respect for, and an implicit faith in, those uniformities of action which all things disclose. By accumulated experience the man of science acquires a thorough belief in the unchanging relations of phenomena – in the invariable connection of cause and consequence – in the necessity of good or evil results. Instead of the rewards and punishments of traditional belief, . . . he finds that there are rewards and punishments in the ordained constitution of things; and that the evil results of disobedience are inevitable. He sees that the laws to which we must submit are both inexorable and beneficent. He sees that in conforming to them, the process of things is ever towards a greater perfection and a higher happiness.

Thus to the question we set out with – What knowledge is of most worth? – the uniform reply is – Science.

After repudiating traditional religion, Spencer has, as so often is the case, transferred its longings and fantasies to something else which acquires absolute value and becomes the centre of worship: idolatry returns. Science has found it difficult to carry off the role assigned to it by Spencer – or not, at least, single-handed. Nor has it wanted to. Its focus has been on the how rather than the why, on facts and general laws rather than values.

Huxley – who is usually identified as Arnold's great adversary – held views that were less absurd, more measured, less philistine than Spencer's. In his famous lecture 'Science and Culture', delivered on the occasion of the opening of the Science College in Birmingham, whose benefactor had stipulated that no provision be made at the college 'for mere literary instruction and education', Huxley simply made the point that – *pace* Matthew Arnold (whose

views he was implicitly correcting) – science too, was part of High Culture, whose essence is the criticism of life, and that 'the best that has been thought and said in the world' includes science. Science, too, may enlarge the intellect, open up the mind to new modes of being and understanding.

In a post-religious world, science and art share, and sometimes contest, the commanding heights of human culture. Each has been misrepresented in different ways and been disabled by exaggerated claims for its role in life, based upon a misunderstanding of the separate but complementary functions of both. Art has suffered from utilitarian expectations. These have laid it open to condemnation on the grounds of uselessness, impotence, etc: 'poetry changes nothing'. Science has suffered under the burden of spiritual claims and then been condemned because it cannot fill the absence of God, because it addresses the question How? and fails to address the deeper question Why? Art is attacked for inoperancy in the objective world, science for failing to satisfy needs of the subject; art for ignoring the material hunger of the great masses, science for ignoring their spiritual hungers. This is as irrational as complaining that *Le Rouge et le Noir* teaches one nothing about snooker; or that *Philosophical Investigations* is a lousy detective story.

If there is an over-riding thought in this book it is that we have to separate the Kingdom of Means from the Kingdom of Ends and judge the things that serve the two Kingdoms separately and accordingly. This seems obvious and yet it proves surprisingly difficult to keep in mind – perhaps because we still bear within us the collective memory of religious belief which spanned both Kingdoms. Believing in an intrinsic moral law in the universe meant that one could expect to prosper materially if one served God spiritually; being useful was a means to salvation that went beyond use in this life; a rain dance, which was both art and technology, was simultaneously an act of worship addressed to something that transcended this life and at the same time an act that served this life; God was both a metaphysical and a moral force – half Big Bang and half petty-minded moral policeman, the Ground of both the starry sky above and of the moral law within. We need to awaken out of this assumption that the Kingdom of Means and the Kingdom of Ends necessarily coincide.

I have of course exaggerated and polarised for polemic purposes. There is more than a **soupçon** of irony in the contrasted titles of the two parts of the book: 'The Usefulness of Science' and 'The

Uselessness of Art'. Yes, there is a laudable prejudice in favour of the useful in science. The recurrent question – asked as much of new theories as of new techniques and technologies – is 'Does it work?'. But, of course, science is more than merely useful: it does not disappear without remainder into applications, into technology. There are 'experiments of light' as well as 'experiments of use' and the increasing body of knowledge about the world, both applied and non-applied, applicable and non-applicable, feeds back into – or should feed back into – our sense of who and what we are, even if science has nothing to say about why we are, or how we are to treat one another, or why there is something rather than nothing. (The arts, however, are curiously mute these days on this as well.) Yes, science is always provisional, always *en route* to better understanding, greater mastery, of the natural world – science progresses, art does not – and is firmly rooted in the Kingdom of Means; but it is a cultural organism that has more than roots. And just as science is not without its illuminations, so art is not entirely without its uses: it is not inconceivable that the arts have had a civilising influence at some times, have played their part in the moral advance of mankind, howsoever indirect (though it remains uncertain to what extent they owe this to their involvement with religion and the moral authority derived from religious precepts). To this extent the arts may claim a modest place in the Kingdom of Means.

Let me end with a *profession de foi*. At the highest level, art and science converge. The mathematisation of nature is an inspiration as well as a tool: after all, Western mathematics began as a way of interpreting matter in musical terms and of listening into the music of the spheres. And the art of the past is a spur to greatness, to achievements that may practically benefit mankind. Art and science both contribute to the great adventure of human consciousness in its attempts to surmount the contraints of its life and to transform ordinary daylight into the substance of a vision. At the highest level, where the Kingdom of Means is subsumed, the two cultures merge into one. Whether, as Grevel Lindop (op. cit.) suggests, this point of convergence marks the emergence of a third culture and this third culture is religion, I would not like to say. I sincerely hope that, if it is, the religions of the future will be utterly unlike the religions of the present and the past.

Part I

The Usefulness of Science

1
Omnescience

The concern behind these essays on 'The Usefulness of Science' has been expressed with admirable succinctness by Lewis Wolpert in his recent book:

> Science is arguably the defining feature of our age; it characterises Western civilisation. Science has never been more successful nor its impact on our lives greater, yet the ideas of science are alien to most people's thoughts.[1]

It is deeply unsatisfactory that most people should be distant from the major cultural force of our time, being engulfed in the technological consequences of science but having no insight into its basis, its methods, its powers and its limitations.

While nobody who wishes to be considered a responsible citizen of the world has a right to be ignorant of and muddled about one of the major determinants – for good or ill – of planetary health, I am here less directly concerned with 'most people' than with humanist intellectuals who, ignorant of science themselves, have been influential in ensuring that such ignorance should be acceptable and that a knowledge and understanding of science should not be regarded as central to general education. My theme will be recognised, therefore, as that of the Two Cultures – the deep divisions of outlook and knowledge between individuals educated in the sciences and those educated in the humanities.

The problem of the Two Cultures is, it seems to me, even more pressing than when C. P. Snow gave his Rede lecture[2] in 1959 and F. R. Leavis' response – the infamous Richmond Lecture[3] – did much to bring serious debate to an end, supplanting it with gossip and what Mary Midgley has described as 'tribal warfare'. Added urgency comes from deepening confusion about the place of science and technology and about the powers and responsibilities of scientists and technologists in addressing the problems of the planet and its inhabitants. This confusion – and an associated

contempt for or hatred of science and technology – has been compounded by writers such as Bryan Appleyard[4], who condemn science on the grounds that it is anti-human and de-spiritualising, and Alan Gross[5], for whom science's claims to providing objective truth about the natural world are derided as tricks of rhetoric, and by a thousand muddled and ill-informed articles in 'quality' newspapers in which the inhospitality of the planet, the unassuaged hungers of the human spirit and the immemorial tendency for people to be nasty to each other are all laid at the door of science and/or technology.

The theme of the Two Cultures has a huge and deeply folded surface and I am uncomfortably aware that any discussion of finite duration will be unavoidably simplifying, trading in generalities to an unwelcome degree and dealing only patchily with its complex subject. Caricature is almost inescapable as the characters of the 'scientist' and the 'humanist intellectual' are wheeled on-stage to be discussed. The idea of a single wall dividing two areas of knowledge – one accessed by humanist intellectuals and another accessed by scientists – is a grotesque reduction. There are barriers **within** the sciences and humanities: many poets are ignorant of and despise philosophy and many philosophers return the compliment. On the other side of the notional divide, we may note that biologists may have only a limited grasp of quantum physics and physicists a mere smattering of biology. Compared with what we might know if we had enormous longevity, and an infinite appetite for knowledge combined with commensurate retentive powers, we are all deeply and widely ignorant.

The necessity for simplification in part explains why discussion in this area invariably generates more heat than light. Thirty years on, Snow's Rede lecture is more remembered for the scandal generated by Leavis' vituperative attack upon it than for the many telling points which, with all its faults, that seminal lecture made. Considerations of space force me to be less even-handed than Snow was; for I shall be addressing primarily the failure of humanist intellectuals to engage with science and not scientists' ignorance of those things that preoccupy humanist intellectuals, though of course, the failures are bilateral.

Nevertheless, the issue seems worthwhile addressing even in a less than entirely satisfactory way: if a thing is **really** worth doing, it is worth doing even badly. For the problem aired by Snow has certainly not disappeared in the decades since he wrote, as is

dramatically illustrated by the depressing results of a recent survey into the general public's understanding and knowledge of science:

> One-third of the British believe the sun goes round the earth, over half believe antibiotics kill viruses as well as bacteria, one in seven think that radioactive milk can be made safe by boiling it. As for DNA, many people think it has something to do with computers, rocks or stars.[6]

These are not isolated scotomata but part of that more general ignorance suffered quite painlessly by those whose education has somehow failed to awaken in them an appetite for the larger truths. As such it is not a matter for separate surprise. What is astonishing, however, is that ignorance of science is shared by others who, not without reason, think of themselves as well-educated and who take a lively and critical interest in wider issues and ideas: journalists, senior civil servants, teachers in higher education establishments. And though most of these will have caught up with Copernicus' daring heliocentric conjecture, it is a safe bet that few will be able to give any of the evidence for it.

We are not talking about small gaps in an otherwise extensive knowledge of modern scientific thought but, on the contrary, near-total darkness encompassing such matters as: the difference between the Special and the General Theory of Relativity; how a radio works; the mechanism of contraction of the muscles that make ordinary life possible; current thought about the nature of matter and the origin of the universe; and how the word processors upon which rejoinders to this essay may be typed actually function. Ignorance of the **facts** and laws uncovered by science is complemented by a deep unfamiliarity with its concepts and an inability to understand its methods. This last is reflected in the common belief that there is such a thing as **the** scientific method, as if this were some kind of a recipe; a failure to appreciate the complex interaction of mathematical and/or experimental skill, intuition, persistent thought, background knowledge, rigour, honesty, imagination and a sense of the probable, in the generation of hypotheses and the design of experiments to test them. And ignorance is rounded off by a less-than-rudimentary understanding of the technology in which science is implemented.

That such 'omnescience' is usually unaccompanied by any desire to amend it, that individuals who often have a passionate interest in

quite abstract matters – such as discriminating and enumerating the modes of sensibility found in the works of Saint-Amant – are entirely deficient in curiosity as to what science has revealed to us about the world, that they as it were lack a whole dimension of intellectual libido, should be a matter for intense astonishment. And yet it is taken for granted. Indeed, it is fiercely defended: those who deplore educated non-scientists' ignorance of science do so at their peril. Leavis' malicious and incoherent response to Snow's Lecture is only the most notorious instance of refusal of dialogue.

What are the reasons for this omnescience? The most obvious is that scientific discourse is difficult and it is reasonable to assume that humanist intellectuals share the common human preference for avoiding difficult things. Even an elementary equation, such as the one representing the law of universal gravitation

$$F = \frac{Gm_1 m_2}{d^2}$$

is more opaque to non-scientists than all but the most intractably obscure modern verse. And if we venture into more difficult areas, a few lines from August Stramm at least give the promise of meaning while, to all but an initiated few, the Schrodinger Wave equation does not.

Of course, it is not necessary to be at home with complex equations to have a perfectly adequate understanding of the achievements, the insights and the methods of science. But it has been suggested (often by those who feel defensive about their ignorance) that, equations apart, scientific writing is not only difficult but unnecessarily so; that scientists, untrained in the use of the semi-colon, are semi-literate; or that they deliberately cultivate a jargon that will keep out the tourists. There is little reliable epidemiological evidence that scientists are particularly bad prose writers; in my own experience, when it comes to writing barbarically, scientists are amateurs compared with, for example, literary theorists.[7] There is equally little evidence that scientists deliberately write badly in order to ensure that non-scientists shall not be privy to their deliberations. What evidence there is suggests that much of the difficulty professional science writing presents to non-scientists is not due to the mischievous use of jargon designed to keep out the non-initiates but to a highly compressed, economical discourse in which are embedded many concepts for which there is

no need in ordinary life or equivalent in everyday discourse. What we see in science writing is not so much gratuitous jargon as the necessary deployment of technical terms. The difference between the two is stated quite easily: the use of jargon increases the number of words required to express something while the use of technical terms reduces it. If a typical short letter to *Nature* were re-written using only words that would be immediately understandable to the scientific omnescient, while meeting the necessary standards of precision, it would occupy many volumes. Fully describing what DNA, let alone messenger RNA or oligonucleotides, is to a layperson determined not to make him or herself informed of the background cell biochemistry would be an endless task.

An interesting study published by Charlotte Bell, a lecturer in English, compared the style and readability of contributions to the *Lancet* in the 1880s and the 1980s.[8] She concluded that articles in the journal had, indeed, become more technical and difficult in the intervening century but that this was entirely justified, as it reflected the increased intrinsic difficulty of the topics covered. The reader of a scientific paper is entering a conversation that has been going on for over 2000 years. Each step in science builds on the last – as E. M. Forster pointed out,[9] science progresses in a fundamental sense in which art does not – so its discourse inescapably deviates increasingly from that of everyday life, except inasmuch as it feeds back into and changes everyday discourse.

Professional science writing, with or without equations, is thus inescapably difficult. This does not, however, mean that non-scientists can be excused engaging with science: there is no shortage of reliable popularisations that assume only a modicum of numeracy on the part of the reader. All that is required is some effort. That effort does not seem to be forthcoming. Why?

Lewis Wolpert has identified a further source of resistance in his book *The Unnatural Nature of Science*:[10] the findings of scientists are often contrary to common-sense expectation. We encounter this early: when, on being told that the earth is round not flat, we can't understand why people in Australia don't fall off. Wolpert has explained the counter-intuitive nature of science in evolutionary terms with which I would not entirely agree: 'our brains have been selected to help us to survive in a complex environment; the generation of scientific ideas plays no role in this process'. Evolutionary explanations of specific cultural phenomena are always somewhat suspect (as I have argued in *The Explicit*

Animal).[11] After all, the brains of humanist intellectuals and laypeople, who have difficulty with scientific concepts, have been selected by the same evolutionary pressures as those of scientists who seem at home with them. Perhaps it is sufficient to say that science is unnatural because it aims to view the world in a manner as liberated from the ordinary standpoint of human perception as possible. Of course, it encompasses – or aims to encompass – what is made available to human perception (otherwise it would be of neither interest nor use) but treats that as only a special case. The General Theory of Relativity which places all possible viewpoints on an equal footing is the supreme expression of this. This repudiation of the privileged view of the ordinary unreflective observer may be what makes science particularly hard.

The objectivity of science is connected with more homely reasons for its difficulty. Science is difficult for many people because they find it hard to concentrate on and this in turn is because it is about as remote as possible from gossip. It doesn't appeal to the airhead in us. What Thomas Nagel poignantly titled the 'view from nowhere' – the totally objective view that is the asymptote of scientific enquiry – is far from the egocentric particulars of everyday life and the self-absorption that is our natural and comforting standpoint. Most people are infinitely more interested in who went to bed with whom than in the structure of the hormones by which sexual desire is modulated or the process by which sexuality evolved. As Ulrich, the hero of Robert Musil's *The Man Without Qualities* remarks, most people are more interested in the specific who than the general what – in individual cases than in the general laws they instantiate.

The humanities are closer to this ordinary gossipy interest than science is. The kind of effort routinely demanded of professional scientists is rarely required of humanist intellectuals. Reading a novel appeals to something closer to our everyday curiosity than reading a scientific treatise. A poem is infused with the feelings and intuitions of everyday life, howsoever complex and elaborated these are. The stories told by historians are closer to the tales told in pubs than to a scientific account of a natural phenomenon. No wonder those trained in the humanities find science unattractive and desist from any attempt to overcome its difficulties.

This is not an entirely comfortable option. As Lionel Trilling has said, 'the exclusion of most of us from the mode of thought which is habitually said to be the characteristic achievement of the modern age is bound to be experienced as a wound to our intellectual self-

esteem'.[12] One way of dealing with this unease is to cultivate a contempt for science and for the technology flowing from it. This contempt needs to be rationalised, to be legitimated. In what follows, I shall examine various legitimating tactics: the misuse of the Romantic critique of the Industrial Revolution; the attempt to cut science down to size by undermining its claims to truth; the assumption of huge spiritual damage done by science so that it is responsible not only for the 'gadgetry' but also for the 'murderousness' of this age; and fantasies about non-scientific solutions to meeting the material needs of those living on this planet. As well as examining the motives behind the denigration of science, I shall point out the dangers posed to the health and happiness of the planet when a large section of the intelligentsia is ignorant of and hostile to technology and science.

If I do my job properly, I may cause considerable offence in certain quarters. For the tale I have to tell is not only about ignorance and muddled thinking but also about hypocrisy – the habit of inveighing against the iniquities and disasters made possible by science while taking its benefits for granted; about jealousy – putting science in its place to secure one's own place in the sun; and about idleness – the tendency to dismiss ideas, – *locating* them, rather than thinking through, with or against them. At the very least, I want to show that the distaste for technology, epidemic in those trained in, and teaching, the humanities, is simply not adequate to its object; shallow disdain for science – and such disdain can only be shallow – is a major failure of the intellectual imagination. For the spirit of enquiry exemplified in the sciences, and their rigour and honesty, and the application of science in technology are great sources of hope for mankind. This claim will be deeply offensive to many humanist intellectuals who, as Merquior has pointed out, 'have every interest in being perceived as soul doctors to a sick civilisation'[13] and for whom the contribution of science to that sickness is an important part of their thinking and a mainstay of their self-esteem.

I ought to make plain that my wish is not to get everybody into laboratories (though we shall need more people who are technologically competent if the world is going to be safe) but to advocate a wider diffusion of scholarly knowledge about science and a more informed debate about its nature and achievements and also about the problems that face this, the greatest, most mysterious and most important collective human endeavour. I shall end with a

reasoned plea for a convergence of the two cultures and suggest that we should recognise the deeply similar values inherent in, and virtues common to, any truly worthwhile cultural enterprise, whether it belongs to art or science, and recommend that science be regarded as part of the humanities. This is taken for granted by many scientists who are understandably irritated that the pursuit of scientific knowledge is regarded as something entirely lacking in ordinary human values. (They are, of course, equally irritated by the sociologists of knowledge – whom I shall discuss – for whom science is not so much the pursuit of objective truth as a form of herd behaviour steeped in 'all-too-human' values.) Richard Feynman's response to a request from a Swedish encyclopaedia publisher for a copy of a photograph of him playing the bongo drums in order 'to give a human approach to a presentation of the difficult matter that theoretical physics represents' is a magnificent expression of this irritation:

Dear Sir,

The fact that I beat a drum has nothing to do with the fact that I do theoretical physics. Theoretical physics is a human endeavour, one of the higher developments of human beings – and this perpetual desire to prove that people who do it are human by showing that they do other things that a few other humans do (like playing bongo drums) is insulting to me.

I am human enough to tell you to go to Hell.[14]

2
Poets, Scientists and Rainbows

> Now I a fourfold vision see,
> And a fourfold vision is given to me;
> 'Tis fourfold in my supreme delight
> And threefold in soft Beulah's night
> And twofold Always. May God us keep
> From Single vision & Newton's sleep![1]

Even amongst tenured academics in university departments of English few would claim to be blessed with four-fold vision, but many still seem to derive a good deal of self-approval from being kept by God from Single vision & Newton's sleep. The jibe 'Newton's sleep' encapsulates much of Romantic hostility to science, as 'dark satanic mills' captures revulsion at industrial technology. Blake's unflattering portrait of Newton (on the cover of this book), naked and muscular like a forerunner of the Chippendales, at the bottom of the sea of space and time, shows a fanatical measurer, 'conquering all mystery by rule and line'. 'Newton's sleep' has long been a rallying cry for those who are opposed to science and all its works; for those educated – or partially educated – non-scientists who need to adopt an attitude of contempt towards the science and technology that had its spectacular dawn in the seventeenth century, and of which Newton is the emblematic figure. The appeal to literati of the Romantic hostility to science has outlived pretty well every other aspect of Romanticism and it shows no sign of waning. Indeed, Blake's claim that 'Art is the Tree of Life, Science is the Tree of Death', draws added sustenance from Green thinking, both sound and unsound. In short, the received version of the Romantic critique of the First Industrial Revolution provides the necessary basis for that moral superiority which disdains both the equations of the scientific thinkers and the greasy hands of the technological tinkerers. I shall argue that the Romantics have been misappropriated for this purpose, but let us look at the popular image first.

The standard story is that 'the bankruptcy of eighteenth century rationalism' was succeeded by a superior poetic vision that placed the human heart at the centre of things. This vision routed Newton's ideas, Newton-worshippers such as Pope and Voltaire, and a Newtonistic mechanical-corpuscular world picture advanced by scientists such as Lagrange and Laplace, in which the entire universe (including man) was composed of different arrangements of atoms moving in accordance with Newton's laws of motion.

This standard story, promulgated by people who should know better, is wrong at several levels. For a start, it assumes that the Romantics confused Newton's ideas with the Newtonismus of the eighteenth century, whereas many poets, notably Shelley, were well aware of those elements in Newton's thought that went beyond mechanical atomism, though they would not have been fully aware of Newton the alchemist, or that his conception of Absolute Space was essentially theological. More importantly, the standard story overlooks how deeply ambivalent was the attitude of the Romantics to science.

Though dislike of science seems to have been a theme in English Romanticism, it is not an inevitable component of Romanticism as such. Chateaubriand, the Father of French Romanticism, speaks in his *Memoirs* of Newton and Homer in the same breath. And German Romantics were as likely to be excited by the mysterious world opened up by scientific investigation as repelled by the scientific attitude to things: the triumph of the poetry of the heart proclaimed by writers such as Schlegel and Novalis did not diminish their interest and excitement in science. It was not science but (to use Schlegel's words) 'petrified and petrifying reason' and the **scientism** of Enlightenment figures such as La Mettrie, Hartley and Laplace that was the enemy. Goethe's feelings towards science, and towards Newton in particular, were likewise rather complex. Indeed, his anti-Newtonian *Theory of Colours*, though infertile as a contribution to the physical theory of light, has proved seminal in psychophysiology.[2] Moreover, he was prepared to mount detailed arguments against Newton and to carry out laboratory experiments rather than merely reject current scientific thought on grounds of distaste. Interestingly, his opposition to Newton's colour theory was Plotinian – 'if the eye were not sun-like how could it see the sun?' – as was Newton's own dissatisfaction with his mechanics.

As for the English Romantics, they wavered between admiration of Newton's mighty vision and achievement, and fear of the

mechanistic world picture that they thought could be inferred from it. A similar ambivalence pervaded their attitude to science as a whole. Coleridge – who was a close friend and admirer of Sir Humphrey Davy – was for a long time committed to the quasi-Newtonian materialist associationism of Hartley, after whom he had named his son.[3] And Wordsworth's description in *The Prelude* of Newton's statue, which he could see in Trinity courtyard from his room in St. John's, as

> The marble index of a mind for ever
> Voyaging through strange seas of Thought, alone.[4]

is hardly derogatory. Nor is his reference later in the same book of *The Prelude* to 'the great Newton's own ethereal self'.[5]

Nevertheless, it is the negative views that have stuck in the collective memory. In consequence, hostility to science inspired by Romanticism is more unqualified than that of the Romantics themselves. This may be because, as Weissman[6] says, the Romantics contributed to the process by which in England art and science parted company. Subsequent hostility was consequently more unqualified, as it was assumed from a position of ever-increasing ignorance. From a greater distance, science can be confused with scientism – a point to which I shall return – and can therefore be more sweepingly dismissed as inadequate or irrelevant or, worse, 'the Tree of Death' in whose shade the flowers of the imagination will wither and die.

If the anti-scientific temper of Romanticism was more pronounced in English, as opposed to French or German, Romanticism, this may also be because the Industrial Revolution, with the industrialisation not only of work but of life itself, developed most rapidly and had the most brutal consequences in Britain. For the first time, technology – seen as the fruit of science – began to dominate life; and, for the vast majority, the benefits were outweighed by the savagely adverse effects of the industrialisation science had made possible. Increased productivity had produced, not a better-fed and better-clothed populace, but dark Satanic Mills and abused and impoverished millworkers. The greater wealth it created was concentrated in fewer, more powerful, hands rather than distributed amongst those who were caught up in its creation. Those who had exchanged the Ecchoing Green for the cacophonic roar of the machine were rewarded with appalling working and living

conditions, uncertain employment, poverty, ill health, execrable surroundings, and early death. The hellish treadmill of factory life that continued virtually unreformed until the twentieth century, and described so vividly by Marx in *Capital*, seemed to justify Blake's inclusion of science in the 'mind-forg'd manacles' that imprison the human spirit.[7]

The world, or significant parts of it, have changed since Blake was writing and the application of science in technology has been the main agent of change. It is difficult to speak of dark Satanic Mills in England any more and dark Satanic By-passes and dark Satanic Theme Parks do not carry the same resonance. World-wide environmental pollution and poverty in the developing world are invoked to supply the deficiencies in the anti-scientific case. (I shall deal with these – and the larger question of whether science has had an overall beneficial effect on the world – in due course.) As it stands, the argument that science has forged manacles, at least for the present generation of English people, does not have much empirical support. Beneficial changes in infant mortality, in nutrition, in the duration of an attack of cystitis, in the burden of labour, in the chances of reaching and enjoying a healthy old age, in protection against the excesses of cold and heat, in the range of activities and interests an individual normally cultivates, and so on are the fruits of a technology increasingly the result of the application of scientific discoveries. The indisputable material benefits of science, not evident when the Romantics were writing, requires its opponents to invoke other, more **spiritual**, bases for their hostility to science, as we shall see presently.

It is worth reflecting a little more on the current use of Romantic opposition to science and technology. Just as it is convenient for those who invoke the Romantics to support the anti-scientific case to conceal, or to be ignorant of, romantic ambivalence, it is equally convenient for them to conflate what was justified in the Romantic critique of the brutalisation of life and labour that marked the Industrial Revolution with a critique of science *per se*. This confusion of science with misapplied technology deserves closer examination.

Wolpert's *The Unnatural Nature of Science*[8] usefully clarifies the distinction between science and technology, and technology and its uses. Science, he says, produces ideas, whereas technology results in the production of usable objects. Until very recently, these two have not gone hand in hand. There were significant technological achievements, even in ancient cultures, but these were not based

on science inasmuch as there was no evidence of theorising about the processes involved in technology nor about the reasons why it worked. A knowledge of celestial mechanics was not necessary to make one a good engineer.

The separate development of science and technology is less and less evident. To take only one example: the emergence of electronics, which has utterly transformed our ability to communicate in, to explore and manipulate the world, would be unthinkable without advances in the fundamental physical sciences. The present intense interaction between science and technology – the conscious exploitation of technology in experimental science and the equally conscious rooting of technology in science – has accounted for the extraordinary acceleration of the rate of technological advance, so that in some fields ten years is a geological epoch.

The wavering hostility of the Romantics to science was fuelled by understandable horror at industrialisation, by their being witness to the first period in history in which labour was dominated, indeed in factories enclosed, by technology of the most brutalising kind. The First Industrial Revolution, however, was driven primarily by social and political and organisational change. The underlying advances in the application of basic science to production were relatively modest. Science – and consequently labour – has moved on a long way since then. The subsequent penetration of science into technology has not led to even darker, yet more satanic mills. On the contrary, it has brought about a progressive gentrification of the labour which the resulting machines demand. For many, the dark satanic mill (with much technology and little science) has been replaced by the rather brighter and less satanic keyboard (with much science and a rather less obtrusive technology). Indeed, it was the comparative primitiveness of the technology that required the mills to be dark and satanic – and political indifference, laissez-faire economics and a Tayloristic disregard for human fulfilment in labour that permitted them to be so. The mills of the Second Industrial Revolution are light and non-satanic in proportion as their technology is science-based.

In summary, simplification of the Romantics' position – so that their equivocations are reduced to one clear hostile voice – combined with failure to take account of the context of their critique has enabled their views to be applied uncritically to the contemporary influence of science and technology. The Romantic rebellion against the political and social conditions and the

technology of the First Industrial Revolution is extrapolated to a global anti-scientific hostility. As a result, we are still required to believe that science, far from being a liberator of the mind, actually increases the ability of the mind to forge manacles – mental as well as physical, spiritual as well as material.

This is the basis of my argument that the deepest trench between the arts and the sciences has been dug by humanist intellectuals teaching their students to exploit, mispresent or uncritically misapply a Romantic contempt for science and technology. At any rate, misapplied Romanticism has been a crucial factor in the emergence in Britain of a disastrous educational system, hardly changed in this respect since the 1840s, in which those who study humanities at university level rarely have a knowledge of science above a second-form level.[9] I doubt whether the Romantics would have welcomed having had this baleful influence via the educators and legislators influenced by them. It is difficult to imagine Shelley or Coleridge or de Quincey or Wordsworth being comfortable with remaining ignorant of a mighty human endeavour that has utterly transformed human life and the way humans can think about those lives.

Those who concede that, at least in the twentieth century, science-based technology has made us materially better off (something I shall discuss later) still maintain that its influence is malign – so that it is better to remain ignorant of its methods and its results – because it is inimical to the imagination. This belief has two components: that scientists themselves are unimaginative; and that the products of their activities are a threat to the imagination of non-scientists. I shall deal with these in turn.

Let us first examine the view that scientists are unimaginative creatures, that they are literal-minded, fact-and-reason-bound Gradgrinds who deny the existence of whatever cannot be demonstrated to take place within the laboratory or to be consistent with chilly first principles of the kind that Newton himself laid down. This is rarely expressed so explicitly otherwise it would be seen for the nonsense that it is. Great imagination is essential to great science: to generate the ideas that are checked against observation, to fuel the dreams that drive enquiry, to send the voyager 'across strange seas of Thought'. Without imagination there is no science, only dull cataloguing of the contents of the world, a Baconian parody of science that the great physicist Rutherford dismissed as mere 'butterfly collecting'. Great science requires leaps of thought, occasionally gigantic, even outrageous; and even merely

good science is not possible without hypotheses and conjectures that go beyond what is known, that discern patterns, general principles, mechanisms as yet unjustified by current knowledge. Science is not fact- but intuition-driven – as Popper (and Medawar after him) argued.[10] The mind, and in particular the scientific mind, is not a bucket into which data drift like falling leaves, to be sorted into general inductive laws; rather, it is a searchlight which seeks out data that correspond to the hypothesised law. The scientific world picture does not simply crystallise out of passive, unfocused gawping. As Max Planck, the father of post-classical physics, said, 'It is not logic but creative fancy which kindles the first flash of new knowledge in the mind of the researcher who pushes forward into dark regions'.[11] The as-yet-undiscovered is always 'a dark region'. Creative fancy in science has yet deeper sources, as Max von Laue, the discoverer of X-Ray crystallography, explained: 'theoretical physics arises from deep-felt need to perfect the physical world picture in the sense of its unity'.[12]

The extent to which science at all levels is driven by the imagination has been widely documented,[13] though it is Grand Science that has produced the most famous cases. Copernicus' heliocentric theory was deeply influenced by aesthetic considerations and Kepler's adoption of Copernicus' theory was also aesthetically motivated: 'As I contemplate its beauty with incredible and ravishing delight, I should publicly commend it to my readers with all the forces at my command'.[14] He pursued his own researches with the aim of 'showing more harmonies': the idea of the Sun (the Father) at the centre of things also caused him 'ravishing delight'. The expression of his aesthetic sense in his formulation of scientific theories was constrained, however, by the data on planetary motion patiently accumulated by Tycho Brahe. Moreover, the laws Kepler deduced from those data were aesthetically and theologically shocking to his contemporaries: the planets did not describe circular paths or maintain constant velocity as had been taught since ancient times; on the contrary, their orbits were elliptical and their velocities varied inversely according to their distances from the sun.

Newton's alchemical and theological preoccupations are now well-known. At his death he left over a million unpublished words on these matters. Behind the intuitions that made the great achievement of his Laws of Motion possible were (aside from his mathematical and experimental genius and his ability to think hard

about problems for longer than anyone else – weeks and months rather than minutes) quasi-theological notions about the nature of space and time. His Neo-Platonic vision of space as God's mind or sensorium permitted the intuitive leap that created the law of universal gravitation and linked the movements of the planets with that of humbler objects on the earth. All this, and a sense of undiscovered worlds, undiscovered possibilities. As he famously said towards the end of his life

> I do not know what I may appear to the world; but to myself I seem to have been only like a boy playing on the sea-shore, and diverting myself in now and then finding a smoother pebble or a prettier shell than ordinary, whilst the great ocean of truth lay all undiscovered before me.[15]

If this is not quite the Ecchoing Green and Blake's childhood paradise, it is, as Keynes has pointed out, far from the image, promulgated by the anti-Newtonians, of 'a rationalist who taught us to think on the lines of cold and untinctured reason'.[16] Like the young Einstein, he was pre-eminently happy in his intuitions and believed in them sufficiently to subject them to experimental test and mathematical proof and to undergo the appalling rigours of concentrated thought this required. Like all very great scientists, he was impelled by a sense of the unity of things and of a hidden order which, as Whitehead has compellingly argued, unites the Greek vision of 'fate, remorseless and indifferent' (the laws of physics are the decrees of fate) with the medieval vision, deriving from monotheism, 'that every detailed occurrence can be correlated with its antecedents in a perfectly definite manner, exemplifying general principles'. 'It is this instinctive conviction, vividly poised before the imagination, which is the motive power of research'.[17]

> To experience this faith is to know that in being ourselves we are more than ourselves: to know that our experience, dim and fragmentary as it is, yet sounds the utmost depth of reality: to know that detached details merely in order to be themselves demand that they should find themselves in a system of things: to know that this system includes the harmony of logical rationality, and the harmony of aesthetic achievement.[18]

Einstein's genius, more explicitly that of a pure theorist than Newton's, has been frequently portrayed as residing in his powerful

aesthetic sense. His greatness, characterised by Pais as an incomparable ability 'to invent invariance principles and make use of statistical fluctuations'[19] is rooted in an intense and unwavering intuition of, and belief in, underlying order and of the beauty of that order. It was this that enabled him to think with incredible tenacity, in obscurity and solitude, in the ten years that led up to the Special Theory of Relativity; to withstand a further ten years of false trails and unremitting mental effort before the emergence of the mighty General Theory; and to continue, increasingly out of tune with his time, for thirty years struggling in vain to develop a Unified Field Theory.

This excited intuition of order and beauty is an essential condition of great science – great experimentation and great discoveries. And not merely at the highest level. Many will be familiar, through Jacques Hadamard's accounts,[20] with how scientists and mathematicians are sometimes afforded, when thinking about other things, or on the verge of sleep, the intuitions that show them the way out of an impasse or open up totally new modes of thought. Kekule's story of how the structure of the benzene ring came to him as he dozed by the fireside – the ring was presented in the form of dancing flames writhing like snakes, one of which turned into the mythical Ourobouros, the snake biting its own tale – is reminiscent of Coleridge's story of the writing of Kubla Khan – minus the Pretext from Porlock. I would venture the wholly unscientific estimate that there is more imagination behind the humblest law in chemistry than is to be found in the majority of the works of imaginative literature. The great collective adventure of science has been the result not of great pedantry – though honesty of observation, imperfect of course but less so than in any other walk of life, is essential – but of great boldness in thought. This has never been more true than at the present time where post-particle physics, cosmology, molecular biology, to name only the most obvious instances, make much so-called creative writing seem pitifully constricted.

Of course imagination is not enough: the history of science is littered with 'beautiful theories slain by ugly facts'. (Though knowing when occasionally to disregard, or at least to question, a few ugly facts when they conflict with a beautiful theory, is another – somewhat dangerous – aspect of scientific theory.) The world of science is not like the world of so-called experimental art where every experiment gets published and where there is a prize every

time. For science does not consist in generating any old hypothesis and, like a dishonest lawyer or certain literary critics, invoking one or two selected bits of evidence in its support. The hypothesis that the original data support are tested against a different set of data. The highest test of a scientific hypothesis is its prediction of novel facts. Practical applications also provide stringent tests of scientific laws. Many of the most general laws are subjected to continuous and merciless tests day in day out in the functioning of the devices which have been designed in accordance with them. Much of the successful technology that now surrounds us from the cradle to the grave is an enormous unacknowledged test bed for the great scientific laws.

Thus, although imagination is a necessary condition for the production of a new scientific law, it is not the sufficient condition of the truth of that law. As Claude Bernard said, 'outside of my laboratory, I let my imagination take wing; but once I go into my laboratory, I put my imagination away'. In this way the scientist sees what is before him, not what he wants to see. This is a test of integrity. Imagination that distorts results in accordance with the experimenter's wishes leads to fraud, to 'findings' that others cannot repeat, to failure and, in the not-too-long-run, personal humiliation.

Evidence that imagination of the highest order is deployed in the pursuit of scientific understanding will scarcely dint anti-scientific hostility. Yes, it will be conceded, great scientists are visionaries in their way; doubtless, they are madmen of the right sort. But that is beside the point. What concerns – indeed repels – us is the world picture they have created: the triumph of classical science has led to a loss of spirituality. Science is one of the major elements in that rationalisation which Weber, expropriating Schiller's poignant phrase, said occasioned the 'disenchantment of the world'.[21] Scientific rationalisation displaces magical elements of thought even as it extends its systems of laws over the known world and these systems are brought into ever-increasing consistency. The scientific world picture is saturated with explanation actual or imminent: whatever is encountered is not unique but takes its place as an instance or exemplifies laws that are themselves instances or examples of larger laws.

Keats famously protested against the scientific 'disenchantment of the world' in 'Lamia':

> Do not all charms fly
> At the mere touch of cold philosophy?
> There was an awful rainbow once in heaven:
> We know her woof, her texture; she is given
> In the dull catalogue of common things.
> Philosophy will clip an angel's wings,
> Conquer all mysteries by rule and line,
> Empty the haunted air, and gnomed mine -
> Unweave a rainbow, as it erewhile made
> The tender-personed Lamia melt into a shade.
> (ll. 229-36)

Here 'philosophy' – personified in Apollonius the sage – stands for both philosophy in the modern sense and 'natural philosophy' in the sense familiar to Newton. Newton is the stanza's most obvious target; for it was he whose *Opticks* had explained the rainbow as being due to the differential refraction of the different components of white light through raindrops – and so brought the rainbow down to earth by seeing it as a manifestation of the same process as is observed in light passing through a humble prism.

The importance to the Romantics of this particular act of scientific disenchantment is underlined by Weissmann:

> At a memorable dinner in 1817, Keats and Wordsworth agreed that Newton was the opposition. He had destroyed all the poetry of the rainbow by reducing it to its primary colours. 'Wordsworth was in fine cue', and at the end of the evening, Keats and Wordsworth joined the toast of Charles Lamb to 'Newton's health, and confusion to mathematics!'[22]

Natural piety leaps up to meet the rainbow, natural philosophy pulls it down in order to pull it apart: we murder to dissect.[23] This is a viewpoint that is still granted widespread and unthinking sympathy wherever English Literature is taught. It is a perverse response to Newton's magnificent conjecture. His *Opticks* lies at the origin of a great intellectual adventure that has sailed on very strange seas of thought indeed. Out of the arguments and experiments that it has directly and indirectly occasioned over three or more centuries have come the concept of the aether, the electromagnetic equations of James Clerk Maxwell (with their

prediction of radio waves), the General Theory of Relativity and the wave theory of matter. The story is not over yet and the sense of excitement and mystery has not abated. For Newton did not 'explain' the rainbow, in the sense of explaining it away, or dismissing it as a suitable object of thought. Rather, he connected it with other phenomena that excited his interest equally: the colours seen in thin films, the light passing out of prisms, etc. For him the rainbow was not an isolated mystery but one manifestation among many of a more universally mysterious phenomenon: light.

This brings out a more general point: a truly scientific explanation does not destroy the mystery of the explanandum but makes it part of a manifestation of a greater mystery. It does not disenchant, only delocalise enchantment. The explained is doubly beautiful: both in itself and in the laws (themselves unexplained) of which it is a manifestation. Explanation links the explanandum with something deeper to be explained: it moves towards a larger unity, rather as does that monotheism from which, as Whitehead suggested, science is descended. Moreover, as many scientists are aware, explanation is itself mysterious. As Einstein said, 'the greatest mystery of all is the (partial) intelligibility of the world'.[24] To which we could add: and an equal mystery is the human intuition that that intelligibility might be extended by the active uncertainty of thought and investigation. The manner in which the world conforms to our thought, so that we can extend our knowledge and understanding of it by thought, the extraordinary correspondence between mathematical formulae and the real world of human need, which most people take for granted, should be a source of wonder and of joy. This, with a rigorous attention to the object of enquiry rather than to our own preconceptions, and a willingness to co-operate with others in advancing understanding, may be truer 'natural piety' than Wordsworth's self-approving cardiac gymnastics – at least as they have been interpreted by those with a sub-Wordsworthian axe to grind.

Of course many scientific theories have a very limited application and may seem stultifying for that reason. But the kind of theories – for example Newtonian optics or mechanics – that have attracted most execration are not limited in this way. From Thales to Weinberg, science has always aspired to an understanding whose scope has been co-terminous with the universe; and that universe itself, because of scientific discovery, has been expanding outwards into the remoteness of space and inwards into the nanoscopic interstices of the atom.

Many, however, claim to be repelled by science because its predominant metaphor is that of the machine rather than the organism, so that the philosophy of nature is a mechanical philosophy. Newton, in particular, is blamed for inspiring the master theory, towards which some science aspires, of a clockwork universe in which mind, the spirit, human feeling and even human meaning have no place.[25] This does science, and Newton, an injustice. As Koyré points out, Newton's unique greatness was not only in his union of mathematics and experimentation but rather in a much broader view of reality: 'besides religion and mysticism, Newton had a deep intuition for the limits of a purely mechanical view of nature'.[26] Attraction at a distance, as is exemplified in gravitational forces, required the pervasive presence of something that was more than atoms and motions. The absolute space that he invoked to make sense of inertial forces was the sensorium or mind of God. Indeed, it has been argued that Romantic pantheism such as Wordsworth espoused is descended from Newtonian thought about the nature of matter and force and that the metaphysics of *Prometheus Unbound* shares a common Neo-Platonic ancestry with Newton's world picture.[27] The Newtonian *esprit de geometrie* was alive in Spinoza (though Descartes provided his model), that 'God-intoxicated man' so admired by Goethe.

As I have already noted, there has been much confusion of Newton's thought with the Newtonismus of certain of his followers. The machine-like, mindless universe of Enlightenment thought is at least in part directly anti-Newtonian, though advanced under Newton's name. It reached its most spectacular expression in Laplace's *Mecanique Celeste*; though even this has a Lucretian austerity and beauty that has appealed to many imaginative writers of a materialist persuasion. Laplace's vision was most clearly set out in *A Philosophical Essay on Probabilities*, where

> he asked us to imagine a demon who knows the exact position, velocity, and mass of every piece of matter in the universe, who knows Newton's laws of motion and of gravity, and who can solve instantaneously and with complete accuracy any computation involving these laws. [This] demon would be able, Laplace asserted, to calculate the exact position and velocities of all the pieces of matter in the universe for all future and all past times. The whole history of the universe in every detail, the origin of stars, planets, life, and man, the rise and fall of empires, would,

for the demon, be computable from its exact knowledge of the physical state of the universe at any chosen time.[28]

Laplace's conception of a mind able to foretell the progress of the universe for all eternity – if only the masses, starting configurations and initial velocities were given – and the delicious impiety of his rejection of God as 'an unnecessary hypothesis', added to its attraction. Within a century, however, it had been rejected by many scientists as (in Mach's words)[29] 'a joyful overestimation of the scope of the new physico-mechanical ideas', 'a **mechanical mythology** in contrast to the **animistic** of the old religions'. More recent developments – in particular the discovery of quantum indeterminacy and the recognition of non-linearity of the input–output relations of dynamical systems – have undermined the Laplacean vision and shown that the world may not be 'demon-computable', even at the macroscopic level, in the way that Laplace fantasised.[30]

Anti-Newtonian or not, the belief that the universe is a great machine whose contents are merely different configurations of atoms has been transformed by the theoretical advances and discoveries of the last two centuries. 'Newton's Particles of Light' have undergone wondrous metamorphoses at the hands of his successors – who have been uninfluenced by Blake's attacks on them. Einstein, for example, famously criticised the conceptions of (absolute) space and time so crucial to the Newtonian world picture. However, he built upon Newton – showing the latter's theory to have limited instead of universal scope – rather than (as is often commonly supposed) refuted him. The world picture of science has become infinitely more complex and the human observer, so tragically marginalised in materialist thought, has re-entered the calculations of physicists: the ghost haunts the universal machine even at the subatomic level.[31] Of course, the scientific world picture remains resolutely sceptical and agnostic, even atheistic. God remains an unnecessary hypothesis. But God is scarcely a major player in contemporary humanities either.

To defend the Newtonian or any scientific world picture on grounds of aesthetic or metaphysical taste, however, is already to concede too much. The point about a scientific theory is not whether one likes it, but whether it is true and whether it 'works', in all the various senses that that word has. We should not reject a theory on the grounds that it seems to tell us things about ourselves or the

world that we do not like to hear. Or that it presents a demoralising or despiritualised picture of the world. As Nietzsche said, one should be prepared to 'live on the acorns and grass of knowledge for the sake of truth'. Unfortunately some of those trained in the humanities are prone to confuse questions of taste with questions of truth: 'I do not like this theory' becomes 'This theory is not true', and expressing one's dislike of a theory is taken as a proof of its inadequacy.

Scientific theories may reasonably be criticised on four sorts of ground: they are untrue to the facts; they do not predict novel facts; they are incoherent; they are incomplete. These are valid reasons for rejection or modification. The world picture of physics and of theories modelled upon physics can be criticised on the grounds that it is incomplete; in particular that the theories do not take account of, or explain, consciousness or the emergence of meaning.[32] Since, however, they are true – or as near to the truth that we have so far reached – of the physical world, they cannot be rejected, even less ignored.

Why, when it is obvious that theories in physical science are not only of such obvious practical importance but also central to an understanding of the reality that surrounds us, are they disdained by many whose training is in the humanities? One of the problems, as I suggested earlier, with scientific theories is that they are hard work. Understanding comes only slowly and may not come at all. Hard work may be unattractive to some whose primary disciplines are in the arts, where pleasure – and often immediate pleasure – is a prime consideration. Except for the gifted few who can retain pages of proofs in their heads – rather as Mozart was able to hold an entire symphony in his mind – a page of equations does not yield easy or immediate pleasure. Pleasure, if it comes at all, comes much later as the meaning of the arguments dawns as intuitions.

This is rarely admitted so directly as a reason for rejecting science. Instead, it is suggested that its crabbed discourses are a threat to sensibility; that too much acquaintance with science prunes the delicate tendrils of the imagination and causes irreversible spiritual damage. Even if it were not so difficult, it would still put the soul at risk because science, as I discussed in 'Omnescience', is less explicitly related to personal experience than, say, poetry or literary criticism. Science far exceeds individual experience, since its scope is co-terminous with that of the expanding known universe. Not only, therefore, is it remote from gossip, but it threatens to render

individual experience null and void, and make the individual feel himself to be a mere 'insect on an atom of mud' as Voltaire expressed it. And it falls short of individual experience: actual feelings and sensations slip through the net of its general statements and abstract terms. For this reason, science is external to us and cannot easily be integrated into our daily consciousness of who and what we are.

Naturally, it is not easy to relate one's own experience to knowledge that has developed as a result of the progressive liberation of consciousness from the individual point of view towards 'the view from nowhere'. But, although 'Being Here' cannot be mathematised, it is salutory to examine oneself and one's world through the lens of abstract, tested, general statements, and so to come upon oneself as from afar, to see oneself as an instance rather than all-in-all. The demands that science make upon us are no more strenuous in this regard than those that are made by religious doctrines and no more perverse. If relating the small facts that engage us to the great facts that enclose us is a hard task, so be it; it is, as I shall claim in 'The Uselessness of Art', also central to the great ambition of art.

The traditional belief that prolonged exposure to scientific knowledge and thought may damage the soul is a strong one. It is connected with a deep-rooted feeling that to ask precise questions, to make careful observations, to discover general laws and to use them to predict, to explain and hence to be able to control the phenomena of the world – in short, to 'Conquer all mysteries by rule and line' – is fundamentally impious. This quasi-religious intuition may in part explain the plight of Wordsworth's 'Star-Gazers', who seem like clients in a brothel:

> Whatever be their cause, 'tis sure that they who pry and pore
> Seem to meet with little gain, seem less happy than before:
> One after One they take their turn, nor have I one espied
> That doth not slackly go away, as if dissatisfied.[33]

And why the attitude exemplified in this entry from Amiel's diaries met with such sympathy:

> Reflection dissolves reverie and burns her delicate wings. This is why science does not make men, but merely entities and abstractions.[34]

And why, finally, one particular passage from Keats' letters should have been quoted so often and almost invariably with approval – such that (as in, for example, W.J. Bates' *Negative Capability*) it has become the cornerstone of an aesthetic:

> I had not a dispute but a disquistion with Dilke, on various subjects; several things dovetailed in my mind, & at once it struck me, what quality went to form a Man of Achievement especially in Literature and which Shakespeare possessed so enormously – I mean *Negative Capability*, that is when man is capable of being in uncertainties, Mysteries, doubts, without any irritable reaching after fact & reason – Coleridge, for instance, would let go by a fine isolated verisimilitude caught from the Penetralium of mystery, from being incapable of remaining content with half knowledge.[35]

There are the seeds here of a corrupt doctrine: to be a Man of Achievement, one must practise being 'content with half knowledge'. To plunge too deeply into science is to display that 'irritable reaching after fact & reason' which plays merry hell with the Negative Capability that is the mark not only of the great creative spirit but also of the Man of Sensibility. From this it is but a short step to the suggestion that the hard mental effort associated with science clouds the mind, coarsens the sensibilities and blinds one to the eternal. This is a belief that has had dire consequences for the humanities, none more than in the 'discipline' of English. That considerations of effort can outweigh those of truth touches upon a deeper corruption to which I shall return.

Let me now return to Blake. It is a great irony that Blake's assault on Newtonian thought and 'systems' in general should itself be a system of sorts and one that, as Michael Schmidt points out, can itself 'traduce imaginative originality'.[36]

> I must Create a System or be enslav'd by another Man's
> I will not Reason & Compare: my business is to Create.[37]

Few of those who approve of Blake's strictures on Newton will fully understand the system he was creating in opposition to him. They may be forgiven this ignorance: only those who have tried to read the prophetic books, failed to derive pleasure and illumination from them, and have sought the help of commentaries – of which there is no shortage of distinguished instances[38] – and have still failed, can

know what true sleep is. There is something deeply depressing about the number of scholarly careers that have been devoted to the patient exposition of a system that has no authority other than that borrowed from the dew-cold beauty, the childlike freshness and poignancy of a handful of early lyrics.[39] The prophetic books, apart from occasional moments of brilliance, are turgid beyond belief, whatever the delights of Reasoning and Comparing they may offer those scholars and critics who find employment in them. But those of us who do not look to Los, Urizen, Luvah, Golgonooza, Ulro and colleagues for tenure might be forgiven for preferring Newton's so-called sleep to Blake's private menagerie of personified abstractions. May God us keep from four-fold vision & William's sleep!

3
The Eunuch at the Orgy: Reflections on the Significance of F. R. Leavis

It is nearly thirty years since F. R. Leavis, infuriated by the wide currency given to the views advanced in Snow's Rede Lecture[1] responded with a lecture of his own. As was widely observed at the time, the Richmond Lecture *The Significance of C. P. Snow*[2] plumbed new depths in academic debate. Instead of attacking Snow's arguments, Leavis attacked Snow; for he saw Snow's lecture not as containing a case to be answered but as itself a portent of a degenerate culture. In a prose almost crippled by the weight of sarcastic intent, he asserted that Snow – whose status as a 'Sage' infuriated him – had an 'undistinguished mind', apparently about as undistinguished as it was possible to possess this side of coma. He supported this assertion not by demonstrating faults in Snow's arguments but by spiteful reference to the latter's novels. He stopped just short of saying that Snow had an ugly face and that he served damned filthy sherry.

Even at this distance, Leavis's sneers have the power to shock, to anger and to disgust. The immediate result of his lecture was that the question of The Two Cultures ceased to be a subject of serious debate and became instead a delicious scandal. The long-term result is that the deplorable situation to which Snow had drawn attention, in an admittedly crass, at times vulgar and somewhat self-regarding fashion, has not altered in the slightest. The 'omnescience' described earlier demonstrates how, as we approach the twenty-first century, many of those trained in the humanities have yet to catch up with the science of the sixteenth.

There is little point in rehearsing Snow's case; the facts about the omnescience of humanist intellectuals that he deplored cannot be denied and, as was indicated in 'Omnescience', things have not improved since he wrote. There is equally little purpose in combing Leavis's response for reasoned dissent: there is none. So why blow on the embers of an old dispute that Leavis reduced to an

undignified squabble? Why tilt at windbags? Precisely because Leavis's anger and his refusal of argument are symptomatic, and his attitude towards science is still widespread among those who teach or who have been trained in the humanities. Even those who diverge from his political, literary-critical and pedagogic views acknowledge his importance as the individual who placed 'English Studies' at the heart of humanities teaching in the universities, and as 'undoubtedly the single most influential figure in twentieth-century English literary criticism'.[3] This influence is transmitted not only by his writings and the writings of those who have been influenced by him but also, and perhaps more importantly, through the example of his personality and his posturing. The embattled visionary, surrounded by ignorant, corrupt and unredeemably narrow and stupid (or shallowly clever) adversaries, the profound thinker at odds with a frivolous and superficial age, an age consumed by greed and, because it has lost touch with the deeper realities of nature and human feelings, devoid of true values, is an attractive role model – even for those who would repudiate Leavis himself. Internalising such a role model as one's self-image makes it possible to live an unhurried existence within the walls of an institute of higher learning, adding to the ant-heap of exegesis under which canonical but unread works are buried, and still enjoy a sense of permanent moral superiority, rather than recognise oneself as a high-consuming mouth making a contribution of uncertain value to the productive process.[4]

The vulnerability of Leavis's central positions, insofar as they can be discerned through the fog of rage and self-righteousness, has often been noted. Raymond Williams' critique of the mythical 'organic community' that Leavis used as a stick to beat the modern world was definitive. As he pointed out in *Culture and Society*,[5] Leavis overlooks the exploitation and penury that dominated pre-industrial rural life. Williams refrained from observing that there is something particularly hypocritical about a man, whose means of subsistence comes from writing words about words, books about books, advocating for others a life marked by more direct contact with nature. Leavis's habit of existential self-refutation is equally impressive in his assumption of the Arnoldian mantle while laying down the law in a decidedly non-Arnoldian manner. Arnold's rejection of provinciality, and his emphasis on the need 'to get yourself out of the way' so that you can 'see the object as it really is', were mocked in Leavis's own example.

So Leavis is an important indicator of the level of confusion at which one is permitted to operate in certain 'disciplines' while still commanding a hearing. He is, in this crucial sense, a representative figure. To use a Leavisite formula, Leavis exhibits 'a multiple typicality'; and to see this is to be reminded of how alien the standards of discussion routine in science are to many trained in the humanities. And to see also, perhaps, why to them science seems so remote that ignorance of it hardly counts as ignorance at all. Leavis would rank high in the demonology of an intellectual culture that valued rigour and the search for truth. Instead, he is 'the most influential figure in twentieth century English literary criticism'. Nothing could be further from the scientist contributing to a collaborative international research effort, building with others and on the work of many thousands of others, than this solitary know-all articulating his tastes as if they were revealed truths.

Even more pertinent to our present argument is what Leavis actually retained from Arnold. In his charitable assessment of the Leavis-Snow controversy,[6] Lionel Trilling, in a manner reminiscent of a parent dealing with an angry and upset child, tries to work out 'what the matter is': Snow's unpardonable crime is apparently that he does not agree with Leavis's quasi-Arnoldian position that literature (and only literature) is 'criticism of life'. For Trilling this is an explanation, even a vindication, of Leavis's response, though it does not excuse his venomously bad manners. What Trilling's explanation lets slip is the assumption, widespread among non-scientists, that science is not also a criticism of life – and at the deepest level. It is assumed that science is part of the life that has to be criticised by the educated, part of the object that the educated mind may inspect (from a great distance), and not part of the mind itself or crucial to its education. This was not precisely the position that Arnold himself held (in a considerably more polite exchange) against Huxley – as we shall discuss presently. The assumption that science is not criticism of life is, of course, untenable. From Copernicus onwards, the findings and speculations of the scientists have been a continuous threat to collective, unreflective beliefs about the nature and purpose of human life, the position of man in the order of things and the origin and destination of the universe; in short, 'a criticism of life' in the best and deepest sense.

Trilling's charitable diagnosis of the Richmond tantrum also overlooks the extent to which it was a reflex response to a perceived threat: Snow's views undermined Leavis's sense of his own position

in the scheme of things. Leavis was not alone in experiencing that threat but his response is most revealing. The anger behind the Richmond Lecture is the anger of an all-knowing man encountering the suggestion that his knowledge is severely limited and that what he knows may not be as central as he had thought. To realise that there are more things in heaven and earth than are dreamt of in the curricula of departments of English is, for someone like Leavis, unbearable anguish that must be avoided at all costs.

This is betrayed in the last few pages of the Richmond Lecture where he suddenly becomes coherent. Like Snow, he says, he looks to the university to be 'a centre of human consciousness: perception, knowledge, judgement and responsibility'. Unlike Snow, however, he would see 'the centre of such a university **in a vital English School**' [emphasis mine] – which would consequently be the centre of a centre of human consciousness. The megalomaniacal claims for such a school – concentrating on training for maturity in literary studies – have been characterised by Norris in his introduction to *F. R. Leavis*: the school would 'be the one hope of renewal and growth in an otherwise irredeemable "mass-civilisation"'.[7]

One catches a glimpse of such fantasies in Leavis's reference, towards the end of his Richmond Lecture, to the 'essential Cambridge' that he holds up against the 'academic Cambridge' he associates with Snow. The 'essential Cambridge' turns out to be Dr and Mrs Leavis and a few like-minded friends. A comparison with the non-essential Cambridge is instructive. In the decades in which Leavis was at Downing, the non-essential Cambridge was transforming our conception of the nature of matter, laying the foundations of the new astrophysics, creating whole new branches of mathematics, and, in the legendary Medical Research Council laboratory, making some of the most important discoveries in the entire 2000-year history of biology. These included working out the structure of DNA – and so advancing our understanding of genetics and of cell biology. This eventually made possible many developments which before had not been dreamt of: gene therapy for congenital diseases, transgenic species to increase food production in places where starvation is the condition of daily life, a deeper understanding of the mechanisms of carcinogenesis. These discoveries, aside from their practical significance, also had the capability of transforming our sense of our nature. For Leavis, apparently, this was small beer compared with the work of the essential Cambridge: proving to its own satisfaction that Charlotte

Yonge was an important forgotten novelist; that Dickens was childish, uneducated and immature; that Richard Jeffreys was probably superior to Thomas Hardy; that Dickens did, after all, write one 'completely serious work of art'; that Flaubert, Proust and others were not worth reading; that Dickens was the Shakespeare of the novel, etc. (All the different views on Dickens were published by Leavis at one time or another. They are documented in Michael Bell's book on Leavis.)

Leavis's claims can be understood as a response to deep anxiety. For what the 'essential' Cambridge must have found difficult to accept – because it undermined its own claim to centrality – was that, for good or ill, the major intellectual and social event of recent centuries had been the progress of science, and the transformation of our world and world picture this brought about. This anxiety, and the denial it gives rise to, is widespread in the humanities. This is not surprising; for it cannot be pleasant for the innumerate to discover the centrality of the mathematisation of nature to our culture; or for those whose professional business is ultimately with matters of taste to be reminded of the importance of the unattainably different level of rigour and conceptual sophistication prevailing in subjects of which they have little understanding. Auden spoke of feeling when amongst scientists like 'a shabby curate among bishops'.

It is easier for those like Auden whose literary achievements are undoubted than for those who work as literary critics to admit to such feelings. And the uneasiness may cut much deeper. One thinks of the eunuch at the orgy who has always been first with the gossip and knows who does what to and with whom. One day, he is forced to realise that he doesn't really know what is going on. Unable to experience sexual desire himself, he realises that his knowledge is not real knowledge. Far from being in the centre of things, he is for ever on the margin.

More sophisticated defensive reactions are available to those for whom the most important fact about science is that it marginalises their own activities. One is to assert that science is essentially dehumanising, as Bryan Appleyard[8] has asserted, and to suggest that the industrialisation of death in modern wars is an expression not only of the technological possibilities opened up by science but also of the spirit of science itself; that we should see the concentration camp, rather than the washing machine, antibiotics or international airlifts of food aid, as typical consequences of the

application of the scientific method. The implication is that the less we know about science the better it will be for our humanity. (I will deal with this prejudice presently.)

Another way of reasserting the centrality of literary studies to human consciousness and so of marginalising scientific knowledge – so that to be ignorant of science is not to be importantly ignorant – is to offset lack of true knowledge by increased knowingness. This is like the eunuch compensating for never having experienced the sexual desire that makes the inner sense of the outwardly senseless behaviour of the others at the orgy simply by knowing much more of the gossip than anyone else. He is uniquely expert on everyone else's amatory gyrations. This compensatory increase in knowingness is reflected in developments in the field of literary studies.

I have elsewhere discussed (*Not Saussure* and *In Defence of Realism*) the displacement of literary criticism by literary theory and the expansion of the scope of literary theory to encompass all discourses, not merely literary ones. Theorists are able to 'place' texts, in the sense of putting them in their place. This has been most widely touted as a strategy to deal with the sense of inferiority a literary critic may feel towards creative artists (see *In Defence of Realism*); but it also serves to deal with Auden's 'shabby curate' syndrome. The theorist, who floats above all texts, is not marginalised by any of them. He can forget that he has not the faintest inkling of the techniques of science, that he could not follow most scientific papers beyond the first paragraph, that the mathematical methods and the statistical techniques which are the true heart of science are unknown to him.

A particular example of this strategy is 'narrative theory' which treats science, philosophy, literature and literary criticism etc. simply as different modes of storytelling. Cristopher Nash's recent collection[9] exemplifies this approach. Rom Harré's contribution, 'Some Conventions of Scientific Discourse', is especially pertinent.

Harré argues that scientific documents 'are far from unvarnished descriptions of uncontested facts'. Scientific discourse has adopted 'a peculiar rhetoric' of 'deindexicalisation' (in which, for example, the third person is preferred over the first person singular) in order to give the impression of objective truth. But what is presented as 'the' truth is merely the truth according to a certain community whose membership is closely regulated. One of the modes of entry to the scientific community is to learn to get difficult equipment working; one knows one has got such equipment working when one

gets the results the community approves of. There is a circle of mutual legitimation here – a circle that is closed off against any genuine access to nature itself. In addition, character references may support one's claims to being one of what Harré calls the 'good guys': 'personal character is often quoted as an epistemic warrant'.

The aim of Harré's 'microsociology of scientists' is obviously to debunk science. Those who wish to cut science down to size and so to rationalise their own ignorance of it, may try to relativise its truths, as Harré does, by 'demonstrating' on the basis of anecdotes, gossip etc. that science consists of tales that command respect primarily because they have been accredited by a certain group of cognoscenti. And this will be very gratifying to those who may be oppressed by the comparative lack of rigour of their own subjects. Scientists, like literary critics, are in the business of getting their stories ('HIV is the cause of AIDS', 'Dickens is a childish, immature novelist') believed.

Harré's own story carries a momentary plausibility – and has transient appeal to someone like me who always has trouble getting his apparatus to work – but this passes as soon as one reflects on the fact that the activity he is describing as simply another exercise in story-telling has utterly transformed man's sense of himself, his power of acting on the world, and the form and content of his daily life. Our whole lives are embedded in the embodiments of the practical truths of science. And the speed with which this has come about is astounding. As John Maynard Smith[10] has pointed out, if a two-hour film were made of vertebrate evolution, tool-making man would appear in the last minute; and the period between the invention of the steam engine and the use of nuclear power would take less than a hundredth of a second. And to take a specific example of the utmost contemporary importance: the recognition of AIDS as a specific disease, the establishment of its cause, the precise delineation of the extraordinarily complex effects of the virus, the beginnings of a strategy for searching for a cure, have all been accomplished in little more than a decade. At the beginning of the 1980s, the terrible spectacle of young men deliquescing to pus before their horrified doctor's eyes was utterly mysterious; now the causative agent has been identified and it is better known than any other plant or animal virus. The idea, so obvious now, that the procession of rare diseases suffered by certain homosexual men in New York was the manifestation of immune deficiency, that this could be brought about by a virus, and that the virus did this by

writing itself into DNA (reverse transcription) is a series of daring leaps of understanding, all the more daring for being constrained by the discipline of a careful and complex science.

None of this seems to puzzle Harré or make him question his 'rhetorical analysis'. Alan Gross's critique of the truth claims of the natural sciences is even more deeply rooted in a rhetorical analysis of scientific discourse. Style in science, he claims

> is not a window on reality, but the vehicle of an ideology that systematically misdescribes experimental and observational events. It is their ideological stance that makes contemporary scientists the legitimate heirs of medieval theologians: theirs is not a dispassionate search for truth, but a passionate conviction that the truth is their quotidian business.[11]

Science has no privileged access to the truth about the natural world: its special authority is socially constructed and it has rhetorical force but no ontological or epistemological basis: 'science is less a matter of truth than of making words' and science has no special relationship to nature: it is simply the sum of all the things the scientific community can, by fair means or foul, persuade itself to believe. Scientific knowledge is not special but social, the result not of discovery of what is out there but of persuasion as to what is out there.

He illustrates the role of rhetoric in scientific discourse by a detailed analysis of the famous understatement at the end of Crick and Watson's even more famous paper of 1953 describing the structure of DNA: 'It has not escaped our notice that the specific pairing mechanism we have postulated immediately suggests a possible copying mechanism for the genetic material'. The rhetorical figures here are irony and litotes. He could not have chosen an example more damaging to his own case. The Crick and Watson paper lies at the head of 40 years of molecular biology. The helical structure of DNA has been confirmed as objective fact repeatedly since then and it has led to a myriad of other major discoveries that have profoundly changed our approach to, for example, the diagnosis and treatment of disease. The use of gene therapy to treat otherwise untreatable diseases, a direct result of insights based upon the Crick and Watson paper, has proved that scientific discoveries are not mere rhetoric. Gross may believe that scientists are susceptible to rhetoric but he cannot, surely, believe that cells are.

If science were merely the art of persuasion, the deployment of rhetorical tropes and the mobilisation of social forces, in order to impose a view of the world upon others, then it is impossible to see how science could have ever been effective. Why does this word processor work, why do antibiotics cure, why do plane navigation systems guide people across the world, if the underlying science has no relationship to natural reality but is merely the result of a shouting match in which the most charismatic figures and the most cunning arguers are able to carry the day? As Feynman famously said at the end of his personal report on the NASA disaster, 'For a successful technology, reality must take precedence over public relations, for nature cannot be fooled'. Non-human matter, over which science has given human beings such enormous power, is not impressed by rhetoric. Likewise, if science really were as Rom Harré (who is himself deeply knowledgeable about science) portrays it in 'Some Conventions of Scientific Discourse' – a social activity in which truth is established at least in part by the authority and charisma of the high priests and by the activities of acolytes who secure admission to the priesthood by getting their apparatus to work – we should have scarcely moved out of the Stone Age.[12] Every hi-tech regulator of our environment that works reliably, every successful treatment of overwhelming infection, every word processor that enacts its routine miracles of information processing, is a testament to an objective truth in science that may not be absolute (whatever that may mean) but which goes far beyond the kind of clique-consensus truths that Harré and Gross focus on.

Rhetoric and social forces of course play a part in the collective enterprise of science, just as they do in other human activities. But they are not the only factors; indeed, they are less important here than in every other human activity. The accumulated heritage of Western science – all that distances us from Thales and Pythagorus – is precisely what goes beyond rhetoric and herd behaviour; the things that survive the fading of the rhetoric in the journal and the lecture hall and the changing of the herd. Harré's and Gross's account of science does not distinguish between science and Lysenko-science. Of course the bullshitters and the liars may hold front-stage for a while. But in the end they are found out and their 'contributions' (unlike those of Ampere, Maxwell, Boltzmann, Crick, et al.) are forgotten. Time weeds out the few results that are established on the basis of the charisma of charlatans. Nor does it explain why science-based technology is powerful and magic impotent.

Others within the humanities have taken heart from trends in the philosophy of science which they read as suggesting that scientific theories, formulated within certain paradigms (to use Thomas Kuhn's phrase) are like so many fashions that replace one another for external rather than internal reasons. The power of the Kuhnian critique of science[13] has been exaggerated: the relativising simplifications it has been reduced to cannot take account of the success of science and the fact that it indubitably progresses. Einstein's theories did not invalidate Newton's contribution; on the contrary, they defined more precisely the scope of the Newtonian world picture. Newton's mechanics is not false, except in its assumption of universality: it is true for a world in which the speed of light is infinite and sufficient for most of everyday life where motions are considered whose velocity is small compared with that of the speed of light. The mathematical techniques discovered by the Greeks are the foundations of modern mathematical physics. Copernican astronomy built on Ptolemaic. Much of what Archimedes discovered still stands 2500 years later. Recent advances have not discredited or disproved Harvey's discovery of the circulation of the blood, Hamilton's method of analysing motion, Clerk Maxwell's prediction of radio waves etc.

We tend to exaggerate the errors of the past and the extent to which the science of one generation differs from those of preceding generations precisely because enduring theories that are not overthrown by subsequent discoveries become assimilated into the general scientific world picture; they become part of the ground upon which contemporary science stands. Unsuccessful theories of the past are more visible for this reason than successful ones.

In short, the rate at which hypotheses are born and die in the privacy of scientists' minds and in the publicity of the scientific journals does not prove the relativity of scientific truth: the strong hypotheses overthrown have contributed to the growth of science by stimulating experiment and focusing thought. In many cases – as with Einstein's 'overthrow' of Newtonian thought – the theories of the past are not so much proven false as demonstrated to have limited application. So there is a gradual accumulation of truth; or truth is approached by successive approximations. There is a common pool of ideas and applications growing from all directions.

The Harré and Gross approach to the philosophy and history of science, and to the evaluation of the achievements of scientists, is one that has, in recent years, become distressingly familiar. It is the

latest manifestation of the programme of the Sociology of Knowledge adumbrated many years ago by Karl Mannheim. Wolpert[14] has lucidly and succinctly surveyed the present scene in his devastating critique of the Strong Programme of the Sociology of Scientific Knowledge (SSK). The SSK programme advocates abandoning the idea of science 'as a privileged or even separate domain of activity and enquiry'. Science must be understood not as a means of acquiring objective general truths about the world but as simply another form of social behaviour. Scientific laws are the product of consensus – and must be understood in terms of the prejudices, social pressures and power relations that result in the emergence of consensus and not in terms of advances in understanding, in logical consistency or correspondence with external reality. In this respect it is no different from any other form of knowledge.

The trouble with this 'rampant relativism' (to use Wolpert's term) is that it undermines itself: the claim of SSK's proponents to have acquired objective knowledge about science must itself be simply a matter of rhetoric, socially conditioned and culturally determined. This problem is additional to the failure of SSK to explain the extraordinary success of science in enhancing our power to control the natural world or to predict its behaviour – to explain why, if scientific discourse has nothing to do with natural reality, streptomycin does and magic does not cure TB. Is this a question of the mycobacterium being less frightened by the group dynamics of priests than of those of microbiologists? By focusing on secondary issues – the means by which scientific reputations are established, the motivation behind research, the prejudices of scientists – SSK proponents manage to distract from the central astonishing fact: the incredible scope and power of scientific approaches and scientific thought that are quite unlike anything else in human life.[15]

The irony is that the image of science projected by the proponents of SSK is a more accurate portrait of their own practices than of the practices of physicists and biologists. In the absence of external tests (including the stringent tests that scientific theories endure in the real world of application: is the disease cured, does the space rocket get to the moon, does the bridge stand up, does the word processor store or destroy data?), theses can become established only by an emergent consensus to be carried by rhetoric and the persuasiveness of charismatic individuals. Without the discipline of 'Is it true?', backed up by the harsher discipline of 'Does it work?', there is only rhetoric. SSK is nearer to the world of literary critics – the world of

F. R. Leavis and unargued assertions backed up by moral superiority and scorn ('*The Ambassadors* is a work of Henry James' senility') – than to the world of real science. It is precisely where one is in the realm of the untestable that rhetoric, personal power, *argumentum ad hominem*, refutation or support by *argumentum ad situationem* come to the fore. Lenard's dismissal of relativity as 'Jewish physics' or Lysenko's successful advocacy of Lamarckian genetics because it was politically correct are the exceptions in science; elsewhere, they are, alas, the rule.

Other debunkers of science focus on science fraud. Fraud certainly occurs in science; there have been celebrated instances. But such instances are few enough to be celebrated. Let us suppose that science fraud has been under-estimated. Let us make a wild accusation and suggest that, instead of the handful of papers out of the millions that are published, 5 per cent are fraudulent; this would still make science uniquely honest among human activities. Science fraud attracts so much attention **because** it is comparatively rare. Outside of science, one would be grateful if 5 per cent of documents were **not** fraudulent. If only as few as 5 per cent of discourses in politics were fraudulent! Scientific papers are subjected to a rigorous process of usually anonymous peer review. The universal human inclination to deceit is less easily gratified in science and brings fewer, less certain and shorter-lasting rewards there than elsewhere. Outside of the exact sciences, much of what passes for disciplined discourse is such that tests of verifiablity or predictive value cannot be applied. It would be difficult to imagine testing any of Leavis's self-contradicatory, but authoritative, pronouncements on Dickens for truth or accuracy. There the question of fraud can hardly arise because there is no truth to be fabricated, only positions to be advanced.

Of course scientific rigour cannot be extended to all areas of human life and there are legitimate fields of enquiry and scholarship where the scientific method is inappropriate. Nevertheless, those whose experience of disciplined thought has been confined to the humanities (or the innumeracies), where opinion often reigns supreme over ascertainable fact and testable laws are unheard of, cannot be considered as adequately educated. As I shall argue presently, there will be many aspects of contemporary life – from the interpretation of opinion polls to environmental issues – they will not be able to think about intelligently. A scholar who can discriminate the six modes of sensibility in Saint-Amant but has not

yet caught up with Copernicus should not rationalise his ignorance but amend it; otherwise he will be as much a plaything of politicians in relation to the major issues of our time as the readers of the more down-market tabloids.

4
'The Murderousness and Gadgetry of this Age'

> We flinch from the immediate pressures of mystery in poetic, in aesthetic acts of creation as we do from the realization of our diminished humanity, of all that is literally bestial in the murderousness and gadgetry of this age.
>
> (George Steiner)[1]

The technophobia of humanist intellectuals, in which ignorance is rationalised by moral distaste, is irrational. Nevertheless, it is pandemic. George Steiner's passing reference to 'all that is literally bestial in the murderousness and gadgetry of this age' is but an extreme example of a widespread hostility to the pervasiveness of technology in the present age. The moral differences between Auschwitz and Special Care Baby Units, between machines for making antibiotics and those for delivering chemical weapons, are lost in the withering gaze of the *Kulturkritik*. It is symptomatic of how deep technophobia now goes and how widely it is accepted, that Steiner merely nods affirmatively in the direction of an assumption that the ascendency of technology is linked with what he calls 'our diminished humanity' – as if the logical, fact-driven approach of the science underlying it induces a cold, hard and mechanistic outlook in its consumers. Despite the fact that most people are (as we have noted) innocent of science and many are awash with superstitions,[2] we are to believe that they are transformed by the 'gadgetry' that surrounds them into mechanistic rationalists, Gradgrinds liable to turn into gauleiters. Slightly less absurd versions of this belief are so universal that Steiner does not have to argue for the association between 'the murderousness' and the 'gadgetry' of this age; its shallowness and irrationality are consequently safe from challenge.

The defender of technology has therefore to begin by stating the obvious: that technology is the application of rational or explicit

(latterly scientific) principles to the fabrication of devices which will assist in feeding, clothing, watering, healing, entertaining, defending and informing the inhabitants of planet earth; that technologists search for the most general and reliable solutions to the problems with which they are confronted; that this requires unremitting self-discipline, eschewing idle fantasy (though not creativity) and day-dreaming (but not imagination); that successful technology demands precision, rigour and honesty – elements rare elsewhere; and that the rewards are enormous. As Peter Medawar has pointed out, science and technology are incomparably the most successful endeavours – in terms of fulfilling declared aims – man has ever embarked upon.

Since technology has transformed pretty well every aspect of the lives of most of us, summarising its benefits in a few sentences is a tall order. By way of illustration, consider the life of a middle-aged male technophobe penning (or more likely word processing) his diatribes against technology. Unlike most human beings in history (indeed most organisms) he will not have died before reaching adult life. His surviving to what is now called 'middle' age makes him part of an even more privileged few. His own children will not be the minority survivors of a continuous, natural massacre of the innocents. He will be well fed. He will not be riddled with numerous undiagnosed and untreatable infestations. Any illnesses he has will be cured or, if incurable, significantly palliated. He will not have brought to his middle years the long-term effects of childhood malnutrition or chronic illness. His clothes, if not *haute couture*, will be infinitely superior to the smelly bug-ridden rags that have ineffectively insulated shivering humanity throughout most of history. Irrespective of the weather, he will be writing in an equable temperature. At night he will sleep in a comfortable bed, safe from cold and rain and the depredations of insects and wild animals. Supported above the abyss of pain, hunger, cold, and other unalleviated miseries contingent upon material want, he is privileged beyond the wildest dreams of his ancestors.

It might be objected that the technology behind many of the commodities securing his comfort is not rooted in high science but even this is untrue. The mass production of quality goods – goods that hitherto would have been available only to the wealthiest few – depends upon scientifically based technology. The newer fabrics are the result of polymer chemistry and the highly sophisticated and automated processes by which they are produced are heavily dependent upon electronics – a child, if ever there was one, of high

science. The early technological revolution may have owed more to 'the blacksmith's world than to the Royal Society' (to use Lewis Wolpert's words),[3] but current technology is very much a child of the Royal Society rather than the village forge.

Ironically, the very facts the technophobe requires to sustain his case against technology will have been established by scientific investigation and will be available to him courtesy of the most sophisticated methods of transport and knowledge dissemination: few libraries and fewer computerised databases grow in the wild. The products of his labour will be transmitted to the world at large through a system of publication and distribution that will permit his views, if they are interesting enough, to be read in New York within days of his committing them to print. If inspiration fails him, he can at the touch of a button gain access to great music played to near perfection by the world's virtuosi or turn to the television for an update on world affairs. In short, every aspect of his life – from eating for pleasure or survival to refining his technophobic views and getting them heard – will have been facilitated by technology.

Our technophobe tends to forget this, for successful technology – often as unobtrusive as the wiring in his house or the brilliant discoveries that are woven into the fabric of his clothes – has surrounded him from birth. Familiarity breeds invisibility. Technology is unobtrusive in proportion as it is successful – we tend to notice gadgets only when they break down. (Like the financial support given to us by our parents, successful technology tends to be taken for granted.) In consequence, the technophobe is not only insufficiently grateful to the technology responsible for distancing him from the brutalities routinely endured by other creatures and by most men throughout history; he is also insufficiently astonished by it. He is unimpressed that pictures from hundreds of miles away can be plucked out of the air by a device the size of a shoe box. He is equally unimpressed at being able to listen to the tape recorded voices of the dead. He is unmoved by the organisational and scientific achievement that enables him, without even raising his voice, or stirring from his room, to talk to another continent and address his remarks to one individual out of many millions. He simply fails to notice the delicate interaction between the laws of nature, the principles of aesthetics and the regulations covering product liability expressed in the everyday utility goods that surround him. The collective genius of such items (excavated in some small part by Nicolson Baker in his admirable

The Mezzanine)[4] passes unnoticed and unsung – perhaps because collective genius does not appeal to the Romantic vision, which is repelled by 'ant-like' co-operation, and values only that which seems to have issued from a single individual. (There is a delicious irony in the fact that 99.9 per cent of contemporary verse railing against the destruction of the human spirit by technology does not incorporate a fraction of the genius embodied in the word processors upon which they have been typed or implicit in the process by which the biros with which they have been written have been manufactured.)

If it is a kind of imbecility in citizens to forget the extent to which their welfare depends upon the efficiency of the sewers beneath the city, our technophobe is a world-ranking potato head; for he is able to forget all the ingenuity that separates him from Stone Age life, in which chronic subnutrition, continuous discomfort and early death were the norm. The entirety of Neolithic earth was an underdeveloped country: ordinary life was dominated by hunger and unalleviated illness; daily existence was unsuccessful total war against nature. The lives of those who survived infancy terminated at about the age of thirty.

Our specimen technophobe may protest that he would not wish to rescind all post-Neolithic progress, only that he would prefer to opt for low grade technology – or technology with a human face (as if human artefacts had a less human face than natural objects such as poisonous snakes or the unmet needs such as starvation that nature serves up). But this, at the very least, would rule out the production, quality control and distribution of safe and reliable self-propelled vehicles, effective antibiotics, radios upon which it was possible to make out Bach from static, and much else besides: it would not just be a matter of doing without Arcade games. Only a little bit of the technology we currently take for granted has to be withdrawn to remove most of the comfort we also take for granted. Technology is so interdependent – mass production, quality control and distribution are all very hi-tech matters, even if the commodity in question is fairly low-tech – that a modest retrenchment will have major effects, especially on the under-privileged (who, in a low-tech world, will be the majority). Taking back only a small amount of technology would not mean simply the end of package holidays in the sun or CD players, but also of quality-controlled antibiotics, guaranteed uncontaminated food, warmth in winter (which depends on a high energy output using advanced techniques

based on the science of the last two hundred years), conversations with distant relatives, knowledge of what is going on in Africa, most disaster intervention, health and safety at work etc. etc.

Technophobes do not appreciate the extent to which much of what they value in civilisation is dependent on machines. (Most seem to think that the machine spells the end of civilisation.) If only some of them were at least as intelligent as D. H. Lawrence (hardly an uncritical champion of contemporary culture) managed sometimes to be:

> As I look round this room, at the bed, at the counterpane, at the books and chairs and the little bottles, and think that machines made them, I am glad. I am very glad of the bedstead, of the white enameled iron with brass rail. As it stands, I rejoice over its essential simplicity. I would not wish it different. Its lines are straight and parallel, or at right angles, giving a sense of static motionlessness. Only that which is necessary is there, whittled down to the minimum. There is nothing to hurt me or to hinder me; my wish for something to serve my purpose is perfectly fulfilled. . . Wherefore I do honour to the machine and to its inventor.[5]

Some technophobes may understand that life without machines would be extremely unpleasant and still be prepared to endure these sacrifices for the sake of a low-tech world, but they should consider whether they have the right to wish such sacrifices upon others and whether they would even wish to inflict them upon their children. The longing for a more technology-free world is often based upon a sentimental view of the past or of 'the simple life' and, like sentimentality in other spheres, it is infused with a cruel ignorance. The collective memory of the low tech past tends to recall dances and peasant merriment and forget the agony of physical labour, not to speak of unalleviated cystitis.

Nostalgia for pre-industrial society – triggered perhaps by having one's Sunday walk in the country disturbed by the sound of a combine harvester – should not permit one to forget the penury and injustice borne by the unschooled majority nor the agony of the toil that occupied most of their waking hours. Peasants scything a field may make a more pleasing spectacle to a certain sort of individual than a motor-powered combine harvester in operation, but using a scythe for eighteen hours a day when one has (untreated) arthritis –

a common occupational consequence of years of brutal over-work – is less than pleasing for the scyther. It may be that the rhythm of scything is closer to nature than the arrhythmia – or more complex rhythms – of the combine harvester; but the throbbing of toothache, or a gouty toe, which precisely matches the beating of the heart, is closer than either.

Peter Medawar has remarked[6] on the 'systematic neglect of the benefactions of science' by those who pay attention 'only to the miscarriages of technology'. It is to the miscarriages that we must now turn our attention because they provide the technophobes with the seeming strength of their case. Technology, they argue, has increased our capacity to leach the earth of its resources and so to make it uninhabitable for other species and, eventually, ourselves. Technology has created such weapons of destruction that the very future of the human race hangs by a spider's thread. Technology enables disinformation, as well as information, to be disseminated. If technology has freed some from material need, it has done so at the cost of increasing social control. Technology has massed power in fewer, more dangerous, hands. It has permitted the economic domination of one nation by another. And, finally, in providing us with mechanised solutions to many of the problems of living, it has caused us to become, if not mechanised, at least in part dehumanised. Such assertions are used to justify the belief that man, in finding technical solutions to the protean problems of keeping alive and comfortable on this planet, has seriously lost his way. Although technology is remarkably effective in helping at least some men to do all sorts of things that in previous centuries were scarcely dreamed of, the cost has been too high. Let us look at this more critically.

Consider first environmental pollution. Animals, including man, have been polluting and deprading their environment since the greed of the first locusts wiped out their own food supply. However, advanced technology has permitted this on an unprecedented scale. By and large, global pollution is the result of meeting the needs of some of the individuals on the planet who would otherwise go cold and hungry and die of diseases that are now treatable. Since, even where pollution is life-threatening, the threat is not usually of immediate death (as starvation offers) but of a later death, it might be regarded as an acceptable price for feeding and sheltering and comforting the earth's inhabitants. This is an inadequate counter-argument for several reasons. First, those who benefit from activities

that pollute the planet are often not the same as those who suffer the effects of pollution. Secondly, if world-wide pollution continues to increase, the planet will become uninhabitable for all. And thirdly, not all pollution-making activity relates to fundamental needs: pollution often derives from industrial production that answers to frivolous wishes of the affluent rather than the survival of the poor. These counter-arguments are not, however, decisive.

The greatest drive to planetary pollution is not technology *per se*. Indeed, the more sophisticated the technology, the less polluting it may be. Communication by telephone carries less environmental cost than transporting bodies by steam engines from one end of the country to the other: the information economy is less environmentally destructive than the energy economy. The main drives to planetary pollution are individual greed and the exponential increase in world population.[7] Scientists did not invent human greed; nor can they be held responsible for it. As for the increase in the population, this is a consequence of the beneficent power of technology so to improve the conditions into which people are born that they survive: a rather strange basis for indictment, one would have thought. It would be inhumane to regret the decline in infant mortality. In respect of both human greed and the population explosion, science has discharged its responsibilities admirably. For many years, scientists have warned against the consequences of planetary over-crowding and have provided the means by which fertility may be controlled without denying individuals sexual expression. It has also investigated ways in which these methods may be made generally available and acceptable. But politics, hypocrisy and religious prejudice, backed up by misinformation, have intervened between the scientists' solutions and their implementation. To control the problem of planetary overcrowding in future, we shall have to encourage people to use the methods of birth control that work. The immemorial methods are a high infant mortality rate, infanticide and child neglect and death – which I would submit are undesirable – and sexual abstinence – which is universally unpopular. There remain scientifically-based methods of fertility control which are opposed only by superstition, misinformation, sentimentality and by individuals who have a vested interest in the oppression of women.

It must be remembered, too, that scientists were the first to identify and to quantify the more subtle problems of pollution: it

was careful scientific observation and hard scientific thought that identified the hole in the ozone layer and predicted the problem of global warming, not investigative journalism or culture criticism or the Children of the Celtic Dawn or even the Prince of Wales. The scientists have provided the opinion formers and the politicians with the ammunition to constrain individual greed. That we can think in global terms at all and can communicate our thoughts throughout the globe are themselves achievements of science. The problems of pollution argue not for the abandonment of the scientific approach but for its more extensive and reflective and unselfish application.

What of the role of science in the concentration of power and social control? Readers of Orwell's *Nineteen Eighty Four* may think that advanced technology provides the necessary and sufficient conditions for advanced tyranny. Nothing could be further from the truth: history shows that tyranny can achieve an appalling completeness without the benefit of nation-wide electronic communications systems. The peasants tyrannised by the Lord of the Manor – whose absolute power scarcely counted as a scandal – had little respite from his oppression and little recourse to justice. Nor, on a larger scale, did nations enslaved by other nations – such as the Helots by the Spartans or the Israelites by the Egyptians. While technology may be used to aid oppression, oppression of a high order has been the condition of most of humanity thoughout most of history, and high technology is as likely to be democratising as to support tyranny. One thinks of the Great Pyramid of Cheops whose low-tech construction demanded the labour of approximately 100 000 men for twenty years; of the fact that about one third of the population of low tech ancient Athens was enslaved; of the Roman mines and quarries where slaves were rapidly and systematically worked to death. In recent decades, the most appalling tyrannies have been witnessed in scientifically backward countries: in Brezhnev's Soviet Union, Amin's Uganda, Bokassa's Central African Republic, Ceausescu's Roumania. The most potent allies of tyranny are not science but enslavement to custom and a weak development of that critical tradition whose supreme expression is science. Indeed, modern methods of the transmission of information work for democracy, for the diffusion of power and for justice at least as effectively as they do for tyranny. The misuse of technology in the elaborate machinery of contemporary state

propaganda shows how much harder even dictators nowadays have to lie to maintain their position. Earlier tyrannies were the permanent unchallenged condition of life.

What of the power that technology has given to aggressors, providing them with the facility to inflict suffering on an unprecedented scale? If this can be laid at the door of science – so that scientists can be held solely responsible for the possible destruction of the planet – then science's account must be in debit. The truth is that science has immensely increased our power to realise our intentions. These intentions may be good or evil. We may on the one hand use the latest technology to save the lives of babies who would otherwise die and to help to feed the starving millions; or, on the other hand, to terrorise, or to blow up, the earth. In the vast majority of cases, technology has been used to make the world safer, and life more comfortable or more endurable, to avert the tragedy of premature death. But it would be foolish to deny that it has also been used to support evil. Technology may make wars more destructive than ever before. Atomic weapons certainly carry that potential but actual wars in the low-tech past have been unspeakably brutal and destructive. The Thirty Years War, which antedated the impact of the scientific revolution on technology, wiped out over a third of the population of Germany. Death on a catastrophic scale is always a characteristic of war and it is remarkable how the capacity to inflict it has not been paralleled by an increase in war-related deaths. Offsetting the episodic horrors of mass slaughter facilitated by (though not dependent on) technology, there is the continuing support and comforting of the everyday life of many millions. Should technology be judged only by the former?

If we wanted to abolish the technology that has been put to evil purposes and has enhanced the power of evil men to terrorise their conspecifics, how far back should we go? Consider the earliest technology – the prototechnology of handling fire. Fire has been put to good uses: to keep a baby warm who might otherwise die of cold, to cook dinner, to keep at bay darkness and the beasts of the night. On the other hand, it has been employed for evil purposes: roasting saints, razing the villages of one's enemies to the ground. Moreover it has had its share of environmental catastrophes; the Great Fire of London, which destroyed four-fifths of the City, and forest fires the world over. Should the Promethean 'theft of fire' be, on these grounds, deplored? Should fire have been banned in London after

1666? Indeed, should we move to ban fire from the earth? The very idea is absurd. And, if fire were to be banned, why stop at fire? A stone axe may be used to ward off wild animals or to bash one's neighbour's brains in. Much of the evil men do would not have been possible without their possession of an opposible thumb. The hand may caress; or it may curl up into a fist and deliver a mortal blow. Should we condemn human hands because of the evil use that has been made of them? Should we not recommend their amputation at birth? The case against technology is precisely as strong as that against hands – which may be used to comfort or to strike. If you wanted to deprive human beings of all those things that make them capable of great evil, you would have to deny them all that makes it possible for them to do great good.

This is blindingly obvious; so there must be more to current technophobia than the confusion customary in public debate. There will be an element of *schadenfreude*, delight in the fact that the best laid plans of mice and men often go awry. However, the notion that science and technology are inimical to civilisation – even though they have created the conditions in which civilised life is possible now for the many rather than the few – also flourishes because it has tentacular roots that draw nourishment from a sentimental view of humanity and from something deeper, which I will come to presently.

I have already referred to the sentimentality that overlooks the material want that dominated life in the past. Another form of sentimentality – the 'poor but happy' myth – is the belief that advances in material comfort are associated with 'diminished humanity'. Most studies, from Turnbull's examination of the Ik tribe[8] to Robert Roberts' *The Classic Slum* (a study of Salford life in the first quarter of this century)[9] suggest precisely the opposite: destitution does not make one better-tempered or altruistic; involuntary anaemia is not the royal road to sainthood. Apart from certain over-reported star exceptions, people in nasty circumstances tend to be rather nasty; brutal conditions of life brutalise. Brecht's slogan, 'Grub first, then ethics', captures this. A materially impoverished society is one in which savage behaviour is constrained only by laws almost as savage. To Steiner's condemnation of 'the murderousness and gadgetry of this age', one might retort that while the gadgetry of this age **is** unique, inasmuch as its gadgets work, its murderousness most certainly is not. The history of the world is largely the history of chaos, injustice and suffering: it

is as Nietzsche said, an experimental refutation of the hypothesis of a moral world order. If this appals us more than it did our ancestors, it may be because we have higher expectations of humanity: science-based technology has liberated enough of us from the struggle for nutrition and warmth for us to expect better of ourselves. Now we have grub, should we not be more ethical?

The higher expressions of human spirituality have always depended upon some liberation of the human organism from enslavement to material necessity: grub first, then aesthetics.[10]. Blake's 'mind-forg'd manacles' derive ultimately from manacles forged in the body by material scarcity – the natural condition of every living organism. The power of the maleficent to oppress the human spirit is similarly derived: they gain access to the oppressed through their suffering bodies. Blakean feelings of joy and eternal delight are available only to a body that is in some sort of working order. Far from forging manacles for man, the mind, or at least its collective expression in technology, has done much to break the body-forg'd manacles that would otherwise have held man in their grip. In earlier times, the liberation of a few was bought at the cost of re-doubling the enslavement of the many. Technology has transferred much of that enslavement to inanimate machines. This great act of liberation is typically abhorred by those who already enjoy the fruits of liberation; just as 'materialism' tends to be a jibe flung by those who are accustomed to having washing machines at those who are preoccupied with the struggle to get them.

But the hostility to technology – which would I suspect still be strong even if its successes were unalloyed with failure – goes deeper than an hypocritical distaste for 'getting and spending' (as if life without technology were not unceasing, because largely unsuccessful, **attempts** at 'getting and spending'). There is the belief that technology brings with it spiritual as well as physical ills; that the logical, fact-driven science that underlies it makes the outlook of those who use technology cold, hard and mechanistic. There is the superstition that technological solutions are somehow intrinsically wrong. This taps into an aquifer of ancestral terror deep in the collective conscience. Practical ingenuity is associated with impiety, with spiritual delinquency, personified in the figure of Prometheus – the 'forethinker' – who stole fire from the gods. Prometheus personifies man's increasing tendency to seek secular solutions to the problems of living. The first technologist, he started the process by which the gods' control over man's fate was

loosened. The unfortunate Titan was punished horribly but man, his benefactor, got off lightly. Man, it seems, has been awaiting his comeuppance ever since.[11]

This sentiment is captured in A.D. Hope's poem *Prometheus Unbound*, where the destruction of the earth by an atomic explosion is seen as the logical consequence of the theft of fire. According to this poem, it was Prometheus' continuing punishment, after his release from the rock,

> ... to wander wide
> The ashes of mankind from sea to sea
> Judging that theft of fire from which they died.

To see, in short, what he had done. Those for whom 'technology' means atomic bombs rather than antibiotics are still to some extent imprisoned by the Promethean myth.

Cynicism about scientists themselves and a perverse failure to acknowledge the achievements of their mighty collective enterprise is also a remnant of a religious sensibility. Despising mankind is a tribute secular thought pays to a lost theocentric vision. Even if they don't believe in any of the places we are supposed to have fallen from, technophobes continue to accept the idea of our irredeemable fallenness. Science, being a huge effort to reverse Adam's curse, to deny the inevitability of our fallenness and the justice of our punishment in material want, therefore seems inherently impious. A Rain Dance may be less effective than cloud seeding or water conservation schemes, but it more than compensates for its uselessness by being infused with a collective expression of piety. (True piety, of course, would be astonished at the cumulative achievements of mankind and at the great mystery of human consciousness: that it has access to truths – and falsehoods – whose scope infinitely outsizes the body that houses it.)

The theme of religious impiety is sounded at a more primitive level in the notion that technology somehow does not respect nature, that the mastery of nature is a kind of violent possession akin to rape. The myth of a beneficent nature whose organic identity is violated by human machines that also violate our own nature – the Gaia complex – is one that would repay deep analysis. But it is perhaps worth reminding Mother Nature's more uncritical lovers that nothing could be more natural than a 90 per cent infant mortality rate, that pus pouring from one's leg is as natural as song

pouring from a bird's throat, and starvation is as natural as satiety. To vary a theme sounded earlier, natural rhythms are more completely exemplifed in the rhythmic throbbing of a gouty toe than in an Arts Council-sponsored dance to Spring. Those for whom 'organic' is synonymous with beneficent, and Mother Nature is the source of all good, may find her rather ungrateful; for she sees them, too, as organic and as suitable material for recycling.

A sentimentality about the human past and a sentimentality about non-human nature are fused in the Arcadian idea of those warm, 'organic' societies to which man once belonged and from which he has been expelled by technological advance. To this exile we have been driven by a perverse preference for being alive over being dead, warm over cold, well-fed over starving, for being gainfully employed, rather than engaged in slave labour, and given, rather than denied, access to the cultural riches of the earth. Those who do not share these preferences may perhaps wish to retire to some remote place where they may live out a Stone Age existence and savour Adam's curse to the full. The final proof of their sincerity will be that they relinquish all those technological aids – even their word processors and jet-linked international conferences – that make possible the pleasure of sermonising on their experiences to an instructed world. Those who cannot take this step, but still remain unhappy with the technology that comforts their lives, may rest assured that an eventual closer relationship with nature is guaranteed, whatever they do and whether they like it or not. An unwilled return to the less salubrious and less articulate parts of the nitrogen cycle is the fate that awaits us all.

5
Anti-Science and Organic Daydreams

For many of those who find science distasteful, the question of whether or not it is of net material benefit to mankind is irrelevant. Science is condemned precisely insofar as it is preoccupied with meeting material needs and wants, and (to use Bacon's terms) its 'experiments of use' outnumber its 'experiments of light'. Worse, the successes of science have encouraged scientists – and many others in the centuries dominated by science-based technology – to believe in progress. Progress, however, is an illusion: technology has not commuted the common sentence of mortality nor has it brought a definitive understanding of the universe, even less of our place in it. So the scientists' optimism – even their commitment to improving the world – is condemned as 'shallow'. Technological advances, however impressive, do not solve the tragedy of the human condition, they merely blunt our perception of it. It is this, perhaps, rather than the disenchanted world pictures of mechanistic science, that accounts for its despiritualising influence. Science, with its many solutions to specific problems, induces a collective amnesia of our condition, of the terrible mystery of a life in which death is inevitable. The ordeal of privation is to be welcomed: by waking one out of a cocoon of material satisfaction, it may expose one to a sense of the possible that goes beyond the ordinary, closed sense of everyday life.

The defender of science would be justified in pointing out that no human activity has solved the problem of our finitude and that very little contemporary art even pretends to transilluminate the mystery of living. And if science has not cancelled mortality, it is surely better to die at eighty than at eight months. He might also draw attention to the significant fact that second-order humanist intellectuals tend to be more at ease expressing unqualified contempt for the endeavour to solve material need than first-order creative artists. The latter, in an age when technical intervention can make a huge difference, and when it is therefore possible to be of practical use to the world, are commonly weighed down by what

Martin Seymour-Smith has christened *Kunstlerschuld*[1]. For many of the greatest writers – Vallejo, Broch, Rilke – the fact that 'poetry does not change anything' is a source of deep anguish: if art is not concerned with the remediable miseries of the world, it is condemned by its inutility. They concord with the judgement, expressed in Keats' *Hyperion*, that the highest art is infused with an urgent sense of the miseries of the world:

> 'None can usurp this height' returned that shade,
> 'But those to whom the miseries of the world
> Are misery, and will not let them rest.
> All else who find a haven in the world,
> Where they may thoughtless sleep away their days,
> If by a chance into this fane they come,
> Rot on the pavement where thou rottd'st half'.
> (Hyperion ll. 147–53)

The twentieth-century preoccupation with 'commitment' in art is a direct expression of artists' wish to be of practical benefit, and of the conviction that the obligation to serve in the Kingdom of Earthly Means cannot be offset by service in the Kingdom of Transcendental Ends.

The defender of science may also be tempted to cite the quotation from Hegel that we referred to earlier: Seek for food and clothing first, then the Kingdom of God shall be added unto you. He might also point out that the spiritual content of unrelieved toothache, or of constant shortness of breath from anaemia due to tapeworms, or of unrelieved vomiting is limited and hardly justifies the suffering involved. The case of death from neonatal tetany – in which a tiny baby spends most of its first and only week of life convulsing to death – is an even less compelling example of the spiritual benefits of physical suffering.

C. P. Snow pointed out (in *The Two Cultures and the Scientific Revolution* and the later *Recent Thoughts on the Two Cultures*) the 'moral trap' which comes from a tragic sense of life. Scientists, he added, 'are not prepared to believe that because the individual life is tragic . . . you need not worry if two-thirds of the world are dying before their time and while they are alive have not enough to eat'. An awareness of the irremediable in the human condition does not lessen responsibility for the needs of others, or justify condemning as shallow the melioristic instincts of the scientist. Notwithstanding

that every finite life, howsoever protracted by technology, falls infinitely short of immortality, it is presumably better to give birth to living rather than dead children and not to die in the process, to be well-fed rather than hungry, to be out of pain rather than in it. For the sake of those who are in want, we must therefore work for progress; we must hope for the sake of those who have no hope. As Medawar said, 'To deride hope in progress is the ultimate fatuity, the last word in poverty of spirit and meanness of mind'.[2] T. H. Huxley's sentiments expressed in his essay 'On the Physical Basis of Life' will be echoed by many scientists:

> We live in a world which is full of misery and ignorance and the plain duty of each and all of us is to try to make the little corner he can influence somewhat less miserable and somewhat less ignorant than it was before he entered it. To do this effectually it is necessary to be fully possessed of only two beliefs: the first, that the order of Nature is ascertainable by our faculties to an extent which is practically unlimited; the second, that our volition counts for something as a condition of the course of events.[3]

Of course, it is very easy to sneer at progressive dreams when you are not yourself hungry, cold or facing death from disease; but very few of those who despise science are careless of whether they themselves live or die, or whether they are hungry or wellfed.

If it is agreed that it is honourable to seek to improve the lot of mankind, we must ask ourselves how this is to be achieved. Those who despise the scientific approach and the technology based upon it never make clear what they would put in its place. Magic, wishful thinking, priestly authority do not seem to offer much to alleviate Adam's curse and to make the planet more amenable to human need.

Of course, science cannot solve all the problems of living or even of meeting physical need. While, for many of us, technology has been extraordinarily successful in pacifying nature, it has been less successful in dealing with the suffering that human beings, rather than nature, visit on human beings. The world would be a better place if individuals behaved better and if the institutions which in part determine and often legitimate their behaviour were replaced by better institutions. The dream of achieving this scientifically is a **scientistic**, rather than a scientific, ideal; real life and fiction have provided sufficient dystopian exemplars to put us off centralised quasi-scientific management of society. The equation

BUMPER HARVESTS
+
CORRUPT AND INEFFICIENT
INSTITUTIONS = MASS STARVATION
+
SCIENTISTIC AND
MORALISTIC RHETORIC

which summarises the politico-economic programmes of many centralised dictatorships, is a shorthand reminder both of the limitations of science and of the difficulty of implementing ingenious and honest technology in a stupid and dishonest world. Genetic engineering that makes two blades of grass grow where one grew before may only swell a grain mountain into a Mont Blanc and bankrupt third-world farmers. However, even in the sphere of co-operation and organisation, science has much to teach the world.

Consider the effortless internationalism of science. The edition of the Lancet on my desk has contributors from 22 nations. If one publishes a paper in a prominent journal, it is not unusual to get reprint requests from countries as far apart as Czechoslovakia and Brazil. A scientific journal is a permanent international conference in which the participants are agreed on terminology, on methodology and on the kinds of facts that are needed to back up assertions. All of these limit international misunderstanding to a degree unique in human affairs. There is no human activity less provincial than science. Although debate is sometimes heated and genuine discoveries or novel paradigms may take time to get accepted, the rules of engagement are such as to facilitate, as far as is possible in human life, the uncovering of truth. With the exception of certain notorious horrors – the attempt to refute relativity theory on the grounds that it was 'Jewish physics', Lysenko's ideological advocacy of Larmackism – scientists do not invoke the provenance of ideas or of observations as grounds for discounting them. *Argumentum ad hominem, argumentum ad locum*, argument from authority (except insofar as writers may refer to others' findings in published papers which have been peer-reviewed for rigour of method and statistical analysis) is unacceptable. Those who doubt reported findings can attempt to repeat them in their own laboratories and either succeed or – as in the case of Benveniste's claims for the immunological potency of homoeopathic solutions, or Fleischman's seeming demonstration of fusion at room temperature

– report their failures to replicate them. Or they can check through the page of equations searching for inconsistency. Such constraints impose a collective honesty, whatever the individual temptation to fraud. They make it impossible for a charismatic and dogmatic figure – a Leavis or a Lacan – to dominate a field simply by virtue of force of personality, or an aura of moral or intellectual superiority. Criticism and self-criticism are constant features of scientific discourse which shows how disagreement can be handled, without merely destructive conflict, on the way to the truth.

The scientific community provides models, that the non-scientific world would do well to study and perhaps imitate, of large-scale co-operation between individuals from widely differing backgrounds working towards a common goal. Multi-national clinical trials are now commonplace: a stroke trial to which I am a minor contributor has participants from 30 countries, ranging from Italy to the People's Republic of China. The European Centre for Nuclear Research brings together hundreds of scientists from dozens of countries. Science is thus not only the most successful of all human enterprises but also the most co-operative.

Science is, consequently, comparatively guru-free, and free of the self-legitimating authority that characterises much of human activity inside and outside of academe. There are geniuses in science but they do not thereby gain an authority that extends beyond their actual achievements, and their theories are up for testing like anyone else's, their experimental results for checking like anyone else's. Quantum theory was not discredited in the 1930s and 1940s simply because of Einstein's hostility to it, or at least to the dominant Copenhagen interpretation, even though he had successfully developed one of the most beautiful and admired and far-reaching theories in the history of the human mind. It would be naive to believe that the authority of great men or of the established consensus carries no weight in science; but the argument from authority – 'This is true because I say so/X says so' – is less potent here than in any other collective human activity.

Scientific co-operation and organisation seems to work in places where virtually nothing else does. Whatever one thinks of the use of human resources to explore space, the space programme in the former USSR was one of the few major enterprises in that country that had been driven and directed by scientific experts, and was, despite its enormous intrinsic difficulty, one of the few that had been exempt from the failure that has dogged most of the great

projects in that country. The smallpox eradication programme, directed by scientists and executed in accordance with a plan rigorously based upon a scientific understanding of the mode of spread of the disease, was a complete success. Investigation of how scientists work together, as well as how they think in private, might help mankind to overcome some of the barriers it erects in implementing the solutions scientists make available.

However, humanity is faced by more than man-made problems: fundamentally, our manacles are not mind-forg'd or even society-forg'd but body-forg'd. Ultimately, they derive from the fact that nature has no particular care for one species, or one individual. It does not favour the anaemic child over the hookworm leaching it of blood. Indeed, nature does not particularly favour living matter over non-living, the head upon which a stone falls over the falling stone. So I return to the the question that should – but sometimes does not – seriously exercise those to whom the scientific approach is intrinsically repugnant: what, if science and technology were rejected, they would put in its place to assist mankind in its battle to survive in an essentially indifferent, overwhelmingly non-human universe. To give this question the necessary edge, let us relate it to a specific problem that nature has recently served up to humankind: the catastrophe of HIV infection, the scale of which is only just being appreciated.

It is estimated that, if no cure is found, the HIV/AIDS pandemic will kill, in addition to many millions of males, 3 000 000 or more women and children in the 1990s; that in the major cities in the Americas, Western Europe and sub-Saharan Africa infant and child mortality will rise by 30 per cent; and that more than a million uninfected children will be orphaned because their HIV-infected mothers and fathers will have died from AIDS.[4] The world is in need of help. To whom should it turn? Politicians? Except in one or two countries such as the UK, their role in the crisis has been less than admirable. United States politicians, needing to be in tune with a homophobic electorate, for ten years ignored the problem or made suggestions that would have been at home in Nazi Germany. African politicians have, with a few honourable exceptions, lied to protect the tourist trade and a misplaced sense of nationalist *amour propre*, with the result that in, for example, Central African Republic, between 20 per cent and 30 per cent of the adult male population will die of AIDS in the next decade.[5] Should we look to journalists? After a disgraceful period in which this ghastly disease was treated

in the UK at least as a delicious scandal, the tabloids and the broadsheets have settled down to dishing out information and misinformation in equal proportions: fifteen years into the epidemic prominent newspapers (amongst them *The Sunday Times*) are trying to reassure their readers that AIDS is not a heterosexual disease. Can *Kulturkritiks* help us? Susan Sontag's well-meaning but deeply muddled *AIDS and its Metaphors* is not encouraging. Apart from her irrelevant critique of metaphors of battle in the struggle to control the disease, she questions the idea of a disease characterised by immune failure and consequent opportunistic infection (of which there are many examples other than AIDS) and tries to deny that AIDS is 'really' a disease at all.[6]

What, in the meantime, have the scientists been up to? They have established diagnostic criteria for the disease, have accumulated a gigantic body of knowledge about its manifestations at every stage in every system of the body in every type of sufferer, have determined its cause and its method of transmission, have developed precise and sensitive tests for establishing HIV status, have identified some of the co-factors which determine whether and when HIV carriers actually develop AIDS, have found ways of dealing with many of its manifestations, and of palliating its later stages, and, by brilliant experimentation, have worked out the mechanism of action of the virus and a strategy which may lead to a vaccine in the near future[7] and a cure in the not-too-remote future. All of this has been achieved as a result not only of the highest level of scientific rigour but also of a freedom from the primitive attitudes and prejudices of most of the non-scientific community. Apart from the courage of certain individual sufferers and their supporters, the majority of the wholly admirable players in the AIDS crisis have been clinical and non-clinical scientists and those who have taken a scientific view of the problem. A comparison between the attitudes and approaches of doctors and scientists to AIDS and that of politicians with their talk of quarantine for HIV carriers, and opinion-formers such as journalists, who talked for so long of the 'Gay Plague', reinforces the belief that science is not merely the most successful but also one of the least contemptible activities man engages in.

And yet the public view of the role of scientists has often been hostile. The priority dispute between Robert Gallo and Luc Montagnier over the identification of the causative virus has been given huge publicity, as it provides pleasing evidence that –

surprise, surprise – scientists too have personal ambitions. Scientists have been accused of using the AIDS crisis as a platform to self-advancement. And so on. Even if one granted to these fringe matters the importance they are given in the press, to whom should one trust one's hope for the future? The cultural diagnosticians who delight in putting science in its place with the total authority that comes from complete ignorance? Or the patient researchers working out the docking mechanisms of CD_4 in order to thwart the plans of HIV to write, by reverse transcription, its sentence of death into DNA, the book of life itself? Indignant journalists who write under banner headlines like 'Western Technology Spreads AIDS' (the *Observer*) – a reference to the spread of AIDS by illicitly used dirty needles in Africa (as if all unhygienic practices, such as are routinely observed in certain non-western technologies did not spread infections) – or individuals who make precise and clear statements on the basis of observations obsessionally checked and re-checked even before they are submitted to the rigours of peer review?

The crucial role of the despised – and supposedly inhuman – science and technology in dealing with the greatest health threat of the century will grieve those who would like to adopt other, ideologically more pleasing, approaches. And yet the alternatives to science are unsatisfactory. Blaming the victims and seeing the problem as a manifestation of divine justice have ceased to be fashionable now that the general population feels itself threatened. For a similar reason, the views of the 'deep' ecologists and the 'anthropofugal philosophers'[8] that AIDS is to be welcomed as nature's way of dealing with the population problem and correcting man's total domination of the planet, are now whispered *sotto voce*. Doing rain dances, advocating alternative medicine, hoping the whole problem will simply go away, have also lost their appeal as the epidemic has closed in on people who earlier thought they and their lovers and their children were safe. Of course, scientific medicine is not the whole answer. Education in public health is crucial – though how you educate people out of their desires is as yet an unsolved problem. And science will be less effective than it might be so long as nations and individuals continue lying. Individual, corporate and national greed will also prevent the AIDS vaccines and cures, when they are developed, from being made available precisely where they are most needed. As was pointed out in a Lancet editorial (AIDS Vaccine: hope and despair[9]) the current story is of scientific hope and political despair.

It is revealing that disparagement of conventional science goes side by side with the expectation – often wildly optimistic as regards time-scale – that scientists will 'find the answer'. The assumption that there will be a solution forthcoming from this quarter is deeply ingrained in contemporary consciousness. This raises a connected point: when there is a real problem, the world turns to conventional science and technology to solve it. Just as when you have a real, serious disease – cardiac failure, appendicitis, or a broken leg – flower remedies, reflexology, aromatherapy, etc. are quietly laid to one side and orthodox treatments are sought. This suggests that those who claim to believe in anti- or non-scientific approaches to solving human problems do not, ultimately, believe in them. So why do they profess them? What is it that people dislike so much about science that they will devote so much wishful thinking to advocating quackery of various sorts? That, except when the chips are down, so many (daft) answers to the question 'If you reject science what would you put in its place?' are forthcoming.

Quackery, medical and non-medical, is appealing for many reasons: first, it often offers instant answers; and second, its answers and procedures have intuitive appeal. These characteristics are, of course, closely connected, as is brought out in George Steiner's contrast between science 'which amasses one grain after another in its storehouse only by hard, fatiguing, individual work..' and knowledge acquisition by 'a spontaneous spiritual knowing, which would deliver truths about the outer as well as the inner world, without the trouble of recourse to mathematics or experiments'.[10] Magic thinking has the virtue of coinciding with the prejudices of unreformed common sense – the sun goes round the earth – and offering immediate results, like the witch doctor who can diagnose you without taking a careful history, examining you or seeking help from investigations carried out by colleagues.[11] But there is more to it than this.

Anti-scientific thought often personalises problems and, indeed, the natural world which gives rise to them. This is, for example, a feature of alternative medicine where general treatments for diseases recognised to be instances of universal types are eschewed in favour of individualised treatment that relates the remedy to the personality of the individual. Conventional medicine regards the disease as a universal – for which there is a standard treatment; individuality resides in the patient's experience of the disease and the relationship to the doctor. Personalising pathological processes

is both comforting – as it seems to offer new areas of control and to make additional sense of senseless suffering – and oppressive, as it turns the sufferer from a blameless victim into someone whose personality carries part of the responsibility for the illness. The importance Rilke attached to the rarity of the manifestations of the leukaemia from which he suffered[12] is a poignant testimony to the desire to believe that our suffering is not an impersonal process but a personal destiny, a message addressed to oneself. Diseases in which the causes are unknown and treatment unsatisfactory – tuberculosis in the nineteenth century, some cancers in the twentieth – are more likely to be personalised than those in which the cause is known – fractured femur or tuberculosis in the twentieth century. And they are for the same reason more attractive to quacks. When orthodox medicine can offer a successful treatment for a disease, the quacks find it prudent to move on.

The personalisation of the disease process itself (as opposed to the experience of disease) is an extreme example of the magic thinking – 'mind among things' – that characterises anti-scientific thought and its nostrums for the world's ills. Understanding its background returns us to themes sounded earlier in this work, for it is rooted in hunger for a vision of the world that anthropomorphises the universe, or at least organicises it.[13] Although science has dramatically diminished human helplessness before the non-human universe, its successes derive from a determinedly objective view that outrages our sense of our own centrality and importance in the larger scheme of things. 'The view from nowhere' cultivated by science is remote from the egocentric particulars of everyday life and the gossipy self-absorption that is our natural and comforting standpoint. To the developed intellect, this view diminishes us to a brief nano-nothing in the endless history of the mega-something. It also empties the natural world not only of mankind but also of spirits. The displacement of the theistic and animistic philosophy of nature by a mechanical one has reduced humankind to a very small event on a minute planet. The Copernican revolution that made the earth 'one of the heavenly bodies' (Galileo) demoted rather than promoted that planet. That process of demotion has continued as expanding knowledge has expanded the universe in both space and time. Coleridge's assertion in *Biographia Literaria* that 'We have purchased a few brilliant inventions at the loss of all communion with life and the spirit of nature' both overstates the adverse impact of science and understates its achievements; but it does capture

what lies behind those who would seek alternatives, however ineffective, to the science and technology of our age.

As Wolpert has pointed out (see note 11), it is debatable to what extent we are living in a secular age and the role of science in any secularisation there has been. Let us for the present assume that this is an age without transcendence; how much was this prefigured in the Newtonian heritage? We noted in 'Poets, Scientists and Rainbows' that Newton himself was not entirely at ease with the mechanistic world picture to which his discoveries made such a decisive contribution. His case is for this reason especially interesting – and instructive.

As well as being perhaps the greatest scientist Europe has known, Newton was also one of the most revered and productive alchemists of his time.[14] In his science, the non-mechanistic idea of Absolute Space – introduced to explain inertia – as God's sensorium stimulated his greatest achievements. However, his great laws were formulated within a mechanistic framework; and they were tested against empirical observations consistent with a mechanistic nature that boiled down to qualitatively neutral matter differentiated only by the size, shape and motion of its atomic or corpuscular constituents. The sharply different world picture he espoused as an alchemist was informed by the notion that mind or spirit plays the role of an activating principle in physical nature, and he regarded the elements he experimented with as humours rather than inorganic chemicals. Many would today find the world picture of his alchemy more attractive than that of his science. But twentieth century alchemy is no further on than seventeenth century alchemy, while mechanistic chemistry has long achieved things – including the transmutation of elements – that alchemists only dreamed of. Newton's own *oeuvre* therefore permits a comparison: futile gropings in an attractive, animistic, organic, anthropomorphic world picture (in which the properties and unions of chemicals were understood in sexual, not to say sexist, terms); and gigantic enduring achievement in an unattractive mechanistic world picture.

The question as to what, if we reject science and technology, we should put in their place remains unanswered by the critics of science. And so long as it is unanswered (and not infrequently unasked), we are left with random activity, inoperant gestures, magic and witchcraft to arm us in the struggle against natural and humanly-caused disaster. Hostility to science is rather like hostility to government: there are bad governments and good governments

and even bad things in good government; but without government, there is only lawless anarchy. If there has ever been a time when the planet could be a pleasant place to live on without the comforts of science-based technology, the present is not such a time. With the current level of world population, science, technology and rational, science-based social policies of public health, have ceased to be a mere option. We need the huge unit productivity that technology has permitted in order to ensure that, for example, the present quality of life in developed countries should be maintained. The displacement of the combine harvester with the sickle would soon lead to starvation in the United Kingdom. A barrier to realising this is, as I have indicated, that science has so entered into our thinking that we don't notice how much of ordinary common sense is rooted in science, or reflects the transformation of human thought, consciousness, and our world picture, by science. Many of our views about hygiene, for example, are based in bacteriology as it was developed, argued and tested in the nineteenth century, and, a mechanical, rather than a spiritual, view of illness.

Of course, it would be nice if the objective reality of the natural world corresponded to one's most immediate intuitions; if the animistic philosophy of nature turned out to be the true one and the mechanical philosophy had turned out to be false; if alchemy and not chemistry had delivered the goods. But this is not how things are. Chemists have achieved things – even the transmutation of the elements – that alchemists only dreamed of. The unattractive philosophy of nature – which began with the assumption that it boiled down to 'qualitatively neutral matter differentiated only by the size, shape and motion of its atomic or corpusclar constituents', though it has moved on a long way since then[15] – has produced results that the rival, more attractive view – that mind or spirit plays the role of an activating principle in physical nature – has not. I repeat: twentieth century alchemy is much the same as – and as ineffectual as – seventeenth-century alchemy.

The case of Newton points to an obvious moral to be drawn about the relative value of thinking and of wishful thinking, and about their respective places in science – expressed so well in Claude Bernard's aphorism: 'outside of my laboratory, I let my imagination take wing; but once I go into my laboratory, I put my imagination away'. Mechanistic science, in its appropriate field of operation, may not yield so much immediate joy as, for example, Blake promises to those who succumb to his anti-mechanistic system. But

it delivers. The promise of instant cleansing of the doors of perception may be more attractive, but if they are cleansed in order to see more clearly that one is starving and that one's children are dying of disease, the vision of eternity might not be all that different from that available to the dead of all species.

6

Epilogue: The Consequences of Omniscience

There is a desparate need for a dialogue between scientists and society. This goes beyond the need for the 'public understanding of science', as if all the public has to do is to understand the goals of the scientific community. More than that, we need a shared vision of the way forward for a science that is integrated into society.[1]

I began by reflecting on 'omnescience': the remarkable ignorance of science exhibited by many – perhaps most – humanist intellectuals. I suggested various explanations for this extraordinary phenomenon. In my most cynical moments, I would attribute this ignorance to idleness – science is, after all, difficult for the reasons I gave – and to distaste for something so remote from gossip. To this I would add envy, at the supreme importance of forms of knowledge that lie outside the humanist intellectual's area of expertise and to which only a gifted minority can make a significant contribution. Even if one were not so cynical, it is impossible to overlook a vicious cycle whereby ignorance of science is rationalised by a hostility that ensures continuation of ignorance and a deepening misunderstanding. Distaste for everything to do with science and technology is made respectable by a selective (either strategic or through ignorance) exploitation of the Romantics. Ignorance breeds unthinking distaste which confirms ignorance.

That, at least, is one account of the aetiology of humanist omnescience and why many individuals who consider themselves to be educated and knowledgeable are not at all concerned that they lack even a second-form knowledge of science and an understanding of technology and the relationship between the two. Many other accounts are, I am sure, possible. Whatever the cause, the consequences are disastrous, and I want to end this first part of the

book by indicating some of these consequences and making a plea for a reform to an educational system that encourages the early separation between arts and sciences and looks with complacency on the scientific ignorance of the majority of the population and on the extraordinary fact that a significant proportion of our young people who go into higher education – who will themselves be teachers, administrators, legislators and decision makers – are taught to dismiss what has increasingly become the dominant cultural fact of life as a distasteful irrelevance or a woeful violation of the human spirit.

First of all, the omnescients are missing out on fascinating and wonderful truths about the natural world. Not to know anything about the way organisms, human and non-human, are put together and function to survive, to know nothing of the mysterious nature of light as revealed to science, to be unaware of the mighty laws that seem to govern the pattern of change in the universe – this is indeed to be intellectually impoverished. And it is to have missed out on the greatest collective intellectual adventure of mankind, its mightiest cultural achievement, its most remarkable co-operative venture, to have been denied perhaps the most inspiring aspect of human history; for the story of science, one of struggle, infinite effort, passion interested and disinterested, disappointment and triumph, vision and tenacious search after fact, is greater than the story of any emergent nation. For it is the story of an intellectual community that spans the world; of a united nations of the mind. It is a story that touches on the essential mystery of man 'the explicit animal'.[2] To Einstein's famous assertion that the greatest mystery of all is the partial intelligibility of the world I would add that the most glorious distinction of humankind is the species' intuition that the world might be made more intelligible, and that by what Dewey called active uncertainty – deliberate thought, active observation – this greater intelligibility might be sought.

It is, as I have indicated, an instructive story in other ways. In science, just as no individual has authority in virtue of his position, so no country has authority. The collective scientific effort is unique in the extent to which it is international – agreed practices, agreed terminology, agreed standards of proof and testing. Few cultural activities could be less ethnocentric than science; and this has been true from the beginning, when its practitioners communicated in Latin, to now, when trials of new treatments are multi-national as well as multi-centre. The co-operative search for truth, in which

one's own contribution is likely to be at best that of an anonymous ant to a great ant-hill is perhaps a better model to young people than certain sectors of the humanities where the field is dominated by geniuses or by critics who feel they ought to be and whose views are not open to strict testing. Science teaches humility: the Great Man matters less than the Great (co-operative) Enterprise;[3] on this, 'the incomparable Mr Newton' was clear: 'If I have seen further than others, it is because I have stood on the shoulders of great men'. There could be no starker contrast between this and the emphasis within the arts upon the seemingly autonomous genius of the individual. Within science there is no pretence to absolute originality; nor to completeness. Its message – neither a be-all nor an end-all be – carries a profound educational significance. The current vogue of post-Saussurean thought and empty talk about 'the post-modern condition' shows how hard-wearing the Emperor's new clothes can be when there is no way of testing for the truth of statements and when charisma confers intellectual authority.[4]

Science teaches us that the truth may not actually conform to our intuitions or even to what we would like to be the case. And it teaches us many other things besides: that it is possible to be both imaginative and yet constrained by the discipline of fact and logic; that it is necessary to be patient in one's search for answers and for meanings and that progress can come only from those who are willing to endure partial knowledge, to cultivate active uncertainty, to sit out the feeling of muddled suspense; and that truth is rarely to be found by sitting in the armchair of one's self-confident certainties, pronouncing on the world.

Perhaps the most serious consequence of unfamiliarity with science is its adverse effects on the quality of public debate. First of all, debate about the possibilities and problems and limitations of science and technology: humanist distaste for science puts a stop to useful thought because, at the very least, it puts the object out of focus. For better or worse, science and technology are here to stay, at the very least since people prefer light and warmth and a full stomach to darkness and cold and hunger. New Age rhetoric about dispensing with technology, about the murderousness and gadgetry of the age, about respecting mother nature (who incidentally bumps off 100 per cent of us) will not help us to make those decisions. For that, for the safety and comfort of the world, and indeed to address pressing environmental issues, we must have a better scientifically educated and informed public; or, if that is too idealistic, better-

informed administrators. Ignorant wingeing about and against science and technology simply distracts from the real – and, more important, the soluble – problems, it stops people thinking and licenses wishful or magic thinking, anti-thinking, chattering and gossip. For we have an urgent collective duty to make the effect of science-based technology on the planet less harmful: in this enterprise, enlightened legislation and technological advance go hand in hand.

The way forward here will not be through denying our descendants or underdeveloped countries the benefits of the technology that has cocooned us since birth; but through continuing the process by which unit productivity in relation to the discomfort and duration of labour continues to rise and the amount of associated mess per unit of utility continues to fall. Already what we might call unit pollution (amount of mess per unit product) has fallen where advanced technology has developed in a context of informed and intelligent legislation over the last few centuries, with (in some countries at least – usually democracies) regulation of substances used and emissions produced and more efficient use of resources. Our legislators will need therefore to be numerate and scientifically literate; and so, too, will the general public. The current level of ignorance is therefore cause for concern.

Ignorance of the procedures and approaches and thought processes in science also has an adverse effect on the quality of social commentary in the wider sense. Discussion of issues such as the effects of the health service reforms or the reasons for football hooliganism or (to take a current, very simple, issue) the risk of photosensitive epilepsy associated with Nintendo games involves assertions that are implicitly or explicitly quantitative or causal in nature. It is unfortunate, therefore, that such discussion is dominated by innumerate individuals who have no acquaintance with the conditions under which it is reasonable or valid to make a causal or quantitative assertion. The domination of social comment by worthless chatter, by articles and speeches that would not stand up to any kind of peer review, goes unnoticed by the vast majority of the population. Think how much attention was diverted from political issues to misleading polls in the 1992 General Election, with virtually no discussion of the validity of the polls, which would have been unlikely to have got past the peer review process in *The Journal of Data Massage and Negative Findings*. Public discourse is thus greatly impoverished and diluted by noise.

For all these reasons, ignorance of and disparagement of science by many humanist intellectuals represents a failure of the duty to be self-educated, especially delinquent in those who are themselves educators. Moreover, if the future world is going to be safe, and if we are going to negotiate the tricky times ahead in which the increasing needs of a growing world population will have to be peacably met and the problem of population control addressed seriously, we shall need more, not fewer, people who are intelligent about science. As it is, in the United Kingdom at least, there is a growing shortage of science teachers, applications for science places in higher education are falling, science teaching has scarcely been established in primary schools and, as noted at the outset, the public understanding of science is at an abysmally low level.[5] This must be at least partly because many humanist intellectuals suggest by precept and example that science is not part of general culture. At its least hostile, their attitude is exemplified in Lionel Trilling's passive wingeing: 'The exclusion of most of us from the mode of thought which is habitually said to be the characteristic achievement of the modern age is bound to be experienced as a wound to our intellectual self-esteem'.[6] This invites the response that there is nothing – apart from idleness – stopping humanist intellectuals from becoming as familiar with science as they are with the scholastic trivia that often seem to compel their fascinated attention. If the wounds to self-esteem are not actually self-inflicted in the first place, they are certainly self-perpetuated.[7]

But it is time to abandon the adversarial approach. These chapters have been concerned almost exclusively with one side of the antipathy between humanist intellectuals and scientists. This is unfair because, as Snow pointed out, ignorance and contempt is mutual, not unidirectional. Worse, it might seem to imply an unbridgeable gap between the two cultures. The assumption of such a gap, and of an inevitable opposition, between art and the sciences – buttressed by selective quotations from the Romantics – is destructive nonsense. At the highest level there is a convergence of aims – to enrich human life – and of standards of truth, if not of the methods of establishing it. If there is conflict, it is, as Peter Medawar pointed out, not between Poetry and Science but between poetism and scientism.

Perhaps it is the narrowed use of the term 'humanities' that has perpetuated misunderstanding, suggesting that certain modes of human inquiry and knowledge, such as biology and physics, are

'inhumanities' – a suggestion that might tempt scientists to retort by classifying the traditional humanities as 'innumeracies'. In its original sense, the humanities referred to 'learning or literature concerned with human culture' (OED). 'Human culture' must now surely include science as well as the traditional 'branches of polite scholarship'. Maybe it is not too late to revive Coleridge's dream of 'reconciling the noisy conflict of half-truths'; to imagine a single rich multiform culture, encompassing both art and sciences, whose elements would acknowledge a common commitment to shared values. These would include a reverence and love for what is there. (That experimental science is a form of natural piety may come as a surprise to those who feel that natural piety should stop at beholding a rainbow with an upleaping heart[8].) Other features are honesty; an appropriate level of precision; respect for the rules for making general causal and/or quantitative statements; concentrated thought; imagination or vision; and an unwavering concern for the welfare of humanity. Within these constraints, there need be no limit on variety of themes, methods and sources of inspiration.[9]

It is time, just before we finish, to bring out of the shadows the two benign ghosts who have been hovering in the wings of this debate: T.H. Huxley and Matthew Arnold. Their well-mannered exchange should put the ghost of F.R. Leavis to shame. In 1880, Huxley had delivered an address ('Science and Culture') on the occasion of the opening of the Science College at Birmingham and he took the opportunity to deplore the neglect of science by the English educational system. In particular, he criticised the implicit assumption he had read into Arnold's discussion of culture that 'the best that has been thought and said' equated with literature and excluded science. Huxley argued that science had potentially as much bearing on the practical moral life of society as literature and it, too, contributed to the criticism of life that was central to high culture. Arnold replied in his Rede Lecture, 'Literature and Science' (1881), given, like Leavis's infamous performance 80 years later, at the University of Cambridge. He conceded that the curriculum defining the best that had been thought and said should be extended to include Euclid and Newton and that it was necessary to know what had been done 'by such men as Copernicus, Galileo, Newton, Darwin'. How much one needed to know of matters of detailed scientific fact, and how much of the processes by which facts and laws were ascertained, he was not too sure. What he was sure of was that science should not **displace** literature from the

curriculum. In an age in which the notions of our forefathers have been invalidated by scientific advances

> The need of humane letters, as they are truly called, because they serve the paramount desire in men that good should be for ever present to them, – the need of humane letters, to establish a relation between the new conceptions, and our instinct for beauty, our instinct for conduct, is only the more visible.

It is difficult to read this exchange – Huxley's gentle remonstrance and Arnold's illuminating reply – without regret at the decline in the quality of the debate between scientists and humanist intellectuals in the years since. Huxley and Arnold set the scene for a discussion – how much science does one need to know and what purposes does knowing it serve? – that is yet to take place.

Meanwhile, in advance of that debate, it is evident that the way forward for humanity (as well as for the humanities) lies not in an increasingly shrill rejection of science – there is nothing to put in its place except superstition and ignorance – but in better science and a better-informed society which is willing to put the achievements and methods of sciences to humane use. If the future is, for example, going to be greener than the past, we must have better, not less, science; and a better-educated, not a scientifically ignorant, intelligentsia. Science is our strongest weapon in the fight against impotence and darkness. If there can be such a thing as collective pride in a collective achievement, science is one of the few things of which the human race can be truly proud. Although its applications are often barbarous and stupid, it is in itself one of the least stupid and barbarous of human activities. It seems extraordinary that in the late twentieth century one should have to spell out the not-too-difficult distinctions between science and its applications, and between good and bad applications the use and abuse of the power that comes from science. Perhaps this is because many lack even single vision, and Newton's sleep lies still beyond their brightest awakening.[11]

Part II

The Uselessness of Art

Yesterday, I glanced through Fet's books – novels, short stories and poetry. I recalled the time we spent together at Yasnaya Polyana, our interminable four-handed sessions at the piano, and I plainly saw that all this music and fiction and poetry is not art, that men do not have the slightest need for it, that it is nothing but a distraction for profiteers and idlers, that it has nothing to do with life. Novels and short stories describe the revolting manner in which two creatures become infatuated with each other; poems explain and glorify how to die of boredom; and music does the same. And all the while life, all of life, is beating at us with urgent questions – food, the distribution of property, religion, human relations! It's a shame! it is ignoble! Help me, Father, to serve you by destroying falsehood.

(Tolstoy's diaries, quoted in Henri Troyat, *Tolstoy* (London: Penguin, 1970), translated by Nancy Amphoux, p. 735.)

Introduction

That art is largely useless, especially in the present time, is almost self-evident and yet, when stated baldly, this is a view that will meet considerable resistance. Art lovers and artists – painters, musicians, dancers, above all writers – experience its inutility as a scandal which should preferably be hushed up. But it cannot be denied. If the ultimate criterion of the use of an activity for any organism is survival and for a conscious organism is survival in pleasure rather than pain, then art signally fails to justify itself on either count.

Consider, first, survival. Was anyone's survival threatened by cutting off the Bach supply? Matisse does not cure chest infections or solve the problem of finding something to eat. No poem of Holderlin made the roads safer for children. Literature was once, perhaps, an important source of information, though it is difficult really to believe that farmers ever consulted Hesiod or *The Georgics* for practical advice on muck-spreading or milking a cow with mastitis. At any rate, it no longer has this function; and sculpture, dance and music never had it anyway. As for information about what is going on in the world at large – journalism provides better and more reliable coverage than poetry, fiction, cantatas, ballet or abstract paintings. Art has even lost its function as an instrument of social cohesion – as a successor to myth or as a servant of religion – and so as an indirect force for survival.

Art may contribute little to survival but doesn't it help to make life less painful and more pleasurable – 'more enjoyable or more easily endured' as Dr Johnson suggested? Possibly. But it is not clear that it is more potent in this respect than ordinary companionship, alcohol or other recreational drugs taken in moderation, or even entertainments that might be dismissed as 'empty'. And when it comes to dealing with toothache, to take only a homely example of the pains that tip the account of consciousness into deficit, codeine has much more to offer than even the most engaged reading of Shakespeare's sonnets.

Millions throughout history have lived without art, few without love and none without food. Thus is the uselessness of art demonstrated. The essential scandal of art is that it presupposes that the material problems of life have been solved (or can be

shelved or are unimportant). This is why opera houses and poetry readings and classes on Velasquez have always been an embarrassment: there has never been a time when it has been anything other than bad taste to devote oneself to painting or music or poetry; there are always more pressing things to be done, such as saving starving children from premature death.

Just because art is practically and morally useless, it does not follow that it is valueless. The purpose of this second part of the book is, first, to liberate art from the utilitarian imperative and, with the way thus clear, to explore its true function: to serve 'useless purposes' that go beyond survival, or comfort, or even simple pleasure of the kind afforded by many non-artistic recreational activities. The search for such purposes has two phases: a brief meta-biological discussion of the uselessness of consciousness; and an examination of how art addresses the crucially unsatisfactory nature of consciousness – something that becomes evident only when survival and comfort are assured. The place of art is not in The Kingdom of Means (means **to** survival, means **to** life, etc.) but in The Kingdom of Ends (that **for** which we live, **for** which we survive).

7
Misunderstanding Art: The Freezing Coachman Reflections on Art and Morality

> When an artist wants to be more than an artist – for example the moral awakener of his people – he at last falls in love, as a punishment, with a monster of moral substance. The Muse laughs, for, though a kind-hearted Goddess, she can also be malignant from jealousy. Milton and Klopstock are cases in point.
>
> (Nietzsche)

Tolstoy tells the story of an aristocratic woman at the theatre weeping at the imaginary tragedy enacted on the stage. At the same time, outside in the cold, a real tragedy is taking place. Her old and faithful coachman, awaiting her in the bitter winter night, is freezing to death. The point of Tolstoy's story is obvious: art does not necessarily make people better behaved, or more considerate. The woman was a hard-hearted bitch and art served only to deceive her as to her true nature, to give her the impression that she was a sensitive soul.

The dissociation between the experience of art and a propensity to good behaviour angered Tolstoy. He would have had no difficulty in accepting that art was of little use in solving the problems of hunger and material need but he could not accept its uselessness in the practical world of relations between people. Art that did not promote morality was not worthy of the name. Art was worthless if it did not conduce to good behaviour. The distinctive greatness of the artist lay in his power as a moral teacher.

In *What is Art?*,[1] he savagely attacked what he perceived as the contemporary reduction of art to a mere amusement, recreation or opiate for the leisured classes. Against this, he asserted that 'art

should be an organ co-equal with science for the life and progress of mankind'. And he defined art as an activity by which a man 'infected' his fellow men with feelings that he had himself experienced. The purpose of aesthetic form was simply to ensure that those feelings were transmitted effectively. Art should be judged not only according to how well the feelings were invoked but also according to the quality of the feelings themselves. Great art, which must be accessible to and significant to all men, to peasants as well as to the idle classes, transmits feelings that draw men together in brotherly union.

By these criteria, most of the art approved by his contemporaries could be dismissed: not only the works of Baudelaire, Wagner and Ibsen but much of Beethoven, Bach and Pushkin belonged to the category of bad art.[2] And by the criterion of simplicity and accessibility, his own incomparable novels, whose greatness lay at least in part in their delineation of the complexity, ambiguity and vagaries of character, were worthless.

Tolstoy's late views – sharply at odds with earlier beliefs he had expressed with equal passion[3] – are the more disturbing for emanating from the supreme practitioner of the art of fiction. In *What Is Art?* we recognise the ancestor of those doctrines that have fostered a thousand mediocre, state-sponsored novels in totalitarian regimes; the aesthetic that elevated 'tractor realism', in which cardboard cut-out revolutionary heroes struggle bravely and politically correctly against cardboard cut-out counter-revolutionary forces, above Pasternak and Mandelstam. Tolstoy's criterion of greatness in literature would certainly lead to some major re-evaluations: after all, Barbara Cartland's oeuvre is more accessible to the masses and contains more unequivocal examples of goodness and badness than, say, *War and Peace*.

Tolstoy's later convictions about the nature and purpose of art are too readily dismissed as part of the gathering madness of his old age, his descent from Tolstoy the artist of genius to Tolstoy the Tolstoyan. Even so, the belief that literature may be – indeed should be – a positive moral influence is tenacious. The opposite view – embodied in Wilde's assertion that 'there is no such thing as a moral or an immoral book. Books are well written or badly written. That is all'[4] – can still shock even those who are not cultural commissars in totalitarian states.

Some critics claim, hope or imagine that literature may promote **public** morality; that the representations of the artist can deflect human society from a course dictated by greed, tyranny, cruelty,

selfishness, vested interests, fear, servitude and the rest; that, by awakening the conscience of the oppressor and helping the oppressed to realise their power, art may hasten the reforms or the revolution that will bring oppression to an end. Others have emphasised the role of literature in promoting **private** morality, through refining our consciousness of others, our sensitivity to them, our ability to imagine into them.

It is not only critics but also artists themselves who believe in, or dream of, a morally useful art. For Keats, true poets are 'those to whom the miseries of the world. / Are misery, and will not let them rest.' And this is a sentiment shared by many contemporary artists. Indeed, Martin Seymour-Smith has identified *Kunstlerschuld* or artist-guilt as the occupational hazard of modern poets and writers who fear that 'literature fulfils no useful, only a selfish function'.[5]

The claims made on behalf of politically engaged art are easily disposed of. History demonstrates that literature is as impotent as music in the face of tyranny and terror. Auden's assertion that 'poetry makes nothing happen' has been empirically proved again and again in the twentieth century. The eloquent outrage of great, humane writers has been and is unavailing – quite apart from the fact that a good many major artists have not been on the side of the angels anyway. Where tyrants have fallen, it is difficult to discern the influence of the works and the personal example of those few, immensely courageous artists who opposed the regimes at terrible cost to themselves and their families. The spectacular collapse of Communism in Eastern Europe and the former Soviet Union towards the end of the 1980s is more readily and plausibly understood as a result of economic forces and the inherent instability of all human institutions than as a late effect of the stand of Solzhenitsyn and others in the 1960s and 1970s against the Kremlin, the Politburo and the secret police. A Soviet Union, facing bankruptcy as a result of the arms race and a series of ill-judged military adventures, lost its ability to control the politics outside its borders. It no longer had the strength to crush liberal regimes emerging in its satellites. Once one country had achieved independence, the others saw that their own tyrannical regimes were no longer underwritten from without and that resistance was possible. Artists had only a small part to play in this;[6] as small as the part they have played in the emergence of the new tyrannies, the nationalistic governments of demogogues that are establishing themselves in place of the *anciens régimes*.[7]

One should not be surprised at the political impotence of art. Rigour, scrupulosity, precision, concern for the exact curve of the thing, render the artist unfit for the kind of blunt, direct, usually one-sided, invariably simplifying and often dishonest communication that is most effective in political life. Great art does not simplify but makes more complex. The artist's deepest wish **to see things whole** undermines his polemic power: seeing all sides is the true glory of art and its utilitarian weakness. The sphere of public discourse is too shallow for the artist to swim in with his most powerful strokes. In the world of marches, public meetings and newpaper editorials, his is no longer a special, just another, voice. And a rather feeble one at that. You cannot chop down a tree with a scalpel. One editorial in a tabloid newspaper has the opinion-forming clout of a thousand politically committed plays by a talented dramatist. No work of art can have had an influence on German society and culture approaching that of *Mein Kampf* in the two decades following its publication in 1925. Anyway, the artist has no particular authority or expertise outside the aesthetic sphere – as is illustrated by the terrible misjudgements of passionately committed artists. Pound, Celine, Brecht, Gorky and others of equal stature lent their support, directly or indirectly, to The Great Terrors (though, even as an agent of oppression, Brecht – the archetype of the artist engagé – was as a reed compared with the Stasi: any power to oppress he had through his work depended upon the power of the Stasi to enforce that oppression). Finally, works of art take time to create and to make their way in the public domain; so art is too late and too slow to intervene decisively in particular, evolving situations.

In short, good art – complex, ironic, self-questioning – is feeble propaganda, just as good propaganda, which tannoys the convenient wisdom, is bad art. Which is not to say that art should not have its political angers: they may flow from the generosity of its vision. But the angers, the generosity, while they add to the work's intrinsic merits, do not give it extrinsic force; they may be accounted part of its internal moral texture, not its external moral power. And that intrinsic virtue may lie, as will be discussed presently, as much in form as in content, in the distribution of light and shade, as in what it shows forth in the light.

There may have been a time when art, and in particular literature, was less impotent; a period when mass literacy was novel, and relative political liberalism and the awakening of artists from the

Misunderstanding Art: The Freezing Coachman

hierarchy in which they had occupied a subservient place, created a favourable context in which protest literature would not only be widely read but would also influence the thinking of those who could change things. If there was such a time – a golden age of Dickens and *Uncle Tom's Cabin* – it has now passed. This may be in part because the mass media have taken over much of the investigative and protest function of arts. The arts have lost those offices, just as they have shed responsibility for conveying practical information – the *Georgics* dimension. What poem could usefully add to our knowledge of, and our ability to alleviate, the state of chronic atrocity that reigns in Serbia, South Africa or Somalia? When it comes to reporting the world with a view to improving it, to bearing witness that will spur to action, journalism – with its accessible style and its immediate mass diffusion – is infinitely more powerful than any art. To take only one example: the influence of tele-journalism on shaping public perception of the Vietnam War and making it unacceptable to sufficient numbers of the US people, was infinitely greater than that of the artistic response the war evoked.[8]

Many of those who would concede, however regretfully, the impotence of literature – not to speak of painting, sculpture, music and dance[9] – to influence the course of public events may still cling to the idea that it has a beneficent moral influence in the **private** sphere. Surely it will inspire better behaviour in ordinary individuals even if it is unable to reform power-mad tyrants, corrupt institutions and those whose vested interests lie in supporting them. It is possible to imagine many ways in which literature might conduce to morality:

(a) by showing examples of good people (preferably having a better time than bad people);
(b) by direct exhortation;
(c) by a certain sweet or generous or humorous tone, cajoling the reader to share a tolerant, sympathetic vision of the world, spreading kindness and enlightenment;
(d) by exposing corruption, hypocrisy, cruelty, etc. in professions, governments, families, religious institutions, etc.;
(e) by taking a long term view and exemplifying a wide vision and so liberating the reader from the short-term views and implicitly advocating an alternative to the constricted self-centred vision of daily life; making the case for seeing things *sub specie aeternitatis,* and thereby encouraging tolerance,

maturity, humility, liberating the greedy from their greeds, the consumer from the treadmill of getting and spending, etc.

(a) and (b) are no longer popular and live on only in children's stories. An impressionistic epidemiology of fiction would suggest that literary fiction contains more bad characters than good and that the bad do not necessarily fare worse than the good. Indeed, they may end less stickily than the good. Moreover, in the secular world of most contemporary fiction, the wages of virtue, like those of sin, are death. (c), (d) and (e) suggest that the influence of art in heightening moral consciousness may be more subtle than that of the sermons, parables and plain tales Tolstoy saw as exemplars in *What is Art?* By showing us how people are destroyed by others, how they are corrupted, how they influence one another, do not, say, Henry James' novels increase our sensitivity to others' needs and vulnerabilities and, by enlarging our imaginative grasp of their lives – how they are made and unmade – open us up to deeper, richer, more truly human relationships? Is it not true to say that without the novel and drama, without repeated confrontation with the most skilful representations of, the most precise reflections of, our lives and those whose lives we share, we would be effectively in moral coma? These are views that, in the English language, are particularly associated with the critical tradition of Matthew Arnold, F. R. Leavis and Lionel Trilling.

I am unaware of any empirical data to support these beliefs. The impact on individuals or populations of particular books, or of their cumulative reading experience, would be impossible to study and has not, so far as I know, been studied systematically. Unsystematic observation does not suggest that people who read a lot of good books are more pleasant, less selfish and more willing to contribute to society at large. Those who have to spend much of their lives in the company of the works of thegreat poets – university teachers of English literature, for example – seem to be at least as nasty and immoral as the rest of us and lack even the redemption of doing a job that directly relates to human suffering. The idea of a Lecturer in English being driven, in response to sympathies induced by repeated readings of *Lyrical Ballads*, to help out in Cardboard City seems implausible. He is more likely to rush to the library to check out the references for his latest piece on Wordsworth's compassion for the common man, making sure he hasn't been scooped by some American with a better resourced library and easier access to

Misunderstanding Art: The Freezing Coachman

computerised bibliographies. And we would protest at the *non sequitur* in this bit of overheard conversation: 'He has listened to so many tender and sensitive piano sonatas by now that he should be fairly tender and sensitive himself'. Few people who listen to *Fidelio* are prompted thereby to commit even a little of their lives to pressing for prison reforms or to joining the Howard League. A more typical response is to compare X's staging of The Prisoner's Chorus with Y's, or to speculate whether Z really is up to the role of Florestan any more. Nor would we be likely to accede without question to the suggestion that, as a result of the wider availability of classical music, and the increased duration of exposure of individuals to it, the average moral beauty of the souls in the population will have gone up. (We won't even bother arguing about the trade-off between the intensity and duration of exposure to music.) Nor do we expect those who spend their waking hours saturated in music – conductors, composers, performers – to be better behaved because of it. On the contrary, one is surprised when one comes across a conductor who isn't exceptionally badly behaved. And we are not particularly surprised (though we may be disgusted) when we hear of the Schubertiads in concentration camps and think of the *gauleiter* enjoying his evenings, after a day's work of orphanning or killing children, listening to cradle songs.

This is fairly obvious. But it is the kind of obvious thing that is forgotten when the arguments get complex or abstract, or when the conversation has been going on – as this one has – for a long time, perhaps two thousand years. What it amounts to is that there is little or no direct evidence for the beneficial moral influence of art; all such claims must therefore be based on an *a priori* assumption. There are many reasons for regarding this assumption as intrinsically improbable.

The first is that it is possible to have great art that actually lacks specific referents – for example purely instrumental music and abstract painting. In the absence of reference, it is difficult to see how an art-work can have either moral or political force. I am not, of course, suggesting that all great art is non-referential; only that an absence of moral instruction (as is unarguably the case in a string quartet) does not preclude greatness in a work of art. From which it follows that moral force cannot be a necessary condition of greatness in art.

The second, as is brilliantly illustrated by Tolstoy's story, is that the conditions under which one consumes art and the very business

of being committed to art either as a consumer or a producer are more likely to subvert than to reinforce moral resolve. In order to pay art the attention it demands and perhaps deserves, we need to be insulated from the distractions of everyday life, including those that come from our suffering fellow humans – such as freezing coachmen. The consumer of art wants above all to be undisturbed – by other's noise, by their cries for help as well as their shouts of merriment – and therefore creates the conditions, either explicitly or structurally (library, theatre, gallery, study), to ensure this. Much notice has been taken of the (necessary) selfishness and unavailability of the artist. The selfishness and unavailability of the art lover who wishes to immerse himself in the great works is no less necessary and may be no less complete but has attracted far less attention. One need not go to the aristocratic lady in furs at the Opera to exemplify this selfishness: it is sufficient to consider the absorbed reader's characteristic turned back, his switched-off attention, his Do Not Disturb notice. This is one of the more obvious among the many reasons why, say, reading a book or listening to music is as impotent a means of making us better people as churchgoing. Or why 'those to whom the miseries of the world / Are misery, and will not let them rest' are likely to be unfamiliar with this, or any other, quotation from Keats; why our model of a good person is less likely to be that of a passionate lover of art than a woman who has fostered thirty or more children (and not had a chance to go to the theatre), the committed local councillor who has not read a literary novel in his life or a caring doctor who has never managed to keep awake through a symphony concert since she was a house officer.

Thirdly, art fosters values that are orthogonal to those of everyday morality (and to describe those values as the basis of a 'deeper' morality is to beg the question); for example, aesthetic values relating to form, and values that transcend the 'merely' utilitarian – the 'merely' assumes that you're not hungry, oppressed or in pain – such as the preservation and celebration of past experience **for its own sake**. Even a didactic painting, if it is any good, will attract more admiration for the way a fold in a fabric is rendered than for the sentiment that is conveyed in it.[10] Art generates secondary values of its own – those of the connoisseur, of the art-snob and of the scholar. The corruption implicit in such secondary values is illustrated by individuals whose reading prompts them to exhibit their erudition; for example, the writer such as myself who recalls Tolstoy's famous

story of the freezing coachman not to learn from it but only in order to pass it on – to use it to support an argument about the relationship between art and morality. It is easy to think up other Tolstoyan and meta-Tolstoyan tales: two connoisseurs competing in the subtlety of their analysis of Allegri's 'delicious' *Miserere*; or an adulterous couple discussing the moral impact of 'a wonderful *Dies Irae*' in The Crush Bar, without a second thought as to whether there will be a real *Dies Irae* and whether it will be as wonderful.

And, finally, the manner in which situations and dilemmas are packaged and presented in art is utterly different from the way in which they present in everyday life. Life recounted is inescapably different from life as it is lived. Even the soberest and least sentimental story has an operatic element and is a poor preparation for the plinthless actualities of ordinary life, for a world in which signals are inextricably caught up with noise (at least in part because twenty stories are going on at the same time).[11] Even if the fictional characters are not delineated in black and white, the black print on the white page will still be remote from the much more confused presentations of ordinary reality. (A novel that genuinely replicated the confusion of everyday life – where middles, beginnings and ends of stories are all mixed together and so much is assumed rather than articulated – would be incomprehensible to anyone other than the author.) It is arguable that extensive reading of great novels may corrupt one's judgement of, and response to, other people. After the brilliantly, or at least clearly, delineated characters on the page, the companions of one's own life may seem drab, inferior and, above all, **ill-defined**.[12] It is unlikely that the sentiments we feel for literary characters whose lives we can see as a whole, and from within as well as from without, helpfully educate our emotions for, or train our responses to, real people. Art cultivates our responses to events and situations and people served up in certain ways, profoundly different from those in which they are presented in actual life; by exercising our moral imagination in these quite different ways, it arguably blunts our perception of the moral actualities of everyday life. Events that lack recognisable form may not elicit from the aesthetically trained the emotional response they warrant. In this way the inherent romanticism of most art, its commitment to aesthetic values, is morally corrupting. We feel embarrassment, or even contempt, where we should feel pity or sympathy. The aesthetic sense corrupts our sympathies to a more distanced and distancing pity, and pity to distaste or even contempt.

Anyway, as Whitehead pointed out, the emotions sought through art are largely 'cultivated for their own sake'. If the essence of sentimentality is expressed or felt emotion separated from the commitment to action, imagined responses divorced from most of the reality in which one would have to act, then art, the 'contemplation of the object independently of the will to act upon it', must be quintessentially sentimental. The truth is that art is primarily a spectacle or a reduction of the world to a spectacle. Certainly, representations on the scale and ambition and complexity of novels must develop the detached, spectatorial element in us.[13] Even those novels that are not intended as jewels to be contemplated in abstraction from the world, but lenses through which we see the world more clearly and brightly, are weak moral motors. Tolstoy's expectation that 'the feelings awoken by art would lay in the souls of men the rails along which our actions will naturally pass' seems a pious hope – however great, sincere, moral or earnest the art. After all, the Gospels have been around for a long time, and available to all tyrants for ready reference (indeed, they have been cited by not a few political – and domestic – tyrants).

I have so far assumed that the emotions stimulated by literature are necessarily good or desirable. This may not always be the case. Even identification with characters who have endured injustice or undergone some ordeal may be in some degree masochistic. Fantasies of being subjected to injustice and subsequent vindication (the latter with a completeness possible only in represented worlds) are all-pervasive in literature – in *The Winter's Tale* as much as in rescue operas or Westerns. Such emotions, powerfully evoked by the enhanced clarity of the represented world, are infantile and corrupting, firing dreams of satisfaction and moral revenge. These dreams are unlikely to be realised in the messy real world: no injustice is ever so completely over-turned, no name-clearing ever so absolute, no vindication ever so complete, no revenge ever so sweet, no forgiveness or apology ever so clear-cut, no story-ending so definite.

And there are, of course, other, darker emotional pleasures to be derived from literature. To discover these, it is not necessary to ransack the forbidden shelves where the Marquis de Sade and Leopold Sacher-Masoch peddle their views. One need only consider that, by opening up a reader's consciousness of others and their vulnerabilities, the artist is as likely to corrupt as to make more virtuous. Just because one is more easily able to imagine another's

suffering is no guarantee that one will be inclined to reduce it. A novel that appeals to the generous spirit of the kind-hearted may, by enlarging their moral imagination, make the nasty more ingenious and effective in their nastiness. Referential art is highly unlikely to redirect the spirit from malignity to kindness: the cruel and psychopathic do not necessarily become less so through having their imaginations developed. The enlargement of the moral imagination that permits one to see things more completely from the other's point of view is good only if one's impulses are generous in the first place. The idea that one will read a book generously when one is accustomed to a brutal and mean-spirited and egocentric response to others – when one does not read *them* generously – seems implausible. Likewise, the heightened moral intensity that Leavis, for example, saw resulting from reading, say, the novelists he admired, would be good only if the moral impulses that were thus heightened (and, yes, refined) were themselves good. The moral influence of non-referential art is even more tenuous: Schubertiads in death camps in which starving prisoners played for the pleasure of the guards are only an extreme illustration of the moral nullity of music.

It may be that the moral influence of good art is more indirect than has been considered so far. We may reject the view that simple, didactic 'art' has a powerful effect on practical behaviour; that it can be a direct moral influence. Most critics do. In fact, it could be argued that it is of the essence of the moral force of art that it should act subtly and indirectly. It appeals to the intelligent and sympathetic imagination – to the human being at the highest level of development: its effects are mediated through reasons and their connections with other reasons, rather than through material causes. *The Golden Bowl* is as remote as possible from moral conditioning by praise and blame (or painful and pleasurable stimuli) and for this reason will not be judged by its immediate effects on individual readers or on the world of readers as a whole.

This is a difficult defence. It touches on the fact that the artist's concern with morality is remote from the obvious places where, say, morality impacts on mere survival and comfort, on the symbiotic relationships between individuals that ensure safety and food and warmth. 'Morality' is a huge territory that encompasses all aspects of civility and sensitivity as well as the things that bear directly or indirectly on survival. There are many ways of failing in one's moral duties to others additional to failing to ensure their survival or

physical comfort. Art, it might be argued, serves those exotic reaches of a peculiarly civilised morality that are concerned with the quality of human relationships beyond any merely external function; it is about a mutual awareness that aspires beyond respect for contractual obligations, beyond ordinary kindness or even beyond love in the usual sense; it adumbrates a deepening and intensification of relationships that does nothing for peacemaking, for justice or for breadwinning. Art may therefore serve an impractical morality that makes relationships more, not less, difficult, less not more functional – by asserting that there are many ways of falling short morally than denying another the means to physical survival or material comfort.[14]

This is a difficult view that rescues art from the obligation to serve practical 'ordinary' morality only to make of it something ethically dubious. However, I suspect it is nearer the essence of art – which is (to anticpate our argument) to enhance human awareness; to italicise that useless thing called human consciousness. We may support this with the reflection that admiring the fineness of moral perception in a novel is more about enjoying the perceptiveness (and perhaps the aphoristic way in which it is expressed, or the brilliance with which the perceptions are expressed in the characters and the action) than being moved to a finer morality ourselves. It would be a kind of mis-reading to regard, say, James's novels as a 'guide to life'; just as it would be to read LaRochefoucauld to see how badly people behave and identify the source of their bad behaviour, so that one doesn't fall into the same trap oneself. The 'normal' reading is one which relishes the understanding gained by reading him and enjoys the stylistic perfection of his aphorisms.

A less vulnerable defence would be the suggestion that the moral efficacy of art would be indirect and even delayed. In reply to an interviewer's assertion that 'Art can be considered good only as it prompts to action', Robert Frost famously said 'How soon?'. The assumption that art may not have an immediate beneficial effect but may result indirectly in such effects has its ancestor in Shelley's claim that the poets are 'the unacknowledged legislators of the world'. This is fantastical, not only because, as Auden said, the secret police are the unacknowledged legislators of the world – and, in some countries, are the acknowledged legislators of the poets – but because talk of remote effects is necessarily speculative. For once we start thinking about indirect and remote effects, we are into the

realm of total uncertainty. Chaos theory – not to speak of Kiekegaard's parable of Socrates and the Ferryman – has taught us that causation in complex dynamical systems – and what system could be more complex than the interaction between a book, a reader and his world? – is unpredictable and untraceable once one goes beyond a couple of steps in the chain.[15]

The claim for the power of art as a moral influence – that it conduces to better behaviour in private and intervenes decisively for the good in public affairs, improving collective behaviour – seems baseless. The best we can hope for is that art will not make us worse behaved; that, as we pursue the Kingdom of Ends, we will not lose sight of, or do harm in, the Kingdom of Means. Is art therefore without value? Should the government cease to sponsor art since it will not make the people better citizens? Should parents discourage their children from reading great literature, since it will not make them kinder in their private lives? Of course not. While art may not make individuals morally better, it will introduce them to a greater selection of the meanings that the world may have, and so widen and deepen their experience of life. Though art is impotent to change the course of history for the better, its image of the terrible and wonderful things that happen in history may in some small sense redeem them, if only for a privileged few: helpless to intervene, it will bear witness, and be true to, the world. Indeed, without taking account of the terrible, art will be empty, trivial; and there may be an element of ordeal in the experience of a great work of art. A masterpiece is a place where many disparate, partial meanings meet and are synthesised into a whole; a utopia of consciousness where much that is scattered or fragmented in life is drawn together.[16]

When he said that a pair of old boots was of more use than the entire works of Shakespeare, and that he would rather be a Russian shoemaker than a Russian Raphael, Pisarev was not condemning art, but clarifying its function. Art is only weakly effective in the utilitarian world of practical need and practical morality. One can think of many ways of making better people (parental influence being the most potent) and of making better states (a free press, for example, and a democratic tradition of accountability of those in power); great art does not seem to be one of them. It is neither moral or immoral in the conventional sense: it operates outside the sphere of practical morality, that of the means to survival and to comfort. Its true sphere is the Kingdom of Ends: it addresses the final

purposes of life rather than the means by which life (and comfort and safety and freedom from want or terror) may be secured.

Although it has only a slight external moral force, it does have an intrinsic morality. This is evident in Tolstoy's own incomparable novels. They illuminate the world with an even and just light, and reach with a generosity of imagination into all sorts and conditions of men. Only thus can a writer bear witness[17] and respond to his own moral imperative: to present the world as truthfully as lies within his power to do so, notwithstanding the necessary partiality of his vision. He takes the light of common day and makes out of it the substance of a vision; and he traces the light of a 60-watt bulb to the solar brilliance from which it is descended. To do this, he must abjure mean-spiritedness, parochial prejudice, downright nastiness and be outraged at the outrageous, delight in the delightful (though its deeper reflections may re-define the outrageous and alter our sense of what may afford delight). If his art shows that he is unconscious of the howling injustices and the great issues, then it is unlikely to capture the respect of the passionate and thoughtful; unlikely to cut metaphysical ice and help us to link the great facts that enclose us – that we are unoccasioned, that we are transient, that we nonetheless make the world our own thing – with the small facts that detain us.[18] The anger of the artist, unlike that of the journalist, will reach through the remediable and transient to what is permanent and irremediable in the condition of man.

Nevertheless, he cannot escape moral judgement: we will not allow him to take us to the higher slopes of human consciousness if he loses our respect and sympathy on the lower slopes of ordinary morality. An artist who attempts to combine his transcendental visions with anti-semitism will be rewarded by being remembered not as a visionary but as an anti-semite. Such is the fate of Knut Hamsun, who may stand for all those who do not subject their art to the severest tests of morality and of generosity of spirit. Mean-spiritedness or immorality below the tree-line cannot be redeemed by large-spirited gestures above the mist. We cannot take seriously, or engage seriously with, a work that is manifestly indifferent to the sufferings of the world, or rejoices in them. A work that exhibits moral beliefs that are utterly at odds with our own cannot, because it will not command our respect, command our attention.

A work of art has not only to be true and beautiful but it must also be good. It does not follow from this that it will promote goodness in those who encounter it, or even those who succumb to it. And the

endeavour to 'engage' art politically is based on an exaggerated sense of its power in a sphere not its own. It is absurd to expect that it should make people, institutions or nations behave better; and it is misguided to judge art in terms of its moral intentions or putative moral consequences. Its value – and this is true of fiction as much as of a string quartet, of drama as much as of an abstract painting – lies beyond practical morality. Art and morality are both far too important to be left to each other.

The temptation to believe that the intrinsic and necessary morality in the works of art that have reference to the outside world will translate into an influence on practical morality – on behaviour in the public or the private sphere – so that with a finer awareness will come a richer, deeper sense of practical responsibility, and better behaviour, should be resisted. It may be overcome by remembering the weeping princess in the theatre and the coachman freezing to death outside.

8

Misunderstanding Art: The Myth of Enrichment

To deny, as I have done, a moral purpose to art may provoke considerable anxiety, not least in those whose self-esteem or income, or both, depend upon the importance attributed to the production and consumption of works of art. If art serves no moral function, is it not trivial, empty? Why should it be fostered, sponsored, cherished, taught, encouraged if it leaves the world morally unchanged? There are two sorts of answer to this question. They are superficially different but underneath probably boil down to the same thing. The emphasis in both cases is on inner effects that do not readily translate into outward manifestations.

The first sort of answer – which was touched on in 'The Freezing Coachman' – says, yes, the behaviour of those for whom art is important is not conspicuously better than that of individuals who do not read a novel, never mind a classic novel, from one year's end to another, who have never been to a symphony concert and would no more think of going to an art gallery than of abseiling down a hundred-foot cliff. Indeed, the behaviour of the former may, for the reasons I have already dwelt on, be worse. Nevertheless, this lack of outward difference conceals a profound inner difference. Those who have been influenced by art are more reflective in their behaviour; they act consciously, whereas others act unconsciously. Art-loving humanity is more remote from unreflective animality or unconscious mechanism. When art-lovers are good, they **choose** to be good rather than merely acting in accordance with their training. Consequently, their good actions, although externally similar to those of individuals without art, are morally of a different order – perhaps because they cost them more than they do the unthinking multitude. To put this another way: influenced by art we may do the same things but at a higher level and with greater moral investment. The illiterate, loving, foster mother who brings up and loves thirty children does so at less personal detriment to self-development and

self-fulfilment than the art-loving mother who is denied by her considerably fewer children uninterrupted access to art galleries for a few years. (Analogous claims have been made for philosophy and for religious belief – which up the cost of goodness but make it intrinsically more worthwhile.)

This is an implausible, difficult, dangerous and arrogant doctrine which is unlikely to win much support for art. The notion that good behaviour is more admirable in lovers of the arts because it costs them more as they have a soul to look after, reminds me of a view once current amongst middle class Indians that the poor aren't really poor because they haven't a standard of living to keep up. And it is self-contradictory: it implies that the sensibilities awoken by, addressed in, or cultivated through, art make it more difficult to behave decently, that they add to the price of ordinary kindness, everyday sacrifice, etc. Whereas this may reflect the difference between an individual who consciously chooses the moral ingredients in his or her life – including commitment to others – and one who merely tumbles into them (someone for whom, say, child-rearing is a deliberate sacrifice rather than a continuation of a somnambulant existence), it remains purely speculative – and a perfect basis for the special pleading of the selfish. We shall therefore set it aside.

The second sort of answer accepts the irrelevance of art to morality, either in its outward manifestations or its spiritual content, and looks instead to a different sort of inner criterion for measuring the value of art. Art does not make morally better people, or morally better lives, only inwardly richer people, living richer lives. And this is what I propose to discuss here. Much of what I say will be directed against 'the myth' of enrichment but I do not mean to dismiss as mythical all talk of the enriching value of art. I would not deny that life without art would be greatly impoverished – though caution should be exercised in dismissing 'the unexamined life', since the vast majority of lives are lived without art (unless one extends the term to include football and pop music). But I wish to look critically at claims of the kind made by Whitehead:

> Great art is more than a transient refreshment. It is something which adds to the permanent enrichment of the soul's self-attainment.[1]

in the light of Beckett's contrary view:

At any given moment our total soul, in spite of its rich balance sheet, has only a fictitious value. Its assets are never completely realisable.[2]

Yes, great art is 'more than a transient refreshment' (what this more is we shall discuss in 'The Difficulty of Arrival') but is it really something 'which adds to the permanent enrichment of the soul's self-attainment'?

Many would like to believe this, without perhaps entirely subscribing to the idea that they possess anything quite like a soul: indeed, it is the master-thought behind the belief that art educates (and that it should therefore be part of the core curriculum), that it has permanent, beneficial, civilising effects that go even deeper than inculcation of the civic virtues. This master-thought should be inspected in the light of what we know about the actual experience of works of art, and of what we know about the complexity of ordinary consciousness. I shall argue that the myth of enrichment is founded upon an exaggerated sense of the coherence and continuity of our consciousness and its experience of art.

Let us begin with the experience of individual works of art. It is probably true to say that this rarely if ever takes place under entirely satisfactory circumstances. Consider literature. For all but the shortest pieces, our engagement is repeatedly interrupted. There must be few people who have ever read a novel without pause from end to end and fewer still whose reading regularly takes this form. For most of us, reading is a matter of 'scattered occasions', with large lumps of unrelated life separating the boluses we consume. The sense of gathering atmosphere, and our appreciation of the connectedness and organic unity of the work, and of all those other things that figure so largely in critical discourse, are consequently undermined. The exceptions to the rule that exposure to long works of art is inevitably interrupted are the cinema, concerts of music and the drama in theatre, where continuous attention is demanded and the experience is completed at a sitting. However, for many of us, films, plays and music are most frequently enjoyed at home and are subject to the interruptions that arise from the continuation of ordinary life – the telephone, the shout from downstairs, the shout from within as we recall forgotten tasks. Even where circumstances are ideal for reception, we may not be inwardly prepared: fatigue, preoccupation with other matters, guilt at duties neglected, etc. attenuate our concentration. There are many other reasons why our

receptivity may be less than adequate, aside from physical discomfort and inner and outer interruption. We may lack sufficient knowledge fully to understand what we are reading, listening to, looking at or watching. Rare is the occasion when the experience has been preceded by the necessary research to ensure that reception is not marred by avoidable misunderstanding. Even a modest amount of research – or even retaining what one has been told as one goes along in a book – seems to be beyond if not the capacity then the inclination of many. How often does one hear the complaint that the enjoyment of great Russian novels has been spoilt by getting muddled over characters with similar-sounding names?

The very availability of art makes its arrival in our life rather random; indeed, the most accurate description of our aesthetic life would be as a series of random bombardments. Books, newspapers, snatches of music, glimpses of television, fragments of radio, jostle with one another and with the other events in our lives for mind-space. Most poems are poor weak things scattered through our lives: two hours later, they are forgotten, like a post-coital Don Giovanni mistress. And consider our experience of music. In the imaginary world of culture, individuals sit down to listen to a piece of music, having first composed themselves, and remain with it uninterrupted and in silence from beginning to end. The experience is then completed and reverberates through the soul, leaving it permanently moved, enlightened and enriched. In the real world, we listen to Haydn's Nelson Mass while the squeaky windscreen wipers are battling with rain adding its own percussion on the car roof. Afterwards, we try to hum the catchier bits or oscillate between whistling to ourselves the deeply moving Amen chorus and making a certain sound with the passage of air through our teeth. The Mass is preceded by an altercation with a car park attendant and is succeeded by an unsuccessful attempt to catch the early evening news. By then the music has been swept away by the return of the outside world with its distractions, indulgences and, above all, its responsibilities.

This particular scenario, likely to be greeted with hypocritical disgust and disbelief by a cultural critic, is not uniquely a feature of the modern era of mass media that use the airwaves to send out a million cultural objects like messages in bottles. Music has always been chucked out into a world at random – though, of course, the randomness is now more obvious as the availability of home delivery has separated it from special occasions, or indeed the

specialness of the occasion of music-making. Shakespeare's dramas were played to noisy, disreputable audiences, distracted by the discomfort of worms, cystitis and the unpleasant, obtrusive presence of their neighbours. The ready accessibility of masterpieces of painting through television in art programmes that may be switched off or left on, overheard or ignored through a variety of competing rackets, is not all that much greater a step into alienation than the dusty Blake print on the classroom wall representing the Ecstasy of Creation, or the church that is passed every day by the weary peasant whose mind is on other more pressing matters than symbols of a deeper and further reality. Art has never been protected from what might happen to it when it enters an otherwise engaged human consciousness; and there has never been a time when human consciousness is not already committed or open to being otherwise engaged. Even a professional reader, who may be in a privileged position to be able to read the entirety of a novel uninterrupted (to be properly 'disturbed' by a work of art – *vide infra* – one needs to be undisturbed), has his moments of intermission, his distractions, preoccupations, daydreams, etc.

The context in which artworks are appreciated that I have suggested here seems atypical and even scandalous only by comparison with professional – and hence official – accounts of the experience of art. The professionals (and here I mean mainly critics) have so much invested in their idealised readings, listenings, lookings and watchings that it would be too much to expect them to be honest about actual readings, listenings, lookings and watchings, or even to recall them. Their readings are not to be trusted but they are worth examining in order to see where myths of the experiences of individual works of art (which must form the basis for the myth of cumulative art experiences and so of enrichment) have come from.

Art criticism may be roughly characterised as falling into four classes: the scholarly (what is being referred to here; who influenced whom; when, why this work was written, etc.); the interpretive (what Smith was trying to say here; what this symbol stood for; what the work really means; what it should mean to Marxists like us etc); the technical (the use of key structure; the particular genre to which the work belongs; the type of metre used and how successfully; how the surface tension in the painting is achieved etc); and the affective (the emotions this work induced in me; the delight afforded by the conjunction of features A and B; the chilling characterisation of the Ghost, etc). Most critics will move between

these four classes of statement in the course of the evaluation of a single work. There can be little quarrel with scholarly and technical criticism, so long as it serves the work – and hence its audience – and not merely the critic. (Where the one stops and the other begins is a moot point.) The interpretive and the affective, which deal primarily with the critic's own responses, bring us into queasier territory: the (comparatively) objective description of the work passes over into the considerably more subjective account of the critic's own experience. This is queasy not only because there is little objective basis for what is said, but also because it carries an implicit claim about the critic – about his sensibility, his reading, his experience. In short, it 'foregrounds the critic' to an unwelcome degree.[3] The idealised readings of critics are self-idealising and not infrequently postulate impossible experiences that place the non-professional in an inferior position and encourage him, too, to lie about, or at least misrecall, his experiences.

Consider a relatively mild claim: 'This book is deeply disturbing'. What this probably means is: 'There were times during my reading of this book when I felt anxious/uncomfortable/disturbed'. What it may mean is: 'There were passages in this book where I felt that I should have been anxious/uncomfortable/disturbed'. Why might we be inclined to the latter interpretation? Think of the situation of the critic: he has read many, many thousands of books; he is accustomed to read them in order to formulate a written or spoken response; he has to read them at a certain rate. In other words, the entire context of his reading is that of his own productivity, against the background of his previous endless reading of other books. If we accepted his words literally, replicated in different ways in his reports on endless other readings, we should have to postulate that he is a curious entity in a constant delirium of feelings provoked by books. The truth is that it is somewhere between the job description and the temptation of the interpretive/affective critic to tell a story about a reading that necessarily glosses over the real experience of reading.

Claiming to be 'disturbed' (or 'deeply disturbed') is certainly an important part of the job of a critic specialising in **modern** works. A couple of specimens I have examined elsewhere (*In Defence of Realism*) are worth mentioning, to illustrate how prone such individuals are to making wild and unselfconsciously laughable claims about the effect the books have on them, or upon 'us' – the critic or we non-professional readers who are flattered into believing

we are as sensitive as he is. In his best-selling *Literary Theory*,[4] Terry Eagleton speaks of 'modernist literary forms that pulverise order, subvert meaning and explode our self-assurance'. To take the full measure of the absurdity of this, we need just to contemplate the idea of Terry Eagleton as a man with an explod**ed** – as opposed to explod**ing** – self-assurance! In their book on Donald Barthelme, Couturier and Durand describe the impact on them of Barthelme's 'astonishing' device of including pictures in his short stories:

> All these devices stagger our imagination, baffle our intelligence and eventually induce us to evolve our private interpretation, no matter how extravagant it may be, to escape the tension and embarrassment.[5]

One final example will suffice to support the point that is being made about the official story of reading. In a discussion of a poem by Rossetti, George Steiner writes:

> This Baedeker sonnet is not worth belabouring. But the dilemma of just response which it poses is, I think, representative.[6]

Even if one resists the temptation to unjust response ('I wish I had your problems'), this short passage gives much to get one's teeth into. Think of this: even a mediocre short poem can give the critic something to say about his reading; a yet more complex story – that of a representative dilemma of just response – than an account of his experiences of reading; a story of deciding about the right story to tell about a reading!

Before moving on from the theme of the 'official' (professional) accounts of art experience versus the unofficial (non-professional) unrecounted experiences, I want to make one final, serious point. Many stories of readings (of literature, of painting, of music, etc.) are informed (in both senses of the word) by knowledge – of the artist's antecedents, of his intentions, of his own views about these things. That knowledge feeds into the critic's account of his own response to the work without necessarily feeding into the actual response. He persuades himself that he feels the terror of aerial bombardment – along with the beauty of the composition – when he looks at *Guernica* because he knows that is what the painting is about; he feels the happiness of the newly-married Webern in the Cellostucke because he has read the relevant correspondence, etc. Now, of

Misunderstanding Art: The Myth of Enrichment 101

course, it is entirely appropriate that knowledge should inform response and I am not suggesting that the only authentic critical response is from a position of total ignorance – of the intentions, the antecedents and the autobiographical context of the work. But knowledge brings with it a danger of self-deception, of pretending to oneself that one is experiencing what one is told is there to be experienced. (This is different from the honourable act of responding to an invitation to see if one **can** read/look at/hear a work in a certain way.) The danger is that of confusing one's knowledge of the feelings/experience one should have with the actual feelings/experience one does have.[7]

In summary, critics' accounts of experiences of works of art are not to be trusted, for, as professionals, they have a vested interest in elaborating stories of responses that may bear little or no relationship to their actual responses or to any response possible for a human being. The messy distracted experiences of real readers, listeners etc. are not, of course, inevitable. Art can command, and of course deserves, better reception. But real readers' 'true stories' are a corrective to critics' self-serving elaborations.

With such examples awaiting any non-professional reader of a book that has so much as a Preface, no wonder the non-professional reader finds it difficult to remember, or to report truthfully to himself, his experiences of reading. The pressure to mis-remember, or to reproduce (less fluently and compellingly of course than the professionals) the standard stories of reading, which will be rather different from the story given above of the art-experience in a life that is still going on, of art taken on the wing, will be great.

The discrepancy between actual and reported experiences of art may be even greater than I have described here. When people read, watch, listen etc., it is not always solely for the sake of the works themselves but in pursuit of some vague idea of self-betterment. This may range from the relatively pure motive of the auto-didact to the less pure motive of the individual who reads in order to improve his or her standing, to enhance self-esteem and/or to be able to quote and to show off. There is also the tourist, train-spotting – 'Been there! Done that! Got the tee-shirt' – element: the desire to get a pile of culture under one's belt, that may be linked with the motives just mentioned. Many adolescents pass through a phase of engagement with the arts for these reasons and then keep clear of them for the rest of their lives. Art may also play an important part in the sexual gyrations of youth; it may be, or may seem to be, an

important weapon in the battle against the competition. A gift of a CD of classical music or of a volume of poetry may be used to suggest the possibility of a more exciting relationship than the rivals can offer. Art may be exploited to make one sexually more attractive, by suggesting difference, profundity etc. Art-occasions are very important in courtship rituals of a certain sub-section of the population: they may be exploited, like meals at expensive restaurants, as a way of enhancing chances of sexual conquest. Exhibitions, poetry readings and events like the Last Night of the Proms are also means of romanticising relationships and of laying down memories: 'that Summer evening when we went to. . .'.

Art may be overshadowed by its occasions. The night out at the play may be more important than the play. The time spent queueing for the Last Night of the Proms lasts longer than the time spent under the spell of the music. Attention paid to the actual art may be intermittent: at the very least, it is shared with attention to the occasion itself, to the individual for whom the occasion has been set up. There may only be parts of the event that are sought out: how many Last Night Promenaders have sat through the excruciating boredom of those Sea Pictures in order to join in with Land of Hope and Glory?.[8]

The Last Night of the Proms is an extreme example but an illustrative one. There are other less obvious, and more unselfish, ways in which art can be subsumed to some purpose alien to it and enjoyed not for itself but used in social interaction. For example, playing through for the sake of another a symphony one knows and loves, consumed with anxiety at the time it is taking to get to the passage he knows and loves, expecting any minute a sigh of impatience. Or re-playing a tune one has heard with delight the day before with a view to cheering up someone else. Or sitting through an Absurd play next to a companion who is bored by its 'silliness', preoccupied yourself not by the play but by the attitude you should take to your companion's boredom: irritation with his stupidity because the play illuminates the general human condition or acceptance of the companion's boredom (because the play merely reflects the playwright's rotten life). A theme, perhaps, for a meta-Absurd play. So many attempts to share the experience of art result in the division of attention between the work and the reaction of the other to the work.

The most significant source of 'lateral interference' in the relationship between art and its consumers is the subordination of

art to education. The idea of 'art as education' encompasses not only inner enrichment or development but also externally assessable achievement. The reduction of Shakespeare to texts to be studied for examinations, as a series of tasks to be done, as stuff to be got through, remembered, and regurgitated with rote-recalled critical commentaries, is an obvious example. The relationship between an apparent interest in the arts and parental and teacher praise and exam and career success – so that the pupil reads in the context of knowing that he is pleasing – is another equally obvious. But there are other, deeper absurdities. An experience of my own springs to mind.

Once, crazed by Dinky Toys, I played with them all evening and skipped my homework. As a consequence, I was discovered the following day to be incapable of reciting Macbeth's famous nihilistic outburst on hearing that his wife and co-conspirator had died: the passage beginning 'Tomorrow, and tomorrow, and tomorrow. . .'. My punishment was to spend a drowsy summer evening clapped in detention, a crestfallen delinquent, rightfully convicted of being unable to recall how life (my life, teacher's life, my parent's life, presumably) is/was

> . . . a tale
> Told by an idiot, full of sound and fury,
> Signifying nothing.

Fancy forgetting that! Allowing it to slip one's mind that life was utterly futile! The appropriateness of the punishment was remarkable: what better reminder of the inanity of life than being kept indoors on a crickety summer evening, and so being denied the longed-for futilities of bat and ball? The penalty was as well-earned as that suffered by the man in the nursery rhyme who wouldn't say his prayers and was seized by the left leg and thrown down the stairs. (A fractured neck of femur concentrates the mind wonderfully upon the Ultimate Other and focuses one's thoughts on the Empyrean where He dwells).[9]

I have so far concentrated on the experiences of single works. Our ultimate concern, however, is with the postulated cumulative impact of art upon the inner self, and the notion of progressive enrichment. As a transition to this question of the 'adding up' of works of art, it is worth dwelling for a short while upon the after-life

of art-works, their reverberation in the consciousness after we have laid the book down, left the symphony hall, looked away from the painting. At first, this does not seem very encouraging: what we remember of a novel – even one that has gripped our attention – is often very patchy; the echoes of the music often take the form of inaccurately recalled (or even worse, whistled over) fragments of 'the main tune'; and our mental image of a painting we have just looked at is considerably more impressionistic and rather less impressive than the original. Art objects seem to live on in our minds as grotesque reductions or even parodies. Things, however, may not be as bad as the phenomenology of recall would suggest: think how differently we re-read a novel as opposed to reading it for the first time; and how different a second or third listening to a symphony is from a first. This implies that we have retained much more than explicit recall would indicate; that a tremendous amount of implicit memory has been laid down, so that second time around we know where we are going and have a sense of pattern in the work which we did not have before.

Even so, the life of the work in our mind is more complex and problematic than the simple stories of critics would have us believe. Even a single reading of a novel, in which the 'organic unity' of the whole is set before us, assumes retentive powers that we do not seem typically to possess. Our backward glance does not take in the entire landscape that has been set out before us. And successive readings, or listenings, or lookings, while they may deepen our experience of the work, if only by making it easier for us to grasp it as a whole, may also confuse and muddy our picture. For different encounters will take place in different moods and be driven by variable intensities of commitment. A deeply absorbed reading of a novel may be succeeded by an interrupted, bad-tempered re-reading. A piece of music may move us deeply on one listening and mean nothing on another. How will those two – and many other – different readings interact in the mind of an individual who is not a professional elaborating a master-reading that takes the best out of each of the individual readings?[10]

Enough about the single work. 'Progressive enrichment' encompasses more than the experience or the effects of a single work – though the latter must be its foundation. 'Enrichment' is supposed to be the summed effect of the experiences of many works: of novels piled on to novels, of short stories on to sonnets, of paintings added on to symphonies, of sculptures to essays, and so

on. This notion of progressive enrichment is especially tenacious in relation to literature. There is the idea that, for example, one's literary experience **builds up** – as if it were, in some sense, all present at once, adding up like leaves forming humus or leaf-breath growing to a trunk. At the very lowest level, there is the idea of being 'well-read' and of 'the well-stocked mind', of a living store that is added to over years.[11] In the light of the doubts expressed as to whether even a single work could add up to its totality in the mind – to the unity set out by the critic in his professional, written-down response – this conception of the cumulative impact of the things one has read over years adding up will seem extremely dubious indeed. And the addition across the different arts, with disparate experiences converging to an enrichment of soul, will seem yet more dubious.

First, and most importantly, the notion of enrichment is based upon a conception of the mind as a receptacle gradually filling up. Much modern psychology, insofar as it has an overall theory of the mind (as opposed to behaviour, propensities or cognitive processes) would see the mind as more of a conduit than a bucket: that much of what passes into our mind passes through it rather than adding to its assets. Whether or not one accepts that psychology has anything to tell us about mind working at this level, it is easy to see how the 'increasing richness' idea is based upon the mind as a definite thing – an idea which no longer commands general assent and which is difficult to make coherent, even less find evidence for. It is perhaps, as we shall discuss presently, a hangover from religious ideas about 'the soul'.

At the very best, one seems with works of art to reach a kind of dynamic equilibrium after a while: new experiences and new knowledge are accommodated at the cost of creating new amnesia – so there is no 'progressive enrichment', only, at best, a steady state, with the mind 'holding its own'. This objection may provoke the counter-objections that it is itself wedded to a literal-minded view of the mind as a fixed storage capacity device, rather like a hard disc – or, to use a more homely analogy, to the very 'bucket' theory of mind dismissed a moment ago. Moreover, it assumes that enrichment is about accumulation of knowledge, or something like it, when it could be argued that enrichment is about assimilation of knowledge, its transformation into 'the tissues of the imagination', its shaping or informing of a world picture. But, in a way, the dynamic equilibrium account of 'progressive enrichment' is the best

that can be made of the bucket notion. So, it follows, therefore, that, if even this version is unacceptable, then 'progressive enrichment' has to be made sense of in some other way but because no alternative interpretation seems to be forthcoming.

There are certainly many unanswered questions – such as, for example, how the elements actually add up. How do Ezra Pound, Sir Thomas Browne, Homer, Kant and Leopardi converge within the cultivated individual? And how do they sum with symphonies, paintings, an evening at the ballet etc? Are they like snowflakes adding to a snowdrift, there being a point (or a level of the mind) at which each loses its own identity? In what sense are they then still individually available? How are they present to one in ordinary, extra-aesthetic life? Are they all present at once? In a trivial, partial sense they might be, inasmuch as elements can be retrieved from all of them in response to the appropriate stimulus, that is to say, the appropriate accident. Most commonly, they live on in the form of fragments, passages, things-to-say that come to mind, flashes of recall, prompted by the contingencies of experience. It might be argued that, insofar as they **are** separately retrievable, and so retain their distinct after-life in our memories, they are not fully assimilated into a *Weltanschauung*, a soul-tone, an informed outlook; that it is the wrong result for prolonged immersion in the great literature of the world to lead to, say, a mind stocked with retrievables. Certainly, a well-stocked mind is not always a desirable characteristic: the cultured individual, who invariably has a quotation to fit an occasion, can easily modulate into the literary bore we all dread.

We have no model, then, for progressive enrichment. At any rate, it doesn't seem as if, say, a lifetime's reading experience adds up to some kind of literary super-experience. Which is hardly to be marvelled at if not even the reading of a single book has an unbroken wholeness, nothing at any rate corresponding to the 'organic unity' the critic unpacks or constructs in his report on an ideal, professional reading. Or consider our experience of music. Each piece is a separate event and, although we may grow in knowledge or connoisseurship, it is difficult to see the sense in which we are richer after 100 symphonies than we are after 10. Our first encounter with great music in adolescence is at least as intense and rewarding as subsequent experiences. We may return to Brahms' chamber music again and again for ever-different

experiences; but it is doubtful whether it makes sense to speak of those experiences as increasingly rewarding.

Of course, we have no satisfactory model for **any** aspect of the self, nothing to help us to understand the relationship between the current account of experience and the deposit account of standing structure or stable propensity, between, let us say, sensation and character. But the progressive enrichment idea **assumes** a certain model of the mind, of consciousness – one, moreover, that draws from two conflicting traditions: the religious tradition with a stable soul; and the secular tradition of a self that is transformed through experience.

The most important criticism of the idea of progressive enrichment is that it is untrue to the moment-to-moment reality of consciousness. As Paul Valéry pointed out, 'If the life of the mind could be recorded as a continuity, it would be a revelation of **total** disorder and incoherence'.[12] This is the message repeated by a thousand modern novels. Think of the interior monologues in *Ulysses*: do they not reveal the mind, its beliefs, its knowledge, its convictions, as a colloid of self-mutters, random recollections, images, associations, etc? (It is a special irony that those who believe in the notion of 'progressive enrichment' through the experience of art are often those who take seriously contemporary art – which is frequently characterised by questioning the concept of a stable self, of a steady viewpoint, a person-object.) Even of those who resist the fashionable idea of an exploded, fragmented self, few would dissent from Beckett's observation, already cited above, that 'At any given moment our total soul, in spite of its rich balance sheet, has only a fictitious value. Its assets are never completely realisable'.

There is another way in which the idea of 'progressive enrichment' is unsatisfactory: it commits one to postulating a process that is (a) intrinsically endless, and (b) inevitably brought to a halt at some arbitrary time. Since it emphasises not the experience, the current account of consciousness, but the cumulative effects of such experience, in the deposit account of an ever-enriched consciousness, the purpose of art is referred to as a journey that is not only always unfinished but one that has no clear model of being finished. There looms the rather dispiriting idea of a project that is doomed to failure and, indeed, replicates without modification the wider tragedy of life.

The notion of 'progressive inner enrichment' as the goal and purpose of art therefore ties it into a journey; and this is important in another way. The argument I shall advance presently is that art is about arrival not journeying: that it is, centrally, **not** about journeying to something else, either as seemingly concrete as greater knowledge and erudition, or as manifestly abstract as an inwardly enriched self.

Before putting to bed the idea of 'art' as a pilgrimage of the soul to an enriched and deepened version of itself, it might be worth pausing to consider why the 'journey' idea is so attractive. It must surely be because it borrows glory from the idea of a spiritual journey, a journey towards something like the revelation of God and of one's one relationship to Him. The notion of a large vector that goes through and connects the seemingly scalar moments of life trades on ancestral religious sentiments about the purpose of life. And this is a reminder of the source of much of the 'seriousness' and 'importance' of art: where the practical uselessness of art is recognised, the transcendental, transutilitarian values of religion are gratefully expropriated.

To seek the purpose, the significance, the justification of art in something corresponding to inner enrichment, then, seems likely to be as unconvincing as seeking these things in the putative moral influence of art. Our experience of individual works does not add up to the kind of whole that the critic postulates in his self-documented experiences, his idealised reports of encounters that have taken place in ideal circumstances. These are idealised beyond plausibility, being untrue to the psychology of human consciousness and tending to confuse the standing structures that can be observed objectively in the work with the evanescent experiences that it translates to in the mind. They are not only at odds with psychology but take no account of the conditions of daily life under which art is consumed. Art may create its special places – of the soul and the imagination – but it has to pitch its bivouac in the chaotic littleness of everyday life. There is no permanent, privileged place in the soul for its places; the return from the ecstatic pleasures of the Opera to the theatre cloakroom and the wet rain outside is both abrupt and inevitable, as Hanno Buddenbrooks found after he had seen *Lohengrin*:

> And then the dream became reality. It came over him with all its enchantment and consecration, all its secret revelations and

tremors, its sudden inner emotion, its extravagant, unquenchable intoxication... The sweet, exalted splendour of the music had borne him away upon its wings.

The end had come at length. The singing, shimmering joy was quenched and silent. He had found himself back home in his room, with a burning head and a consciousness that only a few hours of sleep, there in his bed, separated him from dull, everyday existence.[13]

The artist here is more honest about the place of art in real life than any critic would dare to be, recognising that the artistic experience is always broken off; or interrupted; or divided. It is always multiple. It is inescapably in addition to everything else; it must therefore add to, as well as heal, our dividedness. It cannot be part of a convergence over time towards a kind of unified self whose multiplicity is the surface of a deeper unity. Attractive though that idea is, it seems unlikely that art **does** restore to us a lost unity, that we are unified in art – as creators or consumers – to a degree that we are not elsewhere. It is not thus that art reveals to us a destiny, a destination, of our individual consciousnesses that is otherwise hidden from us; not in this wise that we are made whole and purposeful through art.

In summary, the idea that the point of art is to bring about permanent, progressive changes in the self or soul is deeply vulnerable. Summation across episodic experiences of art to produce a grand total that is reflected in a changed structure and modified tissues of the inner self presupposes a strained and implausible conception of the self and of the mind. It seems profoundly untrue to what we know about the variousness, complexity, incontinence and essential infidelity of human consciousness – something that many artists and critics (when they are not defending their own interests along with the myth of enrichment) have acknowledged. Like most aesthetic theories, it assumes that the consciousnesses of both the producer and consumer of artworks are considerably more unified than they are. It also ties the function of art into a project that is both unfinished and interminable – and this is a recipe for despair.

The idea of art that I will develop does not depend on counter-factual conceptions of what it is to be there, in the world. A true account of the function and signficance of art must be based on the

recognition that life is composed of moments and that art is, at best, a matter of perfecting at least some of those moments – even if those perfected moments reach into other moments in other ways than by being part of a stable entity called 'the inner life'. To understand why art is so important in a secular world, we need a more subtle idea of our wholeness, our connectedness, and our trajectory through the world than is afforded us by quasi-religious myths of progressive enrichment of the self or the soul. There may be a meeting between the idea of 'inner enrichment', that would create out of the experience of art a standing structure of the self, and the idea that I shall advance in 'The Difficulty of Arrival'. This is the 'Intellectual Implex' of Paul Valéry. If we think of art as a means of enabling us to rise above experience without leaving it, to enjoy experience at the level of general ideas while remaining immersed in it through the particulars of sense or of memory; and if we consequently think of the art-work as a tor on consciousness, as a means of possessing the world from a privileged viewpoint, then 'the **intellectual** implex – which means the greatest possible number of connections and associations'[14] and establishes 'a significant tension among ideas and questions that display maximum presence and suggestiveness'[15] – may be the point where the fantasy of the enriched self and the reality of the perfected moment may meet. At any rate, we have here the beginnings of a less vulnerable interpretation of the deepening effect of art: depth is translated into connectedness; into compressed extensity; into *gedichte*. But this is to anticipate further than may be helpful at present.

9
A Metaphysical Interlude: The Uselessness of Consciousness

INTRODUCTORY

Despite overwhelming evidence, the claim that art is useless may be resisted. That art is concerned primarily with the generation of beauty and that beauty has nothing to do with morality, usefulness or even edification, is an ancient position – reaching back as far as Plato and the quarrel between the poets and the philosophers; but in recent centuries it has usually been associated with a frivolous desire to shock or at least has been served up in a nimbus of silliness. 'All art is quite useless' invokes, of course, Dorian Gray and the martyrdom of Wilde, the camp smirk, the desire *épater le bourgeois*, or, to use Barthes' phrase, 'to show one's behind to the Political Father'. The uselessness of art therefore needs rescuing from its status as a dated cliché, from the after-sniggers of the Decadents, as much as it needs defending against the anger of those, such as Tolstoy, for whom, as we noted in 'The Freezing Coachman', all but the simplest, most nakedly didactic art was condemned by its inutility. The uselessness of consciousness is (except as a larger condemnation of the uselessness of existence) less of a cliché. The point of this chapter is to reanimate the familiar idea of the uselessness of art by relating it to the less familiar idea of the uselessness of consciousness. Art is about the perfection of consciousness – rather than ensuring the survival or ordinary comfort of conscious beings. Consciousness, I shall demonstrate, is useless. Therefore art is useless.

Metaphysically based theories of art have as many disastrous as distinguished instances: the noble, if rather muddled, history of philosophically based aesthetic theories is liable to weigh like a nightmare on the mind of anyone treading in this field. The theories tend to take a sledgehammer to crack a nut; more specifically, to mix levels in a rather absurd fashion, as when specific empirical consequences are derived from the fundamental nature of the

universe. Recent examples – such as the flamboyant muddles of so-called post-Saussurean literary theory, in which the dubious ideas about the very existence of extra-linguistic reality and of the possibility of extra-linguistic reference were invoked to support a preference for anti-realistic over realistic fiction – are not encouraging.[1] If, however, art is, or addresses, or arises from, something that is very deep in our nature, we cannot understand it except by considering that nature at the deepest level. My claim that art serves only to heighten, intensify, perfect, consciousness leads inescapably to this question: what purpose does consciousness – heightened by art or otherwise – serve? My aesthetic necessarily has metaphysical roots.

THE USELESSNESS OF CONSCIOUSNESS: BIOLOGICAL PERSPECTIVES

The orthodox view is that consciousness came into being because it was **useful** for the individuals endowed with it. Consciousness is to be understood in terms of its role in assisting survival: if you know what's coming and can see it in advance, you will be in a strong position to ward it off if it's bad, or to take advantage of it if it's good. Consciousness is a permanent state of advanced notification and, moreover, it permits planning ahead, an inner state of advanced notification. That is the orthodox view. My own position is that human consciousness is largely without purpose and that it cannot therefore be understood in terms of biological utility. To deny that human consciousness serves a useful purpose is not only to reject biological explanations of the emergence of human consciousness but also to deny its status as a biological phenomenon. As one who has been brought up within and still largely continues to think within scientific orthodoxy, I am aware that this is no minor heresy. It has major implications for our sense of who we are, since (it is hardly necessary to say) consciousness is an all-pervasive feature of humanity; it assaults one of the great received ideas of this present century – that animality lies at the heart and root of humanity. It is not only scientists and philosophers who unquestioningly accepted the biologisation of human consciousness and of humanity. One could name any number of creative writers whose conception of human beings has been

decisively influenced by Darwinian metabiology: from pocket ethologists like D. H. Lawrence and Gide to jungle-law Social Darwinists such as Jack London, for whom the animal nature of man is an unquestioned given.[2]

I have elsewhere dealt at length with the pretensions of neurophysiology and cognitive neurobiology to explain consciousness[3] and I do not wish to repeat what are essentially technical arguments. Here I shall focus solely on the question of the origin of consciousness, on its **occasion**, for this alone is relevant to the present thesis.

Since 1859, *The Origin of the Species* has provided the great framework for theoretical metabiology, and its union of mechanistic and teleological explanation has stimulated and directed empirical research at many levels. The theory has, of course, itself evolved in important ways. There have been spectacular advances in our knowledge of the genetic principles that lie at its root and of the application of mathematics to the biology of populations. Moreover, the nature of the problems that evolutionary theory attempts to solve has been made more explicit and addressed with infinitely greater sophistication. Richard Dawkins' already classic account of orthodox neo-Darwinian thought, *The Blind Watchmaker*,[4] has characterised the fundamental challenge of evolutionary theory as being that of explaining how the miraculously complex organisms that inhabit the planet could have emerged by chance. Physical science is still a long way from producing a plausible account of the emergence of the first organisms or even of the organic compounds upon which they are based.[5] Evolutionary theory, however, assumes that these things have somehow come into being and takes the story from thereon.

Organisms are in place but they are faced with numerous threats to survival: adverse physical circumstances, predators, disease, and other organisms (from the same or different species) competing with them for the wherewithal to survive. Since resources – food, shelter, etc. – are generally available in constant, finite quantities while reproduction tends towards a geometric increase in the numbers of a species, there will inevitably be a high mortality among offspring. Only the fittest will survive. The losers will die young and as a consequence fail to reproduce and to transmit their genetic material. Because of the stability of genetic makeup, reproduction normally results in offspring that, within certain limits of phenotypic

variation, have rather similar characteristics to the parents. However, every now and then, mutations occur which result in offspring that are significantly different from the parents. Most mutations are disadvantageous, even lethal; but a small minority will be beneficial, resulting in characteristics favourable to survival; their carriers will consequently have an increased likelihood of reproducing. Their genetic material will be preferentially preserved.

As a result of this process of selection operating on a population subject to random mutations of genetic material, there will be a gradual trend over time – very gradual, over vast stretches of time – towards the emergence of organisms adapted ever-more exquisitely to survival in a hostile world. Although mutations are random, their selection for survival is not: discrimination in favour of the better adapted will ensure that an accumulation of essentially directionless changes will have overall direction. No Grand Design, only time and chance, is required to account for the emergence of the exquisitely complex, highly adapted organisms that populate the earth. The neo-Darwinist vision of the dialectic between random mutation and non-random survival, resulting in progressive evolution towards the planet's current portfolio of species is brilliantly summarised by Richard Dawkins:

> We have seen that living things are too improbable and too beautifully 'designed' to have come into existence by chance. How, then, did they come into existence? The answer, Darwin's answer, is by gradual step-by-step transformations from simple beginnings, from primordial entities sufficiently simple to have come into existence by chance. Each successive change in the gradual evolutionary process was simple enough, **relative to its predecessor**, to have arisen by chance. But the whole sequence of cumulative steps constitutes anything but a chance process, when you consider the complexity of the final end-product relative to the original starting point. The cumulative process is directed by nonrandom survival. (*The Blind Watchmaker*, p. 43)

That Man is an animal whose emergence can be accounted for by the same mechanisms as that of other animals is of course a central tenet, and the source of the enduring fascination and scandal, of Darwinian thought. Those who have felt uneasy with this have often deployed arguments characterised by lack of rigour, or downright dishonesty, or prejudices that exemplify both. Many apparently

prefer to be God's worm than an ape's remote descendent. Not all anti-Darwinian arguments, however, are as empty or dishonest as those that characterise creationist thought.

Some of the most interesting ultimately derive from Goldschmidt[6] who pointed out that the organ systems seen in all but the most primitive creatures would require many thousands – perhaps many millions – of mutations before they were sufficiently developed to be of use. The first several thousand mutations would not therefore confer advantage and there would be no basis for preferential survival of the genetic material incorporated in them. The chances of the random aggregation of all the mutations necessary to produce the organ system in the genetic material of the species would be vanishingly small. The theory of evolution requires, as we have seen, an accumulation of small steps that selective survival shapes into bigger steps; by contrast, organ development would seem to require very large steps to occur. Goldschmidt suggested that, from time to time, big mutations occur and although the majority of these would have been lethal, a very small number would have been compatible with survival. These 'hopeful monsters', in addition to millions of smaller mutations, drive the evolutionary process forward.

This solution seems to create more problems than it solves and Dawkins deals with Goldschmidt's puzzle by suggesting that even an embryonic organ system – for example a single photosensitive cell – would confer some 'edge over the competition'. Small steps in the right direction could thus accumulate over immensities of time until sophisticated sensors such as eyes could emerge. Could this explain the emergence of consciousness? Dawkins thinks of the photosensitive cell as the precursor of the eye of the conscious organism. By analogy, a vibrating cilium may be seen as the ancestor of the ear. Parts of the surface of primitive organisms that are specialised, so that they can be affected by incident energy with certain highly narrowly defined physical characteristics and trigger reactions to external events, are regarded as ur-forms of the sensory systems that seem to lie at the basis of consciousness in higher animals.

This analogy is false in a way that is crucial and fundamental to any discussion of the evolution of consciousness. Chemical photosensitivity *per se* is not ur-consciousness; otherwise the photosensitive cell that switched on and off the street lamps in response to changes in ambient light could be regarded as being, in

some primitive sense, conscious. Nor is it a **step towards** consciousness: a single photosensitive cell does not bring an organism any nearer to consciousness; nor does a battery of such cells, howsoever complex their connections with each other or with devices such as muscles that permit and shape an adaptive response. It is far from self-evident that sheer numbers of cells would bring about the jump between the energy transduction – the conversion of one form of (unconscious) energy into another form of (unconscious) energy – that is the essence of photosensitivity and the transformation of energy into awareness that is the essence of vision. Photosensitivity is the *sine qua non* of vision; but is is not identical with vision. It does not count as a sensation of brightness, even less as an ordinary experience of the familiar, meaningful visual world.

Consciousness cannot therefore be gradually approximated by a series of ever-more-complex physical devices guiding adaptive movements, such as photosensitive surfaces attuned to certain physical stimuli, arising out of a series of mutations. Whereas **physical** organ systems may arise by progressive evolution, **consciousness** – which is not a mere matter of physical energy transfers – cannot. Photosensitivity (or acoustic sensitivity) does not straddle the matter/consciousness divide; and successive elaborations of photosensitive (acoustically sensitive) devices do not self-evidently lead to consciousness 'by degrees'. One cannot be a teeny-weeny bit conscious on the way to being fully conscious, any more than one can be a teeny-weeny bit pregnant on the way to being pregnant.

This last is a difficult point to grasp: we are so used to thinking of degrees and intensities of consciousness in ordinary human life that it is all too easy to retroject them into the emergence of consciousness *per se*. Photosensitivity may well give an individual an edge over the competition but it is not the same as vision.

More to the point, there is no reason to assume that conscious vision does confer 'a competitive edge' to the organism possessed of it over (unconscious) photosensitivity. One could imagine an evolutionary pressure to develop ever-more sophisticated photosensitive devices that would shape ever-more precisely adapted movements in response to patterns of light and shade corresponding to predators, food, dangers and shelter. The more complex and reliable the device, the more successful the organism. But one cannot imagine an evolutionary pressure to produce consciousness,

since there are no grounds for thinking that what is achieved by consciousness on behalf of survival – the bottom line in utility so far as evolution is concerned – could not be achieved equally well, or better, by unconscious mechanism.

It may seem rather odd to suggest that consciousness has no advantage over blind mechanism when it is obvious that an unconscious human being is more vulnerable than a conscious one. Surely consciousness – knowing what one is doing, knowing what lies ahead, etc. – has survival value. So it would seem; but this is to consider the matter from the point of view of an organism that is typically conscious – and hence needs conscious planning – and so to start from the wrong end. We tend to underestimate what can be achieved by non-conscious matter because we habitually focus on the limitations suffered by usually conscious organisms when they lose consciousness; or on the restricted capabilities of artefacts such as robots – unconscious automatons – compared with conscious organisms. Comatose human beings cannot survive without the continuous attention of others: once you're conscious, it's a good idea to stay that way. Robots are ludicrously ineffective in dealing with situations outside of the closely-scripted universes in which they have been designed to operate. An objective approach to the question of the comparative survival value of consciousness versus that of increasingly complex unconscious mechanisms requires that one should consider it from the standpoint of the evolutionary process as a whole; that is to say, starting out from the consciousness-free universe into which, according to Darwinism, consciousness is supposed to have emerged in response to the evolutionary imperative. The specific survival advantage of consciousness will then start to look less convincing. For there is no useful repertoire of behaviour that cannot, in principle, be achieved through unconscious mechanism.

Most organisms navigate through the world, parsing unseen a text of unforeseen contingencies, without the benefit of obvious consciousness. The fly, for example, executes remarkable feats of avoidance and pursuit without conscious vision in the sense that we have conscious vision. The successive roles taken by worker bees in their short lives – nurse, honeycomb maker, honeycomb cleaner, honey gatherer – switched on in sequence are individually complex and very different from one another and yet do not require consciousness. It may be argued that flies and bees have a sort of primitive consciousness that we cannot imagine. These kinds of

arguments are unresolvable. What is beyond dispute is that there seems to be little correlation between the **level** of consciousness and the capacity for survival either of the individual creature or of the species as a whole, of the genetic material it carries. Many long-lived individuals and long-enduring species-as-a-whole are effectively without consciousness, and many conscious organisms and species-as-a-whole are or have been short-lived. As Mary Midgley put it, if it is species longevity or individual longevity, even immortality, you are after, then an amoeba is 'just the thing to be'.[7]

There are, however, even more compelling instances than self-navigating flies and multi-skilled bees of the power of unconscious mechanism to achieve extraordinarily complex goals. The growth of organisms, and of the organs within them, afford the most spectacular examples. Consider the construction of what is (according to the human brain) the most complex object in the world: the human brain. Its development in the embryo necessarily takes place in the absence of consciousness. A foetus is able to grow its own brain without the intervention of a single plan, thought or idea: trying to bring a brain about by deliberate thought would be sure to have disappointing results. And this is not because the growth of a brain is totally stereotyped: from the moment the first cell is laid down, the situations into which the growing brain grows are unique, within a fairly baggy set of constraints. And we could look beyond the individual brain to the process by which the brain evolved – or, indeed, to the evolutionary process as a whole. By making mind unnecessary for evolution, evolutionary theory emphasises how much can be achieved without consciousness and how this dwarfs what can be achieved by consciousness. Evolutionary pressures, therefore, would not dictate a preference for conscious organisms over ever-more-complex mechanisms.

One could even argue that such pressures would dictate a positive preference for mechanisms over consciousness; that consciousness is actually a liability. After all, animals with highly developed consciousness have prolonged periods of extra-uterine development and of comparative helplessness and vulnerability. It is not too fanciful to link the peculiar horrors of the way humans treat each other with the unique development of their consciousness. The prolonged and massive nastinesses of human wars are predicated upon a highly developed organism that plans and has protracted and abstract and carefully nourished grudges. The evil psychological games that may poison human sexual relations are

likewise dependent upon the proliferation of imaginative skills. The unconscious cells in a multicellular organism or the elements in a giant sponge or the inhabitants of an ant colony get on better and more safely with one another than do the conscious citizens of human communities.

The many seemingly maladaptive consequences of consciousness have led philosophers such as Schopenhauer to characterise man as 'the sick animal' and consciousness as his sickness, and prompted Dostoyevsky (in *Notes from the Underground*) to suggest that human consciousness was a 'mistake'. Kleist brooded on how much was lost when consciousness entered the scene – which could be regained only when consciousness achieved an impossible totalisation:

> the aesthetic . . . charm, free grace is reserved to the automaton and the god; that is to the unconscious or an endless consciousness, whereas every reflection lying between nothing and infinity kills grace. The consciousness must, this writer thinks, have gone through an infinity in order that grace find itself again therein; and Adam must eat a second time from the tree of knowledge in order to fall back into the state of innocence.[8]

Consciousness is thus not only biologically superfluous: its higher development is socially hazardous.[9]

The assumption, implicit in evolutionary explanations of consciousness, that survival is better served by increasing consciousness than by developing better unconscious mechanisms, that deliberate action is always or usually a better bet than automatic behaviour, looks very vulnerable indeed. Much life-preserving activity takes place better in the absence of consciousness and the most complex life-supporting actions – for example the development of a brain in an embryo – can be accomplished only by unconscious and automatic processes.

There is an additional important reason for denying that consciousness could have been brought into being by evolutionary pressures. Any pressure to requisition consciousness in a world free of it would be rather impotent! There is simply no consciousness to be requisitioned in the exclusively material world of neo-Darwinism. Those who grasp this point fall back on the assumption that consciousness does not have to be 'requisitioned' as it will inevitably arise as a by-product of the development of increasingly

complex nervous systems designed to control adaptive movement. But even this notion of consciousness as an unlooked-for free gift coming out of the evolution of nervous systems sits uneasily within the physicalist framework of neo-Darwinism. There is no way of explaining why an increasing number of connections between increasing numbers of neurones should accidentally give rise to something totally different from those neurones. It is only retrospectively that we can see a connection between complex nervous systems and consciousness; and only retrospectively that we fancy that this connection is a necessary one. Moreover, once the nature of that spurious, *a posteriori*, necessity is clear, it becomes equally obvious that consciousness, having emerged in an automaton exhibiting a high level of complexity, could just as well disappear at yet higher levels of complexity – and higher levels of efficiency in terms of preserving genetic material. One could imagine increasingly efficient automatons evolving **past** consciousness. Consciousness, instead of being the highest expression of the evolutionary process (and not even neo-Darwinians are able to shed the metaphor of the tree of life, with conscious human beings at the top) would be a window through which automatons passed as they evolved towards ever-more precise adaptation to the ecological niche in which they found themselves.[10]

Taking the long view implicit in neo-Darwinian evolutionary theory, there is no reason within matter why it should have a tendency to achieve conscious organisms; or – taking an even longer view – why matter should differentiate into organisms that have conscious, explicit purposes on the one hand and, on the other, non-organisms upon and through which their purposes are enacted. The appearance that there are evolutionary pressures towards increasing consciousness is due to looking backwards along a process that led up to us.

Specifically **human** consciousness presents a serious additional problem to Darwinism: it absurdly exceeds its evolutionary brief. The interest that some human beings have in the nature of the stars and in events that took place billions of years ago is only an extreme example of the tenuousness of the connection between most of the preoccupations of civilised consciousness and organic survival. So, even if one had an evolutionary explanation for the emergence of animal consciousness, this would not account for human consciousness, since the latter is only distantly related to the former.[11] The huge distances between human and even other primate conscious-

ness are easily illustrated. One has only to think of the differences between an animal's typical need-driven behaviour and human salaried labour; between animal tropisms and instinctive discriminatory responses on the one hand, and the complex classifications and re-classification systems employed by human beings; between an animal deferring to a pack leader when a prey is caught and a human carefully choosing the cheaper items on a restaurant menu so as not to alienate his boss whose treat it is; between an animal seeking shelter and a human agitating for a pay-rise to cover mortgage repayments or negotiating more favourable terms for a long-term loan; between learning through operant condition and organising a babysitter so that one can attend next year's evening classes. Every attempt to assert the uniqueness of human language has met with fierce denials of those differences; but no-one could deny the uniqueness of human discourse about discourse. Metalinguistic activity is utterly unique to human beings, is all-pervasive and central to what it is to communicate. It is not merely because they have other pressing engagements that chimpanzees do not write treatises on comparative linguistics, on the writing style of other chimpanzees or on the rhetorical or suasive dimension of apparently factual communications. All these activities associated with conscious humans are difficult to assimilate to evolutionary theory. (And they suggest that it is about as useful to think of us as animals as it is to think of a forty-year-old man as a neonate.)

Evolutionary theory offers two sorts of explanations of the structures and properties of living creatures: either they contribute directly or indirectly to survival; or they represent the junk left over from previous stages of evolution, from earlier drafts of the species. Consciousness does not yield to either kind of explanation. Its initial emergence cannot be explained in terms of its adaptive value; and its continuing presence cannot, therefore, be accounted for as that of an evolutionary left-over hanging on. The theory of evolution, therefore, fails signally to account for consciousness, in particular the consciousness exhibited by human beings. It is significant in this regard that neither Dawkins in *The Blind Watchmaker* nor Darwin in *The Origin of the Species* refers to the evolution of mind or consciousness. Darwin does refer to instincts – as forms of mental powers – but emphasises that 'I have nothing to do with mental powers, any more than I have to do with that of life itself. We are concerned only with the diversities of instinct and of the other mental faculties in animals of the same class'.[12] Butler's complaint

that Darwin 'banished mind from the universe' was directed against Darwin's removal of mind (or purpose, or Design, or conation) from the evolutionary process and so from the unfolding of the universe. It should have been directed at the fact that the theory of evolution could not explain consciousness or the emergence of creatures such as ourselves who are, most importantly, conscious. It not only ejects God's mind from the Universe but makes mind itself pointless. The Darwinian vision – which assimilates human nature to animal nature and so to material mechanism and hence inanimate matter – is consequently invalidated by serious incompleteness. We conscious human beings are, it seems, a separate mystery from that of life and from that of matter.

That it is necessary to point out that consciousness is not the kind of thing that can be captured within the explanatory framework of Darwinian metabiology is a measure of the degree to which our notion of consciousness, and in particular human consciousness, has been so diminished as to make it almost invisible. Thus diminished, it can plausibly be thought of as the evolutionary after-thought, the hypertrophied version of animal cunning, which it is reduced to in ordinary scientific thought. Once human consciousness is restored to visibility, other aspects of consciousness become visible.

ART AND HUMAN CONSCIOUSNESS

Foremost among these other aspects is the fact that consciousness makes survival explicit, rather than merely being implicit as persistance or stability. It is thus associated with the emergence of questions about the purpose of survival: survival 'for what?'. Human consciousness may not be a particularly effective **means** to life but it does create the question of the ultimate **ends** of life. Consciousness makes possible the explicit valuing or devaluing of states of affairs – and the possibility of questioning values and of demanding new values, new needs to be satisfied. While evolutionary forces may account for the material properties of organisms, it cannot explain how it is that certain organisms value the material properties of the universe that surrounds them. An organism does not have to find its food tasty in order to ensure that it eats it, even less does it have to be a gourmet to have the right tropisms. Valuing what is of survival value is unnecessary to survival if the right mechanisms are in place.

The association of consciousness with the emergence of value opens the way to an even deeper critique of consciousness than that deriving from its lack of biological use. Consciousness may be considered as worse than useless. For just as there would have been no pleasure without consciousness, there would equally have been no pain, either; and history suggests that pain has probably got the upper hand. And if the unique capacity of man to murder his conspecifics and to enjoy the infliction of suffering is taken into account, the moral sense that comes with heightened consciousness does not improve the balance sheet, either. Consciousness does not pay for its keep.

Perhaps the kindest thing that can be said about consciousness is that it is only slightly more useless than life seen as a whole or matter seen as a whole. Anyway, we are stuck with it. The major spin-off of this capacity to experience our interchanges with the environment that seems to serve no adaptive purpose whatsoever is that new non-adaptive values and new pursuits to serve those values emerge. We are explicit, self-conscious animals burdened with the mysterious gift of making evaluative sense of things – including ourselves. An equally mysterious side effect of this burdensome gift is a hunger to complete, or bring to some culmination this sense of things: hence man the metaphysical animal.

And man the art-making animal. For although historically the hunger to round off the sense of things has had its most universal expression in religion, increasingly (non-religious) art has taken on this function. Secular art, like religion, is about rounding off the sense of being consciously alive and the ultimate purpose of that to which so many of our conscious purposes are directed. If consciousness is a useless making-explicit and value-creation that is utterly unoccasioned and mysterious, art is a highly developed expression of this making-explicit, of consciousness not as means to an end (survival) but as the bearer of ultimate ends. It is the medium though which non-adaptive values are most purely expressed. In art, consciousness no longer even looks like serving any useful purpose and seeks, instead, its own perfection.

The burden of my argument may be summarised as follows. Consciousness serves no practical function whatsoever – it is quite unnecessary – and art is the ultimate development of the essential uselessness of consciousness. Therein lies the glory of art: it takes to its furthest extreme the unique distances, arising out of explicitness,

which human beings open up from the material world of mechanism and the biological world of survival-related function. Art is a supreme realisation of the free creation of meaning in an intrinsically meaning-free universe. Such meaning transcends, at least in virtue of having nothing to do with, the closed meanings of practical use, of those things that are necessary to survival and ordinary comfort. Subordinating art to any kind of utilitarian external purpose which will support survival – and this includes most moral, political, and didactic purposes – consequently degrades it, especially as these functions are better discharged by other things. As a source of such transcendent meanings, and as the servant of ultimate ends, secular art may claim to have taken on the mantle of religion.[13]

We might relate consciousness without art to the consciousness embodied in art as follows: consciousness brings meanings but these are, in a sense, imposed meanings, shaped by an organic heritage (though there are no meanings in or for unconsciousness organisms). In art, we experience to the full the potential of consciousness for the restructuring and reordering of experience so that new meanings – new distances from the organic and material – are created, distances that confer upon the organic and the material a new identity as the Other, opposed to a shifting Same. Art, as we shall discuss, is (to use Sartre's phrase) 'the world assumed by a freedom'. The emergence of consciousness creates the possibility of subjective meanings that are unrelated to objective function. Although the meanings experienced by conscious beings relate much of the time to functions that in turn subserve survival, it is the generation of subjective meanings – of meaning enjoyed for its own sake – that is the unique potential of consciousness, and that which is served with unique intensity in art. Our emotions – such as fear and desire – may serve survival (not as well as automatic reaction-complexes without experience) but it is only in art (and in human beings) that, as Whitehead pointed out, they are cultivated for their own sake.

Consciousness is the bearer of meaning into a universe that would otherwise be without it. Human consciousness makes these meanings explicit. And art is the dance of such meaning. As Heidegger famously defined it, *Dasein* (human being-there) is that being whose being is an issue for itself, that in virtue of which there are issues and the material world – matter – actually matters. And art brings that 'being an issue for itself' to the forefront, beyond its

expression in the endeavour, made conscious in us, towards organic survival. Art is distanced from our physical condition, our status as needing organisms, our material needs: it is the greatest possible distance from these things.

Is art then a perversion of consciousness, a distortion of its essential purpose? Hardly. If consciousness has no purpose, then art, which is useless, realises the deepest potential of consciousness rather than traducing some pre-ordained purpose: the free creation of meaning. Art is the happy (and unhappy) and unnecessary accident of consciousness rendered in italics, in experience that recurs upon itself through representation, or more importantly, through the moving stasis of form, which permits it to know itself. Art is the dance of human consciousness celebrating existence for its own sake.[14] Such a view liberates it from subservience to useful purpose, from serving survival, from most of what comes under the rubric of morality, politics, and education. As I wrote in *In Defence of Realism*:

> Man is the only form of matter that is astonished at its own existence and capable of conceptualising its own mutability in the terrifying idea of death. Realistic fiction, linking the small facts that engage us with the great facts that enclose us, mediating between the truths that are uncovered by abstract thought and the small scale truths of daily life, is the most compendious expression of that astonishment and that terror.[15]

For 'realistic fiction' read 'art'.

10
The Difficulty of Arrival

Sometimes for an hour you are, the rest is what happens.

(Gottfied Benn)

LIFE AS A PROBLEM

The Uselessness of Art

The story so far has been essentially negative: I have focused on what art is not, on the functions it does not discharge. In particular, I have emphasised its practical uselessness. It is obvious that art cannot be justified on the basis of the material benefits it brings. And, as was argued in 'The Freezing Coachman', exposure to art doesn't seem to do much for the morality of nations or of private citizens. After millenia of great art, people behave collectively and individually just as badly as they ever did. If anything has softened the brutish egocentricity of the human animal, it has been technological advance in meeting material want, rather than art. Well-fed individuals in a warm room may be more sensitive to one another's feelings than hungry bodies in the cold air. To quote Brecht: Grub first, then ethics.

So apologists of art seek elsewhere for its purpose. They look inward, suggesting that art enriches the self and that it has educational value. This claim, too, has proved vulnerable, being grounded in an exaggerated sense of the coherence and continuity of our consciousness. The experiences of art – reading, looking, listening – are always in some sense broken off; or interrupted. And they are multiple: as well as being **additional** to everything else, they don't quite add up.

To discover that art is useless, and that it doesn't 'enrich', even less 'educate', in a conventionally understood sense, will come as a blow to some. The blow may not be palliated by pointing out that

consciousness, too, is useless. Nor will the double blow of the uselessness of art **and** of consciousness itself be softened by the reflection that neither is more useless than life seen as a whole or matter seen as a whole. But the uselessness of art is upsetting only if use is considered to be identical with value, so that the useless is valueless. And this is certainly not the case: the useful often has only indirect value, not being valued in itself but in virtue of serving to bring about valued states of affairs or to terminate or prevent states of affairs that have negative value. Value is wider than use, and use is the servant of value. My intention in pointing out the practical and moral uselessness of art, and its failure to bring about a cumulative enrichment of the soul, is not to diminish its value but to show where its true value lies. Since I believe that art is always misrepresented and degraded when it is suborned to some useful purpose that it cannot fulfil, my aim is not to undermine art but to uncover its essential glory.

The function of art is not to be found in the world of use, in the Kingdom of Means, but in the Kingdom of Ends. It is not, of course, the only feature in the landscape of that Kingdom. There are many other things we do for their own sake, for the pleasure they give us. So what's special about art? After all, drinking alcohol gives pleasure and so do stroking the cat and, it is rumoured, playing football. Yet we have an entirely different attitude to these other pleasure-giving, time-killing activities. We are convinced that there is something more serious, more important, about art than playing tiddley-winks or even the 'serious fun' of professional sport. So what is this 'more serious' about if it has nothing to do with usefulness? What value lies outside both practical use and ordinary pleasure?

To address this, we need to return to consciousness: though it is useless, we are stuck with it. We are explicit, self-conscious animals burdened with the mysterious gift of making sense of things – including ourselves. An equally mysterious side effect of this burdensome gift is a hunger to complete, or bring to some culmination, this sense of things: hence the unique character of man as the metaphysical animal. And herein, I shall argue, we shall find the essential purpose and value of art: art is about trying to round off the sense of being consciously alive and so about the ultimate purpose of that to which so many of our conscious purposes are directed. While historically the hunger for completed sense was most universally expressed in religion, in a secular age this is expressed in (non-religious) art.

Art then addresses not so much a metaphysical problem as a need that must be understood metaphysically. To understand the nature of this need and to see how, outside of art it remains unsatisfied, I want to examine the problems that bedevil the Kingdom of Ends; in particular to subject to sympathetic but critical examination the most sustained attempt to dwell in that Kingdom that most of us undertake: the annual summer holiday when we are liberated for a uniquely long time from the productive process in order to seek experience for its own sake. The frustrations that attend this secular haj – and indeed much ordinary experience without the mediation of art – tell us a lot about human consciousness and why it needs art.

That it is better to travel hopefully than to arrive is an observation that remains true despite its descent into cliché; for arrival (except in the sense of reaching some practical or external goal) is elusive. I shall argue that our need for art is rooted in the difficulty, perhaps the impossibility, of **arrival** in the Kingdom of Ends and there experiencing our experiences.

The Systematic Elusiveness of Cornwall

Perhaps it is because there cannot, at this late stage in the history of pretty well everything, be a convincing pretence to beginning at the beginning, that I am going to settle for a rather local beginning, one personal occasion of some of the ideas set down here: our yearly family holiday, the annual dismounting from the press of responsibility and arrangements (which sometimes seems to take the form of a mere change in the press of responsibility and arrangements). Much of what follows is a teasing out, a distillation, of a growing unease at and frustration with, our not being able properly to arrive on holiday. And though the argument will travel to places that have little to do with holidays, it is this difficulty – and the need to make something positive out of it – that has prompted me to try so to order my thoughts that they shall seem to hang together, and to constitute a journey with a point of arrival.

For over ten years we have holidayed in the same place: the same rented cottage in the same Cornish village. This is not through inertia or because we can't afford to go to Spain but out of a positive decision not to change a winning formula. After our first visit, we said we wanted to come back every year forever. With Cornwall I associate some of our happiest hours (as well as one or two unhappy ones) and the afterglow and foreglow dominates the rest of the year.

The Difficulty of Arrival

At any given time, I am a certain conscious distance from our Cornish holiday. We often refer to it; the family album is dominated by Cornish photos; and my study is cluttered with memorabilia of the village and cottage where we stay.

The outward journey is a relay of landmarks and the successive holidays are themselves increasingly poignantly landmarks. They have charted the growth of our children: the development of their interests from (say) the movements of slugs under stones to the tactics used by tank commanders in the Russian campaign; and their changing awareness of time – from the shoreless, unformatted, innominate days of infancy to a mapped out year which gives habitation for hopes and worries about events months ahead. They have marked the changes in our careers – in my own case from a humble junior doctor to an (of course) equally humble but better-paid professor. The holidays, in short, are an instrument for revealing the slow, large-scale changes in our circumstances, a series of frames in a time-lapse video of our lives.

And so each year, we look forward to that magic, climactic moment when we **arrive** in Cornwall, **arrive** in our holiday. And therein lies the difficulty. Increasingly – and we adults now acknowledge it openly and my diary has discussed it for some years – we note the lack of an absolute sense of arrival. And this despite the fact that every holiday is in many ways better than the last, fulfilling our intentions more precisely. To anticipate: we have an insufficient sense of being on or in the holiday we had imagined or looked forward to; as if holidaymaking demands a sharper, more continuous, more specific, sense of being here and being of ourselves and this sense is denied us.

The feeling of insufficiency takes various forms. The most obvious and illuminating is **our inability to determine the precise moment at which we have definitely arrived** – after which we can confidently say 'We are here. The holiday has begun'. Is it when we cross the Tamar and know that, geographically, we are in Cornwall? When we read TIREDNESS KILLS TAKE A BREAK and Mrs Baggit tells us to look after Cornwall and take our litter home? No, we are still fifty miles from the cottage. Is it when we first see the sea? There are quite a few miles of narrow lane yet to go. Besides, you can't do anything with the mere sight of the sea. Surely, then, it is when we first reach the cottage. But there is so much unloading to do and pressure to do it quickly before our illegitimately parked car becomes a road block and our arrival is

celebrated with official fines and/or unofficial abuse. Unloading – decanting possessions in large blocks – passes over into unpacking – distributing individual items. Putting a particular pair of underpants in a particular drawer, or discovering that a treasured toy or an essential gadget has been forgotten, is hardly arrival. Manifestly not: it is too much like housework, too detailed and too interior, and faces too decisively away from the sea. And, in the early years, too fraught to be holiday-like: the hasty distribution of effects was shadowed by an anxiety that, when our backs were turned, somebody would discover a way to fall down the ungated stairs or off a wall. What about when we first go into town to buy provisions – and find that the general store is not so general as it used to be? This, surely, is a way of being arrived: renewing acquaintance with the village and the villagers (fewer of whom than expected remember us from previous years). No; for it is a journey and circular to boot. Moreover, the children's impatience tells us that it is only a preliminary. They have unnegotiable ideas about what shall count as arrival. Our holiday hasn't begun until bared feet have touched sand.

And so, in an endeavour to arrive as quickly as possible ('weather or not' – the annually re-dusted joke), we prepare for the beach. We pack food, drink and toys, and clothes for all contingencies – a wide range, given that the evolution of British weather is a classic exemplar of chaos theory. At last, oppressed by the weight of our possessions, we arrive on the beach. We find a suitable place: out of the wind, not so close to the sea that the tide will soak our sandwiches, nor too near to the youths with the ghetto blaster or the topless teenage girls braving the non-tropical Cornish air. The windbreak is erected, our mallet adding to a chorus that simulates the forging room in Nibelheim. We spread out our possessions. We sit down on the blanket, already covered with sand and spilt coffee, exchange smiles and prepare to subside into stillness. But not for long. Someone's spade has been forgotten and a packet of football stickers has mysteriously disappeared. Several additional journeys are required to placate a child's grief. And numerous further adjustments – of the position of our camp, of the direction of the windbreak, of the distribution of our bits and pieces – are also necessary. Eventually, everything is in place.

Have we now at last arrived? Not at all. Even leaving aside the cloud that is homing in on the sun like a heat-seeking missile, we know that it is not enough merely to be touching sand. A **game** must

be underway. Cricket, for example. So up we get to define a pitch, to put in whatever stumps have survived the journey, assign individuals to teams and try to resolve without recourse to the European Court of Human Justice the dispute over who is going to bat first.

This, surely, is the moment of arrival: awaiting with bat in hand the ball which will be hit so hard that it will land in the sea. Or is it? Even when you are playing cricket, even when you are the privileged one with the bat – a minute portion only of the time devoted to the game (a much greater proportion being spent chasing after the ball that someone else has hit or missed) – you have to wait – for the bowler to get the ball, and to complete his run up to the stumps. There is more waiting when you have missed the ball and there is discussion as to whether you or the inattentive wicket keeper should chase after it. And when you have hit the ball, and almost score what looks to you like a six, you are rewarded with more waiting – more motionless journeying towards an ill-defined goal.[1] The entire argument is symbolised in the fact that the moment the ball finishes coming towards you (and it has been on its way since the holiday was first dreamed about), it starts its journey away from you. The arrival between the journey towards and the journey away is the infinitesimally brief moment of contact between ball and bat.

Perhaps this is the wrong model of arrival. Isn't **doing** things on the beach – even archetypal, much-looked-forward-to things – a way of losing the beach, and of losing sight of, and so failing to be arrived in, Cornwall? (Even though the sense of being here in Cornwall is fed from time to time by glimpses of the familiar headland beyond the endless adjustments of the rules necessary to ensure both ludic justice and a uniform distribution of happiness.) Is there not an alternative (adult) model in which arrival is the achievement of a certain passivity, rather than engaging in a specific activity? A more genteel version which requires a bit more negative capability than an often-contentious game of cricket? Isn't arrival really a matter of sensation; for example, the first time you feel the breeze on your bare legs (bared more in response to a sense of occasion than to meteorological realities) or the wet sand under your shoeless, sockless feet?

The trouble is, you are obliged to enjoy these sensations *en passant*. Correspondingly, not arriving increasingly takes the form of not being able to focus on them; in particular, not being able to greet, and pay proper attention to, the sea. The endlessly postponed

moment of arrival becomes the moment **when you first look properly at the sea**. Early attempts to lose yourself in the vastness between the foam around your toes and the remote horizon will usually be frustrated. For example, you will be accompanied by someone who frames your contemplation within his handtugging impatience to get to the souvenir shop. In pursuit of this latter aim, he announces, as you remark the spindrift blown off the collapsing backs of the waves, that he needs to go to the toilet. The waves crash on to a shore other than your consciousness.

A couple of days later, however, one of the adults gives the other an *exeat*. One of you is at last alone with the sea. Even though contemplation may be clouded with the kind of preoccupations that comparative peace brings to the surface, this seems at least a nod in the right direction: definitively to arrive is to be engulfed in the distinctive sensations of the place you are arriving at. But still you are not satisfied. It is not enough merely to dandle the sea at the distal end of telereception. To be fully arrived, you must be **engulfed**. This requires actual immersion.

Journeying is therefore resumed: a change of clothes; a long walk across the beach; and an inch-by-inch, sensitive-part-by-sensitive-part, entry into the water, negotiating past the shocks of cold that still, after all these years, retain their power to shock. The inaugural dip seems less arrival than a tribute paid to tradition and expectation. As soon as you are in, you are thinking about another journey: getting out and a version of arrival that includes dry towels and the sun in a sheltered spot behind the wind break. Quick in and quick out and, all duties and arrangements suspended, giving yourself up to the absolute comfort of solar energy.

The stretch of blue sky seems large enough for you not to have to worry about the return of wind and cold. You lie back and close your eyes. Your lids and the world turn to dazzled orange. The warmth on your arms penetrates beneath the skin. The contingent sounds that fill the 360 degrees solid angle around your repose – the voices of the children, the noise of the sea whose bruit between the waves has the continuity of an overheard motorway, the thud of mallets and footsteps transmitted with a curious metallic resonance through the sand on which your head is resting – mingle with the multi-dimensional dance of your thoughts. Assuming that there are no extrinsic obstacles to giving yourself up to the the sun – such as a football landing on your stomach or a piercing cry of woe from one of your children – or a half-extrinsic one – such as some left-over

The Difficulty of Arrival

worry or shred of resentment or the feeling that you ought to be doing something else – do you then, at last, arrive? Consider what happens next. Is it not typically the case that at such a moment all the year's fatigue gathers up in you and demands satisfaction, that you willingly accede to these demands, and that you dissolve into **sleep**? And that when, an hour or so later, you wake, the world has a greenish tinge, it doesn't look like Cornwall at all, you have a slight malaise and if you have arrived it could be to anywhere.

Was **that** the moment of arrival – falling asleep? Certainly, it cannot be faulted for insufficient negative capability. But in other respects it does not impress: arrival cannot (surely) consist of losing sight of the place you have arrived at, and forgetting who you are and what you arrived for. Around here the suspicion starts to grow that the difficulty of arrival is not just a matter of accidental frustrations and jobs to be got out of the way first, before we can arrive: it is beginning to look structural, systematic.

Other candidate moments seem even less promising. For example: the first pint of HSD followed by the first Real Ale Cornish hangover; writing postcards home announcing that you have arrived; the first-morning visit to the 'souvenir' shop; a mid-holiday walk on the coastal path accompanied by a hostile minority report from the children temporarily exiled from their pleasures; a last-day trip to the fudge shop to buy presents for everyone.

Nevertheless, we keep on trying to arrive – right up to when we have to shake the sand out of our towels for the last time, fold up the windbreak, pack up our bellyboards and our wet suits, draw stumps, return to the cottage, clean it up (an activity dominated by the lamentations of the vacuum symbolically bellowing emptiness, with a sound even more meaningless than that of the sea) for the next arrivees or would-be-arrivees, load the car, and drive home.

Unbelievably we are on our way back, engaged in a sad withdrawal in which the landmarks of our outward journey are served up in reverse order. We know that it has been a wonderful fortnight and our hearts and heads and cameras are full of memories and yet we know also that we never quite arrived, were never quite there. This was a special time and yet it seems, as we fill up our north-facing car with petrol at Exeter Services and spend the last of our holiday money, that we let it go, not properly used, incompletely experienced.

We recall how at the beginning of the fortnight, time seemed almost to stand still. How far away from home we seemed by the

end of Day One and how much we had crammed into it! And how, after the first few days, the clock picked up speed, as if inflation was at work. We had suddenly reached the midpoint and a sense of resignation towards, or anticipation of, the ending entered our thoughts. As if colluding with the inevitable, we began to think about things that would happen or we would do when we got home. The theme of arrival began to give way to that of departure. Half way through the second week, we were surprised to discover that we still had several whole days, indeed the equivalent of a long weekend, left over; but, sensing that it was now too late, we squandered those days and gave up on the idea of arriving.

At any rate, the holiday is over for this year and we can only look forward to next year's attempt at arrival. In the grip of the sense of loss – sharper each year as we feel the passage of our children's childhood – that assails us on our return, it seems as if, once again, we had been careless of the hours given to us. How did the days slip away? What happened to the ten hours on the beach that sunny day? Time, even on the beach, had refused to clot into apprehensible duration; instead, it simply passed through us. We let it go just as much when we were happy as when we were cross, just as much when we were idling on the beach – when we should have been basking in pure duration – as when we busied ourself with some formal activity because the rain dictated flight; when we were doing characteristic, archetypal holiday things such as building a sandcastle as when we engaged in the non-holiday activities that the combination of wet weather and children get you into – such as visiting Tunnels Through Time or sitting in a dark, seasonless cinema. Yes, even beach-time, which has the virtue of corresponding to expectation and not being caught up with gross time-consuming travel, was dissipated in journeys: going for an ice cream, hiring a deck chair, looking for a newspaper, re-reading a paragraph of an article that had been read with so many interruptions that getting to the end of it seemed like a pilgrimage. Whatever we did, wherever we were, we seemed to drift from plans to their implementation in further plans in the meshes of plans, endlessly re-planning in response to expected and unexpected outcomes. Journey led to journey, being-here seemed to dissipate to an equilibrium of elsewheres, and time eluded us.

In short, we never found that moment of arrival after which we would have **remained** arrived, in journeyless continuation. This elusiveness was, to use Ryle's term, a 'systematic' one. The failure to

arrive was not extrinsic and ultimately remediable but intrinsic and inescapable. Every candidate point of arrival had a tendency to turn into a piece of *en route*, to be porous with further journeying: every journey, it seems, ended only in more journeys, macro and micro journeys constituting the activity one had arrived at or for, taking one through the point of arrival. And so it went, until the time came for departure and the journeys that led all the way home.[2]

Generalising the Problem

I began my investigation of the difficulty of arrival with holidays because these represent, as I have said, the most sustained attempt to arrive and dwell in The Kingdom of Ends in the lives of ordinary human beings. I want to look at a couple of other examples to show how the problem is not confined to holidays but is ubiquitous in life beyond the Kingdom of Means – if only to forestall the objection that not arriving on holiday is difficult only because a holiday is such a big, vague thing to arrive at or in.

Consider, first another climactic moment of the year, but a shorter one: Christmas. Perhaps there are still souls so in tune with the spirit of Christmas that they know when it begins; for example, the moment Midnight Mass starts. For the rest of us, it is not so clear and there is a tendency to pass without pause from the point at which the preparations are complete to the point at which the tidying up afterwards begins – without anything definite in between. Christmas seems to boil down to organising Christmas. The platitude 'But Christmas is for children' does not advance the argument further: I can remember even as a child finding it difficult to feel that that Christmas really had arrived, experiencing a (non-religious) feeling that there was some moment of arrival beyond even that in which the presents were received. As for the presents, the very heart and essence of Christmas, when did they arrive in one's life: when they were handed over? when the outer wrappings had been torn off? when the packaging had been removed? when the components of the toy had been laid out? when the first interrupted go had been completed? when the process of destruction had started? I had a nagging suspicion that there was a Christmas corresponding to idea and expectation that went beyond the objective climaxes of presents and sweets and meals. And I would say over to myself 'this is Christmas morning', trying to sharpen my awareness of this day that had for forty or fifty days,

forty or fifty bedtimes, been the focus of my dreams – rather like Madame Bovary telling herself that she has a lover in order to infuse actuality with ideas and so make it as real as her dreams. (It is no surprise, then, that Christmas is a favourite hunting ground for Camcorder Man – of whom more later.)

Consider human relationships. Are these marked by a difficulty of arrival? Consider this archetypal story. A traveller arrives at the country house after a long and wearying journey. When is his moment of arrival? Is it when the house comes into sight? When he knocks on the door? When he has a drink in his hand and is telling the story of his journey while eyeing the daughter of the house? Is it when he rises the next morning and reports that he slept well and is looking forward to the day's business? Is it when the business begins? When it is completed? When he rides off and the house is at last, despite many backward looks, out of sight? The question has no answer. The nearest he gets to arrival is perhaps that invisible moment when the preoccupation that motivated his journey is replaced, or marginalised, by another: his attraction to the daughter of the house.

She has found the traveller attractive, too, and writes a long letter on perfumed notepaper. He finds a pretext for coming back and there begins a long courtship, a long journey of each towards the other, frustrated by many outward and inward barriers. What is the point at which they arrive at one another? When he returns and they can exchange glances once more? When they embrace and kiss? When they are at last granted permission to marry? Their wedding day? Their wedding night? Here, there is an obvious climax, but it is, after all, their first time and they don't quite get it right. They need to get to know each other better so that this strange experience shall be genuinely a way of being together. Even when they have acquired the necessary expertise in this area, there are still journeys to be undertaken and completed, goings that lie beyond the comings.[3]

As they have been journeying towards one another, a quite different agenda, a different set of journeys, new definitions of arrival, have been emerging. The couple's relationship, objectified in marriage, has started to assume its objective face. There are duties to discharge, often reflected in aspirations to material progress – better flat, own house, better house; his career and her career; and their children – whose childhood is a huge complex of trajectories. The couple's journey towards one another is gradually displaced by the

journey of their marriage. And that journey has only one ending: external separation by death or divorce; or internal separation when each becomes dead to the other, except as an irritant. It is a journey without an arrival.

The impossibility of arrival, then, is not merely a problem associated with holidays – though holidays, lacking the alibi of useful purpose, illustrate it most dramatically – but of life itself. If we look at the three major candidate moments of arrival in life, none passes the test: birth is too obviously the beginning, rather than an end, of a journey; death is equally obviously a journey's end without arrival; and the sexual climax is not too sure where or what it is arriving at: the other person, the fulfilment of one's desires, the cancellation of one's desires, or sleep. Not for nothing is the orgasm described as 'coming'; while **having come** is beyond the climax, beyond arrival. And this is in the absence of the physical and psychological abuses that mark so much of sexuality in the real world. The rapist's destination is even less clear: for him, 'fulfilment's desolate attic' (to use Larkin's phrase) is the starting point of flight.

The problem underlying the difficulty of arrival is universal. It can be observed in every attempt to achieve a goal – large, small or minute. Even when we are not frustrated by external and internal circumstances, by bad luck, chance, incompetence etc. from bringing about what we intend, there is an ineradicable misfit between the specification of our wishes and any possible enactment. This arises from two sources: the field within which we enact our wishes is porous to an infinity of things that is irrelevant to them; and, secondly, we do not know how to specify our goals in anything but the most general way. No prayers are answered because there is nothing in this world that could answer to them. (This is why failure seems rock solid – for the idea, unachieved, remains intact – while success, when it comes, seems elusive.)

The difficulty, symbolised in the journey of the ball to the bat, is perhaps not so much arriving as staying arrived – about arriving at a place or an activity or an event without going past, through or beneath it – so that one feels one really has arrived. Ultimately, it is about the impossibility of **being** as opposed to **becoming** – or, as in the love affair just discussed, of being together as opposed to merely becoming together. The difficulty of arrival seems to be built into the very structure of human experience. It becomes clearly apparent, however, only where experience is sought for its own sake; where

we are concerned not with means to ends, but with ends in themselves. When we dismount from function, when we leave the Kingdom of Means and enter the Kingdom of Ends, we are haunted by a sense of not being quite there; of not being able fully to experience our experiences.

False Solutions

> – To put it in a nutshell, the moment I feel that a time, a place, an attitude of mind or body, indicates recreation as the order of the day – my whole being protests, yawns, flinches . . . I start thinking about my business, my patients, my career, anything but **that**.
>
> – What a waste! Instead of giving yourself over to the useful activity of distraction, relaxation, refreshment . . . and so forth . . . you set about **fabricating the future**, which satisfies no real need; and there we have our disease of activity very well described.[4]

For reasons I shall discuss presently, the problem is not only universally true of, but also insoluble in, ordinary experience. The best – indeed the only – way to cope with an insoluble problem is not to be aware of it. To become like the child who on arrival in Cornwall, after an eight-hour, 350-mile journey, gets absorbed in the transit of a snail across the cottage lawn or counts and re-counts his holiday money or the stones on the path, or becomes fascinated by a hole in the cottage carpet or by the motif on the sugar packet, and so loses himself in that 'nowhere without no' Rilke spoke of in the *Duino Elegies*, unconcerned whether the things he is lost in correspond to or realise any larger idea dictated by expectation and memory.

Such engulfment in the particular, down amongst the qualia, like a dunnock among the hedgerows, is, however charming, difficult to envy without reservation. Beyond quite a young age, we become attached to larger mental structures, to the *a priori* and *a posteriori* essences that we conjure in our dreams and memories. We are unlikely to welcome the suggestion that the point of arrival might be to forget what you arrived for. Leaving aside the fact that a Cornish snail is no different from the ones available in the back garden at home, it has to be questioned whether you can fully achieve holidaymaking by falling between the meshes of all ideas associated

with holidays and so losing sight of the holiday. This approach may, of course, be acceptable if, having known nothing else, you enjoy the unformatted life of a child and its boundless, even if not infinite, future. Otherwise you cannot but mourn the vision lost in engulfment, just as you mourn lost Cornwall even as the sea, its essence, closes over you, and the sound of the beach and the sight of the cliffs is lost in water that could be any water.

The child's 'solution' is therefore not available to the adult. Some avoid the difficulty altogether by refusing to take holidays seriously, like the surgeon in the passage quoted above. Others use holidays 'to catch up' – to sort out the garden, to read all the back issues of professional journals, to catalogue the butterfly collection. For those brave enough to take genuine holidays, some form of escape from the sense of incompleted arrival is necessary. I shall discuss two such escapes – or attempted escapes – chosen because they seem to me to cast a particularly bright light on the difficulty at the heart of the difficulty of arrival.

The first is that adopted by Camcorder Man (henceforth CM – it usually **is** a man who holds the Camcorder for all sorts of reasons – the most obvious being that the woman is holding the baby or the fort), who devotes most of his holiday to recording what he cannot experience, in the deluded belief that when he plays back his video tape the experience will happen. CM turns over experience to the capturing of images of experience and to the creation of 'memories': he is concerned less with experience than with future transmission of experience. CM is thereby relieved of the requirement to get lost in the view. His immediate task is to identify the most favourable angle from which to shoot. Like his predecessor, the still photographer, when he looks, he looks through his hands framing the shot. He looks not in order to see but to decide whether or not to record what he is seeing. The relevant consciousness, the experience, can come later.

But there lies the problem. For the 'later' in which the fresh-frozen experiences are to be consumed may never come. When will the filmed memories be remembered? When will CM play over his videos? If the time wasn't right to look at the view when he was on holiday – with its privileged leisure and freedom – when will it be right to look at the recording of it? Is it not possible that such a time will never come and all those hours of film will remain as unlooked at as the view they record? Once his holiday is over, CM will always be too tired, or interrupted, or preoccupied. CM's solution doesn't

work because he is not solving the difficulty of arrival, only postponing addressing it, to an even less propitious time – when he is in the midst of other things. If you can't experience the holiday experiences on holiday, you can't experience them at all.

Even if CM does find time to defrost his fresh-frozen experiences, won't he discover that they make the same incompatible demands on him as ordinary experience-for-its-own-sake does: to immerse himself in the particulars while not losing sight of the idea? Of course they will. So there is only one way out. And this is what has made CM and his lower-tech predecessors so notorious, indeed a species to be abhorred and one whose dinner invitations are to be rejected at whatever cost of ingenious dishonesty. For CM will try to offload on to others the responsibility for experiencing what he merely passed through. Or to get them to collaborate with him to produce the experience. He was at a very special place (Piccadilly Circus, say, or the Taj Mahal) and somehow cannot quite believe it, grasp it, experience it. Now the specialness of the moment – its recovery as an idea – is to be achieved indirectly through the astonishment of friends who stayed back home. CM has proof to others that he was there; from which it follows that he really **was** there. The cost of recording that he was there – being busy with camera angles and hold-it smiles, and preoccupied with the treachery of technology that always threatens to let him down at the last moment and all the fiddle necessary to call back the straying tresses of the moment – is the destruction of the last shred of the experience of being there. But this, he believes, will be justified by (and hidden in) the perfection of the experience, its transformation into publicly visible reality. He was really there – and so had the experience of being there then – because his friends can now see him being there.

Alas, this does not work because the friends CM has trapped into sitting through his plotless *cinema verité* always say the wrong thing, want to talk about something else, or fall asleep and refuse later invitations to dinner with an ingenuity that takes his breath away. The postponed, transferred experience never comes and he is no more really there later on than he was at the time.[5]

There is an alternative way out for the adult faced with an inability to experience what he has journeyed in order to experience. This is to replicate on holidays the busyness and seriousness of working life. The holiday is turned over to semi-serious tasks – I have cited catching up on the gardening or cataloguing the butterfly

collection – or to non-serious tasks approached in the spirit of seriousness. Consider the father on the beach persuaded by the children to lay aside his newspaper to help build a sand castle. In a very short time, he is organising them, directing that one to do this, urging this one not to slacken etc. And he will continue, disgruntled at the children's infidelity to the task, long after they have tired of castle building, frantically digging ever deeper moats, adding yet more turrets, sculpting steps and boring tunnels with unyielding concentration. Two hours, three hours, pass. The result is a masterpiece. But in an hour or so the tide will come in. The castle will deliquesce to amorphous sand and nothing will remain of his work. What more striking model of futile busyness could one hope for in human life – a process of building that long outlived the children's interest (though this will revive as the waves start to encroach on the walls), whose product does not last longer than the time it took to construct? And yet the process has served its purpose: it has relieved the builder of the burden of trying to be in an arrived state, of experiencing the experience for which he has come. The castle is a pretext for another journey – a journey towards its own completion; so never mind that the sea or the beach rake will cancel it almost as soon as it is completed.

The 'taskiness' of ordinary working life can be incorporated more systematically into holidaymaking. At least part of each day can be devoted to some scheduled activity; or the holiday itself may take the form of a trek or a tour. The difficulty of arrival is then circumvented by ensuring that journeying never stops, that the holiday is about arriving, yes, but not about being and staying arrived. On the trek – for example, walking the Pennine Way – each day has a target, a job to be done, work to be completed, for which the reward is a hot bath, a cold pint and a sound sleep. The holiday is a story of cumulative achievement. The car tour includes that element as well – miles on the clock, miles towards tea, towns ticked off, countries visited – but is even more safe from the demand to experience. Places are 'done': they become the accusatives of tasks rather than the objects of experience. We sit in the square at Bruges with a glass of Stella before us, not looking but planning, road maps on the table, assessing the scale of tomorrow's challenge – the journey to Cologne – our talk full of sensible ideas about how to avoid traffic jams. Like the bikers in Thom Gunn's poem, who are 'always nearer by not keeping still', tourists arrive by perpetual travelling. At the other end of the spectrum, there is the terrible

ordeal of the orienteering holiday at the end of which there is something called 'satisfaction' or something else called 'achievement'. The prize doesn't justify the hunt; but, as Pascal also pointed out, that is to miss the point, as it is the chase and not the quarry that people pursue.

Finally, the holiday may be subordinated to some entirely objective purpose: adding to one's expertise (becoming an authority on Cornish castles); picking up a sexual partner; reading the books one would never be able to tackle in the busyness of everyday life. Dedicating the holiday to some external purpose misses the point of it – or at least, the point as seen from the point of view that is being developed here. Moreover, all of these projects are themselves open-ended, arrival-less. They do not address the problem of holidays at the level at which it may be experienced: the business – or anti-business – of dismounting from labour and the Kingdom of Means and entering the Kingdom of Ends and experience. They do not, that is, address what it is that lies underneath the difficulty of arrival: the flaw in the present tense of human consciousness. A more radical solution is called for. But this requires a deeper understanding of the problem.

Diagnosis

In order to pursue the claim that the difficulty of arrival is rooted in a fundamental flaw in human consciousness, I shall enter upon what may seem like a digression, though it will bring us close to the heart of the matter. We shall arrive, that is to say, by stealth. I want to consider Kierkegaard's problem – or category – of **repetition**.[6]

The difficulty of arrival is considerably exacerbated – perhaps only fully experienced – after the first, the unforgettable, the founding, holiday. In subsequent holidays, arrival doubles up as return and experience has the role of confirming memories, of securing repetition. With successive returns, we find ourselves rather like those who go to the great art galleries not so much to see great paintings as to check out, or be in the presence of, the originals of the reproductions they know so well. Since the postcards came first, the paintings have a third order, rather than first order, status: existing in relation to the second-order postcards, they are effectively reproductions of the reproductions. In the case of holiday re-visits, it is postcards of the mind we are chasing, mental images that have been elaborated by reminiscence, assisted by all

sorts of memorabilia such as real postcards. The postcards of the mind are even less easy-going than the anticipations based on words and images.

The pursuit of the past is further frustrated because those who are pursuing it have themselves changed. The child who was transfixed by a lugworm cast or waited impatiently for the Piskie Gift Shop to open has given way to the reader of books on World War II and to the maker of model aeroplanes. The crying infant who had continually to be placated over a six-hour journey now surfaces from a book from time to time to make a caustic comment on the fact that we are exceeding the speed limit. (Indeed, the journey seems too easy; the frictionless passage down the M5 – in a more reliable car than ten years ago – is hardly journeying at all compared with the heroic ordeals of the past, and this is another reason for attenuation of the sense of arrival.) The changing structure of our children's consciousness has altered our own. And we ourselves have different hopes and hungers. Plans have been fulfilled or long since definitively dashed. We are coming to Cornwall from different places in our lives.

And this is one reason why it is difficult to visit the same place twice. Even moments of pure repetition do not repeat. Consider the doze on the beach. How much remains unchanged: the feel of the sun on face, the sound of the sea, the near and distant shouts of children and the cries of babies, the rhythmic thud of mallets adding up to an arrhythmic chorus, the snap of towels in the wind, the transmission of footfalls through the sand. This, surely, is return: recurrence of absolutely the same sensations. It is not; for the sensations have different contexts. Different human voices wake you and you drown in a different sea. Whether it is the Cornwall of one's children's infancy or (as with Kierkegaard) the Berlin of one's student days, the way back to the past is blocked by inner obstacles. The avenues and trees may be as fugitive as the years, as Proust sighs, but their departure is hastened by the inner fugitiveness of the avenue-bibber and the tree-sipper.[7]

So much is obvious and it is one reason people shrink from going back to a place where they have been happy. Or they choose to go back only in spirit: sifting through the inner and outer memorabilia – the hour of reminiscence, the evening with the photograph album. This, however, is unsatisfactory: the imaginary visit is fragmented and frail, vulnerable to the slightest interruption from the front door or the telephone, liable at any moment to dissolve in the ordinary

tiredness of a Wednesday evening. So people do, after all, weaken and go back literally to the place where their holidays' memories point. And the delight of anticipated re-discovery is striated with a certain tension that things will not be the same. The place may, of course, have changed physically: the beach hut may have been replaced by a multi-storey leisure complex. But empirical clash between observed and remembered fact is merely accidental and, in a sense, beside the point.[8]

A more pertinent and poignant tension comes from a deeper conflict between the idea of the past and the reality that actually corresponds to it, so that we journey towards **ideas** of experience that no experience can realise. Ideas differ from any possible experience in two rather fundamental ways.

The first is that sense experience is so much more **detailed**; it is baggy, obese with contingencies. My conception of the game of cricket on the beach did not include any of the very particular items of which it is composed – that particular shot, that seagull flying overhead, that thin man shouting to his wife. The beach hasn't suffered structural change but our memories did not include this particular sunlight, that woman in a green skirt walking that yappy dog, that kite straining on its string, this particular sensation of the little one tugging on my hand or this particular fullness in my stomach. Compared with actuality, even the most detailed memories are sketchy, incomplete, catching only what we are now pleased to think of as the essence. The place we revisit in pursuit of re-experience of our memories is freighted with contingent details, none of them necessarily at odds with the specification, but none of them part of the memory either. Secondly, the idea is given all at once in an instant of anticipation or recall, while the experience unfolds over time. The idea has a clear **form** which the experience lacks. That is why experience is riven by a sense of insufficiency, why we feel that we are not quite experiencing it. Hence the difficulty of arrival which, we discovered, is not accidental or incidental but quite systematic and essential. The sense that, once everything is in place and the things that blow us off course are dealt with, we shall arrive is misleading.

The essential difficulty of return is due to the unsatisfactory relationship between ideas and experiences. We can't return because we cannot visit an idea or revisit an experience that has become an idea: the experience of reality has as its context more reality; whereas the idea has as its context mental images transilluminated with loss,

nostalgia, longing. And so we move near to the heart of the problem – a problem reaching to the heart of us, to the heart of consciousness – which, according to Kierkegaard, is that of the 'relation of opposition between actuality and ideality, an opposition discovered through repetition'. For, although we have been talking about the impossibility of **return**, the intention has been to cast light on the impossibility of arriving in the first place. Finding it impossible to **be there again** – in the fullest sense we should like to be – is an aspect of the impossibility of **being there at all**. If we strip away accidents of external and internal change, we see our inability to return to a place for what it truly is: a manifestion of our inability fully to come to that – or any – place even for the first time. For in order really to come to a place, to enjoy the sense of having fully arrived there, whether it is a first visit or a re-visit, it is necessary to resolve what is in fact an unresolvable tension between experience and idea – either between current experience and experience that began as an idea (anticipation, preconception), as in the case of first-time arrival, or between current experience and experience that has grown into an idea (memory). Even though when we arrive for the first time we are not apparently revisiting or trying to recapture a place, our difficulty is very similar to that of achieving repetition. For we bring to our destination an idea seeking confirmation, embodiment or fulfilment, expectations based on what we know, or know of, the place we are coming to. And so **all** our arrivals are like returns, a search for the equivalent in our senses, in what we actually experience, of our conceptions – in the case of the first visit **pre**-conceptions. Every visit, therefore, even the first, is a re-visit.

The difficulty of any arrival is that of achieving a present moment in which the idea and the experience, our knowledge and the data of our senses, are one, are co-conformable, so that we know what we experience and our experience conforms to our knowledge. The failure of experience to correspond to idea, to satisfy it, is not merely a question (as it is so often presented) of the real **falling short** of the ideal. On the contrary, as I have emphasised, reality often exceeds ideality, at least in the sense of being more detailed, more complex and more richly unpredictable. It is not merely a matter of a conflict between romantic ideal and drab reality but between a purified, mind-portable version of reality and reality itself.[10]

The impossibility of repetition confirms, if any further confirmation were necessary, that the difficulty of arrival is not a problem uniquely to do with holidays. Nor is it merely accidental, to be

solved by a better organised, better-funded package. It is about the ends and aims of life beyond the Kingdom of Means, about fulfilment beyond the tasks of survival, about consciousness beyond work and responsibility and unchosen distraction. If it is particularly apparent on holidays, this is because, for a uniquely sustained period of time, we are concerned solely with having experience for experience's sake, not for the sake of some useful purpose: we travel to a place in order to experience rather than to be busy and to achieve; we look for the sake of seeing rather than in order to obtain information. Under such privileged circumstances, the difficulty of **being fully there** – which is what the systematic elusiveness of arrival is all about – the difficulty of apprehending the present moment, becomes uniquely apparent. It is then that the mind feels like a fist that has lost sensation but has lost none of its power: though it can grip, it feels as if it has lost its grip.

The difficulty of being fully there – or of achieving the feeling that one is fully there – derives from the fact that the requirements for being fully there are incompatible with one another. You are fully there when the idea and the experience, the preconception and the actuality, coincide; under such circumstances you not only experience, you know **that** you are experiencing, know **what** you are experiencing. This requires that you should simultaneously be immersed, indeed engulfed, in experience and yet at the same time be above it in the sense of not having lost sight of what, in general terms, the experience is and how it relates to other experiences. To achieve arrival, immersion in content should not extinguish the sense of overall form.

And so you must take the beach game, with all its attendant sensations, seriously and focus on the return shot without allowing the characteristically Cornish cliffs to be blotted out. The ice cream should not occlude the valerian, even when it has been dropped. The tanned legs of the girl lying face forward on the sand should not attenuate your sense of the Cornwall of storms, wreckers, smugglers and of the holidays of the past ten years. In other words, you should be able to see Cornwall whole, retain it as an idea, while you are still committed to the individual experience that may or may not be encompassed within the idea and will certainly not be soluble in it without remainder.

Trying to arrive, in the sense that is emerging here, is like trying to dissolve into an idea, trying to be immersed in an idea as if it were a sensory field. Such dissolution is impossible, not only because the

idea in question is extremely complex. (It is extremely complex. It includes ice creams consumed under certain circumstances, the sound of the sea, tamarisk, beer in the open air, the feeling of the breeze on your bared legs, cold wet suits, and long uninterrupted conversations. But it is not infinitely hospitable. For example, it probably excludes visits to the cinema, arguments between adults, and more than a certain amount of tarmac or Monopoly.) Such dissolution is impossible also because, for reasons already given, consciousness cannot dissolve into one of its own conceptions, howsoever generous the tolerance built into its specification. The conditions of arrival cannot therefore be met; which is why holidays – a time when one cannot plead being too busy to experience one's experiences – may sometimes seem to make almost oppressive demands on us, even (or especially) when the paradise one has paid for corresponds to the brochure with neo-realist precision.

So what is at stake is the whole problem of **being there** in an absolutely complete or satisfactory sense. The difficulty of arrival is a revealing symptom of the flaw in the heart of the present tense, in the heart of consciousness. This was what Proust engaged with so massively in *Remembrance of Things Past*: *'l'imperfection incurable dans l'essence même du present'* ('the incurable imperfection in the very essence of the present moment'). Nothing in adult experience corresponds to the childhood world of imagination opened up by words, above all by reading – the world of names. Nothing in Venice realises 'Venice'; no actual bearer of the title could embody the refinement of spirit uttered in the title 'Duc de Guermantes'; no loved one could be equal to the intentional object into which he or she has been transformed by the lover's imagination. ('Wine', as Flaubert said, 'has a taste unknown to those who drink it': the taste of wine drowns the idea of it.)

'Pleasure' Keats says in *Fancy*, a perceptive minor poem, 'never is at home':

> At a sweet touch Pleasure melteth,
> Like to bubbles when rain pelteth. . .
> Summer's joys are spoilt by use,
> And the enjoying of the Spring
> Fades as does its blossoming;
> Autumn's red-lipped fruitage too,
> Blushing through the mist and dew,
> Cloys with tasting. . .

And he recommends that we should foreswear experience and 'let winged fancy wander /Through the thought still spread beyond her: /Open wide the mind's cage-door . . . ' and enjoy in the depths of winter the **notion** of Summer, of Spring and of Autumn. In short, recover at the level of the idea, of possible experience, what is not available in, or rapidly fades, in experience itself.[11]

That this carries with it the potential for decline into decadence and sterility is explored by Huysmans in *A Rebours*, and in the character and preoccupations of its repulsive hero Des Esseintes, whose mind 'has reached the October of its sensations'. He has lost all joy in experience and inhabits a sealed castle of ideas. He visits England by going to the English pub at the Gard du Nord to savour the connotations of England, he makes scents stand for the variousness of the world (smell being the sensory modality of pure connotation) and he attempts to revive his flagging sexual pleasure by mediating his sexual experiences through those of an innocent youth he corrupts. Only a raging toothache and his delight at relief from this can deliver him temporarily from the sterile castle of his ideas.

For Proust, salvation for a consciousness lost in the uncombed variousness of experience (itself muted by the anaesthetic of habit necessary for practical survival) lay in recovering what had been lost of anticipation in a very special form of recollection: involuntary memory. Involuntary memory does not, like voluntary memory, merely retrieve localised, third-person facts, but excavates entire first-person worlds. The impressions that trigger such memories are simultaneously experienced in the present while being placed in the context of a distant past ; the past encroaches on the present and the moment is thus lifted out of time. The individual who enjoys, indeed is possessed by, accesses of involuntary memory partakes of their extra-temporal nature. He is lifted out of time and so experiences what he truly is, not a mere succession of moments but a self extended across time, deposited in time through the temporalising activity of his own consciousness. For Proust, very pertinently to our present concerns, the impression unites the idea and the experience:

> So often, in the course of my life, reality had disappointed me because at the instant when my senses perceived it, my imagination, which was the only organ that I possessed for the enjoyment of beauty, could not apply itself to it, in virtue of that

ineluctable law which ordains that we can only imagine what is absent. And now, suddenly, the effect of this harsh law had been neutralised, temporarily annulled, by a marvellous expedient of nature which had caused a sensation . . . to be mirrored at one and the same time in the past, so that my imagination was permitted to savour it, and in the present, where the actual shock to my senses..had added to the dreams of the imagination the concept of 'existence' which they usually lack, and through this subterfuge had made it possible for my being to secure, to isolate, to immobilise – for a moment brief as a flash of lightning – what normally it never apprehends: a fragment of time in a pure state.[12]

Involuntary memory, triggered by a sensation that rhymes with a past experience, unites the actuality of experience with the ideality of a mode of anticipation and of recollection not reduced 'by preserving of them only what is suitable for the utilitarian, narrowly human purpose for which it intends them'. The synoptic sense of the (idealised) past rooted in a present physical experience – a taste, a sound, a smell – realises the Kierkegaardian ideal of repetition: 'living in eternity, yet hearing the hall clock strike' (*Repetition*, p. xiv).

Proust's preoccupation was not, of course, unique. For many continental philosophers, the elusiveness of the present moment, of the moment of arrival – when experience corresponds to the idea of it, when we feel as if we really are **here** – is a consequence of the nature of time itself and of the temporalising – as well as temporalised – nature of consciousness which denies it complete self-possession. The flawed present tense of the self is like music: it inheres in hastening away from itself though in music this hastening away is also hastening towards – as we shall discuss presently. Anticipation and recollection seem to have an ideality denied to the present; but they, too, are flawed, though the flaw is a different one: they lack the quality of 'existence', of actualness, of a completed 'thisness'.

In our daily lives, then, we are 'never quite there'. In the present, we elude ourselves and the world eludes the grasp of a fully self-possessed experience. This inability fully to be there has haunted philosophers from Heraclitus onwards. Our being is becoming: the self subsists in moving away from itself. Man, according to Kierkegaard (in *Either/Or*), 'does not have a stable existence at all, but he hurries in a perpetual vanishing'. Without the category of repetition 'all life dissolves into an empty, meaningless noise'

(*Repetition*, p. 149). Repetition is both the 'interest' of metaphysics and 'also the interest upon which metaphysics comes to grief' – a theme that has preoccupied existentialist philosophers. Most notably and most eloquently among them, Sartre dwelt brilliantly (especially in *Being and Nothingness* and in *Nausea*) on the non-coincidence of consciousness with itself, on the systematic elusiveness of the I, and on the related non-coincidence of the (universal) word with the (particular, actual) thing. And this feeling that we somehow elude ourselves is reflected too in this passage from the *Duino Elegies*:

> For we, when we feel, evaporate; oh, we
> breathe ourselves out and away; from ember to ember
> yielding a fainter scent.[13]

ART AS A SOLUTION

> The creation of art is the only metaphysical activity to which life still obliges us.
>
> (Nietzsche)

The Problem Summarised

From a consideration of the difficulty of arrival, I arrived at the notion that there is a tension between two functions or dimensions of human consciousness: between more-or-less sensory experience and more-or-less abstract knowledge; between moments that pause on the edge of a dancing chaos of contingencies, and the larger projects and ideas, the forms and structures, we pursue through, or attempt to realise in, those moments. The impossibility of repetition and the difficulty of arrival are both aspects of the failure of actual, physical experience fully to correspond to the ideas presented in knowledge and mediated through anticipation and memory. We cannot realise even our realised plans, because no moment can conform purely to the idea, to the general form, of itself projected in those plans. At the time when we have the experience, the larger structure, the larger form, of which it is a part – or to which it might be related – is concealed from us, whatever we might see in retrospect or imagine in prospect. The present moment lacks that

transparent relation to such structures necessary to afford a sense of where we are, a sense that we are **here**, that goes beyond mere orientation and ordinary, often slightly stale, recognition.

Experience, then, is undermined by the general ideas it fails fully to instantiate. Anticipation (fed not only by past experience but by knowledge derived from others' reports on their experiences, from what we have read and heard) and memory are twin critiques of the present tense of experience. There is consequently an incurable wound in that tense – the only tense that human consciousness really has. The difficulty of arrival is the difficulty of **being** – according to a specification in which knowledge and experience, abstract, general understanding and an intense sense of the particular, *quidditas* and *haeccitas*, are united. The requirement to arrive in this way, to be completed in this fashion, is close to the religious demand for 'mindfulness' and the mystic's search for an absolute self-remembering in which knowledge coincides with existence, the material, particular self is transparent with knowledge, and knowledge is solid with material presence.

It is evident that opposition between ideality and actuality cannot be resolved by camcorders postponing the moment of experience, nor by turning the Kingdom of Ends into a place where a series of tasks is to be completed. The thesis I shall advance here – tentatively and with a good deal of qualification and even unease – is that resolving this opposition is a – possibly **the** – function of art. That at least in the secular West, at the present time, it falls to art to address the wound in the present tense, and to dress it and perhaps for a while to heal it. Art is about achieving arrival and arresting, however momentarily, becoming to being. A fundamental impulse of the artist (and the delight afforded by art) is rooted in the need to satisfy, if only intermittently, the hunger to **be** entirely where one **is**, so that subjective reality and objective situation coincide, and experiences are fully experienced. Art helps us to be more solidly **there** than even anticipation imagined we would be; more **in** the present moment even than we might remember ourselves as being when, in an old-age pruned by loss, we wake on a dark cold 4 a.m. and remember the sunny days by the sea with the children who have now grown up and left us.

I shall deal with objections to my thesis in some detail later, but it would be as well to say at once that I recognise the stupidity of subordinating something as complex and profound and various as art to a single task – howsoever 'metaphysical' that task may be. It

would be both arrogant and vulnerable to suggest that I have identified the sole purpose of art or to state categorically that even in a secular society only art serves this purpose. A more modest, and appropriate, assessment of my thesis is that it is an attempt to answer the question, what kind of function art might have, given that it serves no practical and moral purpose and that the notions of inner enrichment and of the educational value of art are highly suspect. My thesis, in short, is an attempt to indicate the kind of things that art might do on the far side of use and why use is irrelevant to, or only incidental to, art.

Irrespective of whether the function I have assigned to art is its only function, I believe it to be a central one.

Art, Form and 'the Moving Unmoved'

How does art address the wound in the present tense? How does it reconcile the sensory and intellectual dimensions of consciousness, the particular experience of what is there with the general idea of what might be there, our abstract notions with our concrete sensations? To understand how art unites these adversaries, it is necessary to invoke the general concept of **form**.

To describe this concept as 'complex' would be a spectacular understatement. For, like art itself, 'form' is an intricate nexus of notions. Moreover it has evolved through history but, for a variety of reasons, among them the unsurpassed genius of those who first thought about form, it has retained its earliest meanings alongside more recent ones. 'Form' for this reason would not unfairly be described as, semantically, a coral reef. The complexity of the term is compounded by its being used as a battle cry or, conversely, a jibe in aesthetic and other disputes. It permeates not only aesthetic but also metaphysical, psychological, scientific, sociological, mathematical and other discourses. The term, in short, has a seemingly limitless plasticity: a semantic polyp, perhaps, rather than a coral reef.

It is important, therefore, to keep things simple and focus on the core idea of form as **the shape of a thing**. In the case of works of art which are composite and multiple, 'shape' refers less to the outline than to the 'inner shape' or **arrangement of parts**.[14] The arrangement is an orderly (or calculatedly disorderly) one: form in art is largely about (even in rebellion against) 'due shape, proper figure'; the form conforms to – or, more recently, refers to, plays with, undermines – a model, type or conventional pattern.

The Difficulty of Arrival

This doesn't say very much about how artistic form differs from forms encountered outside of art or, within art, about the difference between the great and the mediocre. It is easy to speak of idealised, geometrical forms in the visual arts; of the surface forms of literature – rhyme, rhythm, narrative line, etc.; of the tonic and the dominant in music. But this will not demarcate good artistic forms from less good ones and might suggest that art could be created according to a recipe. Moreover, any specification of form that was common to all arts at all times would be very abstract indeed: the highest common factor would be a very low one. Besides, there are aspects of form in individual works of art that seem to go beyond all specifiable features; that are, in other words, uniquely realised in, uniquely expressed in, the work itself. There is a sense in which every great work of art is **sui generis**.

This should signal the limitations of the theory that follows, though I will try to address some of them in due course. For the purpose of present discussion, however, one feature seems to be crucial. We may think of form in art as that by virtue of which things otherwise experienced or considered separately are brought together as one: that **unity in variety** which conveys the sense of sameness in difference. We may look beneath this to a sense of **stillness underneath change**, and to the Aristotelian idea of form as the **moving unmoved**.

Let us then run with the key notion of form as the agent by which unity is achieved across variety, a unifying order, a principle of coherence. If we think of the difficulty of arrival as the failure to obtain experiences that correspond to ideas that are at once larger and lighter than them, then art would address this problem by providing such experiences. By bringing together things that are separate in space and/or time, without sacrificing their separateness, the work of art embodies the large notions that otherwise elude us and makes them experienceable; or, to put it another way, affords us experiences that are transparent with ideas. How is this unity-in-variety achieved?

Consider symmetry.[15] This unites all the things that lie on either side of a plane of cleavage, howsoever heterogeneous they may be among themselves, through a one-to-one relationship with the elements on the other side: even if the elements on each side do not belong with one another, their contribution to the matching halves unites them. Or think of a set of musical variations: there is change or variation but the variants are united by the invariant that is

necessary for them to count as variations.[16] Or metaphor – defined by Aristotle in the *Poetics* as 'the intuitive perception of similarity in dissimilarity' – which unites two partially similar objects and so overcomes that within them which is dissimilar: it is therefore a way of poetically discovering in or imposing upon the variety of the world a greater oneness. (A good metaphor is both an image and an idea; as Arnold said in 'The Study of Poetry', it is in poetry that 'thought and art are one'.) Or certain recurrent or persisting features – rhyming sounds and rhythm in poetry and music, or motifs in literature, the visual arts and music – which assert that things have not changed, despite the changes that have taken place. Or the cyclical form of a piece of music that modulates from the Tonic to the Dominant key and then back to the Tonic key: there is no 'net' progress; rather stasis in change.

The common function or effect of these formal features that unify across variety is to integrate experiences that would otherwise be separate. Incongruous and disparate things may be brought together: outrageous couplings, dissonant discourses, disjunct objects; all the nears and fars of the world; booty from the four corners of the empire of experience. This permits an experience arising out of the work that expands into and fills the lineaments of something larger than experience; something, in short, like the ideas that we hope to experience when we seek out experience for its own sake. A work of art is a concretely realised idea – an idea as large as those that haunt our consciousness through anticipation and memory; larger than those that are realised in ordinary experience and which, as we noted, often undermine or devalue ordinary experience. The fundamental tendency of art is to extend the 'mindful' through form, through an arrangement of parts, which enables many to be presented through the one, unity to be found in, or imposed upon, variety.

The formal structure integrates over time in music, over space in the visual arts (though we seem to unpack space from music and we experience paintings and sculptures in time), and over multi-dimensional hyperspace in referential, non-iconic forms such as literature. In non-referential arts such as music and abstract painting, it is the actual sensory experiences – sounds, colours – that are integrated, while in the case of referential arts such as literature and representational painting, the elements that are integrated are not there *in propria persona* but by proxy, as referents. The distinction is not sharp; poetry, for example, may

work at the level of word-sounds (actual sensory experiences) as well as at the level of word-meaning, and integration takes place at both levels.

The means by which integration through form is achieved vary enormously across the arts: in music, rhythm and interval, melody and harmony, constituted by the relationship between notes, between chords, between variations, between movements; in visual art, the pattern of shape and colour, symmetry and contrast, repetition and variation; in verse, metre and rhyme and the ordering of referents; in fiction, the ordering of events, the structure of plot and theme, recurrence and repetition and contrast. The common feature is that temporally and/or spatially and/or conceptually disparate things are gathered into a unity: the many becomes one, without losing its character of multiplicity; change becomes stasis; movement is unmoving.[17]

How does this solve, or at least palliate, the difficulty of arrival? It is perhaps easiest to understanding this in the most obviously formal of all the arts – music, an only weakly referential art whose ordering of parts is not significantly determined by an external (extra-musical) reality. Think of the relationship between idea – or form – and sensation in the experience of a melody. Each note is fully present as an actual physical event and yet, because the music conforms to a form that shapes expectation and assists recall – through conformity to the rules of harmony, of contrast and symmetry, of progression and repetition – the note is manifestly and explicitly part of a larger whole. There is no conflict therefore between the form or idea of the music and its actual instants. Our moments of listening are imbued with a sense of what is to come and what has passed. The form to which the music conforms – that ties what has gone and what is to come with each other and with what is present – shines through its individual moments.

The continuous genesis and satisfaction of expectancy in the listener is based in part on previous experience of instances of the form to which the work belongs and in part on previous experience of the piece itself. In the case of 'difficult' music, where forms may emerge over longer stretches of sound and the standard expectations will be defeated in order to be satisfied in different ways, expectancy may have to be 'trained' by previous exposure – to the style or genre of the music and, probably, to the piece itself. Several listenings may be necessary before, say, the succession of notes in a piano sonata persuades us of its absolute rightness and of

the validity and reality of the sound world it seems to catch up or show forth. It takes time, that is, for us to see, to experience, the pattern in the music; repeated listening is necessary for this to acquire an *a posteriori* inevitability. (Repetition in art, as opposed to life, can be based on the certainty that the same elements will be served up in the same temporal or spatial order – though the recipient is free to choose otherwise.) Once the pattern has been recognised, all of it exists at once, even though it is gradually being realised in time, so that from the first note we are arrived and stay arrived. There is both movement and stasis; in quasi-Aristotelean terms, the unfolding sound realises form as the 'moving unmoved' (or 'the unmoving moved'). The difficulty of arrival, for a consciousness that in ordinary life seems to move past or through its goals even as it reaches them – so that it does not somehow realise them even when it achieves them – is thus overcome.

Of course, the music has its journeys – it manifestly is a journey from a beginning to an end – and in great music we feel as if we have travelled great distances to and through a remote *paysage* of sound. But the journeying is never merely a piece of *en route*: the unfolding of the form fills and fulfils the sensation of the present moment with the past and the future, rather than undermining it with the past and the future. Each moment requires every other moment, for the reason that will be clear from Yehudi Menuhin's description:

> Music creates order out of chaos; for rhythm imposes unanimity upon the diversity; melody imposes continuity upon the disjointed; and harmony imposes compatibility on the incongruous.

The leitmotif, recurring throughout the music like an involuntary memory, ties together the beginning, the middle and the end, making it all one. The retrospective light it casts on all that has gone before creates the feeling that we have been arriving all the time and that, indeed, we are arrived.

When the music '. . . is heard so deeply /That it is not heard at all, but you are the music /While the music lasts . . .'[18] we are completed in an experience that is truly experienced. We are here and at the same time **know** that we are here, and the knowing does not undermine the experiencing by creating and serving a hunger beyond experience that attenuates, distracts from, even obliterates it. So although music, too, has its journeys, its continuous aways and

towardses, these are not separate from arrival, or parasitic upon some alibi of arrival: a fever of fulfilment is maintained even as fulfilment is laboured towards. We listen to music not in order to get to the end of it; or we recognise that to do so, – say, to sit through a symphony, to listen through or past it merely in order to find out what happens in the end, or who wrote it – is a perversion of the musical experience. We want to see the form build up not merely in order to satisfy our curiosity as to what it is going to be, so that the present moment is something to be got through, but to undergo the experience of the form building up. The building-up of form and the physical experience of each stage do not undermine one another. The destination of the music does not erode the present experience: journeying is standing arrival; form and content are one, the latter transilluminated by and evident in the other; becoming, conforming to its own form, is arrested to being. Meaning is at once completed and in process; unfolding and unfolded.

Music is a perfected journeying which is continuous arrival. That is why, although it is so clearly intrinsically temporalised, it is a liberation from time: it has the hurry of time, but in it the away and the towards of time are united. And that is why, also, there are moments when, listening to it, we have the sense of enjoying our own consciousness in italics: like a hurrying river dilating into a lagoon, our becoming has dilated into being.[19]

Aesthetic and Ordinary Experience

The extent to which the identification, enjoyment and appreciation of the formal properties of art is innate, a universal of human consciousness, as opposed to being conventional, taught, and culture-relative is disputed. *Gestalt* psychologists attempted, in postulating 'Laws of Good Form', to relate aesthetic principles to the fundamental properties of the human mind and, indeed, to identify an aesthetic element at the heart of perception itself. The expectancy that enables us to complete an object that is only partly visible or to anticipate the next step in a series of sounds is informed by a sense of 'Good Form' and 'Good Continuation'.

Perhaps consciousness is instinctively aestheticising at this very basic level, so that it is a sense of form that separates ordinary, meaning-filled experience from a 'blooming, buzzing confusion' of sensation, and ordinary reflection and thought from a delirium of memories and ideas. Certainly it seems that a form-finding (or form-

imposing) and unifying tendency in consciousness is necessary to transform a series of sensations drawn from different senses into the perception of an object, and to bring together the successive deliverances of different senses into an experience of a world: the production and perception of form lies at the heart of the intelligibility of the sensible world. We recognise objects through certain general or formal features; and by the same means, larger spatial and temporal arrangements are identified, or extracted, from the flux. To see, as Goethe said, is to theorise. Without such a faculty or propensity in ordinary consciousness, it is difficult to see how art could be either produced or enjoyed.

Acknowledgement of the aesthetic element in ordinary consciousness generates problems, however. If we accept the Gestalt psychologists' idea that a sense of Good Form lies at the root of the expectancy, shaped by the past, that explicitly links the present with the future, and is essential to our completion of inescapably partial experience into a complete world, then we might be at a loss to say what is special about the aesthetic sense we associate with the production and reception of art. Why do we need art and how is art demarcated from other aspects of human life? We could put this question another way. If ordinary sense experience is rich in forms, if every moment of perception presupposes the construction and/or identification of general and universal forms, if we recognise the contents of the world as instances of general types, in what way is experience deficient?

The unsatisfactoriness of daily experience is not due to a deficiency of forms. On the contrary, the moments are abuzz with an **excess** of forms. Think of ordinary conversation, which is composed of forms: of individual words that realise formal structures at both the level of sound and of meaning; of sentences, which are highly ordered and obey complex structural rules; and of larger orderings beyond the word and the sentence. Even the simplest anecdote has a beginning, a middle and an end. Why, then, do we need specifically artistic forms? Forms encountered in or extracted from or synthesised by ordinary daily experience are transient, or nascent, and on a small scale. They compete with one another and so cancel each other out, like a multiplicity of signals adding up to noise, or several perfect waves summating to mere turbulence. The seeming formlessness of successive moments of ordinary experience is of course comparative: the fugitive forms with which the present moment seethes are smaller than the great

structures, the unities and the wholes, that are figured in memory-and-knowledge-charged anticipation and which we are driven to seek out and realise in experience.

We need art, then, because ordinary consciousness falls short of fully uniting particular physical experiences with these larger forms derived from knowledge. That is why experiences seem incompletely experienced. Yes, we have the micro-arrivals of experience – after all, perceived objects are here before us, and we and they are here – but these do not match up to the greater and more sustained arrivals demanded by memory and anticipation. Just as without this fundamental form-creating faculty of consciousness, art could neither be made nor appreciated, so it would not be necessary, either: for we would not suffer that sense of the incompleteness of sense, of the failure to realise the idea of experience in experience itself, to which, I am arguing, art answers. The very formal sense that makes ordinary experience possible contains the seeds of the formal hunger that makes ordinary experience insufficient. Art is concerned with larger, more explicit and more stable forms than are experienced or experienceable in everyday life.

These forms may be constructed out of the material of everyday life – as in referential or representative art (literature, painting, etc.) – so that much that would otherwise be dispersed is brought together and the recipients are afforded a synoptic view denied them in daily life. Or the forms may be autonomous – as in abstract painting and music. Or, finally, be somewhere between the two as, say, in iconic painting or more recent art where figurative elements are used non-figuratively as motifs. Even in the case of representational and referential art, where 'the arrangement of parts' is determined at least to some degree by the organisational properties of the represented object or the referent, there are autonomous formal features. In literature, these include rhythm, rhyme, larger metrical patterns, the unfolding of the plot, the interaction of plots and sub-plots in the convergence and divergence of events. The selection of items in narration (which is not, after all, replication) permits the exploitation of motifs in the establishment of structure, of conscious dissonances between situations and voices, the manipulation of thematic contrasts and harmonies. For this reason, it is recognised that referential and representational art is, as has often been pointed out, not so much a reflection of nature as the creation of a second nature – though this second nature may, of course, be true of and true to the first.

The Reception of Form

The extent to which the form of a work of art – or the form (of a world) revealed through or in a work of art – is appreciated will vary from individual to individual. Some (very few) can grasp and enjoy the formal relations between the elements of an entire symphony; more will be able to experience them over the duration of a single movement; and some over only brief passages of melody. An individual may be more alive to the formal structures in one art than another. More people are, for example, able to appreciate or experience the form of a chapter in a novel than the form of a symphonic movement. (This is in part because a novel has a **referential** form, for example, the 'story-line', as well as an internal form, such as a pattern of symbols or recurrent leitmotiven.)

There may be variations even within a given individual in sensitivity to a particular art-form, even to a single work. Our experience of listening to a piece of music for the first time is quite different from that of subsequent listenings, and each of these may be different from one another. Likewise, re-reading is a very different experience from reading (with or without the intervention of literary critics). The first struggle through a complex poem is nothing like a hundredth re-reading, which is often like a return to a familar corner of one's own mind. Re-reading a novel has only a family resemblance to reading it in ignorance of how it ends. When Gide said, 'one writes to be re-read', he meant that he wrote for an audience of re-readers sufficiently liberated from vulgar curiosity as to how things are going to turn out to be able to appreciate the formal power of the work.[20] However, we all of us have some sense of artistic form: there must be few people who are insensitive to the storyness of a story or who do not feel the formal beauty of a melody – whether it is the recurrence of a Wagnerian motif or the playing of a familiar pop tune.[21]

The question of length and the scale of forms is a difficult and important one and it touches, as most aesthetic questions do, upon both the psychology of response and the issue of convention. The problem does not arise seriously with music (or most music, anyway), with short poetry or, of course, painting and sculpture. Long poems and novels present difficulties. Valéry (after Poe) famously suggested that a poem could not be more than a hundred lines long; anything longer was really a series of shorter poems with linking material. This would not satisfy the admirer of *Paradise Lost*

or of *The Faerie Queen*.[22] And it is easy to think of the latter, in particular, as a vast country of *topoi* rather than a single, massive embodied form. The problem would seem to be even more acute in the case of novels – especially large ones. Fiction typically has the unifying element of the plot, or of the interaction between plots. First time round, the plot is merely story – which we may think of as a withheld fact, or a group of withheld facts, combined with the means of creating an appetite for them. Second time round, the plot may be thought of in more purely formal terms: the re-reading is not a journey towards a revelation but a realisation of a trajectory whose goal is already known – rather as in a familiar piece of music. (As noted already, in a work of art, but not in life, there is genuine repetition – not only of the events but also of their temporal order.) And there are additional forces for coherence in the novel: recurrent themes (for example that of involuntary memory in *A la Recherche de Temps Perdu*); *leitmotiven* (cultivated with especial consciousness in Thomas Mann's Wagnerian novels, but evident throughout literary fiction – think of all the allotropes of fog that permeate *Bleak House*, of the black and white butterflies in *Madame Bovary*); symmetries (as in the hour-glass cross-over in *The Ambassadors*); and so on. All of these permit a great novel to become a living whole and its huge tracts mind-portable so that they can be realised as a form. E. M. Forster's claim about the 'massive musical forms, the great chords' sounding in *War and Peace* emphasises this hidden unity, this formal wholeness beneath the 'loose, baggy' (to use Henry James' adjectives) surface of fiction.[23]

I am not, however, obliged by my thesis to believe that the limits of a form have to be identified with the limits of a particular work of art. A work of art may exceed a 'mindful' – whatever it is that can be accommodated within a mind at a given time – and may have to be regarded as a series of mindfuls. The extent to which works of art are appreciated as a whole will vary from reader to reader, listener to listener, viewer to viewer and from time to time in the same recipient.

Conclusion: Art and Arrival

In the Kingdom of Ends, outside of art, there seems to be an imbalance between (abstract) idea and experiential content. Form, structure, may be obscured by the contingencies of the moment, so that experience is opaque, does not know or recognise itself, or

know itself sufficiently to feel **what** it is an experience of. Alternatively, the idea may be out of proportion to its realisation in the physical moment. Think of all the preparation – the planning, the booking, the packing, the travelling, the unpacking, the further packing and unpacking, further travelling and loading and unloading – necessary to reach the moment when an ice cream is dropped on the sand or someone chases, slightly cross, after a ball that has been hit miles too far while someone else, slightly bored in the outfield, toys with a lugworm cast. Or the frantic hours of digging and shaping and sending out for more buckets and prodigal spending on spades and directing and shouting that go into making a castle whose fate is to be dissolved by the sea within an hour of completion. Such a minute statue placed on such a huge plinth! What we get from art is not simply experiences – or proxy experiences in the case of referential and representational art. These are available *ad libitum*. Nor is it simply ideas – these, also, are two a penny. What art affords us is ideas rooted in experience, ideas embedded either in sensory experience (as in music) or particular referents (as in fiction).

The difference between art and ordinary experience may be summarised in this way: experience is integrated into a world; art integrates more widely, at a higher level, across that world; and it makes 'ordinary' integration – implicit in the partially achieved wholeness of the perceived world or of the perceived sequence or pattern – more explicit. This integration is achieved through the unity-in-variety of form. When we submit to a work of art and dissolve into its form, we are united within ourselves. Idea and experience are as one and we may, if only temporarily, arrive.

OBJECTIONS

We Are Already Arrived

The first, and perhaps most telling, objection is that we do not require any art in order to be fully there. One form that this objection may take is to point out what I have noted already – namely that our ordinary experience is composed of forms and that daily life is composed of arrivals: we are, after all, **there** in our perception of concrete objects that also make abstract and formal sense. These are, however, micro-arrivals and do not answer to the

demand for experiences that will correspond to the larger ideas awoken by anticipation and memory.

But what of the argument that the difficulty of arrival is not a fundamental or universal one; that nobody in pain needs help in order to arrive at where he or she is? That, far from being elusive, the experience, the world, of the suffering self is inescapable. Our inability to experience our experiences is scarcely an issue when we are being tortured, even if the enemy is only a humble toothache. In order to be 'entirely there', all we need is to drop a brick on our foot. Moreover, those who are hungry or suffering the anguish of bereavement or the various sorts of terror the world has to offer – most people for a good deal of their time – do not need anything additional to make their present moments sufficiently real. And even when we are not in actual discomfort, we are usually caught up in the present, oppressed by the press of events, possessed by the demands the world makes upon us in return for the demands we make upon the world. Behind this objection are venerable traditions: pinching oneself to make a situation real, self-flagellation to heighten self-presence, undergoing ordeals in order to exist more authentically.

Suffering does not seem to me to be a particularly attractive alternative to art. It catches up many opaque elements. Much pain, for example, is senseless sensation, unilluminated by knowledge – as well as being intrinsically undesirable. It is not synoptic, boils down to its own moments; it is anti-knowledge, anti-idea, anti-meaning.[24] Even when chosen, it nails one to the particular, is a matter of successive windowless moments, unilluminated by past or future. (And the choosing of pain is often a brief moment compared with suffering the consequences of the choice. The large literature on sexual pain seems to overlook how the instant of sado-masochistic, ecstatic sexual pain is outweighed by the hours, beginning with the wait in the A&E department, of meaning-impoverished discomfort.) More importantly, most suffering is unchosen – and our concern here is with the ultimate ends and aims of human life and consciousness, and therefore with what one does when one **has** choice. Pain may 'cure' the sense of the insufficiency of presence but only at the cost of downgrading consciousness; it is no more a solution to the difficulty of arrival than are coma or death.

To be in pain or fear is to be enslaved. Art is the opposite of enslavement, even self-enslavement. In one of his most famous essays, Sartre defined art as 'the world appropriated by a

freedom'.[25] This definition is vulnerable, not the least to the argument, with which Sartre himself is most famously associated, that **every** moment of consciousness is the possession of the world by a freedom. Nevertheless, the definition captures something essential about art: that it is the means by which we may possess the world that usually possesses us. Art is concerned with the completion of our freedom in those times (admittedly rare and privileged in our own lives and in the collective life of mankind) when we are not involuntarily engulfed by the present moment. It is under such circumstances, precisely when we are not fastened to unsolicited, unpleasant experiences, that experience may become elusive, unreal, and the difficulty of arrival an issue. When we are not apprehended by pain, fear or anguish, or even mere busyness, the present moment, the self, becomes inapprehensible. Art is about making delight as solid as pain; about being at least as totally **there** in positive moments, when one is joyful and open to others, as in negative moments of pain, solitude and loss.[26]

There are Arts: There is No Such Thing as 'Art'

To ascribe a single over-riding function to art may seem to imply that art is a single thing. Any discussion of art in general must yoke together objects, activities and experiences that are fundamentally and irreducibly different. Painting, sculpture, music, poetry, fiction: it would be difficult to think of a more heterogeneous collection of activities. Any talk about 'art' that is not mindful of the great differences between the individual arts is in danger of being banal and unfocused. As Eduard Hanslick said

> We can't get a general metaphysical definition of art from which the aesthetic principles of any specific art can be deduced: for one thing the works of art themselves must be the starting points; and also, each individual art can only be understood by studying its technical limits and inherent nature.[27]

My aim, however, is not to deduce aesthetic principles of **specific** arts. There is unlikely to be a metaphysic of rhyme or a demonstrable relationship between the structure of human consciousness and the sonata form. And metaphysics will certainly not explain how a particular work has – or fails to have – a

particular effect, why one work is good and another is not, or help to differentiate between the reasons why something is good versus the reasons why it is enjoyed. I am concerned only with the needs to which art is a response, the origin of those needs in the fundamental character of human consciousness, and what it is about art that enables it to meet them. In short, with what the arts, across their enormous differences, have in common: the property of instantiating a formal structure while being rooted in particular experience; the capacity to satisfy idea-hunger without deserting particular experience.

The reason why this property is easiest to discuss in relation to music is that it is a non-referential art and its forms are, therefore, more completely embedded in particular **physical** experiences. The music **is** what it sounds; it can never (to allude to the old joke about The Ring Cycle) be 'better than it sounds', in the sense of entirely rising above the sounds it is composed of. (It can never fail to deliver what it promises: it **is** what it promises.) Form and content are mutually embedded, and inseparable. By contrast, other types of art-work may reach out to an 'external' referent. For example, a representational sculpture refers to an individual, or type of individual: it is a sculpture **of**; it has a highly focused, externally targetted 'intentionality'. Although it is naive to think of Michelangelo's 'David' as being about a particular absent individual called David, it certainly is about an idealised or archetypal young man. This specific 'aboutness' is even more evident in the case of representational painting. The aboutness of literature is much more wide-ranging: compared with painting, the ratio of material substance to referent is tiny.

Music's lack - or relative lack - of external reference has suggested to some, most famously Schopenhauer and Pater, that it is the purest of the arts - almost Valéry's 'art purged of idols'- that, uniquely, it realises the powers and purposes of art. Because they are not shaped or regulated by referents (in Schopenhauer, by the world-as-idea), the forms of music are not borrowed from the external world: nothing naturally occurs in sonata form. Its language is autonomous and has no extra-musical uses – something that the French Symbolist poets in particular envied it for. The fusion between form and content is all the more complete because the latter exists only in order that the form should be realised. Music is not burdened with a duty of fidelity to an external world: it lacks an extra-musical agenda. It has therefore been seen as the paradigm

of the arts and its condition that towards which all other arts should 'aspire'.[28]

Certainly, the union of form and content, which is supremely possessed by music, must be possessed in some degree by all arts if they are to serve the purpose I have identified. This is why the choice of music to illustrate the notion of form as the 'moving unmoved' and its relation to the function of art is a natural one. But this brings the danger of exaggerating the extent to which arts are non-referential, establishing an autonomous realm rather than expressing external, non-artistic reality. Non-referentiality can be seen as a deficiency as well as a virtue and it could be equally argued that music is the least typical as well as the most typical of the arts. Its lack of clear connection with extra-musical reality, or of precise reference to elements in the rest of our lives, certainly makes it utterly different from what has, arguably, been the dominant art form: literature.

This much I would concede: the relative non-referentiality of music enables us to see the 'artiness' of art most clearly in it. But it does not follow from this that non-referentiality is an essential feature of art, its *sine qua non*, so that referential art (such as representational painting or literature) is inferior as art and all art ought to aspire to the condition of non- or self-referentiality. The confusion between non-referentiality, musicality and artistic superiority has given rise to harmless idiocies – such as the belief that abstract art is closer to music than representational art (that, indeed, it is a kind of colour music) and because of this counts as more 'advanced' than representational painting. But this misunderstanding has had more serious adverse effects on thinking about art.

Consider, for example, the influential school of poetics originating from Jakobson. Its proponents maintain that the essence of literary language is the foregrounding of the material tokens of language – the actual sounds – at the expense of their referents. In literary, as opposed to other uses of language, words draw attention to themselves. Literary discourse is characterised by opacity and self-referentiality. This, it is claimed, is particularly evident in poetry whose 'poeticalness' is manifested in such devices as rhythm, onomatopoiea and rhyme. The thesis has a *prima facie* plausibility: rhythm emphasises the temporal form of discourse; onomatopoeia its material basis; and rhyme, an echoing of the materiality of language, both draws attention to that materiality and punctuates (and so makes explicit) the temporal form of the discourse. Together

these devices increase the interaction between the moment and the linguistic and intellectual form unfolding in time. In this way, the abstract idea is more deeply embedded in the material of its representation.[29]

So there **is** a quarter-truth in structuralist poetics. Unfortunately, presented as the whole truth about poetry, it becomes three quarters untruth as well. The quarter-truth of Jakobson's ideas overlap with my thesis. It is possible to see the fusion between abstraction and token particularity, between absent general referent and present sounds in poetry, as a (rather modest) realisation of the fusion of sensory experience and knowledge. At any rate, it makes comprehensible the notion that, of all the forms of literary discourse, poetry is closest to music. 'The music of poetry', however, remains a complex and vulnerable concept that cannot be identified solely with the organisation of verbal sounds but must be related to the interaction between the latter and the organisation of ideas. *Pace* Mallarmé, poetry is made with ideas as well as words. As Valéry, Mallarmé's greatest disciple said, a poem is a 'prolonged hesitation between the sound and the sense'.[30] Any suggestion that poetic music resides in its sounds alone can lead only to the conclusion that poetry is a rather low-grade instrument, with a range somewhat short of that of a penny whistle. Moreover, despite Jakobson's claim, poeticalness is not co-terminous with literariness. There are many literary forms – most notably the novel – where the material tokens of language are not foregrounded. In the novel, as in most prose, the words on the page are almost inaudible (except when we are invited to imagine and so hear the accents in a piece of dialogue): we see the meaning rather than hear it.

In short, non-referentiality and total autonomy is **not** a condition of art or even of great art. The non-musical arts, importantly, state as well as suggest. The proportion of statement to suggestion will vary from art to art. What is merely suggested in a portrait – a whole life ('Thus is his face a map of days outworn'), a tone of soul, a social or historical context – may be made explicit and unpacked in a novel. Of course, no art will pandiculate: what is said will always be surrounded by a nimbus of the unsaid. A leaf-by-leaf account of a forest is not the way of the artist. The art of referential art is to gather sufficient particular experiences together to embody the form; to show forth the idea through experiences. The Cornwall we could not arrive at is captured by glancing references to the cliff path, the trajectory of the ball as it heads towards the sea, the dropped ice

cream, the sandy footmark in the cottage doorway, the moonlit foam, the delighted or crying children, the moment in the filling station. Reading this, we share in the moments, in the experience and yet do not lose sight of its whole, or the sense of a whole. The things that we experienced in serial disorder are made to co-exist: 'Here Time becomes Space'. The river of succession – the moments that passed through us as a procession of inchoate and warring forms – broadens and deepens to a lagoon. Cornwall is at once experienceable in minutiae (so it is not a brochure abstraction) and known as a whole: the idea and the experience, the moment in time and the arrested form, are brought together and we, who could not arrive, arrive. The world is captured in a moment and the moment flowers out into a world – the world we could not, when we lived it moment by moment, grasp as a whole – so that we reciprocate its grip on us with a grip as strong.[31] Literary art gives a more permanent existence to a whole that has only fugitive and partial existence in the privileged states of anticipation and memory.

This is beyond the scope of (wordless) music. So, if literature is jealous of the purity of music, of its non-referentiality, its possessing its own non-shop-soiled language, then music should be jealous of literature, with its precision of reference. Evocation through selective reference is something music cannot achieve (not at least without the help of words). Literature, therefore, is not merely inferior music (as the Symbolists who listened enviously to Wagner sometimes seemed to believe). Verbal art listens into the music of everyday life: 'the music of what happens'.

In summary, there are different ways of achieving the 'moving unmoved' of artistic form and the fusion between the experience of particulars and the larger notions they relate to. There are many different kinds of arts. But it does not follow from this that there is no such thing as 'art' and that disussion of the function of art is necessarily empty. The differences between the arts are important. But they are also revealing because they help us to see what, deeply, the different arts have in common; to understand more about the common purpose I ascribe to them.

There is More to Art than Form

I have focused on the idea of form and so would seem to be emphasising the formal qualities of a work of art to the exclusion of all else. I want to correct this impression and to relate the story so far

to traditional aesthetic theories and to the question of the variety of the purposes and instruments of art.[32]

There are three main trends in aesthetic theory which, respectively, emphasise the following features supposedly distinctive of art: imitation, expression and form. Sheppard identifies a fourth type of theory, according to which the common property of all aesthetic objects is not imitative or expressive power or form, but something called 'beauty'. Such theories do not clearly separate the distinctive properties of artworks from their function or the means by which they exert their power and have their value. For example, the assertion that the essence of art is imitation is ambiguous. Does it mean that art simply (descriptively) is imitation? Or that the purpose of art is to imitate? Or that successful imitation lies at the basis of the power and effectiveness of all art? Moreover, the fourth theory is not necessarily additional to the others. Beauty may well be simply the result of the imitative, expressive or formal qualities of the work – the end to which the one or more of the others are the means.

We have related the aesthetic impulse to the larger ideas that underlie, drive and (because they are unrealisable) undermine experience in a way that is important in the Kingdom of Ends. The challenge of art is to realise, to embody, large forms. Whereas in music, the forms are additional objects in the world – they are made out of music – in visual art and literature, the forms are, directly or indirectly, made out of or utilise the substance of the world: the art refers to the world and the world feeds into the art. This is not to suggest that in these more-or-less representational arts, the end is exact mimesis of a piece of the world; for in that case Camcorder Man would be the supreme artist or (as Plato scornfully suggested) a mirror would be all that was necessary to turn oneself into an artist.

It is important to appreciate the limitations placed upon mimesis. All art is mediated through materials and through conventions. There are the basic conventions – such as the conventions that govern the ordinary use of words in language or the translation of three-dimensional space on to a two-dimensional surface with brush-strokes in painting. These basic conventions may be to a lesser or greater degree arbitrary in the Saussurean sense. Self-evidently, Michelangelo's *David* is composed of less arbitrary signs than a poem: the word 'arm' is more arbitrary a sign than the iconic sign of David's arm in the statue. And in addition to these basic

conventions (which are also used outside of art), there will be secondary conventions – mannerisms of depiction, metrical rules, etc. The work of art cannot for this reason be a transparent window on to a bit of reality in virtue of replicating it. Mimesis, in the sense of precise imitation based on replication more or less of the physical properties of part of the world, is only a small part of what even referential art is about.

Mimesis *per se* may intensify our awareness of the object – and so locally heighten consciousness – but this will not be a result simply of representation or re-presentation. After all, we are surrounded from morning till night by representations of objects: almost every visual field is littered with pictures. In order to intensify consciousness, representation has to gather up into the object or event or situation or corner of the world, its implicit significance, or somehow make it significant. In visual art, literal mimesis is transcended in two directions: (a) the object may be transformed or played with to make both it and a style more evident; and (b) the object may be made to stand for a whole class of objects. In fact, the metonymic function – whereby the represented object is made representative – has a vertical and a horizontal dimension: a face, a street, a hay-wain may typify a whole class of faces, etc. – this is the vertical dimension; but it may also stand for the way of life, the life, the world, from which it is drawn. A street scene **becomes** Paris in the 1800s, becomes nineteenth-century Europe. (A commanding image may help itself to do this by becoming emblematic – that which we think of when we think of Paris, etc.) A depicted tree stands for an open series of trees – and for the days and summers that surround them. The denoted object invokes a world of connotation. This capacity to invoke more than is represented may be exploited in art that deals in abstract forms and patches of colour: the brown patch entitled 'Liverpool Autumn' (Roger Hilton) seeks to trigger a nexus of thought and ideas. Whether it does this depends upon how much we, the spectators, are willing to put in; our feeling of generosity or good will to the painting.[33]

The power of visual representation to go beyond mimesis – so that a small canvas can suggest a world – is greatly exceeded by literature where representation is mediated by arbitrary signs and we should speak rather of the expression of meanings of objects or of reference to objects rather than of representation or mimesis in the literal sense. (Though of course much of drama is mimetic in a very literal sense.) We are familiar with the idea of a writer invoking

a world and this can, with an appropriate choice of elements, be achieved with remarkably few referents.[34]

The world that is captured in the painting or the piece of prose has an explicit form, just as the small objects and events – the cats and the dogs and the journey across the road – in our lives do; but it is much larger than those small objects and events. It is as large as the ideas that we are unable to realise in our experience. The intrinsic, formal properties of the work of art and the compression of immensity into small spaces, work to ensure that the representation – with its metonymic power to stand for classes of objects and its controlled spread into a nexus of connotations – is mind-portable. The form through which the work of art is unified unifies and makes accessible to the moment of consciousness a great section of the world – equal to the ideas that haunt and hollow the experiences that can't realise them. This is the connection between the formal and representational aspects of art. They are not alternative defining features of art but work together to fulfil the function of art.

What about expression? The expressive theory of art is multiply ambiguous. The theory may imply any of the following:

1. Art expresses objects – e.g. depicts them.
2. Art expresses (represents, exhibits) feelings
 (a) of the artist;
 (a) of the recipient.
3. Art is intended to transmit feelings from the artist to the recipient.
4. Expression is the basis of the aesthetic value of art.

In its commonest use, the expressive theory is that art is about the expression of emotion and that the work of art is the vehicle by means of which the emotions of the artist are transmitted to the recipient. The value of the work is to be measured by the completeness and precision with which the emotions are transmitted and, possibly (as we noted of Tolstoy's theory in 'The Freezing Coachman'), by the intensity and the moral quality of the emotions. How does expression of emotions relate to form?

To answer this, we need a theory of emotions. There are several things to be noted about emotions. The first is that they fill the world with meaning; even in the Kingdom of Ends, emotionally laden experience carries a plenitude of (often superfluous) meaning. When we are angry, delighted, etc., we are not oppressed by a sense of not quite being there. The second thing to note is that emotions

feed on, validate, themselves: anger talks angry talk, delight finds more to delight in, love loves and so justifies itself. Although anger is fulfilled meaning, it is always looking for further meaning as it talks itself up and finds angry-making things in the world. It is self-perpetuating and, yes, in a sense self-perfecting.

Despite this self-perpetuating element, emotions are not, of course, eternal. They are not immune to invasions from the outside world nor to spontaneous inner decay; but they are remarkably exclusive so long as they last. In its completed state, an emotion is (as Heidegger pointed out) a state of attunement, a mode of openness, to the entire world. I would go beyond this passive interpretation of emotion and support Sartre's suggestion that an emotion (far from being a local physiological tempest) is world-making, world-synthesising, world-organising. As Wittgenstein said, 'the world of the happy man is different from the world of the unhappy man'. Emotion unifies the world. Even at the height of his emotion, however, the individual has a sneaking sense of its lack of objective validity: the angry man has an uneasy feeling that the universalising tendency of his anger is absurd – like Mrs Rooney's cry, 'Christ what a planet!', when no-one would help her up the station-steps in *All That Fall*. The meaning with which the emotion floods the world lacks objective basis, as we are aware when we observe others in the grip of an emotion we do not share or when we see others amused at our anger or bored by our stories of the outrage that has just befallen us. Although the emotion is a means of possessing the world, it is also something that possesses us: it is not entirely an expression of our freedom. It bears the stigmata of parochialism and triviality. And when we are not in the throes of ordinary emotion, we feel a hunger for more meaning, for deeper ideas than those which trigger, govern and feed the endless circuit of our petty emotions – emotions we may wish to snap out of and will certainly, from the pressure of external stimuli impinging upon our feeling-world, fray out of. Nevertheless, like art through its formal properties, emotions are unifying.

This brings us to the heart of the relationship between art and emotions: art, by inducing emotions, utilises a faculty by which consciousness finds in and imposes upon the world a greater unity than it has to the uninvolved gaze. An emotion promoted though art, a **disinterested** emotion triggered by others' representative experiences, by larger ideas, rather than by our own self-centred preoccupations, has the world-unifying property of emotion

without the demeaning origin, and so may correspond to an experience as large as our ideas. As Whitehead pointed out, 'the cultivation of the emotions for their own sake' is one of the prime characteristics of aesthetic experience. But this serves the deeper purpose of art: to bring together more of the world in order to permit experiences that are large enough to correspond to the ideas that haunt us.[35]

I hope that the foregoing makes clear that, although I have approached art through form, my theory is not formalistic in the sense of underplaying the importance of other elements. Though it does give form a central explanatory role, my theory can take into account mimetic – representational or referential – elements as well as the emotionally expressive properties of art. The unifying idea is unity itself – unity over a large span of experience, making possible experiences that have the scope and clarity of those ideas that elsewhere undermine experiences by so greatly exceeding them. In referential art this is achieved by accessing a large part of the world unified by form and controlled connotation: we may think of a poem for example, or a novel, as enclosing a huge hyperspace. Form may additionally operate through emotion to reinforce the unity of the space indicated (and so enclosed) by the work. The work consequently permits the integration of more of our experience into the moment of consciousness. Moreover, referential works may give us access to different worlds, different minds, different lives and so extend our range of experience, permitting us to imagine into the experiences of others, as well as integrating the experiences we have had. In the case of non-representational art, form is yet more explicit and the signs, which fall back into themselves because they do not signify anything definite outside of themselves, have an enhanced and thickened presence. Music, too, is associated with emotion and that emotion then fabulates an imaginary world composed of pieces of one's own world lit by the feeling released by the music. In all cases, one is afforded a view over larger sections of one's experience and the world than ordinary experience usually permits.

It is thus possible to subsume the four major theories of art – the representational (referential, mimetic), the emotive, the formal and the theory according to which artworks are defined simply by their quality of beauty – under one theory, based on form. The quality of beauty in art is the enlarged view that it permits us: beauty is a tor on the plain of consciousness. The formal, the mimetic and the expressive are not at odds; after all, discourse utilises a highly

formalised system of arbitrary signs and these are referential and may be intensely expressive. (In the case of literature, the forms may range from single words, through sentences, through much larger, organised formations – such as stories and, ultimately, novels.) The formal elements permit unity and, through this, enable great vistas to be opened up.

There may be tensions between the formal and the representational aspects of art: fidelity to the chaos of ordinary life points in the opposite direction to the wish to give the work a clear form, and the use of much larger forms in which the organisational elements are highly explicit. Nabokov speaks of a novel being the product of a quarrel between the writer and the world. The public face of such a novel should, of course, bear no trace of that quarrel.

What both representational and non-representational art have in common, the condition towards which they **both** aspire, is that fusion of the actual with the idea of itself necessary to achieve the arrival that consciousness dimly intuits as its destination. We may think of fiction as occupying the middle ground between the pure, non-referential forms of music and highly specific referential forms such as representational painting. What literature loses in material presence – text on a page is hardly to be compared with an orchestra in full flight – it gains in the range of its reference. It is in literature above all that the scatteredness of everyday life, the dissolution of arrivals into journeys, is redeemed. The Cornwall that eludes us in Cornwall, the holidayness of holidays that dissolves as we holiday, the beachiness of the beach that leaks away like water through sand as we play on the beach, is recovered in the perfected memory of fiction that prompts us, the readers, to perfected memories of our own. It is in literature that we come closest to bringing together the cliff walk and the lost toy, the game on the beach and the waves smashing against the rocks. A novel enables one to arrive in one's own life by invoking those experiences that one has not quite fully experienced and bringing them together in a way that they could not be together at the time. This does not require a hyper-realist replication of the remembered world; on the contrary, it is easier to achieve the synoptic view through a few well-chosen elements that mark out the distances the world contains, triangulation points that catch up the space between them.[36] The art of literary depiction is to mobilise a vast complex of associations from which a world can be unpacked – like the universe gathered up in an aroma of recollection when sensation triggers involuntary memory.

Does reality, Proust narrator wonders (Volume I, p. 201, of the Kilmartin translation), take shape in memory alone? If it does, it cannot be retrieved through voluntary memory. This lacks the synoptic powers of involuntary memory: it replicates mere details. As Beckett says, in his book on Proust:

> The man with a good memory does not remember anything because he does not forget anything. His memory is uniform, a creature of routine, at once a condition and a function of his impeccable habit, an instrument of reference instead of an instrument of discovery. The paean of his memory: 'I remember yesterday as well as today...' is also its epitaph and gives precise expression of its value.[37]

Involuntary memory, on the other hand, is as fugitive as experience: although it is no mere replication of experience – on the contrary, it is a revelation of the world that was the implicit form or framework of that experience – it is transient and, by definition, eludes the grasp of the will. Nevertheless, the experience of involuntary memory gave Proust the idea of what art might be, of what it might achieve. Involuntary memory reveals both the possibility and the necessity of art; the feasibility and the importance of its project. The sense of paradise lost and the sometimes delighted, sometimes anguished, intuition of the possibility of paradise regained (the two go together) gives the project of recovery its urgency and writing its content. Literature, which aspires towards a synoptic view over a world (so powerful that it seems, for a while, like **the** world) and is at the same time permanent, even objective, achieves what involuntary memory hints at. At its height, literature is an endlessly reinvokable involuntary memory; an ideal consciousness, an ideal experiencing, of the kind adumbrated in involuntary memory but brought under the ambit of the will.

Of all the arts, literature is closest to the special **repetition** of the past that permits experience to be recovered and so experienced fully in the way that it could not be experienced at the time. It is as if literary art discovers for us the *a posteriori* secular, immanent essences to which our experiences amount. The secular revelation (as opposed to the religious revelation of *a priori* transcendental essences) is the fullest realisation of what was there (or in the case of writers of loss such as Hardy, poignantly **wasn't** there), of how so many things belonged with one another, of the hidden nerve of

association that held the world together. (There are artists in whom the secular and religious revelations converge, often with the former serving the latter: Bach and Messiaen, Raphael and Roualt, Dante and Milton.) In the secular revelation, the principle of unity of the world is the synthetic power of the individual consciousness that holds so many disparate things together; in the religious revelation that preceded it, it was God. So, in the perfected memory of art, Cornwall rises up from the sea of preoccupations and particulars, like the *cathedrale engloutte*, and we see it as we have never seen it before. Almost as a reversal of the process by which the Word was made flesh, the travails of the flesh are made Word. For Mallarmé, this is the essential destination and ultimate glory of consciousness: *tout le monde existe pour aboutir dans un livre.*

At the same time, literature shares with the non-referential arts such as music the fundamental property – which is most powerfully exemplifed in music – of bringing together material experience and an abstract overall form, so that the experience knows where it is going, knows what it is, and journeys arrivingly. And only when we have lived our lives again in the perfected memory (or the perfecter of memory) called art, have we truly lived.

The point that the arts have profound differences – so that the noun 'art' just about holds together as a collective term – is one, therefore, that I gladly concede, so long as it is accepted that they have an important common aspiration – the perfection of experience – and a common method – the fusion of the moment of experience with a large idea or form of which it is part.

Art as a Moment-Enhancer

I can see another source of resistance to my thesis arising out of my emphasis on the perfection of experience. If art is about the moment of experience, how does it differ in value from other moment-enhancers – for example, recreational drugs? This question has a particular force in relation to music; for it is closest to, say, drugs inasmuch as our encounters with it could seem to boil down to a series of unrelated ecstasies – an overture, followed by a concerto, followed by a symphony; a concert followed by a tape in the car on the way home; Bach last thing at night followed by Taverner in the morning and Stockhausen at noon – which may seem like a succession of fixes unconnected with one another or with whatever else is going on in our lives. Any connectedness would seem to be

merely internal: the piece connects with itself in the process of realising its form; the realised form connects with other examples of the same or different forms.

It would be dishonest to deny this difficulty or that music can be consciously used, like a drug, to boost one's mood: 'the brandy of the damned' as Shaw rather grandly called it. And if, as Valéry asserted, the purpose of poetry is to have a certain effect on a reader, isn't poetry also simply a safer but rather less effective and reliable agent than drugs for altering consciousness – one suitable, perhaps, for those who are frightened of the police? The answer is obviously no, but it is perhaps less obvious why it should be no.

The purpose of art may be to bring about the perfection of the moment but in order to do so, it has to bring together elements from many different moments: art is about connectedness. The elements of a work of art are themselves connected with one another in their co-operative effort to realise the form; but they are also connecting inasmuch as they bring together otherwise disparate elements of the world. This bringing together may have many dimensions. There is the intertextual dimension, whereby the work's conformity to a certain genre (or its transgression of genre rules and boundaries) invokes other works of the same genre. More importantly, there is the connection between the work of art and its historical and social context. Our enjoyment of it is deepened by knowing something of this. This is more evidently true of literature than of music, but even in the case of the latter, appreciation (which goes beyond immediate pleasure) is deepened by understanding, by knowledge, however scanty, of its context. It is more obvious that we cannot understand a poem without connecting it with many other things; and so without mobilising our own implicit internal connectedness, the connectedness of our experience and knowledge, and our potential for a wider and larger sense of things. In literature, of course, this connectedness will be occasioned by the referents of the work: a reading of a novel may bring together vast tracts of our lives or of the world, by awakening a complex of associations. A great poem is, as I have already suggested, a realisation of Blake's contention that every thought fills immensity: it unpacks that immensity, or makes it available, by compressing much into a small space. (Profundity could be defined as 'compacted immensity'. Compare the German word for poetry: *gedicht* – condensation.) So in order that art should work on us and enable us to realise these connections in our life, we have to work with it. We are concerned here not with escape and

oblivion but with remembrance, recollection, reflection and wakefulness. The awakened and self-wakening, the actively imagining, consciousness of an individual yielding to and possessing a work of art is utterly remote from the drowsy passivity of a drug addict succumbing to another fix.

There is another crucial distinction between works of art and recreational drugs as perfecters of the moment, as bringers about of effects. Although both are causes of altered states of consciousness, only the work of art is the object of the altered state, as well as the cause of it. The novel that intoxicates us remains the content, the object, the referent of our intoxication; or its content mediates our access to the referent of the intoxication. The work of art does not disappear without remainder into its effects on us. By contrast, the drug effaces itself in its effects (unless something is going wrong: the bad trip; the sixteen pints of beer that are ominously reasserting their independent existence and imminent likelihood of return): it is not the **intentional object** of the altered mood it invokes. As Proudfoot (to whom I owe much of this argument) points out, 'a drug (cause) might make me delighted with my fingernails (object)'.[38] The work of art is not merely the cause or agent bringing about my altered state but its continuing rationale. There is a great difference, indeed a great distance, between a cause and a rationale. The effects of the work of art – the moods, the thoughts, the memories – refer back to the work itself. This distance is greatly increased since the work itself has referents: the referents of the effects of the work also reach back into the work. The difference between a poem and a drug could therefore be presented diagrammatically:

DRUG → MOOD ⟶ RANDOM CONTENTS OF 'LIT-UP' WORLD
 (INTENTIONAL OBJECTS OF MOOD)

POEM → REFERENTS ⟶ EFFECT ⟨ REFERENTS OF POEM
 (e.g. MOOD) RANDOM CONTENTS OF THE 'LIT-UP' WORLD

The Difficulty of Arrival

Since its referents tend to be inward, music seems closest of all the arts to drugs in being a bringer-about-of-effects unrelated to the outside world, a perfector of the moment that threatens to collapse inwardly into referenceless or randomly referential intoxication. Literature seems less prone to this danger. There is always, to a lesser or greater extent, a further consequence of the encounter with a work of literature which is not merely a jewel to be admired but a lens to transform one's perception of the world – this is the sense in which, as Auden says, 'great books read us'. This effect on the reader may be accompanied by a loss of authorial control over his or her response. The sentiments invoked by a novel and regulated by the author's unsentimental vision may, when they generalise across the reader's world, degenerate into mere sentimentality, free of the connectedness that confronts emotions with their consequences and their cost. Nevertheless, this impact is still channelled through, and regulated by, the referents of the novel and so is subject to a certain amount of 'quality control' by the author. The consequence of reading *War and Peace* is unlikely to be an isolated and ecstatic contemplation of one's finger nail while others around you are going through Hell. (Which is not to deny the importance of the accidental powers of even great art, unanticipated by the author, and the irresponsible responsiveness of, for example, the reader of the novel.) Nevertheless, the perfection of experience in all arts is always associated with **some** disconnection from the outside world – the world of responsibility and of concern for and relations with others – which is one of the reasons why any claim for the moral effect of art must be treated with the utmost scepticism, as I did in 'The Freezing Coachman'. The gaze and attention of a person reading a novel or a poem is averted from the reality current in the outside world. But it is not so remote that he or she loses touch with that world completely, as would someone consuming drugs which offer a series of isolated moments, of ecstasies unconnected with everything else in one's life: 'little doses of oblivion'.[39]

Art, in particular literature, has a significant civic element in the broadest sense of inviting participation in a wider social discourse that points to a collective experience, a shared memory and concern, so that its referents extend beyond any individual's present moment. Of course, it is easier to say this than to determine the limits to which art should refer to, and assume, and be subsumed within, the public domain. Art that is widely appreciated (as opposed to art produced for 'therapy' which has many makers but

few takers – see below) must be in touch with a common or collective element in experience. That a work of literature can recover, and so perfect, the experience of an individual artist and yet speak to many different recipients – so that it seems to them to have an objective authority as well as a personal resonance – is not as paradoxical as it sounds. Even in our depths, much of our sense of self is communally derived (though the temporal and spatial extent of that community is a matter of considerable contention and the degree to which the self is a communal product is a key issue in twentieth century thought[40]); consequently at least a part of deepening self-consciousness will be heightened consciousness of others, or of collective experiences and value.

There is danger in assuming an identity of the private and the social self at too superficial a level. This is perhaps evident in some aspects of Augustan poetry where satire, social observation, the use of more or less abstract concepts in more or less philosophical discourse, are dominant, and the over-riding values are intelligibility, clarity and what has conventionally passed for logical order. The danger is that of an art that is too external, too wedded to the forms and assumptions of a certain area of and epoch in public discourse, too second-order, too composed of pre-packaged elements of thought and feeling, too remote from the uncombed chaos of actual individual experience. True Art may shrink to 'True Wit' which (according to Pope's *An Essay on Criticism*) is

> Nature to advantage dressed,
> What oft was thought, but ne'er so well expressed. (ll. 297–8)

This is a vulnerable and extreme articulation of the valid assumption that art has deep social roots and that the inner world articulated by the artist is the outer world of the society to which he or she belongs, so that art is committed to elegant re-expression of the well-known, the self-evident, the taken-for-granted.

> Something, whose truth convinc'd at sight we find,
> That gives us back the image of our mind. (ll. 299–300)

is a prescription that may imprison art in the received ideas of its time and encourage too superficial an identification of the inner recesses of the individual consciousness with the outwardness of the

public domain.[41] The prescription of an art that will be immediately accessible to everyone and will touch in the prescribed manner on issues that are laid down as being of central importance has been more consciously and more systematically imposed in the totalitarian regimes of the twentieth century. Its only outcome has been the elevation of right-thinking mediocrities and the persecution of geniuses.

Nevertheless, if writing originating from a stranger is to reach into disparate corners of the selves of strangers, bringing together many separate moments into a moment of synoptic vision, it will have to reach into many corners of the objective, external world, however 'expressionist', 'anti-classical', 'imaginatively dissident' or 'Dionysian' the work may seem or aspire to be. (And no art is as Dionysian or anti-Apollonian as a fight in a street.) Besides, there is a large space between, on the one hand, incoherent jibberish expressing in 'the language of the self' experiences and connections between experiences that have only personal significance and, on the other, the reiteration in ever-more polished language of reassuring commonplaces and received ideas. This is an adequate space for literary art to find, and endlessly renew, itself.

So, although art is about the perfection of consciousness in the perfection of the moment, this perfection partakes of more than the moment. There are the objective elements of structure which reach across the work, which outlast the moment, and out of the work to the genre to which it belongs. These alone ensure that the work points beyond the recipient and transcends the moments of his experience.[42] This, taken in conjunction with the 'civic' elements discussed just now and the essential synoptic genius of the great works, meant that engagement with art, far from being merely a succession of experiences, is a liberation from the ordinary condition of being a succession of experiences that do not realise any larger conceptions. Although, as I emphasised in 'The Myth of Inner Enrichment', even the experience of art is inescapably episodic (we listen to the symphony and then catch the bus and return to our worries), it is less completely so than other experiences – with the exception, perhaps, of those by which we are unwillingly possessed, such as chronic pains, persistent anxieties and nagging responsibilities.

Of course, the experience in some sense remains a matter of moments. But then this is true even of religious experience. Kierkegaard observed that

> it is only momentarily that the particular individual is able to realise existentially a unity of the infinite and the finite which transcends existence. This unity is realised in a moment of passion.

He adds that

> modern philosophy has tried anything and everything in the effort to help the individual to transcend himself objectively, which is a wholly impossible feat; existence exercises its restraining influence.[43]

All consciousness is a matter of moments – but there are moments that reach out and touch other moments, moments that are uniquely infused with something that goes beyond moments. Such are the moments afforded by the encounter with great art. The world we are in, by which we are possessed, into which we are dissipated, the very framework within which experience takes place, enters us and we see the moment from a perspective that, although distancing, does not alienate us from experience.

Because the experience of art is, even so, of the moment, there is no 'before' and 'after' art, with permanent gains and lasting salvation. The experience has endlessly to be renewed in different ways. Art, we may say, offers intermittent or temporary relief from the permanent condition of not quite being there. Nevertheless, works of art are not merely experiences to be had, jewels to be contemplated, but also lenses to alter perception; a great work of art is boundless in this sense and its effect is by no means confined to the moments of its consumption. Indeed, one does not consume art in the way that one consumes other goods of the world. A great novel cannot be consumed in the way that an airport paperback can be consumed. It is inexhaustible, reaching beyond what we can encompass in a single reading; and, in that sense, it consumes us.

The Thesis Lacks any Sense of the Different Role Art has Played in Different Cultures at Different Times

Anyone with the slightest historical sense may be tempted to advance a further, yet more damaging, objection: what you say about art has nothing to do with the function of art in cultures and

times remote from the here and now; that, even though art does sometimes have as its purpose the perfection of the present moment of consciousness through the fusion of idea or form and experience, this is, howsoever important, only one of the many functions of art and, in the case of much art, or art in most historical epochs, not a central one. We have, it seems, avoided the trap of asserting that all the arts are the same to fall into the even greater trap of asserting that art has a central function which is the same for all peoples across all ages. Historically, artists, it will be emphasised, have less often been concerned with the perfection of the moments of experience, the healing of the flaw in the present tense, than with, say, instructing their fellow men – morally, politically, and even practically. (Not to speak of those who have been driven by other, less altruistic impulses, such as dazzling their fellow men, exacting revenge or earning a living.) Writers, in particular, have often been possessed by a social mission, by an urge to right perceived injustices in society or to reaffirm forgotten values. A multitude of intentions and needs and purposes may be evident in or served by the writing and reading even of a single work – or a single page. At any rate, art being a supremely social activity, has always been embedded in other things as well as being profoundly influenced by the technology through which it is expressed. (Archimedes, Caxton and Edison have had at least as much influence on the course of art as Euripides, Michelangelo and Goethe.)

Consider just one art: music. It may have started with crooning dialogues between mothers and children or been inspired by a desire to emulate birdsong – perhaps in the hope of learning the secret of flight in soaring melodies! It has been a branch of mathematics and physical science (serving the dream to access heavenly harmonies and find the very substance of the world). And it has been used as an adjunct to warfare, to courtship, and to the major and minor ceremonies of the tribe.

Perhaps the strongest element in the case against any universal theory of art is the changing relationship between art and that other great expression of human metaphysical (and alas other) impulses – religion. Art was at first not clearly separated from religious ceremony, the invocation of the gods and their appeasement. Music and dancing were most fully elaborated as an integral part of religious ritual. Greek tragedy, the ancestor of much literary art in the West, emerged from the annual Passion of *Dionysus*, 'the ritual play in which the *dromenon*, the thing done, was the sacrificial

slaughter of the god, either in human form or as a bull'.[44] Dudley Young has even suggested that art and religion had a common origin in the rain dance of our chimpanzee ancestors. When art did become distinct from religious ritual, its main themes were religious and its function was to serve religion and, through this, celebrate, reveal and elaborate the power and glory of the gods – or God. This remained true from the Dionysian tragedies of the Greeks, through Byzantine and Islamic painting, to late mediaeval art, whose exponents were the anonymous servants of the church. It was only with the Renaissance that the making and enjoyment of art fully crystallised out as an activity separate from religion. Human figures and perspectives seemingly true to actual human perception increasingly displaced religious figures painted in a conventional, iconic fashion that had little to do with sensory experience. Although religious themes remained important, they were approached increasingly from the outside until, by the twentieth century, they have been reduced in many instances simply to a means by which an artist may confer greater resonance upon his work or measure his distance from the past.

There are many ways of characterising the journey of art away from religion. Here is one trajectory. With the changing theme and function of art, the artist emerged as a creator in his own right and his work was increasingly related to a source of secular patronage: he painted to commission. When patrons were kings and aristocrats, there was still a remote connection to religion, not only through the conventional commissioned themes but also through the convergence of upper state and church, most explicitly in the divine appointment of kings. With time, wealth rather than title became the defining characteristic of the patron. The divine appointment of Moneybags was less easy to sustain. The demystification of the patron and the romantic rebellion against the standing and values of the ruling class reinforced one another and paved the way for artistic resentment at the untalented power-brokers to whose commissions artists worked and the emergence of the rebellious egocentric, even demonic, artist as antipodes of the anonymous Gothic craftsmen. The artist served inner gods remote from, and at odds with, the society in which he found himself and its secular and sacred gods. The divorce of art from religion was completed in the separation of the artist from the very society which sustained him. This was particularly clearly evident in the evolving self-image of the French poets of the Nineteenth century. The proud and sterile

The Difficulty of Arrival

isolation of the 'knights of Nothingness' (as Sartre dubbed Mallarmé and some of his fellow symbolists) emerged as a result of the interaction between the continuation of the romantic dream of the poet as *mage* and an increasing scepticism towards the social mission of the artist (and the humanitarian optimism as regards progress that lay behind it), a loss of faith in man and god and a hatred of vulgar reality.

Music, perhaps, was secularised earlier because it travels more easily: it can be overheard. As early as the sixth century BC 'Individualism was in the air and convention suspect; and the interpreter of a tradition intimately associated with religion became a virtuoso bent upon giving pleasure to an audience' and Terpander 'impressed his individuality upon the traditional [melodies] so that they were handed down as his personal compositions'.[45] Even so 'serious' music – or highly organised musical occasions – intended for edification and entertainment is relatively recent. There were no purpose-built music rooms in London until the end of the seventeenth century. And music for pleasure as we now understand it – serious music as readily and widely available as humming or drunken singing at a party – has been dependent on advanced technology: the privileged experience of the king and courtier is now available to all. Indeed, the privileged condition may now seem to be to escape it.

The evolving relationship between art and religion may be seen more clearly in the case of painting perhaps because, unlike music, paintings, until recently, did not travel: they could be seen only in the places for which they were commissioned. The development of a secular literature was slowed by another constraint on dissemination: the requirement that those who enjoyed it should be literate. It remained therefore largely the province and privilege of the aristocratic and priestly castes (and the latter's successors, independent scholars) until literacy was more universal. The essential lineaments of the evolution are the same:

(a) priest invoking the sacred ⟶
(b) artisan/craftsman serving religious institutions ⟶
(c) artist/craftsman serving aristocratic/churchly patron (serving his own rather than God's pleasure) ⟶
(d) artist/craftsman serving bourgeois patron ⟶
(e) bitterly independent artist hostile to the secular and (perhaps) the religious values of the society in which he finds himself.

The great journey from the undifferentiated participant in a religious ritual to an assertive individual who, according to Sartre, writes only for himself is a measure of the distance art has travelled from its origins in religion. This distance is not cancelled by certain set-piece attempts to return art to its ritualistic beginnings in carefully time-tabled presentations in subsidised theatres: there is an entire world and several millenia of evolving self-consciousness between helpless and unreflective immersion in the terrors and ecstasy of ritual and attempts to revive it in the Dionysian frenzies of the Theatre of Cruelty supported by the Arts Council.

Anyone, therefore, who believes the function of the cave paintings in Lascaux to be the same as that of a novel by Virginia Woolf, a poem by John Ashberry or even a painting by Jackson Pollock is obviously deluded. My thesis does not require subscription to this delusion. As we follow art in its crystallisation out of religious ritual – as when, for example, the ritual is formalised in liturgy and liturgy gives way to drama and the *missa solemnis* becomes oratorio – and follow the displacement of explicitly religious values by aesthetic ones (with some harking back to the transcendental validation of religion) – and the ebbing and flowing of the emphasis on fun and entertainment and the parallel fluctuation in the relationship to the patron – we see mighty transformations of the contents, the function of and the discourse about, art. The function that my thesis emphasises – the perfection of the experience of an individual considered in his or her solitude – is individualistic. It would be absurd to suggest that this has always been its function and perverse to deny that art may have begun as something quite different. Tribal poems and chants, Homeric narratives, the psalms, are communal not individualistic, and the 'recipient' is not so much a consumer as a participant, one who is immersed, engulfed, consumed. It is important to recognise a past in which art was inseparable from the religious response to the terrors of life that, for example, gave birth to the Dionysiac rituals designed to help men to forget their solitude in the face of death, physical threat and the infinite heavens. But to concede this is only to say that art has its roots in something quite different from what it has become and that it has become quite different from its quite different roots. There is as little connection between tribal chants and a chamber concert as there is between a rain dance and a grant application to the Science and Engineering Research Council. How far cultural activities should be governed by memories of their roots is a difficult issue.

But as things stand, art is far from its religious and ritualistic and communal origins and a theory of art should not have to pretend otherwise.[46]

Admitting this does not require that I give up my thesis, only that I should not pretend that it is universal. Mine is not an account of what art always has been and should always be, of the eternal essence of art. More modestly, it is a theory of what art is now, with the scope of 'now' remaining undetermined – at least a century or two. And it is linked with my position that the social functions hitherto attributed to art – religious, moral, political, education, informational – are now, in the West at least, secondary. If there has been a time when they were central to the purpose of art, this has now passed.

It is hardly to be expected that there should be a single, for-all-time answer to the question of the function of art. After all, 'art' is not a simple concept: it may be best thought of as a complex or nexus of ideas. Moreover, the attempt to determine the purpose of art may have more than one motive. It is not impossible, for example, that a theory of the function of art may be as much a statement of what one thinks art **ought** to be, or of what one would like it to be, what one would like it to do for oneself, as an account of what it is or does or is generally accepted to do. The term 'art' is a placemarker that holds open a certain amount of territory available to be quarrelled over by all sorts of worthy causes and high principles. It is a rallying cry or a forming-up position for rallying cries: 'Art is the collective's deepest mode of self-discovery'; 'It is the light that leads the way to a more just society'; 'It is that in virtue of which self-completion is possible'; 'It is a means of reasserting the shared values necessary to maintain the cohesiveness of society'. This is what it is..or what it should be . . . or what I should like it to be . . . etc. The distinctions are blurred.

Anyway, I concede that my thesis has a limited historical scope. The question arises as to whether my emphasis on **the** moving unmoved of form can accommodate the more recent past and the present – modernist art, which emphasises the decay of form, and post-modernist art, which takes this for granted and mockingly mixes incongruous forms. An obvious response is to argue that works rebelling against traditional forms and defeating expectations based upon previous aesthetic experience are themselves asserting new forms and making possible new aesthetic experiences: anti-forms are the emergent forms of the future, for it is the way of art

that the form of its forms will change. The trouble with this easy response is that, by recuperating all deviation from form for form itself, it makes the theory invulnerable to disproof. It is better, perhaps, to point out the empirical fact that the subversion of form is only a small part of the current preoccupation of art. Much contemporary music, for example, is concerned with explicitly developing new forms which, like the old, are based on symmetries, contrasts, etc. (though utilising a greatly extended portfolio of acoustic possibility) – sometimes, one is tempted to think, to the exclusion of pretty well everything else. Formal organisation is central to, for example, Stockhausen from *Kreuzspiel* onwards, to Messaien, Boulez, the West Coast Minimalists, Schnitke, Harrison Birtwhistle. . . Admittedly, in some cases, it is easier to find the form in the programme notes than in the music, and it seems less a matter of *forma informans* than an exoskeleton or a *post hoc* rationalisation. In this century, poetry has often seemed to play on the extreme verge of form, in the littoral zone where organisation gives way to a stochastic series of elements matching the randomness of thought, public events, private recollection and present experience, where structure crumbles to bric-à-brac. Even so, there is an implicit invitation to discover form in, or impose form upon, the scattered fragments; we are offered, that is to say, an 'open form', or an assemblage of disjunct items that we are at liberty to synthesise into a unity. Examples that spring to mind include Great Moderns like Pound as well as more recent figures such as Ashberry. Of course, the appreciation of these open forms depends upon previous experience of closed forms. The closure is provided by the reader whose previous experience has led him to expect a completed form. Such works are not as simply parasitic as the effect of the following

> There was an old man in a tree
> Who was horribly bored by a wasp

is upon the expectations trained through exposure to a thousand limericks. No; they play at a much deeper level with the expectations of organisation and unity; they reach beneath a critique of art to an exploration of the aestheticising and organisation principles in consciousness itself. But they are, nevertheless, in some sense secondary. They remain forms that rely upon the expectation of form. And, although they examine our idea of form, many modernist (and even more post-modernist)

works merely allude to forms and in this sense fall short of the requirement to 'make it new' – to make new harmonies out of old dissonances, new expectations out of old surprises, new conventions out of old rebellions.[47]

The theory I have put forward, therefore, while not pretending to be a theory of the eternal function of art, is applicable to the recent past, to the present. I also believe that it will apply to the artworks of the foreseeable future – as I shall discuss in a separate work. Only a megalomaniac or a *maitre à penser* could hope to do more than that.

'Stationary Blasts'[48]

The occupational hazard of aestheticians is to suggest that art is utterly different from all else in life. They forget that art is rooted in ordinary experience (and if it wasn't would be as inaccessible as tensor calculus) and in non-artistic activities. This is true in a narrow, literal sense: the art-song has originated from the hymn and the folk song; the poem from ditties, anecdotes, and shared village gossip; the Great Canvas interacts with the lesser canvasses of the cartoon, the scrawl and the daub. But it is also true in a much wider and deeper sense: the pleasures and delights of art reach into other pleasures and delights, into play in a wider sense, and many less respectable sources of joy and terror and heightened consciousness. The tendency to exaggerate the extent to which art is set off from the rest of life is manifested in the tendency to talk up art and talk down life, so that art seems to be the repository of all that is worthwhile in life. I have already dealt with the 'talking up' of art, particularly in 'The Myth of Enrichment'. I now want to address the talking down of life and in particular to distance myself from the suggestion that art alone can afford aesthetic experiences.

Consider the thesis that at the heart of the aesthetic experience is the revelation of the 'moving unmoved'. The moving unmoved can be found outside of art. In nature, it is exemplified in the 'stationary blasts of waterfalls' and 'woods decaying ne'er to be decayed', in the repeated rhythms and spatial harmonies of the sea, in the great views that permit our eyes to encompass a multiplicity of objects. In daily life, where the perfected moment points beyond itself and reaches deeper into itself, it is found in the beauty of the human body. All living things are sites of change that, nevertheless, retain their unchanging shape: they are, as Gowland Hopkins so brilliantly said, 'polyphasic systems in dynamic equilibrium'.

One cannot deny the presence of the 'moving unmoved' in nature; nor does it make sense to maintain that there is an absolute difference between the spontaneous beauty of life and nature and the manufactured beauty of art. If the beautiful did not exist outside of art, or could not be perceived outside of it, it would not exist or be perceived inside it, either. Of course, the statue of David is beautiful not only because David is beautiful – because it merely replicates something that was beautiful in itself. The statue is an idealisation. Moreover, representation permits contemplation: the work of art allows its object to be experienced independently of the requirement to act upon it, as Schopenhauer suggested. Even if we accept Nietzsche's bitter critique of this view, we may still retain the less specific claim that art uproots objects from the contexts in which they are normally dissolved or buried, the framework, the conventions of our perception, that make them invisible. (The term 'object' here is intended to encompass a thing, a person, a situation, a landscape, a section of the world.) In this way, we might say that art brings out the inherent beauty of the object. This inherent beauty is a necessary, rather than a sufficient, basis for the beauty in or of the work of art. Or, to put this less vulnerably (since artists may make beauty out of things that are experienced in everyday life as ugly, and there is a powerful aesthetic theory stemming from Kant that beauty is not inherent in things but only in aestheticising consciousness), the perception of beauty outside art is necessary for the creation of, and experience of beauty within, art. Art, however, makes that beauty **explicit**.

Although 'stationary blasts' and 'woods decaying ne'er to be decayed' – examples of the 'moving unmoved' – are to be found in nature, what are not found in nature are brilliant descriptions of waterfalls as 'stationary blasts' or of woods as 'decaying ne'er to be decayed'; nor, in nature, are these things connected with a nexus of other images from nature, with sentiments, ideas, recollections and a human being's feelings about himself and his place in the scheme of things. By this means, natural phenomena are made explicit and symbolic – as Alain Robbe-Grillet noted with such scorn.[49] The 'moving unmoved' forms of nature are developed in art, in the sense both of being made explicit (or more explicit) and in being subsumed in a wider connectivity out of which emerges those larger forms which will answer to the larger hungers for general meaning realised in embodied ideas, in 'concrete universals'. Moreover, there is a two-way process: the observations of the

poets change our experience of nature. The Lake poets not only celebrated the beauty of the Lake District but uncovered and transformed and even, in some small part, invented it; at the very least, they changed fugitive, scattered impressions into something more permanent; a still form. As the formula has it, the artist mediates between man and nature; or between humans and that which lies outside of them. The best metaphor of this process is Goethe's image of the artist as bending down to the flowing stream (an example, if ever there was one, of a 'moving unmoved') and lifting out of it a perfect sphere.[50]

The Otherness of Great Art[51]

Art is about the recovery of our experiences, either directly, as in referential art, or indirectly, as in the case of music which sets our consciousness in italics and frees us to dream of our past and of the world. Such a view runs the danger of cosifying art. Are not the 'large forms' that art makes available to us the mere echo of ourselves, the familiar image of our perceptions and preconceptions? Isn't there too much of the Self and not enough of the Other in this theory of art, too much self-affirmation and too little self-transcendence? Do we not see here a narrow, complacent aesthetic whose ultimate expression is the Podsnappery Dickens brilliantly delineated in *Our Mutual Friend*?

> Mr Podsnap's world was not a very large world, morally; no, nor even geographically: seeing that although his business was sustained upon commerce with other countries, he considered other countries, with that important reservation, a mistake, and of their manners and customs would conclusively observe, "Not English!" when PRESTO! with a flourish of the arm, and a flush of the face, they were swept away. Elsewise, the world got up at eight, shaved close at a quarter-past, breakfasted at nine, went to the City at ten, came home at half-past five, and dined at seven. Mr. Podsnap's notion of the Arts in their integrity might have been stated thus. Literature; large print, respectively descriptive of getting up at eight, shaving close at a quarter-past, breakfasting at nine, going to the City at ten, coming home at half-past five, and dining at seven. Painting and sculpture; models and portraits representing Professors of getting up at eight, shaving close at a quarter-past, breakfasting at nine, going to the City at ten, coming

home at half-past five, and dining at seven. Music; a respectable performance (without variations) on string and wind instruments, sedately expressive of getting up at eight, shaving close at a quarter-past, breakfasting at nine, going to the City at ten, coming home at half-past five, and dining at seven. Nothing else to be permitted to those same vagrants the Arts, on pain of excommunication. Nothing else To Be – anywhere!

Even if it is accepted that this is an unfair parody of the emphasis on self-affirmation rather than transcendence in my thesis, the latter may seem to encourage Mr Podsnap's sin of being one who is too much at ease with works of art: a consumer – in the sense of one who consumes rather than is consumed by art. This is hardly likely to be an adequate aesthetic if art really is to take on the mantle of religion, to act as the vehicle of a secular spirituality that would succeed 'the river of churchly truth'. Examples of art that express the other, the alien, even the monstrous, readily spring to mind: for someone like myself, this would include West African ibeji, the music of Indonesia, Sumerian literature. For the first readers of the Epic of Gilgamesh, the novels of Dickens, pop music, pre-Raphaelite painting might serve a similar purpose, had these artefacts been around in 2000 BC. In each case, however, comprehension would be limited, as it always is when we stray far from home territory. We have to recognise that our own conception of art is inescapably as narrow as the reach of our cultural presuppositions. Not only is the idea of art, and the associated ideal of beauty, relative to certain cultures; so, too, is the assumption of beauty as an ideal, as Herbert Read reminds us:

We live in a tradition of the Renaissance and for us beauty is inevitably associated with the idealisation of a type of humanity evolved by an ancient people [the Greeks] in a far land, remote from the actual conditions of our daily life. Perhaps as an ideal it is as good as any other; but we ought to realise that it is only one of several possible ideals. It differs from the Byzantine ideal, which was divine rather than human, intellectual and anti-vital, abstract. It differs from the Primitive ideal, which was perhaps no ideal at all, but rather a propitiation, an expression of fear in the face of a mysterious and implacable world. It also differs from the Oriental ideal, which is abstract too, non-human, metaphysical, yet instinctive rather than intellectual.[52]

There is an art with which one feels at home: the art of one's own cultural group, however wide that is. Only against that background of feeling at home is one open to otherness. For me, there will always be an irreducible element of incomprehensibility about the art of ibeji, if only because the rituals to which they were so central are utterly alien to me. I cannot believe what those who participated in those rituals believed. My relationship to them is, therefore, that of a spectator, of a consumer, a privileged visitor to an imaginary museum.

There is a curious inverse insularity associated with the belief that one's appreciation of art should be able to extend to all cultures throughout all of history and that one's tastes should encompass 'alien' art. This is a twentieth century view that first arose in certainly economically dominant great cultures that penetrated the world and, alongside the imposition of their own mores, values and aesthetics, expropriated those of other cultures to swell the collections of art galleries and museums; and secondly out of the development of technology that permitted the emergence of Malraux's 'museum without walls' and the great multicultural jumble of bric-à-brac to roll pauselessly through the eyes, ears, hands and minds of the cultured. It is not a view that would have been tenable in any previous periods of history. Few Sumerians would have flocked to Indonesian music festivals; the Greeks would have known little of West African culture; there is no record of the literati of Baghdad in the sixteenth century fighting over copies of translations of Shakespeare. The cultivation of the art of other cultures and the emphasis on the 'otherness' of art is new; and it is a response to a sense that the otherness has gone out of life. The Gods no longer terrify us; we are sealed in a four-dimensional continuum of unremitting rational explanation; the world, as Weber said, is disenchanted.

This is an argument not for an art of the monstrous, of the revelatory alien, but for an art that may, amongst other things, make the familiar strange; not for a universal or would-be universal consciousness mediated through alien art but for a consciousness that is fully conscious. Such an art will be primarily an art of 'recovery', of remembering, of perfected memory, of reflection. The great forms that art uncovers in our past will be a transformation of our past; an awakening to it, yes; but also, in virtue of this, an awakening from it. To represent the past and to connect so many disparate things in it in the hyperspace of fiction, in the memories

invoked by painting, in the reminscicence licensed by music that composes onself, is to transform it into 'something rich and strange'. At least part of the art of art is the defamiliarisation of the familiar, so that it may be seen. Sometimes it will be necessary to enter utterly alien territory to sharpen one's sense of the home patch, to leave the laral domain to discover it on return. But it is the return that is the most important. It is here that consciousness comes to itself and knows that, despite it all, it **is** here because it **had been** here; in the reiteration of self-presence and a more intense awareness of the mystery of being the thing one is.

This must not be taken to imply that art does not extend one's experience, widen one's sympathies and permit one to imagine into the lives and even the consciousnesses of others.[53] But this must be distinguished from the obligation to inform or to instruct. Novels may be about distant places, distant times and people who are, to 'us' (whoever we are), remote but their primary aim is not to transmit information about those distant places and times and those remote peoples. Otherwise the duties of art would be unending – or limited rather arbitrarily. If the purpose of art is to inform us of what it was/ is like in other parts of the world at different times and for different sorts and conditions of people, then it is going to have to cover thirteenth century Hanseatic merchants, cocaine barons in twentieth century South America, enslaved Helot women in Sparta, professional boxers in China, neonates with poorly controlled epilepsy in prehistoric Iceland, etc., etc. There would be no end, or only an arbitrary end, to the art-assisted exploration of the human neck of the space-time continuum.[54] Certainly art will invite us to share in the experience of others and this will encourage us to recognise the equal reality of individuals we may have been inclined to see only as background to our world and preoccupations. This will, however, still depend at least in part upon a more literal sort of recognition: recalling one's own experience and pouring that recollected experience into these others. To take a crude example, sympathising with and recognising the humanity of the Roman centurion may involve pouring into the account of his difficulties with maintaining discipline and the respect of his soldiers one's own experience of exerting authority. Or, to take another, even more crude: to imagine into the terror of the slaves working on the Great Pyramid of Cheops, one has to instil into them one's own fear of heights, of physical pain and of the terrifying gaze of ruthless authority.

The Difficulty of Arrival

Thus experiences by proxy become a way of pouring the wine of one's experience into the new bottles of another, remote individual. The more remote the character, the setting, the situation, however, the lower the ratio of inwardly illuminated, imagined reality to fact (or fiction) one can digest in the sense of imaginatively reconstructing. With the nearer to hand, the ratio will be higher and the calls on one's own experience will be greater: the template of the representation will be more receptive to one's experience. The presentation of a contemporary character from one's own culture will be to a much greater extent an invitation to **recall**, to explicit recognition of what one had only implicitly seen or had allowed to go by without full registration. Even the sense of the alien, of Dark Forces, will be derived from childhood terrors, from fear of the dark, and from other, homely but profound, sources of imaginative energy. Our encounter with the Other is transformed from blank collision to interaction in proportion as we are able to summon ourselves to pour into it.

There may seem to be a tension here between the connectivity of the work of art and the connectivity we demand in the experience that will correspond to the large idea: the former is a connectivity in an object outside of us; the latter a connectivity within us. This is particularly evident when we read fiction. If the purpose of reading a story set in Cornwall were to perfect our own experience of Cornwall, then the logic of the story would be at odds with the logic of perfected recollection: the particular events recounted in the story would have nothing to do with our experience. This apparent difficulty arises out of a misunderstanding: the perfecting of experience in art is not the perfecting of the experiences that we have actually had. If this were the case, we should all have to be provided with our own customised works of art; indeed, we should have to make our own. What the work of art affords us is a virtual experience which, because of the form which makes a unity out of multiplicity and variety, corresponds to the larger ideas, while remaining rooted in the particular – either a specific sensation (as in music and abstract painting) or a specific referent (as in literature). Where the materials out of which the work is made are referential (as opposed to purely sensory experiences), their referents will need to overlap with our own experience (by coinciding or containing common elements) or be sufficiently universal as to correspond to the potential experiences of 'anyone' (within certain cultural limits).

Producers and Recipients

The concern just raised, however, opens on to an important source of complexity – and of confusion – arising out of the different relations that the artist on the one hand and the audience on the other have to the work of art. The world the artist writes about or paints will differ to a greater or lesser extent from that of his audience. For this, and for other reasons, it would surely be surprising if a play meant the same thing to, or served the same purpose for, the individual who wrote it, the actor who played the lead role night after night, and the member of the audience who saw it once. The question this raises is too large to do justice to here but it cannot be ignored entirely in an essay that approaches art from the viewpoint of the individual's need for the perfection of experience.

Let us look at the matter first from the viewpoint of the artist. Consider the crucial passages in *Remembrance of Things Past*, where Proust connects his discovery of the miraculous power and sweetness of involuntary memory with the genesis of his art and, indeed, of the very novel in which the discovery is reported.[55] In my earlier reference to these passages, I emphasised how involuntary memory united a present sense impression and a past – and so idealised – world of memory. By this means 'that ineluctable law which ordains that we can imagine only what is absent' was 'temporarily annulled'. I connected this claim with the role of art in perfecting the moment by uniting experience and idea. But other themes are adumbrated in Marcel's meditation in the Guermantes' library. The intensive manifold of past and present belongs to neither the past nor the present, and so is extra-temporal. Nevertheless, it belongs to the self, whose extra-temporal nature is also therefore revealed. The revelation of this extra-temporal being explained

> why it was that my anxiety on the subject of my death had ceased at the moment when I had unconsciously recognised the taste of the little madeleine, since the being which at that moment I had been was an extra-temporal being and therefore unalarmed by the vicissitudes of the future. (Proust, *A la Recherde de Temps Perdu*, translated by Kilmartin, p. 904)

Involuntary memory brought with it a feeling of being safe: whatever happened to him in time, it could not touch his essential (extra-temporal) self. Even so, his life's task – that of recovering and

preserving the past in a work of art – was not superfluous. On the contrary, involuntary memory showed the way towards achieving that project:

> This [extra-temporal] being had only come to me, only manifested itself outside of activity and immediate enjoyment, on those rare occasions when the miracle of analogy had made me escape from the present. And only this being had the power to perform that task which had always defeated the efforts of my memory and intellect, the power to make me rediscover days that were long past, the Time that was Lost. (ibid, p. 904).

Involuntary memory, providing both model and material, showed the way to his book, rather than replacing it:

> it was time to begin if I wished to attain to what I had sometimes perceived in the course of my life, in brief lightning flashes, on the Guermantes way and in my drives in the carriage of Mme de Villeparisis, at those moments of perception which made me think that life was worth living. How much more worth living did it appear to me now, now that I seemed to see that this life that we live in half-darkness can be illumined, this life that at every moment we can distort can be restored to its true pristine shape, that a life, in short, can be realised within the confines of a book! (ibid, p. 1088)

Tout le monde existe pour aboutir dans un livre. Art would capture, and so confer permanence upon, the world as illuminated by the privileged light of involuntary memory. By this means, the world that had possessed the artist would itself fall into the artist's possession. Indeed, the book, by outliving the artist, would ensure the survival of the remembered world beyond the artist's own life. Bergotte is dead but lives on through his books:

> They buried him, but all through that night of mourning, in the lighted shop windows, his books, arranged three by three, kept vigil like angels with outspread wings and seemed, for him who was no more, the symbols of his resurrection. (ibid, p. 186)

The finished work is a kind of safe deposit for the author's consciousness, developing the larger, inchoate forms of daily life

and, by embodying them in a stable or repeatable object, preserving them. It might be expected that the (private) **self**-preserving, **self**-expressive function of art should dominate over its (public) **world**-preserving, **world**-expressive aspect, if it is to ensure resurrection of the artist rather than mere immortality attached to a name that has lost its body. However, these two aspects are not clearly separate, as Borges has expressed beautifully:

> Through the years, a man peoples a space with images of provinces, kingdoms, mountains, bays, ships, islands, fishes, rooms, tools, stairs, horses and people. Shortly before his death, he discovers that the patient labyrinth of lines traces the image of his own face.[56]

So much for the finished product; but even the journey towards the finished product brings its rewards, howsoever mundane and calculated and uninspired creation may often seem. The artist builds to seize the initiative from time and hence to palliate the sense of being helplessly swept to old age and death. At the very least, the process of building, howsoever difficult, frustrating, even agonising, is a distraction from death; the artist's ambition may be death-inspired, the materials may reach into the death-streaked depths of life, but the protracted struggle with memory, articulation and organisation is a powerful antidote to the terrifying thoughts that assail the reflective mind when consciousness is not pre-empted or opacified by making and mending. Not only the completed building but the process of building prevents the anguish of being incontinent of moments, of being hurried through a landscape one cannot clearly see on the way to a landscapeless blank. Building conceals the abyss more completely than the building does, though this remains journeying, not arrival.

In short, there is a double 'Salvation through Art', arising from the process of the creation and from the finished work. But wait: who is saved? Do not all the benefits accrue to the artist and not the recipient, especially where the art in question is literature: preservation of the past in a perfected form; distraction from the sense of loss and attrition and impending dissolution by building a monument to one's own life and so serving the comforting myth of one's posthumous existence; rescuing a deposit account of bibliography from a current account of loss. Yet without the reader the writer's project would be empty: his own future self would not

be enough to give his project meaning. So how relevant are the needs and motives of the artist to the function of art? The danger of paying too much attention to these things in judging works of art – and in judging something to be a work of art – is vividly illustrated by the critical habit of relating the work to the psyche of the artist (a trend whose worst manifestion is the psycho-analysis of artworks) and the parallel nonsense that is talked about 'art as therapy'. In its most pernicious and dispiriting forms, the latter moves from the claim that we all have neuroses that would benefit from the therapeutic effects of self-expression, via the claim that we are all 'creative', to the assertion that we are all artists and that the artefacts that result from our neuroses are works of art.[57]

Art as therapy confuses the benefit to the producer from engaging in more or less artistic self-expression with the value of the product to others. The fact that it did you a power of good to clear out your bowels does not enhance the value of the product to anyone else; it certainly does not make it any more attractive. Likewise, the reader or listener should not be expected to be concerned about whether making the work of art comforted the artist. Equally irrelevant is the question of whether the work came from the 'depths' of the artist: what matters is whether it reaches the depths of the individual reading, looking at or listening to it. In a sense it is others who determine the depth of the work, just as it is others who determine the objective value of one's thoughts – as Musil pointed out. Art belongs to World 3 (see note 42), to the world of the objective mind, or of the mind objectified in cultural products.

From the point of view of the audience, it is not the neurosis (or even the metaphysical hunger) that drives a man to write or paint that matters so much as the talent. The two may not go together: there is no reason why a heightened sense of our incontinence of time and of the death towards which we are helplessly swept without ever being properly or fully **there**, in our lives, should co-exist with whatever it is that makes for a sense of musical structure or fluency with a pencil. There will be many who have the metaphysical drive to create art without the necessary talent; others who have the talent without the metaphysical drive. For great art, both are necessary.

In saying this, I am trying to avoid the absurdities – and chat-show tedium – that results from approaching the work of art solely from the perspective of the artist – from the standpoint of his or her needs. Why the artist is driven to create is surely of limited

relevance to the meaning of art for the audience and so to the meaning of the work. There will, however, be important areas of overlap. First, the reader or listener has, in order fully to partake of the work of art, to recreate it, to re-produce it, in himself. The reader fully alive to the full meaning of a novel participates in the act of creating it; the listener of the music constructs, as well as discovers, its form in himself.[58] Secondly, the world invoked in literary art is a shared world. The elements and some of the major patterns will be common to the writer and his readers. When he perfects his experience of his world, when he preserves that world, in his works, he is perfecting our experience of our own world, saving **our** world from extinction. In other words, the author's perfection of his experiences offers us a way of perfecting our own similar experiences – or, by contrast, our dissimilar ones. When I read Proust, his perfected past is the perfecting of my past.

This must not be taken, however, to suggest that a novel – or any referential or representational form – is a device for triggering daydreams, for turning us inward on ourselves. If this were the case, there would, as discussed in the previous section, be a constant tension between the direction of the work of art and the organisation (or disorganisation) of our memories. We would be constantly 'drifting off' like an inattentive schoolchild dreaming of escape from the classroom, and would not have that cumulative interaction with the work that would reveal the form to us and enable us to participate in it. No, Proust's prose mobilises elements of our past to fill his shapes that will add up to the great shape of his novel. Of course there will be much in his novel that will not correspond to anything in my own experience – it will contain things I know 'by description' rather than by 'direct acquaintance' (to use Russell's distinction) – but there will be sufficient overlap to seduce me into pouring myself into a realisation of the work in a reading. Where there is no coincidence of experience between writer and reader, there can be no reading, only incomprehension. In the case of (non-referential) music, the perfection of the present moment through the union of form and the instant of content does not require sharing of experiences – except perhaps of experiences of the musical form in question. In either case, the formal structure that brings so much of the variety of the world together into a portable mind-ful will liberate me to delighted contemplation of my own world.

My argument is that there is sufficient overlap of the situation and the role of the artist and audience to give face validity to a theory of

art that encompasses them both.[59] Nevertheless, it is possible to develop a totally different – somewhat more pessimistic – view and suggest that the essential audience of artists is composed of other artists, just as philosophers speak largely to other philosophers and mathematicians to other mathematicians. This is worth exploring a little, if only as a corrective to the sentimental counterfactual claims that 'art has universal appeal', speaking, as Coleridge said of Shakespeare, 'for all men, in all places, at all times'.

Let us take seriously the idea that the artist is driven by a metaphysical hunger, by an unremitting hunger for completion of the sense of the world in a perfected experience that will answer to the need – not otherwise met in everyday life – fully to be there. Such a drive does not seem exactly pandemic in the human race; few seem haunted by an insufficiency of meaning; or not at any rate very often. And when they are, they do not recognise it as such. Appetites and their satisfaction or frustration, hopes and ambitions, fears and griefs, ordinary gossippy interest in things satisfy most individuals' need for meaning and give them a sufficient sense of being there; moreover, they have the strategies discussed earlier for dealing with the threat posed by the Kingdom of Ends.

Those who share the postulated metaphysical hunger of the artist are therefore in the minority. Now consider the more specific claim that art is to take on, or has taken on, the mantle of religion, that it is an attempt to create meaning or meanings as great as those which were once carried by the Word of God – or, at least, by the word 'God' – experiences as solid as the terrors and ectasies of the true believers. A truly serious artist in a post-religious society will be engaged in creating something that will fill the great hole in meaning left by the departure of God. This, too, is clearly not a preoccupation of the majority – or there is little sign that it is. It may be that in a secular society, that single great hole in meaning – which cohered through the idea of a God beyond the reach of our knowledge and imagination – no longer exists but has been diffused into a thousand insufficiencies; so that it becomes an additional preoccupation, or secondary function, of the artist to restore the gap in sense that has been scattered into individual occasions; now that the 'distant, difficult' God is no longer there to be a focus for our sense of the incompleteness of sense, to bring all the insufficiencies of experience together into one great emptiness, not only to respond to the metaphysical hunger but to cultivate it and keep it alive as a driving force.

Whether or not this is the case, the salvation the artist seeks through art is not needed by most of his audience. But if they do not share his hunger (or his hunger for a more permanent and more ultimate hunger than his cycling appetites, for a more permanent preoccupation than the small change of his projects), how is it that art commands such large audiences? An obvious analogical question springs to mind: how, if so few people were prone to visions of God or could be described as in any continuous sense spiritual, were the churches so full and so many individuals involved in churchly activities? The answer may be similar in the two cases.

The Church was a major centre of power. Conformity to the demands of the church was necessary for survival and, for some, was a source of livelihood, authority, power and glory. Art, too, is a social institution and involvement with it may bring a livelihood and a certain amount of social cachet. And for school children and some university students simulating an interest in and engagement with the arts it is necessary for success, even survival. Art supports arts adminstrators, educators, academics, journalists, impresarios, entrepreneurs and, not the least numerous of these, non-artists embarked on a career as artists.

Surely art cannot owe its prominence and prestige simply to a huge, groundless prejudice in its favour reinforced by educators, self-improvers, auto-didacts, the honestly deceived who try art for a while before admitting defeat and returning to less taxing recreations, by the snobs and show-offs attracted by the mystique or social cachet carried by the idea of art and by the vast numbers who earn their living directly or indirectly through it. All prejudices, after all, have some original basis. The basis for the prejudice in favour of art is the fact that the meanings artists play with and try to perfect in their art are borrowed from everyday life. Consider Balzac. Supposing we imagine him trying to fill the terrible emptiness of his life, to deal with his sense of not being quite there, by possessing the entire world and bringing it together under the great form and idea of his *Comedie Humaine*.[60] The meanings he uses, the experiences he incorporates into his novel, are ordinary human meanings and experiences revolving round ordinary human appetites – sex, greed, cruelty, ambition. His creative drive may come from a desire to surpass them all; but they are the substrate upon which it operates, the material through which the great forms are revealed. His audience need not share his hunger or his vision

but may feed upon the food his emptiness consumed in its attempt to satisfy a greater hunger than experience could meet. His readers are not obliged either to consume as a whole the work that answered to Balzac's hunger for an overview of his world, for a culminating vision, his totalising drive to possess the entirety of the reality that so possessed him.[61] The reader may find an inattentive plot-following sufficient to his own needs. If a novel participates in both metaphysics and gossip, one may read it once for the the gossip – who did what to whom – and one is not obliged to re-read it to satisfy the metaphysical hungers that may have motivated the artist.

Great art, in short, is entertaining. Most of those who consume it will do so for the sake of the entertainment it affords (as well as for all the other secondary reasons, hinted above, that people choose acknowledged great art rather than the popular music, fiction, painting etc. of the day: curiosity, desire for self-development and education, snobbery, desire to have read, to have possessed, visited, toured, compulsion, desire to win approval, to impress etc). Until recently, secular artists have **had** to be entertaining in order to earn their living and get a hearing. Great artists have always had the option to be mere entertainers; that they have chosen to be more than this has often (but not always) been at the cost of success. Beethoven could have written any number of more acceptable pieces than those he wrote; there was no need for him to make life more difficult for himself by composing the mighty works – the Ninth Symphony, the Missa Solemnis, the late quartets and piano sonatas – that he produced at the end of his life. He could have poured out quantities of best-selling *tafelmusik*. Only his desire to take things to the limit, to create massive forms that would constitute a new world equal to the one that had him in its grip, only his metaphysical hunger, made these works the agonising and self-destructive necessity they were. Kierkegaard's description of the poet as 'a man who pours out the agony of his soul but whose lips are so fashioned that he produces ravishing music' seems absurdly, almost embarrassingly romantic and self-romanticising, but does capture the distance between the artist and audience, between the writer driven to write by a metaphysical hunger and the ordinary reader, reading to kill time, entertained by his works.

I exaggerate the gulf that may lie between the artist and his audience. But if one is going to make, as I have, strong claims for the deep origins of art, while at the same time presenting the reality of consumption in the way that I have in 'The Myth of Enrichment', it

is difficult not to think sometimes of the audience of non-artists as an innocent party caught in the cross-fire between artists – or of artists talking to themselves. The ratio of those who feel the hunger which art can satisfy to those who engage with art in some way or another is probably about the same as the ratio of mystics to churchgoers.[62]

Such a view of art may impress as merely élitist. And so it is, inasmuch as it maintains that the essential purpose of art is to meet a need felt continuously and deeply only by a few, and that most of those few will be artists (or perhaps philosophers and occasionally scientists) themselves. Insofar as art has wide appeal, it does so in virtue of other things than its answering to a metaphysical need. But it is not élitist in the negative, exclusive sense of the term. The metaphysical hunger to which art answers is universal, but in many it is overshadowed by more brutal hungers, more searing preoccupations. Historically, where that hunger has not been extinguished by more basic ones, it has been appropriated by religion which brings in its train many non-metaphysical preoccupations – of doctrine and denomination, of power, of morality, of group identity and other modes of social conformity – that have all but cancelled the metaphysical element and have led to the discrediting of religion. Now, in a secular age, there is much that can be found to suppress, or pre-empt, the metaphysical preoccupations of the Kingdom of Ends. Our Camcorder moments are but one of many manifestations of our avoidance of the metaphysical obligation opened up by the mysterious unoccasioned gift of human consciousness. No-one, however, is excluded from participating in the great adventure of art. Along with science, it is the major force for changing the outlook of humanity and reforming humankind's self-image. While most do not feel the need for the salvation offered through art, art (and science) create the future of human consciousness in its long and ultimately meaningless journey into newer and deeper and richer meanings. The visionaries change the world in which the non-visionaries of the future will live.

CONCLUSIONS

I have presented a theory of the function of art in this present secular age (or – if it should be questioned whether an age that is

riddled with superstitions and sects and marked by the rise of religious fundamentalism – a theory that **would be** suitable for a secular age). The geographical and cultural boundaries of 'this present secular age' are ill-defined; but I hope I have sufficiently hedged about my theory with qualifications to make it clear that I do not think that I have revealed the eternal meaning of art. Art is part of human life and, as the conditions, the preoccupations and contents of human life change with technological, political, intellectual, spiritual and other revolutions, so too will the nature and purpose or purposes of art. The immediately preceding discussion of the complex questions surrounding the different relationships of producer and recipient to the work of art should alone be sufficient to condemn any brief account of the function of art as an almost laughable simplification. Nevertheless, I stand by its basic premise: that the function of art at the present time is to be found not in any useful purpose – in education, in a social mission to reform the private and public morality of mankind, etc. – but in The Kingdom of Ultimate Ends. Art addresses the famous question in Mill's *Autobiography*:

> In this frame of mind it occurred to me to put the question directly to myself: 'Suppose that all your objects in life were realised; that all the changes in institutions and opinions which you are looking forward to, could be completely effected at this very instant: would this be a great joy and happiness to you?' And an irrepressible self-consciousness distinctly answered: 'No!' At this my heart sank within me: the whole foundation on which my life was constructed fell down. All my happiness was to have been found in the continual pursuit of this end. The end had ceased to charm, and how could there ever again be any interest in the means? I seemed to have nothing left to live for.[63]

Since there will never be a time when all that needs to be done in the Kingdom of Means has been done, the preoccupation of the artist will always be premature: art presupposes that material needs can be forgotten or shelved for a while, and answers the emptiness that threatens to haunt the Kingdom of Ultimate Ends where experience is sought for its own sake. The very existence of art and mankind's preoccupation with it, therefore, is a scandal.

I am also conscious that, in determining the place of art in life, I have, as I have said, tended to talk up art and to talk down life. (This

is an occupational hazard of aesthetic theorists.) Nevertheless, I still feel that my position is sufficiently robust to perform the job marked out for it. For the point of my thesis is to protect or liberate art from theories that would subordinate it to some other, non-artistic purpose; to suggest that art, like consciousness, is *sui generis* and so cannot be reduced to a function, least of all to some useful function. If we need art at all, it is not in order to be better behaved, better educated (whatever that is), to make better political decisions or even to overthrow tyrants, but in order to be more completely alive.

We need art because we cannot experience our own experiences; or feel that we cannot do so to the high standards set by memory and anticipation – those modes of consciousness that are so much closer to ideas than is the mêlée of current-account experience, and that within our consciousness create the ideas of what it is that we experience, or what experience should be. We could never attain those standards because the specification for experience outlined in ideas is at once too vague and too precise: from this perspective, the taste of beer is unsatisfactory not for some remediable cause (such as that it is too vinegary) but for the irremediable reason that it does not correspond to the idea of beer. As Sartre has put it,

> Our feelings and acts are always ambiguous and confused – something inside us obstructs their development, or interferes with them like static on the radio. Tragedy is not lived tragically nor pleasure pleasurably. The need to write is fundamentally a quest for purification.[64]

There is a tension within human consciousness between the particular experience, firmly rooted in sense perception, and the generalising propensity of the mind, expressed not only in explicit intellectual products such as abstract propositions but also in anticipation based upon personal memory and acquired knowledge. The sense-making, generalising property of the human mind opens it up to the intuition of a sense that is uncompleted in sense experience. This creates a longing for particular experiences that will realise ideas, experiences that know themselves without thereby being distanced from themselves. The great forms of art, realised through particulars, the concrete universals of the masterpieces, unite the changing world of sensibilia and particulars

The Difficulty of Arrival

with the static world of intelligibilia by a closer union between events and structure, in the moving unmoved of form.

Ideas have immense scope and at the same time they are uninhabitable; ordinary experiences – even pleasurable experiences, experiences sought in the Kingdom of Ends for their own sake – are socketed in the parish of the moment but have the saving grace of solidity, of actuality, of being of things that are outside of, and so transcend, ourselves. Art mediates between the two, enabling us to experience ideas – whether they are ideas in the narrow formal sense of abstract propositions, or whether they are ideas in the wider sense of the notions served up through memory and anticipation. This is the essence of beauty in art; for beauty is, as I have said, a tor on the plain of consciousness. I have already referred to the 'Intellectual Implex' of Paul Valéry in 'The Myth of Enrichment':

> If we think of art as a means of enabling us to rise above experience without leaving it, to enjoy it at the level of general ideas at the same time as we are immersed in it through the particulars of sense or of memory; and if we consequently think of it as a tor on consciousness, as a means of possessing the world from a privileged viewpoint, then 'the **intellectual** implex – which means the greatest possible number of connections and associations' – may be the point where the fantasy of the enriched self and the reality of the perfected moment may meet. If the function of art is to recover oneself at the level of reflection, to possess as much of oneself as possible, to remain rooted in the particular while enjoying the bird's eye view of the general idea, then the intellectual implex, which establishes 'a significant tension among ideas and questions that display maximum presence and suggestiveness' may answer to this. This is, I believe, a less vulnerable interpretation of the deepening effect of art: depth is translated into connectedness; into compressed extensity; into *gedichte*. ('The Myth of Enrichment', pp. 181–2)

Through the mediation of form, of connectedness, great stretches of our experience and knowledge are unified into something as great as the immensities sketched in ideas: we rise above our lives to a high viewpoint upon them. This effect of art has been powerfully expressed by Flaubert:

When I reach the crest of one of his [Shakespeare's] works, I feel that I am high on a mountain: everything disappears, everything appears. I am no longer a man, I am an **eye**. New horizons loom, perspectives extend to infinity. I forget that I have been living like other men in the barely discernible hovels below, that I have been drinking from all those distant rivers that appear smaller than brooks, that I have participated in the confusion of the anthill.[65]

We become as great as the notions that taunt our experience with insufficiency. The experience of art thus answers to our desire really to be where we are, to coincide with ourselves.

If there is one constant in the history of art, it is the function of art as **the great mediator**: between man and God; between man and Nature; between the individual and Society. But the greatest and most profound of its mediations – and the one that underlies the others – may be within us, between ideas and experience. This is the sense in which art has assumed the mantle of religion in a secular society. Beneath the common concern with the ultimate ends of life there are, however, important differences. Art does not import into life the burdens of duty that religion does: for example, the duty to acknowledge and dedicate one's life to one's Maker. And while art is metaphysical in function, it does not have the metaphysical – the transcendental cognitive – content of religion. It does not offer the terror and the comfort of the traditional doctrines about this world. But it is difficult to mourn these differences of art as limitations.

We need art, then, in order to address the most intimate tragedy of human consciousness – that of never having been quite there; to provide a temporary cure for *l'imperfection incurable dans l'essence même du present*; to offer intermittent relief of our permanent condition of never having arrived. We know that in actual life we cannot arrive. And yet again and again we surprise this hunger for arrival, for more mindfulness in ourselves. Arrival in this sense is at least as important as education or preaching or politics or all the other things that art does so badly and other things do so much better. Art is useless: as Sartre pointed out, 'the world can very well do without literature. But it can do without man still better'.[66] Useless and necessary, art, like holidays, is about experience for its own sake – but, unlike holidays, such experience perfected. So let there be art, rounding off the sense of the world, celebrating the wonderful and beautiful uselessness of human consciousness. Let walking know and perfect itself in dancing.[67]

Postscript: Art, Science and the Future of Human Consciousness

The story of this book has been about the present and the past. It has also been about the gulf between what we have called (in the conventional and convenient but perhaps over-simplifying shorthand) 'The Two Cultures'. I should like to end with a brief glimpse into the future and to speculate about an increasing convergence between the 'useful' sciences and the 'useless' arts.

My position may be caracatured as being about the contrast between a useful but spiritually unrewarding science and a useless but spiritually nourishing art. Such a caracature confuses science with its application in technology and is more confident than I would wish to be in dismissing the civilising, and hence indirectly useful, influence of art. Science at its highest level is rich in illuminations about the nature of the world into which we are thrown and about our own nature. What is true of mathematics – that it is at once a tool, a vision, and a form of intellectual music – is true to a lesser degree of science as a whole. I say 'to a lesser degree' if only because science is always more provisional than art (science progresses, art does not), it is always *en route*. Science is still awaiting its definitive meanings; whereas plenitude of meaning (even if those meanings are discarded) is the essence of art. The preoccupation of artists with what lies on the far side of use, as if the material needs of human beings were already met, is both the glory and the scandal of art.

Nevertheless, we may see the arts and sciences as complementary and co-operative. The noble hope that drives science – in addition to the dream of total understanding – is that technological progress will ultimately alleviate the burden of material need. This may result in a greater proportion of the human race being able to participate in art and feeling the metaphysical ache that is the ultimate occasion of art. To paraphrase Brecht, grub first, then aesthetics. The achievements of science in alleviating the permanent condition of scarcity in which most of humankind has lived will permit more and more of us to dwell in the Kingdom of Ends where the arts find their role.

There is another point of convergence: art will be essential to enable us to come to terms with a world transformed by science and technology. The technology of the future will continue its work of radically changing the conditions of normal human existence – not only our relations to material nature but our interactions with one another in labour, love and the exercise of power and responsibility, and our sense of human possibility. And, finally, the evolving conceptions upon which science and technology are based will change our sense of ourselves – of who and what we are. So science will increasingly share the metaphysical responsibilities of art. Its 'experiments of light' will influence the general understanding just as its 'experiments of use' have transformed material life. As in the past, science will be more than simply a means by which humanity is liberated from eternal enslavement in the Kingdom of Means. Although many of its notions may be difficult, even impossible, to inhabit – after all, they are remote from subjectivity – and we shall still look elsewhere for liveable meaning, this may be less the case in the future. Changes in this direction are already evident in the science of the very large and the very small, with cosmology and particle physics generating deep questions that resonate thoughout discussion beyond the laboratory and the observatory. We may perhaps hope for, and certainly should work towards, a Utopian future – real or imaginary, who knows? – in which there will be a convergence of the Two Cultures towards a single rich culture that will encompass them both.

Plato famously asserted that 'the unexamined life is not worth living'. (In contradiction to Plato's own hostile view of art, I believe that art is central to 'the examined life'.) The supposed worthlessness of the unexamined life is a difficult and dangerous doctrine and may have encouraged an uncaring élitism among thinkers over the millenia, and a contempt for the unreflective majority. For all but a tiny minority throughout history, the exigencies of survival and of ensuring the survival of one's children, the threat of physical or mental ill-treatment by fellow human beings, and the fear of the pain inflicted by illness or natural disaster, have placed 'the examined life' out of the question. Those few whose lives have been 'examined' in Plato's sense owe this to a series of happy accidents and to the support and labours of those whose lives have been unexamined. Even professional thinkers, who may feel they live an examined life, are only intermittently

reflective; the standing achievements of the curriculum vitae belie the episodic nature of thought. Many others whose lives could have been lived reflectively do not choose to reflect in any sustained way. Hitherto, the examined life, and art, have seemed important or essential only for a small group of individuals; those for whom the 'wound in the present tense' discussed in 'The Difficulty of Arrival' is a sufficient preoccupation to require treatment. For the rest, bread and circuses are enough and art has played a minor role in their lives, except insofar as it pays for their bread or can be enjoyed like a circus.

Let us imagine a future different from the past. What will be the role of art in a world in which human beings are increasingly liberated by technological advances from the exigencies of organic life and the sweat of toil and are, at the same time, uprooted from the here-and-now? One possible consequence of the Information Revolution – where the form of experience may be transmitted without the transplantation of bodies – is that access to varieties of experience (including experience for its own sake, as in art) will be less and less dependent on the individual's being in a particular place at a particular time. Reality – in the form of its electronic and symbolic representations – may be increasingly 'table served'. This may be taken further: Putnam's Brain-in-the-Vat thought experiment and our increasing knowledge of the neurophysiology and neuropharmacology of mood and perception remind us that 'experience' may be created within, rather than served up to, the nervous system.

The liberation of experience from place is inherent in the very nature of consciousness. Aristotle pointed out that perception itself involved receiving the form of the perceived object without its material substance. And philosophers have long claimed that there is an intrinsic generality in the contents of perception. This raises the possibility of a customised artificial reality (along with the required or desired moods) created within the nervous system irrespective of the reality outside of it, a prospect that is both exhilarating and sterile, desolating and liberating. The reduction of the world to an enormous theme park served up in a data glove; the use of recreational drugs; and the transformation of the means of production, the means to power and the mechanisms of social interaction are all logical consequences of the autonomous development of consciousness independent of nature. They are

late expressions of man's unique ability to free himself from organic constraint.

By reducing the dependency of the content of consciousness on the material here-and-now as opposed to symbolic and general representations, however, the age of electronic reproduction threatens to undermine the here-and-now altogether, to cast consciousness adrift on a co-ordinateless sea of quasi-experience. The affirmation of the deictic particulars of one's own world, a world seen to be more than a mere instantiation of possibility, will be crucial to the future equilibrium and health of human consciousness.

Art, which mediates between the general idea and the particular event or experience – and hence historically between man and God, man and Nature, man and Society – will take on increasing importance. The 'moving unmoved' of form will figure ever-more significantly in the future of consciousness as it moves towards its unknown and probably ever-receding destination. Whereas art in the past has been the concern of a privileged few, in the future it will slowly move to a central position in human life. In the Kingdom of Ends, art, which is utopian, in the sense of assuming that the Kingdom of Means has fulfilled its goals, is no longer a scandal. The uselessness of art and the usefulness of science converge in the ever-more complete realisation of the possibilities of that mysterious and useless gift – human consciousness.

This, however, is too large a subject for the present. It will be the theme of a future exploration.[1] Meanwhile, we note that the homeland of art is the Kingdom of Ultimate Ends. That is the permanent scandal within which art lives; for if there is hunger and oppression and treatable illness in the world and if millions live in unnecessary misery, there must be 'something beyond all this fiddle' with words and musical notes and canvasses covered with paint. There is, of course: there is the serious world of practical responsibility. But that is not the end of the story: there is another beyond. The transient world of practical responsibility is encircled by the permanent reality of death and the nothingness that comes with death. And there, in the space between the soluble exigencies of need and the inevitability of death, useless art finds its necessary function. With its help, we shall truly encounter the world we are immersed in, see the sea in which we are swimming or drowning. Art will not help us to swim or prevent us from drowning; it will not answer to our desire to be there forever; but it will address our need

to be fully, undistractedly, **there**. And to be there in that sense, at least once, is in a sense to be there forever.

> einmal
> Lebt'ich, wie Gotter, und mehr bedarfs nicht.[2]

To live once like the gods is enough. It isn't, of course; but it gives temporary comfort to think so.

Notes and References

Preface

1. Gayatri Chakravorty Spivak, Translator's Preface to Jacques Derrida, *Of Grammatology* (Baltimore: Johns Hopkins University Press, 1976)
2. Paul Valéry, *Eupalinos or the Architect*, in *Dialogues*, translated by William McCausland Stewart (New York: Pantheon, 1956).
3. Isaiah Berlin, *The Hedgehog and the Fox* (London: Phoenix, 1978) p. 3.
4. Raymond Tallis, *The Enemies of Consciousness* (London: Macmillan, forthcoming).
5. Matthew Arnold, 'The Study of Poetry', in *Essays in Criticism*, Everyman Library (London: Dent, 1964) p. 235.
6. Ibid. p. 235.
7. Grevel Lindop, 'Newton, Raymond Tallis and the Three Cultures', *PN Review*, 1991; 18(1): 36–42.

1 Omnescience

1. Lewis Wolpert, *The Unnatural Nature of Science* (London: Faber, 1992).
2. C. P. Snow, *The Two Cultures and the Scientific Revolution* (Cambridge: Cambridge University Press, 1959).
3. F. R. Leavis, *Two Cultures: The Significance of C. P. Snow* (London: Chatto and Windus, 1962).
4. Bryan Appleyard, *Understanding the Present* (London: Picador, 1992).
5. Alan Gross, *The Rhetoric of Science* (Harvard University Press, 1990).
6. Malcolm Dean, 'How to stop the sun going round the earth', *Lancet*, 336, 1990, pp. 615–16.
7. For critiques, see Raymond Tallis, *Not Saussure* (London: Macmillan, 1988) and *In Defence of Realism* (London: Edward Arnold, 1988).
8. C. Bell, 'A hundred years of Lancet language', *Lancet*, ii, 22/29 December 1986, 1453.
9. E. M. Forster, *Aspects of the Novel* (Penguin: London, 1962).
10. Wolpert.
11. Raymond Tallis, *The Explicit Animal* (London: Macmillan, 1991).
12. Quoted in Lewis Wolpert and Alison Richards, *A Passion for Science* (Oxford: Oxford University Press, 1988) p. 2.
13. J. G. Merquior, *From Prague to Paris* (London: Verso, 1986) p. 308.
14. Quoted in James Gleick, *Genius: Richard Feynman and Modern Physics* (London: Little, Brown & Company, 1992) p. 364.

2 Poets, Scientists and Rainbows

1. William Blake, letter to Thomas Butts, 22 November 1802, in *Complete Writings*, edited by Geoffrey Keynes (Oxford: Oxford University Press, 1969) p. 818.

2. See, for example, Erich Heller, 'Goethe and the Idea of Scientific Truth', in *The Disinherited Mind* (Harmondsworth: Penguin, 1961) for a witty and penetrating, as well as scholarly, discussion.
3. Coleridge's attitude to science is particularly complex. After his initial enthusiasm for the mechanistic quasi-Newtonian associationist psychology of Hartley *et al.*, he became disillusioned with psychological atomism. Then he dreamt of reconciling the 'mechanico-corpuscular system' of the British Empiricists with the 'organic' and 'active' philosophical psychology of contemporary German philosophy – as part of a larger project of 'reducing all knowledges into harmony'. However, he was also arguably – and very quotably – hostile to science: in, for example, *Biographia Literaria*, his philosophical *chef d'oeuvre*, where he deplored the fact that 'we have purchased a few brilliant inventions at the loss of all communion with life and the spirit of nature'.

Professor John Beer (personal communication) has drawn my attention to another instance of the inconstancy of Coleridge's attitude to science. A letter, in which Coleridge sets out a disparaging view of Newton's status, is followed by another in which he begs his correspondent to destroy such a set of arrogant assertions. Professor Beer adds: 'Needless to say the correspondent did not and the letter was preserved for posterity!'

Most interesting of all is Blake's own ambivalence (and here I am again indebted to Professor Beer for pointing out the relevant passages). In *Europe*, Plate 13, Newton is described as 'A mighty spirit leap'd from the land of Albion' (Oxford, *Complete Writings*, p. 243). In *A Descriptive Catalogue*, Newton is ranked with Chaucer and Linnaeus: 'As Newton numbered the stars and Linnaeus numbered the plants, so Chaucer numbered the classes of men'.

Professor Beer's interpretation of the Newton plate reproduced on the cover of this book is that, for Blake, Newton is 'a basically beautiful figure who has restricted his vision'. Although he is a manifestation of Urizen, who closed people's eyes to the divine vision, by 'contracting and bounding', bending over the fallen world, marking out its limits with a pair of compasses, he is not thoroughly evil nor an unredeemably negative force: he is great but misguided.

In Blake's system, the physics of Newton was lumped with the metaphysics and meta-science of Locke and Bacon, with the aesthetics of Reynolds, the poetics of Pope, Dryden and Dr Johnson, with the political theory of Burke and with the theology of the English State Church. Many of those who approve Blake on Newton seem judiciously to forget Blake on Pope, Burke, etc. 'The aggregate of all this', as Harold Bloom points out (in his Headnote to Blake in *The Oxford Anthology of English Literature*, vol. II, p. 12. New York: Oxford University Press, 1973), 'quite unfairly but wholly unforgettably, Blake fused together as the Accuser of Sin, the spectral torturer of English man, of Albion'. 'Unfair but unforgettable' seems to do Blake's version of Newton precise justice.
4. William Wordsworth, *The Prelude*, Book Third, lines 61–4. These lines are found only in the 1850 edition.

5. *The Prelude*, Book Third, line 270. This is found in both the 1805 and 1850 editions. Grevel Lindop, in the mistaken belief that I was arguing (in an earlier version of this essay published in *PN Review*) that the Romantics were uniformly hostile to science, has usefully documented Romantic enthusiasm for science and technology (Lindop, 'Newton Raymond Tallis and the Three Cultures', *PN Review*, 18 (2), 1991).
6. 'Wordsworth at the Barbican', in Gerald Weissman *The Doctor with Two Heads and Other Essays* (New York: Alfred Knopf, 1990). Reading this superb essay – one of several in a brilliant book – I was tempted to echo Donatus' cry: 'Cursed be those who make our remarks before us!'. However, I have found Weissman strengthens my case rather than makes it superfluous. He quotes M. H. Nicolson, *Newton Demands the Muse* (Princeton, NJ: Princeton University Press, 1946), who reminds us of those poets such as Thomson, for whom Newtonian science was an inspiration rather than a target.
7. Though, of course, the only true paradise is paradise lost. Blake's Ecchoing Green is a figment of the imagination. 'Old John, with white hair', laughing away care, 'Sitting under the oak, Among the old folk' hardly corresponds to the documented reality of old age in the pre-industrial organic communities of the past (see, for example, Peter Laslett's *The World We Have Lost*, London: Methuen, 1965). Brutal and punitive attitudes to the elderly in times past have been well-documented in more recent literature (see, for example, M. Featherstone, M. Hepworth, 'Images of Ageing', in J. Bond, P. Coleman, S. Peace, (eds) *Ageing in Society. An Introduction to Social Gerontology*, 2nd ed., London: Sage, 1993). Blake's vision of village life without fear, tyranny, bullying, illness, hunger, pain, is a poignant fantasy of a Golden Age – of a childhood in an organic community we have been taught to feel we might have had and have somehow lost. Certainly, there is little reason to assume that modern factories are necessarily more hateful places to work in than the village smithy, with a boss unconstrained by a tradition of health and safety at work and untroubled by any legislation on employees' rights. The lot of the apprentice, the servant or the farmer's boy was not a happy one. There would be no redress against a drunken bully; and sexual harrassment would be more than just a suggestive comment next to the xeroxing machine. A study of the period 1300–1840 (A. MacFarlane, *Marriage and Love in England: Modes of Reproduction 1300–1840*, Oxford: Basil Blackwell, 1986) has dramatically illustrated how individuals with diminished physical, financial and social resources were often neglected and despised.
8. Lewis Wolpert, *The Unnatural Nature of Science* (London: Faber, 1992).
9. See Lindop ('Newton, Raymond Tallis and the Three Cultures' cited in note 5) for a fascinating brief account of some of the factors that deepened the divide between arts and science education in Victorian England. The rival claims of influential and charismatic figures such as Spencer and Huxley on behalf of science education, and Matthew Arnold on behalf of education in literature, and the wider in-fighting and position-taking (not to speak of vested interests in educational

institutions), are fascinatingly set out by Lindop. His conclusion is worth quoting:

> The structure of academic disciplines in these institutions [the new universities such as those of London and Manchester] was established by men passionately aware of the latest moves in the ideological battle between established Christianity and the world of modern learning ... it is in these struggles that the battle between the Two Cultures has its roots. In a secular intellectual world, where is the source of value and authority to lie? Religion once dead, who takes over? To put it plainly: the Humanities and the Sciences believe that together they have slain Religion. Now they turn on each other and fight for succession.

10. Popper's views are presented most rigorously in *The Logic of Scientific Enquiry* and most accessibly in *Objective Knowledge*. The latter (Oxford: Oxford University Press, 1971) contains 'The Bucket and the Searchlight: Two Theories of Knowledge', as an Appendix.
11. Quoted in J. L. Heilbron, *The Dilemmas of an Upright Man* (Berkeley: University of California Press, 1986) p. 52.
12. Quoted in Heilbron, ibid., p. 57.
13. Against this, Wolpert (op. cit., note 8 above) has emphasised the differences between creativity in the arts and sciences: 'Creativity in the arts is characteristically intensely personal and reflects both the feelings and the ideas of the artist. By contrast, scientific creativity is always contrained by self-consistency, by trying to understand nature and by what is already known'. And he concludes that 'it is only at a relatively low level that creativity in the arts and in science may be similar: a level which includes all human activities that involve problem-solving, from accountancy to tennis'.

 There is much that I would agree with here. Certainly, the science that I am personally involved in – which is more typical of the science practised by most scientists than the 'breakthrough' experimentation and 'daring' speculation which features in the general press – operates within rather narrow constraints and even the ideas that guide it are hardly conceived within a white heat of inspiration. However, much literature of the highest order also acts within the kinds of constraints that Wolpert speaks of. But the ideas that have guided science as a whole and created the framework within which 'humble undergardeners' such as myself operate, are themselves the products of intense thought and an order of inspiration not often found in ordinary problem-solving activities such as accountancy or tennis. And **these** are the ideas that one would wish to become common currency, even amongst humanist intellectuals.
14. I am indebted for these quotations to E. A. Burtt's *Metaphysical Foundations of Modern Physical Science*, 2nd rev. ed. (New York: Doubleday Anchor Books, 1932). Unfortunately Burtt's aim in showing the extent to which the founders of modern science were steeped in pre-scientific mysticism was to undermine the rational basis

of science. Of course, rational science must begin somewhere: in irrational pre-science.
15. Quoted in Richard Westfall, *Never at Rest: A Biography of Isaac Newton* (Cambridge: Cambridge University Press, 1980) p. 863.
16. The phrase is Maynard Keynes' and represents the view he opposed in his essay, 'Newton, the Man', in the Royal Society's volume, *Newton Tercentenary Celebrations* (Cambridge: Cambridge University Press, 1947), pp. 27–34.
17. A. N. Whitehead, *Science and the Modern World* (New York: Macmillan, 1925) p. 11.
18. Ibid, p. 20.
19. Abraham Pais, *'Subtle is the Lord' . . . The Science and Life of Albert Einstein* (Oxford: Oxford University Press, 1982) p. vii.
20. Jacques Hadamard, *The Psychology of Invention in the Mathematical Field* (Princeton: Princeton University Press, 1949).

 Not all the stories are accepted. Recently, Kekule's version of the way the basic features of the carbon chain theory and the benzene ring came to him – recounted by Kekule in a speech on the occasion of the *Benzolfest* (a celebration in 1890 to honour him on the twenty-fifth anniversary of his publication of the cyclic structure of benzene) – has been questioned. In *The Kekule Riddle*, edited by John Wotiz (Vienna: Cache River Press, 1993), it is suggested that Kekule invented the dreams that he claimed led to his discoveries in order to support his claim to priority. It is difficult to be sure, but the message he left his audience with – 'Let us learn to dream, gentlemen; then we shall perhaps find the truth' – is a good one: if the ways things are is counter to our ordinary intuitions and unreflective expectations, we need to dream in order to wake out of ordinary wakefulness.
21. This is a theme to which Weber returns repeatedly. It is dealt with in his study of China; in his discussion of science as a vocation; and in his analysis of the bureaucratisation and rationalisation characteristic of the modern world. The relevant texts, along with an illuminating discussion, are available in *From Max Weber*, edited by H. H. Gerth and C. Wright Mills (London: Routledge & Kegan Paul, 1948).
22. Weissmann, 'Wordsworth at the Barbican'. He derives this story from M. H. Nicolson, *Newton Demands the Muse*.
23. Weissman's interpretation of this story as an expression of hostility to Newton has been challenged by Lindop ('Newton, Raymond Tallis and the Three Cultures'), who cites Benjamin Haydon's *Diary*, the original source of the quotation. It does not, however, seem to me that the diary entry can be read in any other way than as revealing the resentment of Romantics towards Newton because 'he had destroyed all the Poetry of the rainbow, by reducing it to a prism'.
24. Quoted in Jeremy Bernstein, *Einstein* (London: Fontana/Collins, 1973) p. 156.
25. In *The Matter Myth* (London: Penguin, Viking, 1991) John Gribbins and Paul Davies place Newton at the head of a massive movement in science towards a 'cosmic clockwork' view of the universe which has

now collapsed under the triple assault of relativity, quantum indeterminacy and chaos theory.
26. Quoted in Donald Ault's scrupulous, difficult, and brilliant *Visionary Physics: Blake's Response to Newton* (Chicago: University of Chicago Press, 1974) p. 8. Ault reminds us that many poets were aware of those elements in Newtonian thought that went beyond mechanical atomism and he cites Carl Grabo's study of Shelley, linking the vision of *Prometheus Unbound* with the Neo-Platonic and mystical aspects of Newton's thought.
27. Quoted in Ault, ibid., p. 8.
28. R. H. Green, *The Thwarting of Laplace's Demon* (London: Macmillan, forthcoming).
29. Ernst Mach, *The Science of Mechanics*, translated by T. J. McCormack (Chicago: Open Court Publishing, 1892) p. 460.
30. See Gribbins and Davies, *The Matter Myth*.
31. See, for example, P. C. W. Davies and J. R. Brown, *The Ghost in the Atom* (Cambridge: Cambridge University Press, 1986).
32. In *The Explicit Animal* I have attacked the belief that human consciousness can be explained in evolutionary and biological terms and the related assumptions that humanity can be reduced to an animality in turn reducible to configurations of otherwise inanimate matter. I accept the materialistic basis of organic life but not of the 'explicitness' that characterises the 'species-being' of humankind (this is alluded to later in 'The Uselessness of Consciousness').
33. This famous poem is quoted in Weissman, 'Wordsworth at the Barbican'.
34. H. F. Amiel, *Journal Intime*, translated by Mrs Humphrey Ward (London: Macmillan, 1889) p. 21.
35. John Keats, letter to George and Tom Keats 21, 27(?) December, 1817.
36. Michael Schmidt, 'William Blake', in *An Introduction to Fifty British Poets* (London: Pan Books, 1979).
37. Blake, *Jerusalem*, Plate 10, lines 20–1.
38. Most notably Ault's *Visionary Physics.* note 38.
39. Illustrating the truth of Johnson's observation: 'Such is the power of reputation justly acquired that its blaze drives away the eye from nice examination'. Johnson's comment seems more fairly applied to the prophetic books than to *Lycidas*, its original target.

3 The Eunuch at the Orgy: Reflections on the Significance of F. R. Leavis

1. C. P. Snow, *The Two Cultures and the Scientific Revolution* (Cambridge: Cambridge University Press, 1959).
2. F. R. Leavis, *Two Cultures: The Significance of C. P. Snow* (London: Chatto & Windus, 1962).
3. Christopher Norris. Introduction to *F. R. Leavis*, by Michael Bell, p. vii. (London: Routledge, Critics of the Twentieth Century, 1988).
4. On how critics deal with the threat of **Kritikerschuld**, see Raymond

Tallis *In Defence of Realism* (London: Edward Arnold, 1988; 2nd ed. London: Ferrington, 1994), especially pp. 159-70.
5. Raymond Williams, *Culture and Society 1780-1950* (London: Chatto & Windus, 1958).
6. Lionel Trilling, *Beyond Culture* (Penguin: London, 1967).
7. Michael Bell, *F. R. Leavis* (London: Routledge, Critics of the Twentieth Century, 1988).
8. Bryan Appleyard, *Understanding the Present* (London: Picador, 1992).
9. Cristopher Nash, *Narrative in Culture* (Routledge: London, 1990).
10. John Maynard Smith, *The Theory of Evolution* (Penguin: London, 1975).
11. Alan Gross, *The Rhetoric of Science* (Harvard University Press, 1990). Gross's book is demolished by John Durant's article (to which the present discussion is indebted), 'Is Science a Social Invention?', in *The Times Literary Supplement*, 15 March 1991, p. 19.
12. For a further discussion of the relationship between magic and science and the attempt to reduce the latter to the former – or indeed to show that magic is superior to science – see my forthcoming *The Enemies of Consciousness* (Macmillan).
13. Thomas Kuhn *The Structure of Scientific Revolutions* (Chicago: University of Chicago Press, 2nd ed., 1970).
14. Lewis Wolpert, *The Unnatural Nature of Science* (London: Faber, 1992).
15. The relationship between the truth of science and the fact that it works is addressed by Paul Valéry in his dialogue, *Idée Fixe*, translated by David Paul (New York: Bollingen/Pantheon, 1965).

> – If I set about adding up what we **know**, I find the gains are illusory... If, on the other hand, I look at what we can **do** – at mankind's acquisition of real power over a century and a half, then...
> – But how can you separate this fictive knowledge, this substantial power, the one from the other? (p. 100)

> – I mean consider simply the increase in **power**. All the rest, theories, hypotheses, analogies – mathematical or otherwise – is both indispensable and provisional. What remains as capital is simply the powers of action upon things, the new achievements, the **recipes**... Science, translated into technology, **works**. (p. 101)

The implication is that theories may come and go but their enduring remnant is the recipes, the powers, the achievements they leave behind. Whatever the fate of quantum theory, nothing can take away the silicon chip, and all the devices based on it and the transformation of history and human life that resulted from them. A couple of points may be made against this separation of the **truth** from the **power** of science-based technology:

(a) As pointed out in the text, although theories are often superseded, much from the past, and distant past, of science survives indefinitely. The present of science is built on its past: successful

theories and enduringly true facts will be invisible inasmuch as they will be taken for granted as part of the accepted body of knowledge.
(b) It would be an improbable coincidence if a theory that accounts for more of the known facts than any rival theory, predicts novel facts, brings together many other facts and postulates or supports practical technologies, were totally unrelated to what is actually the case 'out there'. The theories and the recipes cannot, therefore, be entirely unrelated.

Even so, the relationship between the truth of science and the success of the technology based upon it is not straightforward. For this reason, it deserves better treatment than the superficial, inaccurate and envy-motivated accounts of the social scientists.

4 'The Murderousness and Gadgetry of this Age'

1. George Steiner, *Real Presences* (London: Faber & Faber, 1989) p. 49
2. The claim that magical and religious beliefs have declined as a result of science is demolished in Lewis Wolpert's brilliant lecture 'Science and Anti-science', published in the *Journal of the Royal College of Physicians*, 21(2), 1987, pp. 159–65.
3. Ibid.
4. Nicolson Baker, *The Mezzanine* (Cambridge: Granta Books/Penguin, 1990).
5. D. H. Lawrence, *Study of Thomas Hardy*, 1914. Quoted in Freeman Dyson, *Infinite in All Directions* (Penguin: London, 1988). Dyson's own view of technology is worth quoting: 'Technology is a gift of God. After the gift of life it is perhaps the greatest of God's gifts. It is the mother of civilisation, of arts and of science' (p. 270). One might also add that technology – the basis of the non-human world's extended amenity to the human will – is one of the greatest of all mysteries as well as a great gift.
6. Peter Medawar, 'Reflections on Science and Civilisation', in *The Threat and the Glory* (Oxford University Press, 1990).
7. The relevant facts are succinctly set out in 'Overpopulation and overconsumption', by Richard Smith. *British Medical Journal*, 306: 1993, pp. 1285–6. Smith points out that 'Population growth keeps people in poverty, obliges them to destroy their environments, and leads to deforestation, water shortages and desertification'. Current population growth results from death rates having fallen everywhere but birth rates having fallen only in the rich world. The figures are terrifying: the world population was 1.49 billion in 1890, 2.5 billion in 1950 and 5.32 billion in 1990. It is likely that further growth in the thirty or so years to 2025 will be between 2.5 and 3.5 billion. If, as is expected, the global population tops 8 billion in 2025, this will mean a fourfold increase in a century. The cost of global population control programmes has been estimated at about 9 billion dollars annually, the amount the world spends on arms every 56 hours.

> As if the population growth is not frightening enough, energy consumption, which has grown out of proportion to the population, is even more dramatic. There has been an approximately 14-fold increase in global energy expenditure between 1890 and 1990. People in the developing world use 0.28 kilowatts a year, those in the developed world use 3.2 and those in what I would call the overdeveloped world (USA) use 9 kilowatts. Modest 'Utopia'would mean 2.3 kilowatts each year per head – a 7-fold increase for poor countries which, combined with the predicted doubling of numbers by 2050, would mean a 14-fold increase in their energy consumption.
>
> The units used by Richard Smith are odd: watts, like knots, are a unit of rate and thus include a unit time component. Energy consumption is best expressed as joules or giga-joules per year. Nevertheless, the essential message is there in his terrifying figures: the imperative to control the world population, to exert downward pressure on consumption in rich countries and to develop yet more advanced technologies to meet future growing needs.

8. Colin Turnbull, *The Mountain People* (London: Cape, 1973).
9. Robert Roberts, *The Classic Slum: Salford Life in the First Quarter of the Century* (London: Penguin, 1973). See also the observations in Note 7 of Chapter 2 above.
10. Or, as Hegel put it, 'seek for food and clothing first, then the Kingdom of God shall be added unto you'. Quoted by Walter Benjamin in his *Theses on the Philosophy of History*, available in *Illuminations*, edited by Hannah Arendt (London: Jonathan Cape 1970).
11. This is a view shared by some physicists, especially those who were involved in the development of nuclear weapons. James Gleick's biography of Feynman, *Genius: Richard Feynman and Modern Physics*, (London: Little, Brown and Company, 1992) vividly describes the scientists' Promethean guilt. See 'We Scientists Are Clever', pp. 203–4.

> The aftermath [of the successful test at Los Alamos] changed them all. Everyone had played a part. If a man had merely calculated a numerical table of corrections for the effect of the wind on the aerodynamically clumsy Nagasaki bomb, the memory would never leave him. No matter how innocent they remained through the days of Hiroshima and Trinity, those who had worked on the hill had knowledge they could not keep from themselves. They knew they had been complicit in the final bringing of fire; Oppenheimer gave public lectures explaining the legend of Prometheus had been fulfilled.

5 Anti-Science and Organic Daydreams

1. Martin Seymour-Smith, *Guide to Modern World Literature* (London: Hodder & Stoughton, 1974) p. xviii.
2. Peter Medawar, *The Hope of Progress* (London: Methuen, 1972).
3. T. H. Huxley, 'On the Physical Basis of Life'; this widely available essay

was delivered as a lecture in 1868 and reprinted in successive editions in Huxley's Collected Works.
4. J. Chin, in 'Current and future dimensions of the HIV/AIDS pandemic in women and children', *Lancet*, 336, 1990, pp. 221–4.
5. G.C. Schild and E.J. Stott, 'Where are we now with vaccines against AIDS?', *British Medical Journal*, 306, 1993, pp. 947–8.
6. 'That AIDS is not a single illness but a syndrome consisting of a seemingly open-ended list of contributing or "presenting" illnesses which constitute . . . the disease, makes it more a product of definition or construction than even a very complex, multiform illness like cancer'. Susan Sontag, *AIDS and its Metaphors* (Penguin: Harmondsworth, 1990) p. 28. This is, of course nonsense. There are many other immune deficiency diseases which may have an enormous variety of presentations depending on the opportunistic infections the individual may catch due to the failure of his/her immune system. No one, surely, is going to say that agammaglobulinaemia is socially constructed.
7. For a recent update, see *British Medical Journal*, April 1993.
8. This movement is discussed in Rainer Friedrich's critique of the postmodernists: 'The Deconstructed Self in Artaud and Brecht', *Forum for Modern Language Studies*, xxvi, 1990, pp. 282–95.
9. Editorial, 'AIDS Vaccine: hope and despair', *Lancet* 336, 1990, pp. 1545–6.
10. George Steiner, *Real Presences* (London: Faber & Faber, 1989).
11. Lewis Wolpert, in *The Unnatural Nature of Science* (London: Faber & Faber, 1992, p. 43) interestingly relates the enduring appeal of Aristotle's ideas to their conformity to unreformed common sense and uncontested intuition:

> The authority of Aristotle's ideas derive in large part from his ability to express in an abstract and consistent manner a perception of the universe that embodied a spontaneous conception of the universe which had existed for centuries. They embody the ideas of many primitive tribes and children.

12. See J.R. von Salis, *Rainer Maria Rilke: The Years in Switzerland*, translated by N.K. Cruickshank (London: The Hogarth Press, 1964).
13. See, for example, Rupert Sheldrake, *The Rebirth of Nature: New Science and the Revival of Animism* (London: Rider, 1993).
14. There is a a detailed and fascinating discussion of Newton as alchemist in Richard Westfall's *Never at Rest: A Biography of Isaac Newton* (Cambridge: Cambridge University Press).
15. John Gribbins and Paul Davies, *The Matter Myth* (London: Macmillan, 1991), is a very readable account of the revolutions in contemporary science that have distanced us from the relatively uncomplicated mechanistic natural philosophy of the 17th century.

6 Epilogue: The Consequences of Omniscience

1. Dai Rees, *MRC News*, No. 58, Spring 1993, p. 1.

2. For the full version of this story the reader is invited to consult Raymond Tallis, *The Explicit Animal* (London: Macmillan, 1991).
3. The scientists in this context would find a surprising ally in Nietzsche:

 WHY SAVANTS ARE NOBLER THAN ARTISTS. Science requires nobler natures than does poetry; natures that are more simple, less ambitious, more restrained, calmer, that think less of posthumous fame and can bury themselves in studies which, in the eyes of the many, scarcely seem worthy of such a sacrifice of personality. There is another loss of which they are conscious. The nature of their occupation, its continual exaction of the greatest sobriety, weakens their will; the fire is not kept up so vigorously as on the hearth of poetic minds. As such, they often lose their strength and prime earlier than artist do – and, has been said, they are aware of their danger. Under all circumstances, they seem less gifted because they shine less, and thus they will always be rated below their value.

4. There is a lengthy critique of post-Saussurean thought and the intellectually derelict tradition behind it in Raymond Tallis' *Not Saussure* (London: Macmillan, 1988; Second edition, 1995) and *In Defence of Realism*. The theme is taken up again in my forthcoming *The Enemies of Consciousness*.
5. The consequences are spelled out in Malcolm Dean's excellent article 'How to stop the sun going round the earth', *Lancet*, 336, 1990, pp. 615–6.

 Begin with the primary schools: two out of three science lessons for 5 to 11 year olds were substandard, according to a report from the School Inspectors . . . Only one out of three schools had classrooms suitable for teaching science, and one out of four would find it impossible. Move up to secondary level (11–18), where only 1 in 7 teachers in the first two years have a qualification in physics or chemistry – and even in the sixth form 20 per cent of chemistry lessons and 30 per cent of physics lessons were taken by teachers with no qualifications in the subjects. Science teaching is in a downward spiral – a shortage of science teachers producing proportionately fewer science students, which in turn reduces the number of teachers.

 An equally depressing picture emerges from the universities, where a recent plan to close 17 out of 49 of the country's university chemistry departments and 20 out of 47 physics departments was just resisted. Meanwhile the soft subjects such as English, sociology, history, etc. flourish and attract more than their fair share of the increased numbers of students entering institutes of higher education.

6. Quoted in Lewis Wolpert and Alison Richards, *A Passion for Science* (Oxford: Oxford University Press, 1988).
7. How different this attitude is from the humanism, characterised by Pater in his essay on Pico della Mirandola, whose essence lies in the belief 'that nothing which has ever interested living men and women

can wholly lose its vitality – no language they have ever spoken, nor oracle beside which they have hushed their voices, no dream which has once been entertained by actual human minds, nothing about which they have ever been passionate, or expended time and zeal' (*The Renaissance*). Or more briefly encapsulated in Terence's 'Nothing human is alien to me'.

8. Constable saw the essential unity of his art and the investigations of the scientist. In 1836, he wrote: 'Painting is a science, and should be pursued as an enquiry into the laws of nature. Why . . . may not landscape painting be considered as a branch of natural philosophy, of which pictures are but experiments?' (Quoted by Raymond Williams in the entry on 'Science', in his *Keywords* (London: Fontana, 1976)).

9. The extent to which the revival of religious belief would play a part in this process of cultural healing is problematic, in view of the track record of religion in fomenting public strife and exacerbating private misery.

10. 'Literature and Science' in *Discourses in America* (1885).

11. Much of what I have said in this chapter has been earlier – and better – expressed, from a position of greater authority, by Peter Medawar in essays that are masterpieces of modern prose. Like Locke, however, I find it 'ambition enough to be employed as an under-labourer in clearing the ground a little, and removing some of the rubbish that lies in the way to knowledge' (John Locke, *Essay Concerning Human Understanding*, Epistle to the reader (edited A.C. Fraser, Oxford: Oxford University Press, 1894)).

7 Misunderstanding Art: The Freezing Coachman: Reflections on Art and Morality

1. Leo Tolstoy *What is Art?* (translated by Aylmer Maude (Oxford University Press, World Classics, 1930).
2. Tolstoy, ibid., p. 196 *et passim*.
3. In 1865 (when, he told Fet, he felt at the height of his artistic powers), Tolstoy had written a statement of his artistic creed in a letter to Boborykin, author of propagandist novels:

> Both your novels are written on contemporary themes . . . but these problems are not only not interesting in the world of art; they have no place there . . . The aims of art are incommensurate (as the mathematicians say) with social aims. The aim of an artist is not to solve a problem irrefutably, but to make people love life in all its countless, inexhaustible manifestations. If I were told I could write a novel whereby I might irrefutably establish what seemed to me the correct point of view on all social problems, I would not even devote two hours to such a novel; but if I were to be told that what I should write would be read in about twenty years' time by those who are now children and that they would laugh and cry over it and love life, I would devote all my own life and energies to it.

Quoted and translated by A. N. Wilson in *Tolstoy* (London: Penguin, 1988) pp. 267–8.
4. Oscar Wilde, *A Picture of Dorian Gray*. Henry James, writing of the artists who gathered in Flaubert's Paris flat on his Sunday afternoons, noted with disapproval that

> The conviction that held them together was the conviction that art and morality are two perfectly different things, and that the former has no more to do with the latter than it has with astronomy or embryology. The only duty of a novel was to be well written; that merit included every other of which it was capable.

Quoted in *The Letters of Gustave Flaubert 1857–1880*, selected, edited and translated by Francis Steegmuller (London: Faber & Faber, 1982) p. 225.
5. Martin Seymour-Smith, *Guide to Modern World Literature* (London: Hodder & Stoughton, 1975) p. xviii. It might be asked whether the artist could deal with his *Kunstlerschuld* not by committing his art, or by making it serve some useful function, but by dividing his own life between creating art (which serves the Kingdom of Ends) and some other activity (which serves the Kingdom of Means). Could he not follow Karl Marx's recipe (in *The German Ideology*) and 'hunt in the morning, fish in the afternoon, rear cattle in the evening, criticize after dinner'? The unacceptability of this 'solution' to many artists may be because they, more than others, want to be one and undivided; and to relate everything to their fundamental hunger. They consequently want their art to be one with their civic duties and answer to their longing to alleviate the sorrows of the world.
6. Eugene Rostow's interesting article in the *Times Literary Supplement* ('Beginnings of the End', TLS 14 May 1993, pp. 8–9) widens this debate. He asks whether the fall of the Soviet Union and the liberation of its empire of satellite states was due to the moral force of high culture; or whether it was brought about by economic weakness and the increasingly visible discrepancy between the Soviet standard of living and that of the capitalist world. George Weigel (whose book *The Final Revolution* Rostow is reviewing) has suggested that moral forces were crucial – but that these emanated most strongly from individuals firm in their religious beliefs. He cites the Pope's visit to Poland in 1979, where he was heard by nearly one third of the population, and claims that it was 'a psychological earthquake, an opportunity for mass political catharsis'. To these reasons, one could add the increasingly clear perception of the discrepancy between the rhetoric of the Millenium and the reality of bread queues, fear, physical discomfort and bureaucratic incompetence in a society where the initiators of the Revolution – those who owned it as their personal destiny as opposed to merely living out its consequences – were a dwindling minority. Under any analysis, the contribution of moral forces seems likely to be small and the contribution of art to those moral forces smaller still. After all, the regimes that are growing out of the rubble of

Communism do not seem especially distinguished by moral fervour and incorruptibility.
7. The assumption that if poets do have an influence on political events it will necessarily be a good one should not go unchallenged. Poets are as likely to be right-wing demagogues or (however sincere) lackeys of left-wing revolutionary regimes as thoughtful mediators on behalf of justice in the public sphere. Indeed, the more unscrupulous they are, the more likely they are to influence public events: compare D'Annunzio with Mandelstam, or Radzovan Karajicz with Neruda, Brecht with Paul Celan.
8. The fact is that, on the whole, artists are poor journalists. There are some famous exceptions – one thinks of Tolstoy's famous reports of the famine in Samara; of Chekhov's account of his trip to Sakhalin Island; of Zola's *J'accuse* – but they are exceptions. And their journalism was not art.

 The impotence of great art is indirectly testified to by those who suggest that totalitarian regimes often produce greater art than dull democratic ones. It is unlikely that such art would bring about the conditions of its own impossibility. Often it is coyly (and in my opinion obscenely) hinted at that it is almost worth having universal oppression for the great art that comes of it. This is doubly flawed: there is little objective evidence that Akhmatova and Mandelstam are superior to Eliot, Yeats and Valéry. Art, it is suggested, is taken more seriously in countries where it is more dangerous to read and write it. If this is the case (and again there is little or no statistical evidence to support it), it may only be a case of the food wagon being mobbed where there is mass starvation (not, I would think, an attractive argument in favour of famine).
9. If the case for the role of literature in shaping public morality and favourably altering public behaviour is weak, how much weaker is that of the other arts. Non-referential music or abstract painting can hardly have much influence on public perceptions of what is going on out there in the big world. Music may acquire referents but these are not stable and are often external to it. *The Ode to Joy* may celebrate the brotherhood of man, affirm the brotherhood of European nations in mercantilism; or (as Gottfried Benn noted) enhance a Nazi rally. A theory of art that cannot accommodate music is inadequate.
10. One way of trying to integrate specifically aesthetic with moral values in art is to suggest that the morality of art lies less in its content than in its form or in the relation between form and content. That is a cunning way of bringing together concern for form (which seems to distract from the business of getting the moral message across) and concern for morality. Leavis, for example, argued in *The Great Tradition* (London: Peregrine, 1962) that works of literature **enact** their moral significance. Their moral content is not so much stated in, as expressed through, them – in their formal organisation.

 > But [Jane Austen's] interest in 'composition' is not something to be put over and against her interest in life; nor does she offer an

'aesthetic' value that is separable from moral significance. The principle of organisation, and the principle of development, in her work is an intense moral interest of her own in life that is in the first place a preoccupation with certain problems that life compels on her as personal ones ... Without her intense moral preoccupation she wouldn't have been a great novelist (p. 16).

This comforting doctrine (reminiscent of Wittgenstein's assertion in the *Tractatus* that 'the aesthetic and the ethical are one') is easier to state (and teach) than to understand or to relate to the specific novels of the writers whom Leavis deemed great and in whom he found 'a kind of reverent openness before life, and a marked moral intensity'. Although there is a great temptation to refer to Wittgenstein's talk of that which can be shown in the form but not stated in the content (and his famous admiration for a poem of Uhland), this temptation should be resisted as the light it seems to cast is only illusory. At any rate, it is difficult to see how Leavis's views help resolve the tension between attibuting importance to the artiness of art, the equal importance of its hospitality to the uncombed chaos of real life and its being subordinated to messy external moral purpose. The most obvious thing to be said about form is that it contributes most to the status of a work of art as a jewel to be contemplated; less to its status as a lens to be trained upon the world; and least of all to its function as a motor to action.

11. Flaubert famously commented on the dissociation between the response to real and to imaginary dramas. His father has just died and his beloved sister is dying of a puerperal infection:

> My mother is a weeping statue ... My own eyes are as dry as marble. It is strange how sorrows in fiction flood me with facile emotion, while actual sorrows remain hard and bitter in my heart, crystallizing there as they come.

The Letters of Gustave Flaubert 1830–1857, selected, edited and translated by Francis Steegmuller (London: Faber, 1981).

12. The relationship between our perception of the people we meet in life and those we encounter may be very complex. Witness, for example, the discussion of the Goncourt Diaries in *Remembrance of Things Past* (Vol 3, p. 728 et seq in the Kilmartin translation). Proust, or his *alter ego* Marcel, is given an unpublished volume of the Goncourt Journal by his mistress. In the Journal he reads an account of a reception and dinner party at which he himself had been present. He is astonished to discover that all the familiar bores are there – but utterly transformed. They seem interesting, like other characters in the Goncourt Journal. He concludes from this not that, underneath, the bores are really interesting but that he has not got the necessary deceptive powers to be a writer, that he is too wedded to the pedestrian truth to be able to produce 'the illuminating magic of literature'. He may as well have said 'illusory'.

13. One does not have to scale the heights of art to run into the cruel spectatorial element at the heart of its value system, its use of the world for its own artistic purposes. I remember a photography competition run by a local newspaper. The results were as follows:

First prize : Hats and Roses
Second prize: Cheeky Kittens
Third Prize : Child Burnt with Napalm

The third photograph did not score so highly on technical criteria, though the judges applauded the 'political power' of the theme.

14. We could imagine the enhanced moral consciousness arising out of contact with literature being expressed not so much in a change of behaviour as in the same behaviour enacted at a higher 'moral level'. There is an analogy here with religious belief, which does not necessarily make you a better person but adds a moral weight to your goodness and badness. You do things after more difficult decisions, and for deeper reasons. This opens on to the murky ethical territory of anti-utilitarianism, where acts are judged not by their effects but by their spiritual cost to the actor. In this territory all sorts of interesting judgements are pronounced. For example, that it is better to spend one's spare time working for charity and give one's spare change to charitable causes than to support the idea of higher taxes which will ensure that one will relatively painlessly, and with less palpable personal cost, give the same amount or more to the cause (cancer research, homes for the homeless) in question. The greater spiritual density of voluntary as opposed to involuntary contributions explains the preference that some have for intermittent high profile acts of giving than for a continuing reality of distributive justice. From the point of view of the recipient, the spiritual content of the act is of limited interest.

This higher, more conscious, morality is not clearly separated from self-indulgence, as Anne Shepherd points out in her chapter on 'Art and Morals', in *Aesthetics* (Oxford: Oxford University Press, 1987). In her discussion of Leavis, she notes that 'the works that Leavis values highly are regularly described as "mature"', they possess "intense moral seriousness" and exhibit self-knowledge. She then points out that

> The virtues of maturity, self-knowledge, and moral seriousness are all 'armchair' virtues, even more than the virtues Arnold finds in the best poetry. Leavis's valuing of 'full-bodied life' stresses the importance of going out and doing things but gives little guide as to what one is going to do. Value is placed on deep experience by the individual rather than on any actions involving others. The self-centredness of Leavis's approach comes out in his talk of spiritual health and sickness. To promote our spiritual health we must become more mature and self-aware, less prone to self-pity and sentimentality . . . However, he never spells out just how spiritual health affects our relations with others. He takes it for granted that if

we are mature, self-aware, unsentimental and avoid excessive aestheticism, then we shall be better people (pp. 148–9).

Shepherd also points out that Leavis never really questions – perhaps he does not even notice – the assumption that literature with mature and self-aware content will have the effect of making us mature and self-aware. Leavis's writings exemplify a tendency, also referred to by Shepherd, to confuse moral questions about the content of art with moral questions about its effects. Tolstoy does precisely this by assuming that good examples will bring about good people and that good emotions in literature will 'infect' its readers with good emotions.

Wilde's Preface to *Dorian Gray* carefully separates the moral questions about the content of art from moral questions about its effects and, beyond this, the morality of the subject matter (the artist does not recognise this) from the aesthetics of its treatment:

> The moral life of man forms part of the subject-matter of the artist, but the morality of art consists in the perfect use of any imperfect medium. No artist desires to prove anything. . . No artist has ethical sympathies.

In the ideal world postulated in Leavis's and Tolstoy's aesthetics, the ethical effect of a work of art would be a reflection of its content and the latter would be assimilated into form. The ethical and aesthetic in art would be one and would be mirrored in the response of the recipient. As Tolstoy wrote in his diary around the time of *What is Art?*: 'The aesthetic is merely one expression of the ethical . . . If feelings are fine and noble, art will be fine and noble too, and vice versa'. (Quoted in Henri Troyat, *Tolstoy*, translated by Nancy Amphoux, London: Penguin, 1970.) Alas, things are not like this.

Nor does the moral impact reflect the artistic quality of the work. I doubt if any book has had as potent a moral influence on me as Alasdair Maclean's *The Last Frontier*, through its portrayal of the altruistic character Jansci who does good for its own sake, at terrible personal cost. No-one – not even Maclean himself – would pretend that this gripping story was great art. Other works that I found morally inspiring in my youth included the film (but not the book) version of *A Tale of Two Cities* and *Reach for the Sky*, the story of Douglas Bader. I would also testify to the overwhelming moral and emotional impact of some journalism – written and tele-visual – where artistic qualities are not important. In contrast, the ethical impact on me of great art has usually been negative, inasmuch as the emphasis in the works that have truly engaged me has been on the futility of things – especially of ordinary life – and the need to distance and disengage oneself from the petty round of the everyday.

15. When Sartre was alive, it was very difficult for writers to throw off his morally oppressive example and admit that they had no appetite for or belief in politically committing their writing. So they played the

'indirect effect card'. A good example of this is Alain Robbe-Grillet's *profession de demi-foi* in *Towards a New Novel*:

> Let us restore to the idea of commitment, then, the only meaning it can possibly have for us. Rather than being of a political nature, commitment, for the writer, means to be fully aware of the problems of his own language, convinced of their extreme importance, and desirous of solving them from within. Therein lies his sole possibility of remaining an artist, and also, no doubt, by means of some obscure and distant consequence, of maybe one day being of some use – maybe even to the revolution. *Snapshots* and *Towards a New Novel*, translated by Barbara Wright. (London: Calder & Boyars, 1965)

It is difficult to gauge the irony or sincerity of the 'no doubt'; but the passage testifies to the anxiety of a writer, who clearly had too many other concerns to be seen to be considering the question of his contribution to 'the revolution'.

16. Sartre memorably captured the essence of art in an aphorism: 'art is the world possessed by a freedom'. The connection between this thesis and his passionate commitment to the idea of engaged art is difficult. I think it goes as follows. The writer writes to be read. In order to fulfil his project of possessing his world, or of bodying forth the freedom implicit in the synthetic activity of his consciousness, the artist requires the generosity of the reader, who will lend his consciousness to realising the world expressed in the writing. For this reason, the artist's desire to celebrate his own freedom must imply a wish that the reader, too, should be free.

The fudge is an important one in Sartre's development: it was an early manifestation of his attempt to slide from the unconditional, inescapable metaphysical freedom of *Being and Nothingness* – we are free to escape everything except our freedom which can be denied only at the cost of descending into bad faith – to the historically and socially conditioned freedom of his Marxism. It marks the beginning of his tragic descent as a writer: his argument that the artist should **engage** was advanced at about the time that he himself died as an artist and after which he produced nothing, apart from his *Autobiography* that could be called a work of art. (These matters will be touched on again later in 'The Difficulty of Arrival'). What will survive of Sartre will not be the things he wrote – out of his sense of duty and self-importance – in support of some of the most iniquitous regimes of the twentieth century but his most *degagé* work of art: *Nausea*.

Towards the end of his life, he fully realised the political impotence of art. This is an extract from an interview he gave in 1969:

> Q. Would you say that anything has changed because of what you have written?
>
> A. ´Not a thing. On the contrary, ever since my youth I have experienced utter impotence. But that's neither here nor there.

> You could say, if you like, that to begin with I wrote a few books which weren't directly concerned with social problems; then came the Occupation – people began to think it was necessary to act. After the war, we felt once more that books, articles, etc. could be of use. In fact they were of no use whatever. Then we came to feel – or at least I did – that books conceived and written without any specific relation to the immediate situation could be of long-term use. And these turned out to be just as useless, for the purpose of acting on people – all you found was a distortion of your own thoughts and feelings turned against you and changed out of all recognition by a young man taking a casual swipe at you. Fair enough – I did the same myself. That's literary endeavour for you – you can see it doesn't produce the results you wanted it to.

('The Purposes of Writing', in *Between Existentialism and Marxism*, Verso: London, 1974. Translated by John Mathers.)

17. This is the artistic justification of the truth-telling of those artists who suffered under the totalitarian regimes that hated their truth. As I have already argued, it seems unlikely that their works did much to hasten the fall of the tyrants – certainly not enough to justify the suffering their truth-telling caused them and their families and their supporters. But they bore witness. Anna Akhmatova has spoken of this in the brief 'Instead of a Foreword' prefacing her great act of bearing witness – *Requiem*:

> During the terrible years of Yezhovshchina [the purges in the late 1930s] I spent seventeen months in the prison queues in Leningrad. One day someone recognised me. Then a woman with lips blue with cold who was standing behind, and of course had never heard of my name, came out of the numbness which affected us all and whispered in my ear – (we all spoke in whispers there): 'Can you describe this?'.
> I said, 'I can!'.
> Then something resembling a smile slipped over what had once been her face.

(Translated by Richard McKane, Oxford University Press, 1969, p. 90).

18. Or as Wordsworth put it in the Preface to *Lyrical Ballads* (1800):

> The principal object which I proposed to myself in these poems was to make the incidents of common life interesting by tracing in them, truly though not ostentatiously, the primary laws of our nature

8 Misunderstanding Art: The Myth of Enrichment

1. A. N. Whitehead, *Science and the Modern World* (London: Free Association Books, 1985) p. 252.

Notes and References

2. Samuel Beckett, *Proust and 3 Dialogues with Georges Duthuit* (London: Calder, 1965) p. 41.
3. This is discussed in Raymond Tallis, *In Defence of Realism* (London: Edward Arnold, 1988). See Chapter 8, 'Foregrounding the Critic'.
4. Terry Eagleton, *Literary Theory* (Oxford: Blackwell, 1983).
5. Maurice Couturier and Regis Durand, *Donald Barthelme* (London: Methuen, 1981) pp. 16–17.
6. George Steiner, *After Babel* (Oxford: Oxford University Press, 1975) p. 14. I am not suggesting that Steiner's brilliant book should be judged by this short passage.
7. This abuts on to the question, which I do not propose to address here, of the relationship between increasing knowledge – say of the context and the techniques of a work – and the 'depth' or 'intensity' of the experience of it. There is no special merit in the ignorant ear or the innocent eye; but there are times when it seems as if knowledge gets in the way of appreciation, distracting the recipient from the work itself.
8. Not that 'Great Occasions' are necessarily bad. At least they protect the experience of art from the invasions or simply reassertions of everyday life. I discussed the moral impotence of the theatre earlier; but its situation is not unique and by no means the most vulnerable. While television drama is not surrounded by so much razzmatazz it can, for that very reason, be more casually switched off and there are fewer apologies for interruption. The novel (which one may treasure as a possession and admire for its cover) can, without much ceremony, be laid aside. A change of direction of glance can extinguish a picture. And music may be silenced when the lift reaches the floor we want. The statue needs its plinth.
9. Educationalists often overlook the extent to which most great art is a response to the anxieties, the questions, the great situations of **adult**.
10. The experience of art has a core shading into a penumbra that merges into general consciousness. We listen to the symphony with more or less exclusive attention. This primary experience is surrounded by secondary experiences: waiting for the piece to start on the radio; listening through it to find out who the conductor is; humming the tune to ourself or listening to our companion doing so; discussing the piece; telling someone about the performance; and so on. How much do these secondary experiences impact on the effects of the primary experience? Do they contribute to the cumulative sense of the piece? Do they dilute it? Do they cancel it?
11. This idea gets added point when one considers the random order in which books arrive in our lives – not that there is a definitive order, an Oxford curriculum. At the moment, I have the following books on the go: *Muscle Function in Health and Disease*, *The Literary Guide to the Lake District*, *The Brothers Karamazov*, *Religio Medici*, and Michael Meyer's biography of August Strindberg. And it has always been thus. How could this be the basis for a process of 'building'? The bricks and tiles and panes of glass seem to be chucked in a heap on top of one another. It may be argued that all development is like this: the growing child acquiring a more or less coherent picture of the world encounters

stories about zebras before it learns the word for custard, knows more about dinosaurs than cookers. But the problem of order is particularly difficult in the case of inner enrichment because there are so many anomalies arising out of the fact that we hear and overhear so much about books before we read them. How much had I read about *The Brothers Karamazov* before I at last got round to reading it?

12. Paul Valéry, *Idée Fixe*, Collected Works, Vol. 5, translated by David Paul (New York: Bollingen/Pantheon, 1965, Pantheon Books) p. 20.

There is a poignant contrast between the cumulative record of one's experiences and the continuing chaos of the moment, just as there is between the wholeness of the book and the fragmentariness of the reading and, on a larger scale, between one's record of achievement or curriculum vitae (the secular equivalent of the soul), and one's moment-to-moment actuality. After all that one knows and has achieved, felt and experienced, at any given moment it all boils down to this: the taste of coffee in the mouth, a sense of being there or not there, a lesser or greater feeling of emptiness, and hungers – a current account that cannot access the deposit account. Chekhov captures this in his wonderful novella *A Boring Story*:

> I am famous, my name is pronounced with reverence, my picture has appeared in the *Niva* and the *Illustrated World News*, I have even read my biography in a German magazine – and what of it? Here I sit, utterly alone, in a strange city, rubbing my aching cheek with the palm of my hand.

14. Thomas Mann, *Buddenbrooks*, translated by H. T. Lowe-Porter (London: Penguin) p. 546. Artists tend to be more honest about the production of art than critics about its consumption. Perhaps because they are daily reminded of the unromantic elements in the production of works of art: the vision is a matter of moments; the rest is a 'mania for sentences' and little notes and checking facts.
14. Paul Valéry, *Idée Fixe*, p. 59.
16. Philip Wheelwright, *Introduction* to Valéry, ibid., p. xx.

9 A Metaphysical Interlude: The Uselessness of Consciousness

1. See Raymond Tallis, *In Defence of Realism* (London: Edward Arnold, 1988).
2. The influence of evolutionary thought has often been blamed for the particular vileness with which human beings have treated their conspecifics in the twentieth century. In practice, it is very difficult to assess how important the assimilation of human beings to the evolutionary process has been to the history of the twentieth century.
3. Raymond Tallis, *The Explicit Animal* (London: Macmillan, 1991).
4. Richard Dawkins, *The Blind Watchmaker* (London: Penguin, 1988).
5. For the trials and tribulations surrounding the experimental investigation of the origin of the biochemical out of the chemical (and hence

living matter out of matter *tout court*), see *Encyclopaedia Britannica*, vol. 22 'Life' (Chicago: 15th ed. 1993).
6. Richard Goldschmidt, *The Material Basis of Evolution* (New Haven: Yale University Press, 1940). This is discussed sympathetically in Karl Popper's 'The Hopeful Behavioural Monster', in *Objective Knowledge* (Oxford: Oxford University Press, 1972)
7. Mary Midgely, *Beast and Man: The Roots of Human Nature* (London: Methuen, 1979). For a more detailed discussion of this – with examples – see *The Explicit Animal*, Chapter 2.
8. Quoted in Thomas Mann's *Dr. Faustus* translated by H. T. Lowe-Porter (London: Penguin, 1968) p. 298 in a discussion of Kleist's essay on the marionette theatre, 'the last chapter of the history of the world'. The marionettes have a grace, denied their conscious spectators, that is recovered only when the trajectory from automaton to God is completed.
9. It might be argued – if it is accepted that consciousness is maladaptive – that it was once of adaptive value and then had maladaptive consequences. Every solution creates a new problem, or a new problem-situation. There are certainly well-known examples of this in evolution, for example, the possession of the sickle cell trait associated with abnormal haemoglobin conferred a relative immunity against malaria. In West Africa, where malaria was pan-endemic, the adverse consequence of possessing this trait – liability to sickle cell anaemia – was a price worth paying. For a modern West African, where malaria is controlled or treatable, the trait, which confers much suffering, is clearly no longer of net benefit. The disadvantage is even more evident for individuals of West African ancestry living in non-malarial zones such as Camden. By analogy with this example, one could argue that the cunning that was developed in order to enable man to be a more successful hunter of animal prey or to deal with a hostile environment becomes maladaptive when it is turned against his fellow-men, who can be hunted or persecuted more effectively than in the absence of this faculty.

This, rather feeble, argument does not address the problem that evolutionary theory fails to make a positive case for consciousness; rather it tries to mitigate the negative case.
10. The evolutionary hierarchy – as if man were the fairy on the top of the Christmas tree – is a compelling metaphor, brilliantly criticised in Mary Midgley's *Beast and Man*. See especially Chapter 7, 'Up and Down', from which the following passage is taken:

> When, however, people began to think about evolution, they made (as commonly happens) no more changes in their way of thinking than they were forced to. They did not scrap the Great Chain of Being. Instead, they simply unhooked the top end from Heaven and slung it ahead into the Future. Its axis now was time. But its associations with value did not vanish. For good reasons and also bad ones, they proved tenacious.

11. This is discussed at length in Chapter 7 of *The Explicit Animal*. Even scientists committed to a biological and evolutionary explanation of human consciousness admit that it is difficult to accommodate the spectacular collective adventures of *human* consciousness and the achievements of culture. For example Lewis Wolpert (who descibes himself as a physical reductionist), suggests that the difficulty individuals have in understanding scientific ideas arises from the fact that they are counter-intuitive. He relates this (as we noted in 'The Consequences of Omnescience') in turn to the fact that 'our brains have been selected to help us to survive in a complex environment; the generation of scientific ideas plays no role in this process'. *The Unnatural Nature of Science* (London: Faber, 1992).

 The lack of any evolutionary basis for science (and other, comparable, cultural achievements) has been put with brilliant lucidity by Thomas Nagel in *The View from Nowhere* (Oxford: Oxford University Press, 1986) p. 79.

 > The possibility of minds capable of forming progressively more objective conceptions of reality is not something the theory of natural selection can attempt to explain, since it doesn't explain possibilities at all, but only selection among them.

12. Charles Darwin, *The Origin of the Species* (London: Watts & Co., Thinker's Library Edition, 1929) p. 194.
13. It is, of course, a bit more complicated than this simple formulation would suggest. I shall be discussing the relationship between art and religion in 'The Difficulty of Arrival'.
14. I am reminded of an observation whose origin I cannot place, that 'the act of writing, like the act of love, is the happy gratuitous expression of vital existence'.
15. Raymond Tallis, *In Defence of Realism*, p. 212.

10 The Difficulty of Arrival

Life as a Problem

1. Apparent arrival may simply open on to waiting: the arrival on the beach becomes waiting to go into the sea, and, once in the sea, waiting for a wave worth catching; or waiting for permission to go for an ice cream and waiting in the queue when permission has been obtained; or, as discussed here, waiting for the pitch to be drawn on the sand, waiting for one's turn to bat, waiting for someone to bowl and to bowl a ball that one can hit, and waiting for someone to retrieve the ball when one has struck it.
2. I have ignored numerous inner and outer obstacles to arrival – worries, trivial accidents etc – because I want to focus on what is irremediable, structural, non-accidental, systematic in the failure to arrive.
3. Is the climax when they fall asleep in each other's arms? Alas, sleeping

together is not being together. As Heracleitus said, 'only the waking share a common Cosmos; each sleeps alone'.
4. From Paul Valéry, *Idée Fixe*, translated by David Paul (New York: Bollingen/Pantheon, 1965) p. 38.
5. The cameraman, who has often hovered reassuringly at the back of big occasions as an insurance against our being unable to experience – that is to say, to realise – them has more recently moved front stage. Weddings increasingly revolve round the business of 'recording the occasion' and turning themselves into footage. Not only the set pieces – the first post-nuptial kiss, the cutting of the cake – but everything in between has to be posed. Moments are set up to be recorded and the ever-diminishing unscripted remainder is required by some visual scribe or other to be frozen while it is recorded. The entire event thus breaks up into a series of *tableaux vivants* where even spontaneous smiles and gestures have to be held long past the point where they have ceased to be spontaneous and guests as well as stars feel inhibited. All live in constant fear of spoiling moments whose purpose is subordinated to the idealised memory, the idealised image, of an occasion that threatens to become simply the process of recording that image.
6. A theme that is sounded throughout his works but definitively confronted in his 'venture in experimental psychology', *Repetition*. I use the translation by H. V. and E. H. Hong in *Fear and Trembling/ Repetition* (Princeton University Press, 1983).
7. Kierkegaard's reason for denying that the recurrence of the same sensation would constitute repetition are more complex and more interesting. 'In reality [i.e. nature, the objective material world], this is not because everything is different, not at all. If everything in the world were completely identical, in reality there would be no repetition, because reality is only in the moment. If the world, instead of being beauty, were nothing but equally large unvariegated boulders, there would still be no repetition. Thoughout all eternity, in every moment I would see a boulder, but there would be no question as to whether or not it was the same one I had seen before'. Nor in ideality alone is there any repetition: 'for the idea is and remains the same and as such cannot be repeated'. It is only when ideality and reality touch each other that repetition occurs (ibid., p. 275). This last point reaches to the heart of my thesis about art.
8. Indeed, **the lack of change** may be the problem. For a consequence of revisiting – so that one is looking at or for the original of the postcards – is that one loses the sense of the new. When everything is exactly as one expects, then it is precisely on this account difficult to engage with. One cannot re-capture what the first visit offered: ignorance of what was coming next, of what lay round the bend in the road.
9. Kierkegaard, *Fear and Trembling/Repetition*, p. 275.
10. We see here Platonic lineaments. For Plato, there was a purified universal, ideal type compared with which all actual objects of sense experience were corrupt, degraded, inferior. Although this type was transcendental, and eternal, it was closer than sensory experience to an (intelligible) mental content, to something corresponding purely to the

word. For Duns Scotus, on the other hand, the thisness, the particular unrepeatable grain of the thing, the *haecceitas*, which exceeds the general verbal or verbalisable essence, exceeds the whatness or *quidditas*, was not a contaminant but, as Gerard Manley Hopkins appreciated, an added richness, an ineffable depth. That the real exceeds any recollection or anticipation of it is intrinsically neither a romantic or anti-romantic truth: it can be construed as either, depending on whether you think that that in virtue of which it exceeds the mental content is diluent – noise added to signal – or added richness. The fact that the instance always exceeds the type can be seen as a transcendent glory or a culpable deviation.

The tension between the idea and the experience may be seen as a side effect of a remarkable, even defining, property of the human mind, that has fascinated and puzzled philosophers since Plato. This is the ability to experience entities both as individuals and as instances of general types. Human awareness thus tends to two antipodal modes: particular sensations and abstract generalities. The development of language, which confers separate existence upon generality, exacerbates this tension, widens this divorce, between knowledge and sensation. For an illuminating discussion of the relationship between mind and generality, see Howard Robinson, 'The Flight from Mind', in Raymond Tallis and Howard Robinson (eds) *The Pursuit of Mind* (Manchester: Carcanet, 1991). The interaction between mind and language in developing a separate realm of general knowledge is discussed in Raymond Tallis, *Not Saussure* (London: Macmillan, 1988), especially the chapter on universals, 'Reference restored'. The implications of the progressive divorce between consciousness and the here-and-now, and the displacement of first-order sensory experience by symbol-mediated experience are of course enormous.

11. I cannot resist quoting from a letter Flaubert wrote from Constantinople, during his great journey to the East:

> I regret not getting to Persia... I keep dreaming of Asiatic journeys ... At other times I get so choked up with emotion that I could weep, thinking of my study at Croisset, of our Sundays. Ah, how I'll miss these days of travel, how I'll keep reliving them, how I'll repeat the eternal monologue: 'Fool, You didn't enjoy it enough!'

The Letter of Gustave Flaubert 1830–1857, selected edited and translated by Francis Steegmuller, London: Faber, 1981). In short, he is looking forward to the time when, returned from his travels, he will regret frittering away his journey in longing for the time when he would return home! ('Pleasure never is at home'!)

12. The quoted passages are from pp. 904 et seq of Volume 3 of the Terence Kilmartin translation of Proust's *Remembrance of Things past*.

13. *Second Elegy*, translated by J. B. McLeish (London: The Hogarth Press, 1967).

Art as a Solution

14. This does not capture the philosophical resonance of form and the reverberations of the millenia-long conflict between Platonic and Aristotelian notions. They are worth briefly noting here because they have importantly fed back into aesthetics.

 For the Greeks, form (*eidos* or *morphe*) was constrasted with matter (*hyle*), form being that in virtue of which matter was differentiated into determinate species or kinds of beings: it was the essential determinant principle of a thing. For Plato, to know the Form (or Idea) of something is to understand its true nature: its form permits the sensible object to be intelligible, graspable by the intellect, to be classified and understood. If you know the Form of Good, you not only know which things or acts are good but also why they are good. Past this point, Plato and Aristotle part company. For Plato, Forms, which are eternal, precede matter and actual things are merely imperfect copies of Forms. For Aristotle, form and matter are on a par: it is substances that are primary and these have both matter and form. While its particular form distinguishes an individual object from objects of other types, all objects have matter in common. Form is extracted by the intellect from successive experiences of individuals that exemplify them: red does not precede objects which palely copy it; rather the form red is abstracted from our successive experiences of red objects.

 Aristotle, in a way that was important for much subsequent aesthetic theory, distinguished immanent forms (such as the soul, which is the form of the human body) from externally imposed ones, such as the form the carpenter imposes on the table when he makes it out of wood. Immanent form explains a thing's development: *forma informans* is the intelligible structure that a thing has when fully developed. The growth or behaviour of a thing is a striving towards realisation or actualisation (**entelechy**) of this form.

 There are many echoes in aesthetic theory of this contrast between externally imposed form and the realisation of an immanent form – the most obvious being the Coleridgean contrast between the organic unity of a true work of art and the conventional order of a secondary, imitative work. Coleridge was influenced by German idealism. Kant's conception of form as a property of and product of consciousness was seminal. Aesthetic form was brought about by the activity of the mind, which was able, through the synthetic unity of apperception, to bring together several disparate things.

15. I begin with symmetry only as an example, not because I think that it is the essence of aesthetic form. The Stoics' definition of beauty, adopted by many writers since, as 'symmetry among the parts of a whole' gives symmetry (and surprising asymmetry) too central a role. Symmetry is simply one type of form, one way of achieving unity in variety and so integrating across experience. Symmetry alone does not, however, account for beauty in art, otherwise all symmetrical things would be beautiful and the beautiful could be made according to a formula.

16. The notion of the invariant – that which remains unaltered in the face of change – is central to mathematics, physical science and biology. It lies at the heart of the beauty perceived in the mathematical representation of the natural world. A still object is in some sense invariant; but so, too, is a moving object if it is moving in a straight line at uniform velocity; or if it is moving at a uniformly changing velocity. We may think of science as the discovery of constancy in change.

This is expressed in the equations or the laws that describe the patterns of change and the correlations between changes. Abraham Pais (in *'Subtle is the Lord . . . '*, his biography of Einstein) identified the ability 'to invent fruitful and illuminating invariance principles' as the key to Einstein's genius. This was at bottom an aesthetic sense, a feeling for the mathematical beauty of the natural world. The equation linking two variables and showing that there is a constant relationship between them may be considered as a first-level invariant. The invariants that Einstein identified were higher order: they described the general conditions under which the laws of motion were preserved.

The beauty of the mathematical vision of the world, then, is its revelation of constancy in change, its finding enduring forms of change and bringing together many (an indefinite number) of actual and potential observations and experiences under the single principle. Equations are the abstract form of the relationship between variables, of functions. Their beauty is inapparent to most people, because their elements are arbitrary symbols – they contain little sensory experience – and perhaps also because they are in a sense frozen. The equation is spatial like a painting but lacks its material presence and its iconic force; it is temporal like music and literature (because it is read) but lacks the committed temporal directionality of either (it can be read either from left to right or from right to left: $F = ma$ is no more canonical than $ma = F$). In short, an equation is the arrested ghostly form of change, the cast of an absent form, rather than a full-blooded 'moving unmoved' like a piece of music. Nevertheless, there are analogies between the transformations of mathematics and a set of musical variations and there is a sense, when one listens to music, of a problem being **solved**: the resolution is a kind of solution. Music and mathematics have had a liaison, since the Pythagoreans taught that musical ratios were a revelation of the true nature of Number and, since Number was the essence of all things, of the cosmos. Music brought men into direct contact with Number which, for the Pythagorean, was the ultimate reality.

17. This rather formalistic account of form is not intended to deny the influence of training in appreciation of, and of wider forces in susceptibility to, aesthetic experience. The influence of education, of scholars and the academy in the world of art is, of course, a mixed blessing and accounts for a different group of connotations – somewhat more disparaging – that the term 'form' may have.

The experience of form in art is mediated through both deeper and more superficial features. In poetry we may think of obvious surface

phenomena, such as rhyme, and deeper principles of organisation that may come from the subtle relationships between thematic and metrical organisation. The surface features are readily mimicked, even by those who have no real creative power. This may suggest that a poem may be achieved by following a recipe and aesthetic creation achieved by the replication of its external forms. By such routes does form descend to formalism and the formal calcifies to the formulaic and the formalistic. The Oxford English Dictionary traces this decline in art, and in life at large, in its definition of one of the meanings of 'form':

> A set, customary or prescribed way of doing anything, a set method of proceeding according to rule (e.g. a law), formal procedure . . . a matter of merely formal procedure, formally. A set method of outward behaviour or procedure, in accordance with prescribed usage, etiquette, ritual etc. Often slightingly, implying the absence of intrinsic meaning or reality. Mere outward ceremony or conventional observance of etiquette.

The point at which, or the conditions under which, the features necessary to achieve a recognisable form in a work of art degenerate into mere formalism is very difficult to define and it is often a matter of bitter contention. Fortunately, this is not something we need to address here.

18. T.S. Eliot, *The Dry Salvages*, V. After the rather pessimistic *receptionaesthetik* in 'The Myth of Enrichment', I have to add that real experiences of art are not quite pure in this way. We never quite achieve the moving stasis within ourselves corresponding to the work. We change even as we listen to music and not all the changes are brought about by the music.
19. Nothing I have to say about forms and patterns offers even the beginning of an explanation of the overwhelming effect a melody may have upon us. The formal structure of the melody accounts for its satisfying rightness but not for its poignancy, or for the happiness that seems to glow within it. What makes a succession of notes into a tune that seems to break out into a lovely weary smile is as mysterious as what makes a succession of recounted events into a story, or a joke funny.
20. This may be an important criterion for differentiating literary from non-literary writing, in particular fiction. Non-literary fiction is read for the plot-following, life-escaping hurried first-time-reading of finding out what happens. For literary fiction, subsequent readings may be at least as important – possibly more important. The gallop through to the end to find out what happens is journeying rather than arrival; whereas re-reading along a journey whose known goal informs its moments, the sense, growing with successive readings, of the overall form – or at least how everything connects with everything else, so that the work affords a synoptic view over a large part of the world – is arrival. That which unravels in time is replaced by something that exists all at once: time slows to space.

21. And pop music is not to be despised, as Sir Thomas Browne affirmed in *Religio Medici*:

 even that vulgar and Tavern-Musick, which makes one man merry, another mad, strikes in me a deep fit of devotion, and a profound contemplation of the First Composer. There is something in it of Divinity more than the ear discovers: it is an hieroglyphical and shadowed lesson of the whole World and the creatures of God; such a melody to the ear, as the whole world, well understood, would afford the understanding. In brief, it is a sensible fit of that harmony which intellectually sounds in the ear of God. (London: Dent, Everyman Library, 1906, p. 80)

22. Michael Schmidt (personal communication): 'The whole tendency of *The Faerie Queen* is to spread meaning evenly through the stanzas, not to rise to the little hiccup of a climax'. And: 'There is..a sense in which the poetry works by extension rather than concentration. One must read *The Faerie Queen* in large passages, for the impact is cumulative. The best effects are so much part of the overall verbal context that they do not detach themselves as aphorisms or vivid images'. Michael Schmidt, *An Introduction to 50 British Poets 1300–1900* (London: Pan, 1979).
23. E. M. Forster, *Aspects of the Novel* (London: Pelican, 1962). The entire chapter on 'Pattern and Rhythm' is fascinating but this passage is especially suggestive:

 Music, though it does not employ human beings, though it is governed by intricate laws, nevertheless does offer in its final expression a type of beauty which fiction might achieve in its own way . . . When the symphony is over we feel that the notes and tunes composing it have been liberated, they have found in the rhythm of the whole their individual freedom. Cannot the novel be like this? Is there not something of it in *War and Peace*?. . . Such an untidy book. Yet, as we read, do not great chords begin to sound behind us, and when we have finished does not every item – even the catalogue of strategies – lead a larger existence than was possible at the time? (p. 170)

Objections

24. I maintain this in the face of a literature asserting the opposite – that pain is charged with meaning and that it may sharpen or deepen our sense of life, as well as being an agent of growth. See, for example, David Morris' *The Culture of Pain* (Berkeley: University of California Press, 1991). My critique of this viewpoint is in *The Times Literary Supplement*, 1 May 1992, pp. 3–4.

 We may not be able fully to realise even unpleasant or tragic experiences – bereavement, for example. Gertrude describes Ophelia, singing old tunes while she drowns, as 'one incapable of her owne

distresse'. The enormous fact of the death of his beloved grandmother can let itself into Proust's consciousness only by the grace of an involuntary memory (a year after her funeral) that reveals her as irretrievably lost. As Beckett puts it (in *Proust and 3 Dialogues with Georges Duthuit*, London: Calder & Boyars, 1965): 'He had to recover her alive and tender before he could admit her dead and for ever incapable of any tenderness' (p. 42).

25. J. P. Sartre, 'Why Write?', in *What Is Literature?*, translated by Bernard Frechtman (London: Methuen, University Paperbacks, 1967).

 This is not to deny that art is about pain as well as joy. From Sophocles onwards, it has borne witness to a world of suffering from which there is no escape except death, in which there is no consolation and which, according to the vision of most recent writers, lacks transcendence. And yet even the stoic comedians harbour a secret intuition, a faith that the mystery of the world is deeper even than its misery and that at the heart of the mystery is a kind of joy.

 Perhaps even that is too much for some to concede: they would prefer to believe that suffering goes all the way down to the bottom of things and that the scream of anguish, rather than the cry of joy, is the truest expression of the real nature of the world. Even such as these – Beckett, Celine, Artaud – are not utterly devoid of hope: the fact that they are artists rather than akinetic terminal depressives testifies to this. They share the hope, in which the artistic impulse is rooted, of creating something of formal beauty out of the world they hate. The profoundest pessimist, insofar as he is an artist, is in the business of seeking out the honey of pleasure and joy. Their spiritual, even metaphysical, toothache is the trigger to their art – its content or referent, even; but their art seeks to find a formal joy, a satisfaction in it. Real toothache, real, permanent imprisonment without trial, not art, are the models of misery untranscended by joy. These conditions, too, force upon us a terrible coincidence with ourselves. But art is about self-coincidence in joy, about making delight as deep, as hard and as real as pain. Even if that delight is derived from taking a true measure of the misery of the world.

 Man, as Whitehead said, is the only animal that cultivates the emotions for their own sake. Those emotions may be unpleasant – terror, repulsion, etc. – and the experience of art may sometimes have the character of an ordeal. But the ultimate aim is liberation from terror and the pleasure of intensified awareness of the world and of one's self. Nietzsche's quoting Cardanus as having said that one ought to seek out as much suffering as possible in order to heighten the joy springing from its conquest is relevant here. But the suffering is of a special sort: there is a world of difference between the involuntary, blind, dumb, opaque, helpless pain of daily life and ordinary physical discomfort and the elective, luminous pain of art which opens on to joy. Sartre pointed out that 'there is no "gloomy literature", since, however dark may be the colours in which one paints the world, one paints it only so that free men may feel their freedom as they face it' (*What is Literature?*, ibid., p. 45).

26. Artists may be joyous optimists or black pessimists (more usually the latter) about actual life but for the most part they are agnostic as to whether at the heart of consciousness – the form experience would take if our deepest intuitions were allowed to permeate our lives, the place above which ordinary life and everyday preoccupations suspend us – is luminous joy, or pain, solitude, endless terror and grief.
27. Eduard Hanslick, *The Beautiful in Music*, translated by G. Cohen (New York: Library of Living Arts, 1957).
28. The famous aphorism comes from Walter Pater's essay *The School of Giorgione* in *The Renaissance*:

> all the arts in common aspiring towards the principle of music; music being the typical, or ideally consummate art, the object of the great *Anders-streben* [a partial alienation from its own limits] of all art, of all that is artistic, or partakes of artistic qualities. **All art constantly aspires toward the condition of music**. (New York: Mentor Books, p. 95)

Another passage from this essay is worth quoting in the context of the present discussion:

> For, as art addresses not pure sense, still less the pure intellect, but the 'imaginative reason' through the senses, there are differences in kind of the gifts of sense themselves.

29. One might nonetheless note in poetry the tension between sound and sense, between the acoustic material and the significance of the verbal tokens. In rhyme, the present sound is paired with the absence of the rhyming sound, thus binding together here and not-here, and subordinating material experience under a form that transcends it.
30. Valéry, *Cahiers*, vol. 11, p. 230–1925. Valéry also famously suggested that poetry is to prose as dancing is to walking. Prose, like walking, has a definite object to which its movements are subservient. Poetry, like dance, is movement for its own sake: it does not transport from one point to another, but 'exists to make me more present to myself'. The analogy is appealing, though the distinction between the functions of poetry and those of prose denies the latter the status of literature. It is easy to find counter-examples – poetry that serves to inform or castigate and prose that dances. However, the analogy has some validity if one uses it to distinguish between the literary and non-literary uses of language and to emphasise how literature is concerned less with business and with getting somewhere than with savouring language, ideas and the world. Nevertheless, it should not be taken to imply that there is an absolute distinction between poetry and prose and that poetry has nothing to say, no expressive or referential goal outside the celebration of language. George Steiner's characteristation (in 'Linguistics and Literature', in Noel Minnis (ed.) *Linguistics at Large*, 1971) of literature as 'language freed from a paramount responsibility

to information' seems a just, accurate and succinct statement of how things are with literary prose as well as poetry.

31. Reciprocating the grip the world has on us is, however, disinterested. We do not seize hold of the world with a view to acting upon or possessing it.

 Disinterestedness is central to Kant's *Critique of Aesthetic Judgement*. When we appreciate an object aesthetically, we have no interest in its real existence. We do not wish to use it, only to contemplate it for its own sake. This view has given rise to a major strand in the aesthetic thought of the last two centuries, in which art is understood as contemplation of the world independently of the will.

32. They are summarised and evaluated with beautiful lucidity in Anne Sheppard, *Aesthetics: An Introduction to the Philosophy of Art* (Oxford: Oxford University Press, 1987). My discussion uses Sheppard's taxonomy.

33. According to Kant, whose views seem especially relevant here, when we contemplate an object aesthetically, we do not classify it as an example of a general kind. My judgement that this flower is beautiful is not a judgement that it is beautiful compared with other flowers, beautiful for a flower, but that it is absolutely beautiful as an object in its own right. (In contrast with this judgement of taste, where the object is seen as an example of 'free' beauty, there is another, less pure judgement, in which the object is judged as an example of its kind, as an instance of 'dependent' beauty.)

 What is interesting about this theory is that the judgement of beauty is applied to objects considered not as instances of types but as **singulars**. It is as if by the intensity of its beauty, the object is liberated from the class into which ordinary perception would place it, and is there before us in its own right, in its own being. It does not dissolve into a node in a network of concepts.

 I would like to develop this further and suggest that, thus liberated from ordinary membership of a type, the object, which still, after all, retains its physical similarity to other objects of its class, is able to reassume its class at a higher level and become an **archetype**: that is why the beautiful object seems to capture the essence of the type to which it belongs. In this sense, the object acquires metonymic power. A flower becomes **the** flower. Moreover, by breaking out of the carapace of ordinary classification, the object is at once generalised at a higher level and more completely revealed in its physical particularity. This simultaneous upward movement towards abstraction, or archetypicality, and downward towards physical reality, fulfils the need for a deeper union of the physical and intellectual than is afforded by ordinary experience. This is the basis for the 'universal perceived in the particular' or the Concrete Universal of Schopenhauer. The connection with my own thesis about art is self-evident.

34. I am not, of course, unaware of the anti-realistic movement in hitherto representational arts, such as literature. Some critics believe that artists and their audiences are unaware that art does not replicate nature but creates a second nature. This belief in the naivety of readers and realistic writers, along with a deal of bad philosophy, worse linguistics

and even worse political theory, has prompted literary theorists to single out for praise anti-realistic novels, which make the 'second nature' or artefactual status of fiction explicit. Neocosmic and anticosmic fictions are regarded as valid in the way that novels that purport to refer to the real world are not. A brilliant taxonomy of such fictions is given in Cristopher Nash's sympathetic *World Games* (London: Methuen, 1987) and the shabbiness of the case against realistic fiction is exposed in Raymond Tallis, *In Defence of Realism* (London: Edward Arnold, 1988).

35. Naturally, not any old emotions will do. Those occasioned by art are expected to be superior to those normally triggered either by the vicissitudes of daily life or by non-artistic representations. After all, the meanest soap that flickers (especially if backed up by strong music) can invoke emotions that lie shallow enough for tears.

The strongest claim for the superiority of the emotions induced by art is the Kantian one that they are directed towards imaginary events and so, in a way, may be thought of as disinterested. This is, however, a little naive. After all, our pity for Little Nell may be simply projected self-pity; our anger at those who brought about her death may be self-indulgent recrudescence of an anger felt on our own behalf. And insofar as those emotions **are** disinterested they are separated from the need for action: they are liable to be merely sentimental, as was discussed in 'The Freezing Coachman'.

The artificial conventions of art maintain the distance between the response to the work and spontaneous, unreflective emotions. A purely conventional work would, of course, be dull and mediocre. The art of much art is to steer a middle course between the convention-mediated and the seemingly direct expression of personal emotion. However, the question of the emotional response of the recipient is even more pressing in the case of drama. The weeping theatregoer in Tolstoy's story (see 'The Freezing Coachman') is a perfect case study of the futility of unreflective emotional responses to drama.

It was this that lay behind Brecht's emphasis on *verfremdung*, or distancing, to ensure that people who came to the theatre were not merely just moved but were moved **to think** – or at least connected their responses with life outside of the theatre. If they were uncritically absorbed in what they saw on the stage, forgetting that they were watching a play, they would not connect it with the real world. Brecht's 'epic' theatre obliges the audience to be conscious observers, aware that what they are watching is not reality but a spectacle. They have to reflect on what they are seeing rather than simply immersing themselves in it, taking the side of this character and that. This is the opposite of Tolstoy's imaginary audience passively 'infected' by the emotions the artist has poured into his work. While epic theatre may have made for a more reflective (if less engaged) audience, it is uncertain whether it changed anyone's political and social behaviour. And it is even more uncertain whether it changed them for the better. At any rate, Brecht recognised that the emotions caused by art should be something other than the emotions felt in everyday life.

If these emotions are disinterested and reflective and connect with wider reaches of human life and reach into larger ideas than ordinary emotions, this may suffice: the emotions become the unifying principle in a world seen *sub specie aeternatatis*. (My own view roughly corresponds to this.)

Others have suggested that art induces specifically 'aesthetic' emotions that have no essential connection with emotions in everyday life. Such was the 'aesthetic emotion' prompted by the encounter with Significant Form postulated in the theory of Clive Bell and Roger Fry. Whether or not one believes that anything corresponds to the idea of such emotions, it is obvious that the emotions induced by art are going to be of a different kind from those we experience in other contexts. Not only are they voluntary but they are 'cultivated', in other senses of the word. We enjoy them and relate them to our appreciation of the work that has prompted them. We may discuss the emotions we might be expected to feel in the light of the artist's intentions. Their triggers are objects of study and comparison. And so on. Perhaps we should talk less about emotions than 'tones of consciousness'.

Susan Langer suggested that the forms of art correspond to the formal features of human emotions in general. Since I am not too sure what formal features individual human emotions could have, even less what emotions in general (irritation, delight, love) could have in common, and less sure yet again how these might correspond to formal features of art (in general), I do not find this very helpful. I would prefer to retain the idea of emotions as sharing with art the ability to unify disparate things.

36. The art of literary art (and perhaps of all representational art) is that of choosing those disparate things in such a way as to enclose the space between them. The artistic tact required to determine the watershed between openness of suggestion on the one hand and mere imprecision, gesturing, handwaving on the other – gauging exactly how much can be left unstated – lies at the heart of literary genius. Literary art perfects memory, the synthetic property of retrospect, by neither losing sight of the overall ideas and sentiments that haunt and shape retrospect, nor divorcing itself from the concreteness of the present or the actual instance. Perfection of retrospect exploits the selective genius of (involuntary) memory without suffering from its fugitiveness. A world thus invoked by suggestion and retrospect becomes, or gives the sense of, an overview. Consciousness, by this means made temporarily a tor on its world, momentarily possesses the world that possesses it.

There is an analogy here with the sexual vision: the beautiful body seems a whole world of otherness and connotation made possessable. The unrealisability of that vision is due to the fact that sexual contact is only with the material basis of a world that is imagined or fantasised. The overview promised to the vision is not, could not be, realised in, for example, touch. Sexual expression is thus always in danger of breaking down to a mere succession of episodes. Nevertheless, bodily beauty seems to be, or to hint at, a tor on the consciousness of the person.

37. Samuel Beckett, *Proust*, op. cit., pp. 29–30.
38. *Aesthetics*, in *Encyclopaedia of Philosophy* (London: Routledge, 1988).
39. This is the difference between de Quincey's opium dreams and the literary experience we enjoy through reading his accounts of them. The former are not artistic experiences, for all their extraordinary richness and intensity – and even intertexuality! They remain episodes, in which consciousness is isolated from other consciousnesses and other moments of itself. Nor are they works of art, although his descriptions of them, being among the great masterpieces of English prose, are.

 The distinction between intoxication by drugs (based on mechanical causes) and intoxication by art (based on reasons) is perhaps less clear and more vulnerable to criticism than I have presented it here. Our love of works of art, like our love of people, is rarely, if ever, entirely reasoned, wholly based upon an objective estimate of their worth; causes, as well as reasons, move us. This does not, however, alter the essential point: that perfection of the moment is about continuity, not discontinuity; about connectedness rather than disconnectedness.

 The philosophical background to the distinction between the respective influences of reasons and causes on behaviour is examined in Raymond Tallis, *The Explicit Animal* (London: Macmillan, 1991), in particular the final chapter, 'Recovering Consciousness'.
40. For an extended discussion, see Raymond Tallis, *In Defence of Realism*. I shall be discussing this further in *The Enemies of Consciousness* (Macmillan: London, forthcoming).
41. This is, of course, a grotesque generalisation about Augustan verse and it has many spectacular exceptions: Gray, Johnson, Pope all produced poems in which conventional feelings and sentiment were expressed with such brilliance and penetration, and given such a deeply personal gloss, as to outshine much of the Romantic outpouring that followed. It is necessary to put the attacks of Wordsworth et al. upon their Augustan predecessors in context and to understand that they were connected with the promotion of their own works.
42. Reader-response criticism and theory has focussed attention on the nature of the reading experience and, in particular, the extent to which readings vary, so that different readers do not merely mirror in an identical fashion the work they are reading. Accepting this variability of readings does not license a dissolution without residue of the work of literature into a multiplicity of responses. This would be to confuse the inner worlds of conscious experiences with an external world of cultural objects. The latter has been called World 3 by Popper. (World 1 is the physical world and World 2 the world of our private conscious experiences. See 'On the Theory of the Objective Mind', in *Objective Knowledge*, Oxford, 1972.) World 3 is the realm of 'objective thought' and of the products of the human mind, such as books.

 Understanding any human artefact requires some appreciation of its connections with other cultural objects and, more widely, of the human culture of which it is a part. It would not be possible to understand, let alone enjoy, a poem without considerable tacit and explicit knowledge of its world. This will include knowing something about the poem's

literary, social and historical context. Since this knowledge will vary from reader to reader, and since the attitudes, emotional set and intellect of different readers will also differ, there will be an indefinite number of potential readings – or reading experiences. Different life-experiences in a wider sense will also influence readings: how I read *Portrait of an Artist as a Young Man* will be greatly influenced by the fact that I am a male student in Dublin in 1920 as opposed to a female student in the West Indies in 1994.

It does not follow from this that the work is a Rorschach ink-blot whose meaning is entirely determined by the recipient. Granted that an expert on Elizabethan literature will derive much more from *The Faerie Queen* than I will because of his knowledge of the provenance of the work, his understanding of allusions and the greater care with which he reads it. And his experience of the poem will be very different from that of Spenser's contemporaries. This is not in question. What is at issue here is **how much** variation is allowed between variant readings, whether we should subscribe to the 'anything goes' school of interpretation and allow a Derridan reading of *The Faerie Queen* that treated the entire work as a meditation on the displacement of 'i' by 'e' (the first person by the third) in *Faerie*.

The belief that all readings of a work of art are equally valid has come not from observation of the readings of ordinary readers but from the endless variant interpretations by professional critics for whom works of art may be used to service their hobby horses.

In short, a wide variety of readings is possible. But the work does not dissolve into these readings. At the heart of the experience of a great work of art is the sense that it is transcended by the work itself. A classic novel is greater than any reading – just as a great symphony can never be exhausted by any one interpretation: Brahms' Brahms transcends both Karajan's Brahms and Wand's Brahms.

43. Kierkegaard, *Concluding Unscientific Project*, translated by David Swenson and Walter Lowrie (Princeton: Princeton University Press, 1944), p. 176. World 3, the realm of permanent cultural objects capturing fugitive visions, in a sense stands for the possibility of making transcendence more than momentary and arrival 'a standing condition'.
44. Dudley Young, *Origins of the Sacred* (London: Little, Brown and Company, 1992) p. 237.
45. 'Music', *The Oxford Classical Dictionary*, 2nd ed., N. G. L. Hammond and H. H. Scullard (eds) (Oxford University Press, 1970), p. 710.
46. The story as I have told it is an enormous, even ludicrous, simplification and one that could have been told in different ways. The point is that the status of the artist and the function and significance of art – and the very existence of art as a separate category of human activity and experience – have varied dramatically in different cultures and in the different arts.
47. As discussed in Note 36, there is always a delicate question with open forms as to how much of the space the disparate elements are scattered across is actually captured or enclosed by them and can be gathered into and attributed to the work. The recipient is required to make the

connection, the closure, and so to do the enclosing. The assumption of authorial intention means that a work of art may not borrow as much from the outside as, say, a Rorschach ink-blot does.

A similar question arises with respect to allusive works of art. How much of the history of western music, and of the decline in its confidence, and of the crisis of western consciousness really can be expressed in Schnitke's Third Quartet, for all that it includes quotations from Lassus's *Stabat Mater* (consonant polyphone; an ideal past), the Grosse Fuge of Beethoven (dissonant polyphony; a problem past) and Shostakovitch's personal motto (simple dissonance; a problem present)? *Post hoc* rationalisation is the occupational hazard of artists and the occupation of critics.

(The fact that great works of art – the late quartets of Beethoven – may be non-referential shows how, at the very least, morality, public or private, has no necessary connection with art. At the very least, referentiality is necessary for the possibility of conveying heightened moral awareness, or demonstrating political engagement. Of course, it is always possible to read such things into the least referential work of art: anger at the coming of war in the quarter tones used in a quartet by Haber, dissent from Communism in the lavish use of purple in a canvas by Kandinsky. But this has to be treated with scepticism.)

48. Here, even more than elsewhere in this essay, I am indebted to Michael Schmidt for detailed criticism.
49. In A. Robbe-Grillet, *Snapshots and Towards a New Novel*. For a discussion of Robbe-Grillet's critique of the over-liberal use of anthropomorphic metaphors in the description of nature, see *In Defence of Realism*, pp. 109–13.
50. At any rate, Thomas Mann presents it as Goethe's metaphor in *Lotte in Weimar* (see the translation by H.T. Lowe-Porter, London: Penguin, 1968, p. 265).
51. Again I am particularly grateful here for Michael Schmidt's valuable criticism. More precisely, I acknowledge that I have here stolen some of his ideas.
52. H. Read, *The Meaning of Art*, Revised edition (London: Faber, 1968) pp. 21–2.
53. For a discussion of the role of fiction in this regard, see, for example, *In Defence of Realism*, pp. 178–9.
54. For example, 'This is the most thorough and telling portrait we have of Latvian peasantry in the 8th century before Christ', 'Never before has the catheter industry received such a vivid fictional treatment', 'For a definitive account of the problems of being an ataxic octagenarian in the chilly wastes of the Russian steppe, we need look no further than this novel', etc.
55. Proust's, *A la Recherche de Temps Perdu* is a curious novel in many ways but not the least because, being about the life of an imaginary character who discovers as his purpose in life the writing of a novel, it is a mezzanine form between novel and meta-novel.
56. Quoted in Jorge Luis Borges, *A Personal Anthology*, edited by Anthony Kerrigan (London: Picador, 1972) p. 174.

It is important not to take too literally the notion of literary art as preservation of the past or of the world. Consider the following passage in Walter Benjamin's wonderfully suggestive essay 'The Image of Proust' (available in *Illuminations*. Edited and with an introduction by Hannah Arendt, translated by Harry Zohn London, Jonathan Cape, 1970) p. 204:

> We know that in his work Proust did not describe a life as it actually was, but a life as it was remembered by the one who had lived it. And yet even this statement is imprecise and far too crude. For the important thing for the remembering author is not what he experienced, but the weaving of his memory, the Penelope work of recollection. Or should one call it, rather, a Penelope work of forgetting? Is not the involuntary recollection, Proust's *memoire involuntaire*, much closer to forgetting than what is usually called memory? And is not this work of spontaneous recollection, in which remembrance is the woof and forgetting the warf, a counterpart to Penelope's work rather than its likeness? For here the day unravels what the night has woven. When we awake each morning, we hold in our hands, usually weakly and loosely, but a few fringes of the tapestry of lived life, as loomed for us by forgetting. However, with our purposeful activity and, even more, our purposive remembering each day unravels the web and ornaments of forgetting. This is why Proust finally turned his days into nights, devoting all his hours to undisturbed work in his darkened room with artificial illumination, so that none of those intricate arabesques might escape him.

57. It has been argued that we all share in the creativity of the artist. This claim goes deeper than the democratising assertion that everyone has a smidgeon of talent, to the suggestion that, since perception is shaping as well as shaped and the world we perceive often exceeds the data upon which it is based, the brain itself is an artist and consciousness, in its synthetic activity, in its completion of sensation in accordance with expectancy and the Laws of Good Form (as discussed earlier), is creative.

 There is perhaps no need to dwell too long on the absurdity of this position: if every optic pathway is a Rembrandt, we don't need Rembrandt; nor do we need education and 'community arts' to encourage us to realise our creative potential, for we cannot, it seems, escape from it.

58. Not an invitation to succumb to the popular Death of the Author fallacy! The reader's reproduction of the novel is not the same as the writer's production of it, nor is his contribution more important or decisive than the author's. What I am determines to some extent my experience of Beethoven's Fifth Symphony; but this does not diminish Beethoven's contribution to the experience.

59. The reader or listener does not, of course, share in the process of building the work of art 'from nothing'; or rather his smaller effort of building does not provide the same distraction from death. He does not have the great joy of 'the great project'. (Flaubert, even in the midst

of the agony of composing *Madame Bovary*, repeatedly expressed an inability to understand how ordinary people could live without such a task to confer structure and purpose on their lives.) Nor can the recipient look forward to posthumous 'survival'. But to be deprived of these things may not be such a privation after all.

The joy of the great project of creation is considerably attenuated by the misery of composition. The reader or listener is also spared the disappointment of a task that is (as Valéry said) 'never finished, only abandoned'; or, if seemingly finished, never marked by a definite moment of completion. The first draft leads to a second draft; the second to subsequent drafts; drafts give way to proofs to be corrected and uncorrected; proofs give way to publication and who knows when publication day is? Publication gives way to a great silence intermittently broken by uncomprehending or hostile reviews. If the writer did not love the task for its own sake – for all the little acts of finishing – he would not do it for its completion!

As for posthumous fame, it is illusory, existing only in prospect: it cannot be enjoyed by its object. Even if the bearer of posthumous glory were to be aware of it, it would be unlikely to bring him much satisfaction, as Sartre reflected:

> Someone said recently that he knew of nothing more ignominious than posthumous rehabilitation: one of our number is trapped, he dies from rage or grief and then, a quarter of a century later, a monument is erected in his honour. And the jackals who make the speeches over his effigy are the **very ones** who killed him in the first place – they honour death in order to poison the living . . . Death cannot be recuperated. ('Purposes of Writing', in *Between Existentialism and Marxism*, NLB, 1974, pp. 27–8)

60. It is not for nothing that Paul Valéry saw *La Comedie Humaine* as a middle term in the progress of human self-knowledge, positioned between *The Divine Comedy* and his postulated *Intellectual Comedy*. All three are kinds of *summa*, attempts to possess the entirety of things and so complete experience by bringing all meaning together in one place. Every great book – or every complete *oeuvre* – attempts to be (and so replace) the Bible, as Novalis said.
61. We could put it this way: the insufficiency of meaning that the artist perceives or suffers is clothed in the meanings of the world that he pours into his art. And I refer here not only to explicit nihilists such as Beckett, Gottfried Benn, Thomas Bernhard, etc., but also to 'driven' writers such as Tolstoy and Dickens who clothed their emptiness in the richness of the world they replicated on the page.
62. It is important not to exaggerate the sharpness of the boundary between artists and non-artists. Artisans, craftsmen, men-of-letters, musicians, would-be artists shade into the real thing. And the lives and preoccupations of artists and non-artists are not so utterly different. Artists, too, are ambitious, have appetites, suffer grief and disappoint

ment, take a gossipy interest in things, fear enemies and ridicule, etc. – in short, drink deeply of the ordinary senses of the world and drown in everyday experience. Moreover, artists have careers, with all the considerations – self-promotion, pleasing patrons, income, feedback from critics and others – that come with careers. And they have specific, craftsmanly concerns about technique and self-improvement and responding to or resisting the influence of others. Conversely, non-artists have their metaphysical moments and free-floating dissatisfaction at life and the insufficiency of experience. It is a question of how much and how often, and of the seriousness with which they are taken.

Conclusions

63. J. S. Mill, *Autobiography*, Chapter V, 'A Crisis in my Mental History' (New York: Signet Classic Edition, 1964) p. 107.
64. J. P. Sartre, 'Purposes of Writing', in *Between Existentialism and Marxism* (London: New Left Books, 1974).
65. *The Letters of Gustave Flaubert 1830–1857*, selected, edited and translated by Francis Steegmuller (London: Faber, 1981) p. 81.
66. J. P. Sartre, *What is Literature?*, p. 220.
67. Quite aside from the consolations of art, writing these pieces has gone some way towards palliating my own anguish. Whether the consolation has come from the process, the product or its conclusion, I am not too sure. In art, it is the work, not its conclusion, that consoles. We have and need art because there are no happy endings: happiness is provisional and not the end of the story; and the end is not happiness. Everything that is given to us, everything we struggle for, everything we achieve, is ultimately taken from us. After our passage through the light, we return to the earth, naked as we came.

At any rate, 'The Difficulty of Arrival' has served my own needs. (And, because this may be true in more ways than I realise, it is difficult to know how much my theory of art is a theory of what I would like to believe art is, or might be, than a theory of what it actually is.) I do not fear the difficulty of arrival as much as I did when I began writing this – on holiday as it happens. It is as if I feel that part of myself, of all of us, is 'in the bag' and there is a portion of time that has not passed through me like water through sand, not been entirely squandered into distraction. In a sense, 'The Difficulty of Arrival' has been for me a way of arriving on holiday. What the arrival has consisted of or will consist is not entirely clear: Having these thoughts and putting them together and so seeing how my local discontents can be connected with big ideas? Drafting and re-drafting these pieces until the idea of a final draft is satisfied? Seeing the pieces in print and imagining that they are read by others? Combatting the indifference or outraged criticism they attract? The possible points of arrival are endless; and by the time they have all been visited, some other journey, undreamt of at present, will be underway and the difficulty of arrival will be faced all over again. But perhaps not in the same way.

Postscript

1. Raymond Tallis, 'The Work of Art in an Age of Electronic Reproduction', in Raymond Tallis, *Theorrhoea and After* (forthcoming)
2. Friedrich Holderlin, *To the Fates*. The lines are translated by Michael Hamburger as follows:

> for **once**
> I lived like gods, and it suffices.

Index

accessibility of art, 80
aesthetics
 of art, 86, 157–9, 169, 189
 in science, 17, 19
AIDS, 35–6, 60–2
Akhmatova, Anna, 232n
alchemy, 65, 66
alternative medicine, 63–4
Amiel, H. F., 26
animals, 120–1
anthropofugalism, 62
anti-Semitism, 92
Appleyard, Brian, 4, 33
Archilochus, xi
Aristotle, 154, 211, 223n, 239n
Arnold, Matthew, xvi–xvii, xviii–xix, 30, 31, 73–4, 84, 154
arrival, difficulty of, 128–50
 art as solution to, 150–62; objections to, 162–204
arts and humanities, xvii, xix, xx, 72–3
 aesthetics in, 86, 157–9, 169, 189
 commitment in, 56, 82
 consumption (experience) of, 85–6, 96–110, 200–4
 criticism of, 30, 31–3, 39–40, 98–101, 108
 division from science of, 3–4, 16, 29, 72
 enrichment by, 95–6, 103–10, 126
 form in, 152–7, 159, 160–1, 165–6, 188–9
 future convergence of science with, 209–13
 human consciousness and, 122–5
 interest in, 4
 lack of reality in, 87–8
 morality and, 79–93, 94–5, 126
 origins of, 183–7
 plurality of, 164–8
 politics and, 81–2
 producers of, 196–204
 Romanticism, 9, 11–28, 45
 as solution to difficulty of arrival, 150–62; objections to, 162–204; 'uselessness' of, 77–8, 126–8 *et passim*; refutations of, 90–93, 94–110, 111–12, 123–5, 150–62
artists, 196–204
atheism of science, 24
Auden, W. H., 33, 81, 90, 179
Ault, Donald, 219n
authority, 58, 59

Bach, Johann Sebastian, 80
Baker, Nicholas, 44–5
Balzac, Honoré de, 202–3
Barthelme, Donald, 100
Barthes, Roland, 111
Bates, W. J., 27
Baudelaire, Charles, 80
Beckett, Samuel, 95–06, 107, 175, 243n
Beer, John, 215n
Beethoven, Ludwig van, 80, 203
Bell, Charlotte, 7, 214
Bell, Clive, 247n
Bell, Michael, 33
Benjamin, Walter, 251n
Benn, Gottfreid, 126, 227n
Benveniste, Emile , 58
Berlin, Isaiah, xi–xii
Bernard, Claude, 20, 66
Blake, William, 11, 14, 27–8, 52, 66, 177, 215n, 216n
Bloom, Harold, 215n
Borges, Jorge Luis, 198
Brahe, Tycho, 17
brain, 118
Brecht, Bertolt, 51, 82, 126, 246n
Browne, Thomas, 242n
Burtt, E. A., 217n
busyness, 140–1
Butler, Samuel, 121–2

Cambridge, 32–3

Index

camcorders, 139–40
Cartland, Barbara, 80
chaos theory, 91
Chateaubriand, Francois René de, 12
Chekhov, Anton, 234n
chemistry, 65, 66
Christmas, 135–6
clinical trials, 59
Coleridge, Samuel Taylor, 13, 16, 19, 27, 64, 73, 201, 215n, 239n
commitment, 56, 82
communication, 44
communism, collapse of, 81
consciousness, 111, 127
 art and, 122–5
 biological perspectives on, 112–22
Constable, John, 225n
consumption of art, 85–6, 96–110, 200–4
contraception, 48
co-operation, 58–60, 69–70
Copernicus, Nicolas, 17
Cornwall, 128–35, 138–9, 143, 146
corruption by art, 88–9
counter-intuitive nature of science, 7–8
Couturier, Maurice, 100
Crick, Francis, 36
criticism, 30, 31–3, 39–40, 98–101, 108
culture, art and, 192–5

Darwin, Charles, 121–2
Darwinism, 112–22
Davies, Paul, 218n
Dawkins, Richard, 113, 114, 115, 121
Dean, Malcolm, 224n
dehumanisation, science and, 33–4, 42–54
deindexicalisation, 34
de Quincey, Thomas, 16
Descartes, René, 23
Dewey, John, 69
diagnosis, xiii
Dickens, Charles, 33, 191–2
Dilke, Charles, 27, 138
DNA, 32, 36
Dostoyevsky, Fyodor, 119

drugs, 178–9
Duns Scotus, John, 238n
Durand, Regis, 100
Dyson, Freeman, 221

Eagleton, Terry, 100
education, 16, 62, 69, 72, 103
Einstein, Albert, 18–19, 22, 24, 38, 59, 69, 240n
electronics, 15
emotion in art, 171–3
English Studies, 30, 32–3
enrichment by art, 95–6, 103–10, 126
environmental problems, 14, 47–9, 71
epilepsy, 71
European Centre for Nuclear Research, 59
evolution, 7–8
 of human consciousness, 112–22
experience of art, 85–6, 96–110, 200–4 *et passim*
expressive theory of art, 171–3
eyes, 115–16

Feynman, Richard, 10, 37, 222n
fire, 50–1
Flaubert, Gustave, 33, 147, 207–8, 228n, 238n, 251–2n
Fleischman, Martin, 58
form, 152–7, 159, 160–1, 165–6, 188–9
Forster, E. M., 7, 161, 242n
fraud, 40
French Romanticism, 12
Frost, Robert, 90
Fry, Roger, 247n

Gaia theory, 53
Galileo Galilei, 64
Gallo, Robert, 61
German Romantics, 12
Gestalt psychology, 157, 158
Gide, André, 113, 160
global warming, 49
Goethe, Johann Wolfgang von, 12, 23, 158, 191
Goldschmidt, Richard, 115
gossip, 8

government, 65–6
greed, 48, 62
Gribbins, John, 218n
Gross, Alan, 4, 36, 37
Gunn, Thom, 141

Hadamard, Jacques, 19
Hamsun, Knut, 92
Hanslick, Eduard, 164
Hardy, Thomas, 175
Harré, Rom, 34–6, 37
'Hedgehog' and 'Fox', xi–xii
Hegel, Georg, 56, 222n
Heidegger, Martin, 124, 172
Heraclitus, 237n
HIV/AIDS, 35–6, 60–2
holidays, 128–35, 138–9, 140–1, 143, 146–7
Hope, A. D., 53
Hopkins, Gerard Manley, 238n
Hopkins, Gowland, 189
Huxley, T. H., xvii, 31, 57, 73
Huysmans, Joris-Karl, 148
hypotheses, 17–20, 38

Ibsen, Henrik, 80
ignorance about science, 5–6, 70–2
imagination in science, 16–20
impiety, 52–3
Industrial Revolutions, 9, 11, 13–14, 15
intellectuals, xiv, xv
 AIDS crisis and, 61
 difficulties with science of, 3–10, 11–28, 29–41, 35–7, 39, 40, 42–54, 55–67, 68–73
intelligence, xiii
interdependence of technology, 45
internationalism of science, 58–60, 69–70

Jakobson, Roman, 166–7
James, Henry, 84, 161, 226n
jargon in science, 6–7
Jeffreys, Richard, 33
Johnson, Samuel, 77, 219n
journalists, 82, 83
 AIDS crisis and, 60–1, 62
journals, scientific, 58

Kant, Immanuel, 190, 239n, 245n
Keats, John, 20–21, 27, 56, 81, 86, 147–8
Kekule von Stradowitz, Friedrich, 19, 218n
Kepler, Johan, 17
Keynes, John Maynard, 18
Kierkegaard, Søren, 91, 142, 143, 145, 149–50, 181–2, 203, 237n
Kleist, Heinrich von, 119
Koyré, Alexandre, 23
Kuhn, Thomas, 38

Lagrange, Joseph Louis de, 12
Lamb, Charles, 21
language, 121
 of science, 6–7
Laplace, Pierre Simon de, 12, 23–4
Laue, Max von, 17
Lawrence, D. H., 46, 113
Leavis, F. R., 3, 4, 6, 29–33, 40, 73, 84, 89, 227–8n, 229–30n
Lenard, Philipp, 40
Lindop, Grevel, xvii–xviii, xx, 216n, 217n, 218n
literature, 174–6
 consumption of, 96
 enrichment by, 105
 form in, 160–1
 morality and, 79–93
literary criticism, 30, 31–3, 39–40, 98–101
literary theory, 34–7
Locke, John, 225n
London, Jack, 113
Lysenko, Trofim, 40, 58

Mach, Ernst, 24
machine metaphor of science, 23–4
Maclean, Alasdair, 230n
magic, 63, 64
Mallarmé, Stéphane, 167, 176, 185
Mandelstam, Osip, 80
Mann, Thomass, 161
Mannheim, Karl, 39
marriage, 136–7
Marx, Karl, 14, 226n
masochism, 88, 163
mass media, 83

Index

materialism, 52
Maxwell, James Clerk, 21–2
means, xvi
Medawar, Peter, 17, 43, 47, 57, 72
Medical Research Council, 32
medicine, xiii, xiv
 AIDS and, 35–6, 60–2
 alternative, 63–4
memory, 104, 106, 175, 196
Menuhin, Yehudi, 156
Merquior, J. G., 9
metaphor, 154
metaphysics, 111–12
Midgley, Mary, 3, 118, 235n
Mill, John Stuart, 205
mimesis, 169–71, 173
mind, theory of, 105
modernism, 99–100
Montagnier, Luc, 61
morality, art and, 79–93, 94–5, 126
music, 173, 176–7, 183, 185
 consumption of, 97–8, 106–7
 form in, 153–4, 155–7, 165–6, 188
 morality and, 85
Musil, Robert, 8, 199
mutation, 114, 115

Nagel, Thomas, 8, 236n
narrative theory, 34–6
Nash, Cristopher, 34
Nature, 47, 53–4, 60, 70
negative capability, 27
Nekrasov, Nikolai, 91
neo-Darwinism, 112–22
neonatal tetany, 56
New Age ideas, 70
Newton, Isaac, 11, 12–13, 16, 17–18, 21, 23, 24, 38, 65, 66, 70, 215n
Nicolson, M. H., 216
Nietzsche, Friedrich, 25, 52, 79, 150, 190, 224n, 243n
non-referential art, 85
nostalgia, 30, 46–7, 54
Novalis, 12

objectivity of science, 8, 34–5, 64
Observer, 62
occasions, 102
omniscience, 5–6, 29, 68 *et passim*

opinion polls, 71
oppression, 49–50, 58, 81–2, 227n
orgasm, 137
Orwell, George, 49
ozone depletion, 49

Pais, Abraham, 19, 240n
Pascal, Blaise, 142
Pasternak, Boris, 80
Pater, Walter, 165, 244n
personalisation of illness, 63–4
philosophy, xv, xvi
photography, 139–40
photosensitivity, 115–16
Pico della Mirandola, Giovanni, 224–5n
Planck, Max, 17
Plato, 169, 210, 237n, 239n
Poe, Edgar, Allan, 160
poetry, xvi–xvii, 97
 form in, 154–5, 160–1, 166–7
political art, 81–2
politicians, AIDS crisis and, 60
pollution, 47–9, 71
Pope, Alexander, 12, 180
Popper, Karl, 17, 248n
population growth, 48, 72
post-modernism, 70
post-Saussurean thought, 70
power, technology and, 47, 49–50
pre-eclampsia, xiv
prefaces, x
pre-industrial society, nostalgia for, 30, 46–7, 54
probability, xiii
producers of art, 196–204
progress, 38, 55, 57
Prometheus, 52–3
propaganda, 82
Proudfoot, M. A., 178
Proust, Marcel, 33, 143, 147, 148–9, 175, 196–7, 200, 228n, 243n, 250n, 251n
psychology, 105, 157, 158
public debate, 71
Pushkin, Alexander, 80

quackery, 63–4
quantum theory, 59

Index

rainbows, 21, 22
rape, 137
rationalism, 12, 20
 loss of spirituality and, 20–5
Read, Herbert, 192
reality, comparison of art with, 87–8
recall, 104, 106, 175, 196
recording of experiences, 139–40, 143–4
referential art, 85
relationships, 136–7
relativism, 39
religion, xvi, xvii, xx, 53, 108, 123
 art and, 183–7
 see also spirituality
rhetoric, 34–7, 39
Robbe-Grillet, Alain, 190, 231n
Roberts, Robert, 51
robots, 117
Romanticism, hostility to science of, 9, 11–28, 45
Rostow, Eugene, 226n
Rutherford, Ernest, 16

sadomasochism, 88, 163
sand castles, 141
Sartre, Jean-Paul, 124, 150, 163–4, 185, 186, 206, 208, 230n, 231–2n, 243n, 252n
Schadenfreude, 51
Schiller, Johann, 20
Schlegel, Friedrich von, 12
Schmidt, Michael, 27, 219n, 242n, 250n
Schopenhauer, Arthur, xi, 119, 165, 190, 245n
science and technology, xv, xviii–xx
 benefits of, 14, 43–7
 co-operation in, 58–60
 counter-intuitive nature of, 7–8
 'dehumanising' influence of, 33–4, 42–54
 division from arts of, 3–4, 16, 29, 72
 future convergence of art with, 209–13
 ignorance about, 5–6, 70–72
 imagination in, 16–20
 intellectuals' difficulties with, 3–10, 29–41, 42, 47, 52–3, 55–67, 68;
 consequences of, 68–73;
 refutations of, 35–7, 39, 40, 42–54; Romanticist legitimation of, 9, 11–28, 45
 limitations of, 57–8
 spiritual loss and, 20–8, 52–4, 55, 64–5
 truth of, 24–5, 37–8, 40, 70
 writing on, 6–7
sentimentality, 46, 51, 54, 88
sexual relationships, 136–7
sexuality, 101–2, 118–19, 163
Seymour-Smith, Martin, 56, 81
Shaw, George Bernard, 177
Shelley, Percy Bysshe, 12, 16, 90
Sheppard, Anne, 169, 229–30n
slavery, 49
smallpox, 60
Smith, John Maynard, 35
Smith, Richard, 221–2n
snobbery, 86–7
Snow, C. P., 3, 4, 6, 29, 31, 32, 56, 72
social commentary, 71
social construction of science, 37, 39
social control, technology and, 47, 49–50
social occasions, 102
Sociology of Scientific Knowledge (SSK), 39–40
Solzhenitsyn, Alexander, 81
Sontag, Susan, 61, 223n
Soviet Union, 59–60, 81
space programme, 59–60
Spencer, Herbert, xvii–xviii
Spinoza, Baruch, 23
spirituality, science and loss of, 20–8, 52–4, 55, 64–5
Spivak, Gayatri Chakravorty, x
Steiner, George, 42, 51, 63, 100, 244n
suffering, 163–4
 relief of, 55–8
Sunday Times, The, 61
symmetry, 153

technology, *see* science and technology

telecommunication, 44
Terpander, 185
theology, 17–18
therapy, art as, 199
Tolstoy, Leo, xii, 79–80, 84, 88, 92, 111, 171, 225n, 230n, 246n
Trilling, Lionel, 8–9, 31, 72, ,84
Turnbull, Colin, 51
tyranny, 49–50, 58, 81–2, 227n

universal theories, 22

Valéry, Paul, x–xi, 107, 110, 160, 165, 177, 207, 220n, 244n, 252nn
values of art, 86–7
Vietnam War, 83
Voltaire, 12, 26

Wagner, Richard, 80

warfare, 50, 118
Watson, James, 36
Weber, Max, 20
Weigel, George, 226n
Weissman, Gerald, 13, 21, 216n
Whitehead, A. N., 18, 22, 88, 95, 173
Wilde, Oscar, 80, 111, 230n
Williams, Raymond, 30
Wittgenstein, Ludwig, 172, 228n
Wolpert, Lewis, 3, 7, 14, 39, 44, 65, 217n, 223n, 236n
Wordsworth, William, xvii, 13, 16, 21, 22, 23, 26, 232n
writing
 on science, 6–7
 see also literature

Yonge, Charlotte, 33
Young, Dudley, 184